THYSSEN-BORNEMISZA FOUNDATION

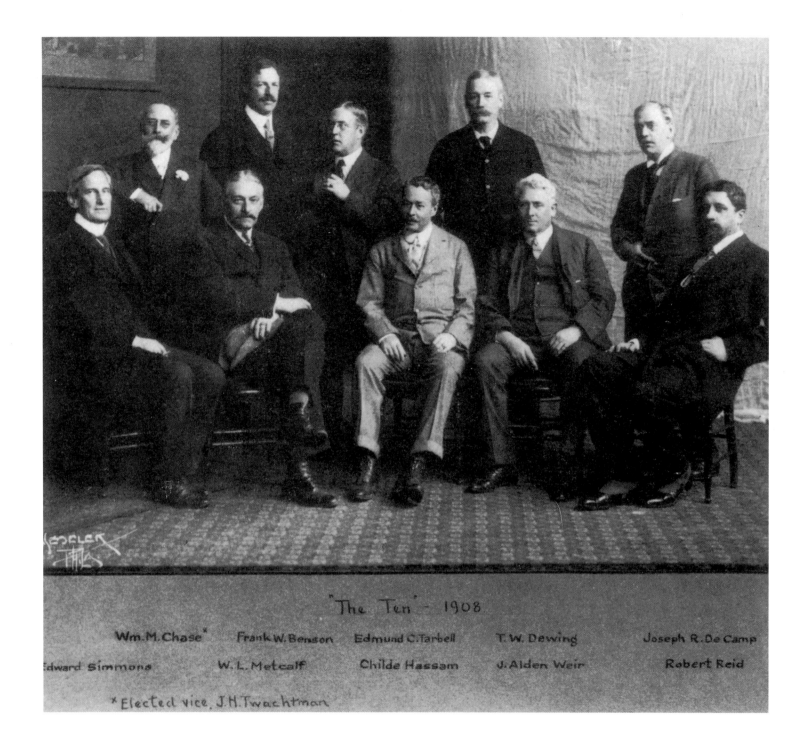

1 The "Ten American Painters", 1908

MASTERWORKS
OF
AMERICAN IMPRESSIONISM

BY
WILLIAM H. GERDTS

THYSSEN-BORNEMISZA FOUNDATION/EIDOLON

DISTRIBUTED BY HARRY N. ABRAMS, INC., NEW YORK

A publication of the Thyssen-Bornemisza Foundation
in cooperation with Eidolon AG in Einsiedeln (Switzerland)
and in conjunction with the exhibition, held in 1990 at the Villa Favorita,
Thyssen-Bornemisza Foundation, Lugano-Castagnola (Switzerland)

Library of Congress Cataloging-in-Publication Data

Gerdts, William H.
 Masterworks of American impressionism: exhibition catalogue / by William
H. Gerdts.
 p. cm.
 ISBN 0-8109-3614-3
 1. Impressionism (Art)—United States—Exhibitions. 2. Painting, Ameri-
can—Exhibitions. 3. Painting, Modern—19th century—United States—
Exhibitions. 4. Painting, Modern—20th century—United States—Exhibi-
tions. I. Title.
 ND210.5.I4G476 1991
 759.13'074'49478—dc20 90-46961

Published by Karl-Ulrich Majer, Eidolon AG, Einsiedeln
Production: Benziger AG Graphisches Unternehmen, Einsiedeln
All rights reserved. No part of this publication may be
reproduced, in any form or by any means, without permission
in writing from the publisher
© 1990 by Fondazione Thyssen-Bornemisza, Lugano-Castagnola
Distributed by Harry N. Abrams, Incorporated, New York. A Times Mirror Company
Printed and bound in Switzerland

CONTENTS

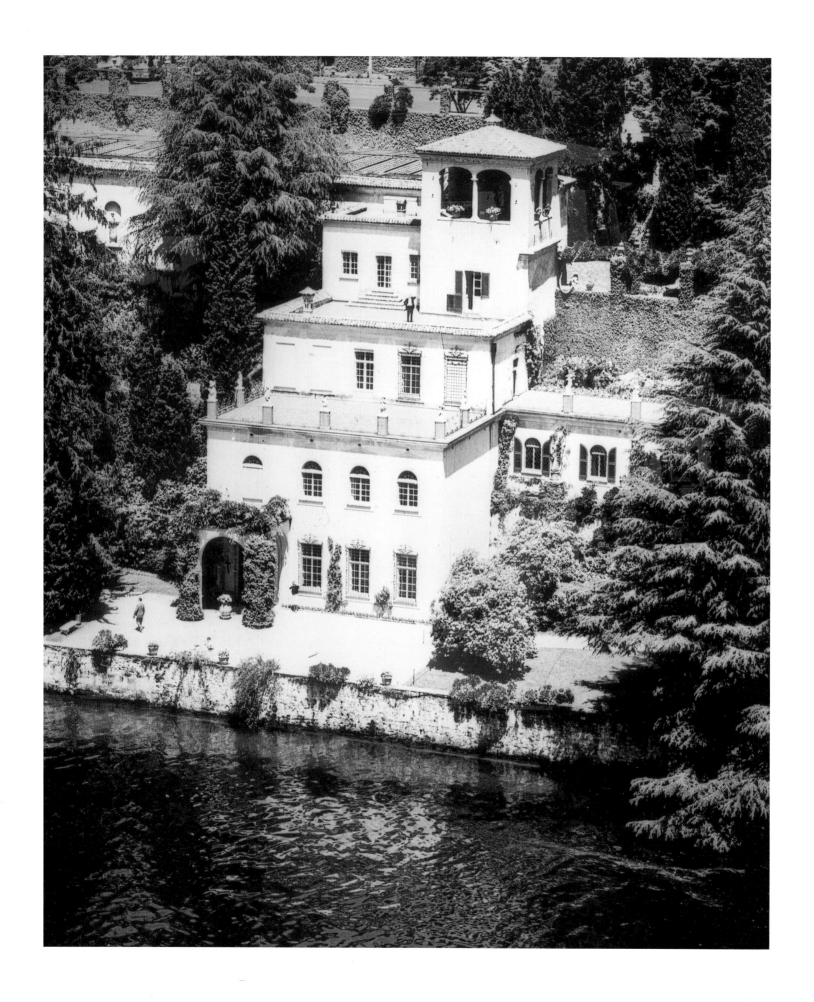

PREFACE

Hans Heinrich Thyssen-Bornemisza

Lugano is a quiet little town in the Southern part of Switzerland, where the collection of Old Master paintings which I inherited from my father in 1947 is housed. I have been adding to this collection all my life, and it now numbers close to 1500 paintings and works on paper by Old Masters, Impressionists and Post-Impressionists, Russian Avant-Garde artists, German Expressionists, Ballet and Stage designers, American 19th and 20th century artists, as well as contemporary artists. Although the gallery of Villa Favorita, where the Old Masters are permanently on display, has been open to the public since the death of my father, other parts of the collection are not exhibited. As the collection grew over the years, it came to the attention of a wider public, and I was often asked to show some of my paintings abroad. As a result, during the past fifteen years more than 30 exhibitions with various selections of some of the most important paintings in my collection have toured the world from Japan to Australia, from the Soviet Union to the United States. Then, in 1983—before anybody had heard about Perestroika—I was offered for the first time an exhibition in exchange for sending some of my Old Master paintings to the Soviet Union. I was able to bring a remarkable selection of the finest Impressionists from the Hermitage and the Pushkin Museum of Leningrad and Moscow to the Villa Favorita, in exchange for showing the highlights of my Old Master collection there. It became such a success in Lugano and in the Soviet Union that I have been organizing shows from other collections both private and public in Lugano since then.

Personally, I started collecting American 19th century paintings in the late 1970's. A magnificent catalogue on American luminism written by Barbara Novak introduced me to this fine period in American painting, and led me to acquire works by Martin Johnson Heade such as "Sunset at Sea" and "Spouting Rock, Newport"—which incidentally was on loan to the American Embassy in Geneva when Presidents Reagan and Gorbachev had their first historical meeting there. Eventually, I added works by the leaders of the American Impressionist movement: Chase, Hassam, Robinson and Twachtman. My most recent purchase is a work by Twachtman painted around 1890–1900 titled "Boats Moored on a Pond".

I now own around 300 American 19th and 20th century paintings, which constitutes the largest group of American paintings in Europe. The exhibition at the Villa Favorita "Masterworks of American Impressionism" documented in this volume, grew out of my interest in American painting, and was intended as an exciting follow-up to the exhibitions of French Impressionism which already had such an impact on the visitors to my gallery. Whereas names such as Monet, Renoir and Degas automatically come to mind when thinking about Impressionism, few people in Europe are familiar with the works of Hassam, Robinson and Twachtman—the greatest exponents of the Impressionist movement in the United States. One hundred years ago, this generation of American Impressionists produced compositions of extraordinary artistic vitality, which can be said to have prepared the way for art of the 20th century. Prof. William Gerdts, the foremost authority on American Impressionism today, accepted the post as Guest Curator. He made the selection of the very best of American Impressionism from public and private collections in the United States, and wrote in-depth essays and catalogue texts, with the thorough knowledge of an expert. In preparation for this exhibition, we met with enthusiasm and generosity when approaching museums and private collectors. I am delighted and infinitely grateful that so many agreed to participate in this show which has united the most important examples of American Impressionism ever exhibited outside the United States, and was called "A Feast for the Eyes" by the Swiss press.

I am convinced that the goodwill and mutual understanding generated by exposure to the cultural heritage of other people have contributed to the recent breakdown of political barriers. In this sense, I appeal to collectors and museums around the world to continue organizing important exhibitions despite the escalating cost increases, and to the general public to take advantage of every opportunity to familiarize themselves with art from near and far.

Lugano, January 1991

2 Glorietta and Gallery of the Villa Favorita

THE ARTISTS

Edward H. Barnard (1845–1909) p. 126–127

Frank Benson (1862–1951) p. 120–121

Maurice Braun (1877–1941) p. 136–137

John Leslie Breck (1860–1899) p. 48–49

Dennis Miller Bunker (1861–1890) p. 34–35

Mary Cassatt (1844–1926) p. 24–29

William Merritt Chase (1849–1916) p. 94–101

Joseph DeCamp (1858–1923) p. 122–123

Dawson Dawson-Watsch (164–1939) p. 50–51

Frederick Frieseke (1874–1939) p. 142–153

Danbiel Garber (1880–1958) p. 132–133

Philip Leslie Hale (1865–1931) p. 124–125

Childe Hassam (1859–1935) p. 52–71

Carl Krafft (1884–1938) p. 134–135

Ernest Lawson (1873–1939) p. 140–141

Williard Metcalf (1858–1925) p. 102–111

Richard Miller (1875–1943) p. 154–155

Joseph Raphael (1869–1950) p. 138–139

Edmund Reid (1862–1929) p. 112–113

Theodore Robinson (1852–1896) p. 36–47

Edward F. Rook (1870–1960) p. 128–129

John Singer Sargent (1856–19250) p. 30–33

Robert Spencer (1879–1931) p. 130–131

Edmund Twachtman (1853–1902) p. 76–93

Julian Alden Weir (1852–1910) p. 72–75

FOREWORD

Irene Martin

In 1983 Baron Thyssen-Bornemisza launched with "Impressionism and Post-Impressionism from Soviet Museums, Part I" the program of annual summer exhibitions which has become a great success. Four years later, Part II was held with equal popularity, and in the Spring of 1990 Impressionist and Post-Impressionist works from the collection of Baron Thyssen-Bornemisza were exhibited. The artists and works of these movements of art are very popular with the public, yet few Europeans are familiar with American Impressionist artists and their work. To introduce Europeans to this important aspect of American art history, the Thyssen-Bornemisza Foundation decided to follow up the exhibitions of European Impressionism with that of American Impressionism.

This is not the first exhibition of its kind to be held in Europe. In 1982 the Smithsonian Institution's travelling exhibitions program organized an exhibition which was shown in Paris and Eastern European countries, but it was not on the scale or importance of the current exhibition. Once a decision to have an American Impressionism exhibition was made, there was no question that the curator would be no other than Professor William H.Gerdts. Professor Gerdts, the leading scholar and authority on American Impressionism, accepted the curatorship of the exhibition on condition that it would be a masterpiece exhibition; if this was to be an exhibition introducing Europeans to American Impressionism, only prime examples by the key artists of the movement would be acceptable. Consequently, loans of the finest works by the major artists have been sought and received. The list is impressive and reflects the generosity and the desire of the lenders to present Europeans with the finest of American art. The Thyssen-Bornemisza Foundation is immensely grateful to many American museums and private collectors who have lent their paintings to this exhibition. To explain the development of American Impressionism, Professor Gerdts has written an introductory essay in this catalogue which traces its history from the first exhibition of French Impressionist paintings organized by Paul Durand-Ruel in 1886 at the American Art Association in New York City to the introduction of European Modernism at the Armory Show in New York City in 1913.

Baron Thyssen-Bornemisza has been collecting American paintings for two decades. The collection now numbers almost 300 paintings, and is the only significant collection of American art in Europe. It is appropriate that Villa Favorita, where the Thyssen-Bornemisza Collection is housed, should be the site of the most important American Impressionist exhibition in Europe.

Organizing an exhibition of this quality would have been impossible were it not for Professor Gerdts and Ira Spanierman. Mr.Spanierman has been of great assistance and support to the Foundation, and I am indebted to both of them for their efforts in making this exhibition become reality.

I am grateful to the gallery staff and interns who have each played an important role in the successful organization of this exhibition.

Lugano, July 11, 1990 Irene Martin
 Administrative Director/Curator
 Thyssen-Bornemisza Foundation

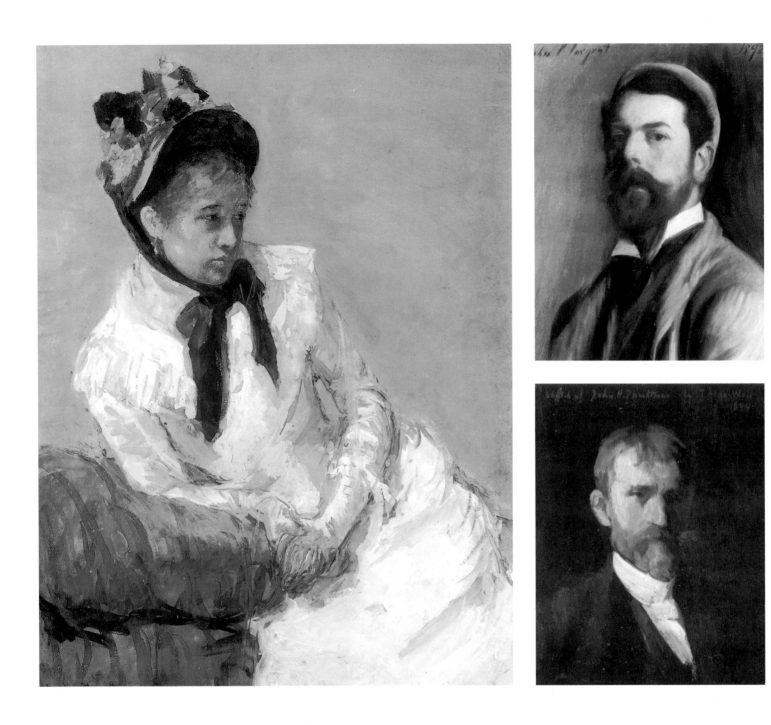

3 Mary Cassat (Self-portrait, 1878); 4 John Singer Sargent (Self-portrait, 1878); 5 John Twachtman (Portrait by J. Alden Weir, 1880)

AMERICAN IMPRESSIONISM

William H. Gerdts

1886 marked the crucial year for American awareness of the artistic innovations of the Impressionist movement. In April, in an effort to recoup his failing financial situation, the French dealer Paul Durand-Ruel mounted an exhibit of the work of Edouard Manet, Claude Monet, Pierre Auguste Renoir, Camille Pissarro, Alfred Sisley, Edgar Degas, Georges Seurat, and other Impressionist painters at the American Art Association in New York City. It was an immense show of almost three hundred paintings, many of which are esteemed today as among the masterpieces of the artists represented. Durand-Ruel had earlier established a reputation in the United States as a perceptive dealer in the paintings of the Barbizon School, and he hoped to repeat that success with the younger and more innovative artists whom he now represented. Nor was he disappointed; a good many of the pictures were sold and new collectors of advanced French art were established. The show attracted a large audience, and a great deal of critical controversy, and so popular was it that when it was necessary to vacate the Association's galleries, the display was transferred to the premises of the traditionally conservative National Academy of Design, where over twenty more works were added, these already owned by American collectors.

Until the 1870s, American awareness of contemporary European art developments had been sporadic and irregular; the mid-century in the United States was a period of strong nationalistic sentiment, one that celebrated a distinctly American nature, fostering an equation of the New World with a new Eden, a concept championed by artists, writers, and philosophers. Many American painters travelled to Europe, and some did study abroad at the time, occasionally in London and more in Düsseldorf, though they were constantly warned to "keep that wilder vision bright", as the poet William Cullen Bryant cautioned the departing landscape painter Thomas Cole in 1829. There had been collections of European paintings in the United States from the late eighteenth century on, though at first these emphasized primarily the work of Old Masters, spurious more often than not.

Individual examples of contemporary European artists occasionally appeared on exhibition in America beginning in the early nineteenth century: French Neoclassic paintings by Jacques-Louis David and others being toured to various cities, and English portraits by painters such as Sir Thomas Lawrence, which had been commissioned by travelling Americans. In general, however, Americans were extremely suspicious both of France and of French art, identifying the latter with a combination of sensuality and violence even while admiring the Gallic sense of design.

In the late 1840s European painting became more accessible to Americans, with several galleries specializing in French and German art established in New York City. A branch of the Parisian dealer Goupil was set up in 1848, and the Düsseldorf Gallery was instituted the following year, partly as a haven for pictures in the face of the tumult of the political revolutions of the period. In both cases, the paintings featured were generally those associated with the principles of the respective academies of Paris and Düsseldorf, and thus Americans came to associate contemporary art with traditional themes and forms. In the next two decades, the European dealers Ernest Gambart and Alfred Cadart periodically sent over collections of European painting for exhibition in New York and other American cities, and these featured a wider range of subject and style, even including the occasional work by Gustave Courbet and Claude Monet.

Newspapers and magazines also commented now and then on art events in the French capital, but such reports were not nearly as common and regular as those issued from Florence and Rome, except at the time of the International Expositions held in Paris in 1855 and 1867. The interest in the art galleries established at such fairs continued with subsequent Expositions held in 1878, 1889, and 1900. Likewise, American artists had not only visited and exhibited in Paris, but had occasionally studied with French masters even before the Civil War, but that earlier trickle of art students became a regular flow as young tyros gravitated to Paris from 1866 on, some entering the Ecole des Beaux-Arts and others studying privately with French masters or entering into the newly established academies, especially the Académie Julian.

But it is vital to understand the motivation of these young men and women; they were not seeking to ally themselves with avant-garde art causes, but rather to learn the fundamentals of traditional pictorial construction. They, along with American critics and American collectors, had begun to recognize the previous provinciality of American art, and they were anxious to rectify this, to establish themselves as the equals of their

European contemporaries and to be able to compete in an international art market, just as the new American rich were now purchasing not only Old Master paintings and *objets d'art,* but also the work of approved French Academic and Barbizon masters such as Jean-Léon Gérôme and Camille Corot. The perceptive critic William Crary Brownell succinctly acknowledged the change in America art in an article in *Century* in May of 1880; he pointed out that American art had lost its characterlessness, and that "We are beginning to paint as others paint." Those American art students travelling for study in Paris during the 1870s and 1880s did not do so in order to fall under the sway of Monet and Degas, though by the late 1880s some were attracted by the aesthetics of Impressionism once they were in France; in all cases, however, the young Americans had first sought academic training.

It is surprising, however, that during the period in Paris of greatest ferment concerning Impressionism, from 1874-86, when the artists of the movement exhibited together, so few American painters and critics evinced any awareness whatsoever. When they did, it was invariably disparaging; even the future Impressionist American J[ulian] Alden Weir described the third Impressionist show of 1877 as a "Chamber of Horrors" in a letter to his family. By and large, however, most Americans were oblivious to Impressionism before 1886. The term was critically in use earlier, from about 1870, but it was generally held to mean pictures that was sketchily painted and that seemed rough and preliminary, and such work was condemned as unfinished. This earlier interpretation of Impressionism generated its own controversy over the merits of the sketch, and the innovative tendency to acknowledge and admire the sketch for its own sake, even allowing such work into exhibitions. Sketches began to appear with the Society of American Artists in New York City, newly founded in 1877 as a display forum largely for the modern work of young Americans back from their European training, in contradistinction to the more conservative painting and policies of the older National Academy of Design. A few years later, in 1882, the American Art Gallery in New York instituted the holding of exhibitions solely devoted to the sketch, a policy which was continued the following year by its successor, the American Art Association. These shows exacerbated the critical controversy.

It should be noted that this earlier interpretation of the aesthetic of Impressionism was associated with artists newly trained not only in Paris but in Munich, and indeed, such work was often marked not only by an unfinished appearance but also by strong tonal contrasts of blacks, browns, grays, and white which were a hallmark of the radical Munich style introduced around 1870 by Wilhelm Leibl, the German artist strongly influenced by Gustave Courbet and a renegade from the official manner of the Munich Royal Academy. Again, Leibl's American followers such as Frank Duveneck, William Merritt Chase, and J. Frank Currier had gone to the Bavarian capital to learn traditional strategies, but were fascinated by the breadth and freedom of Leibl's nonconformity, which they adopted and then introduced into the early shows of the Society of American Artists.

This was Impressionism in the United States, prior to 1886. Actual French examples of the movement were extremely rare in American exhibitions, and only a few such works can be documented in American collections before the Durand-Ruel show. In 1875 Mary Cassatt had persuaded her friend Louisine Elder (later Louisine Havemeyer) to purchase Degas' pastel and gouache *Ballet Rehearsal* (now in the Nelson-Atkins Museum of Art in Kansas City); the work was exhibited in New York City at the 1878 show of the American Watercolor Society, which may have been the first French Impressionist picture on public display in the United States. Manet's *Execution of Maximilian* (Kunsthalle, Mannheim) was shown the following year in Boston and New York, and in 1883 Durand-Ruel sent over a significant group of nineteen Impressionist pictures to the Foreign Exhibition held in Boston, while that same year two privately owned early Manets and a Degas oil appeared in the Pedestal Fund Art Loan Exhibition in New York, a show held to raise funds for the pedestal for Bartholdi's *Statue of Liberty* in New York harbor. So, the confusion concerning Impressionism was gradually clearing up, and its proper identification with the French aesthetic had begun to emerge even before 1886, but that exhibition was crucial both to American patronage of the French Impressionists and American adoption of the aesthetic.

The importance of this exhibition in regard to the acceptance of Impressionism in the United States has been recognized for some time; what has not been acknowledged is its impact upon the selective nature of the American response to the movement. The reviewer in the *Critic* on April 17, 1886, noted that "The tenderness and grace of impressionism are reserved for its landscapes; for humanity there is only the hard brutality of the naked truth . . . One might say that the feminine principle of impressionistic art is embodied in its landscapes and the masculine in its figures." Likewise, the writer in the April, 1886, issue of *Art Age* reflected that "The figure subjects and the landscapes have in common their truth, their magnificent handling, their strength of color and, in some cases, their intentional neglect of tone. But here the analogy ends. The complex problems of human life which make the figure subjects so terrible in their pessimism and seem to fill the air with cries of uneasy souls, have no part in the landscapes. These are wholly lovely, with the loveliness of repose and the tenderness of charity. They are full of heavenly calm."

American critics, and very likely at least some patrons, were aghast at most of the figure pieces by Manet, Degas, and others—the critical literature abounds in terms such as "uncouth", "unpleasant", "ugly", "brutal", "vulgar", "repulsive", "disagreeable", "disgusting", "offensive", "unnatural", "depraved", and "monstrous". The landscapes, on the other hand, were "poetic", "sensitive", "joyous", and "charming". No wonder, then, that once American artists, in turn, adopted the Impressionist aesthetic which some of them, at least, had encountered in the 1886 Durand-Ruel show in New York, they opted primarily for landscape work, while others who were more concerned with the figure applied the strategies of Impressionism to the more traditionally acceptable themes of radiant children and ideal, even virginal young women, and eschewed the scenes of modern, usually urban life found in the streets, theatres, and cafés, subjects preferred by many of the French figurative Impressionists. Early in the nineteenth cen-

tury, landscape had been recognized as *the* American pictorial theme, one that embodied the natural history of a nation that had no appreciable human past. While figure painting assumed new importance in the work of those artists academically trained in Munich and Paris who returned home during the 1870s and 1880s, Impressionism renewed the justification for the primacy of landscape. It was true that such scenes no longer embodied the myth of national identity or even were necessarily American views, but a whole aesthetic philosophy developed in the early 1890s in the Midwest, under the leadership of the writer-critic Hamlin Garland, calling for a native Modernism at once formally Impressionist and thematically distinct to the American heartland.

It is not surprising, also, that of all the French painters represented in the 1886 exhibition, it was Monet, the pure landscapist, who received the greatest adulation and found tremendous patronage among American collectors over the next decade; Camille Pissarro wrote to his son Lucien on July 3, 1896, that "Monet alone is recognized in America, enthusiasm for him has reached such a point that Raffaelli actually heard a lady say: 'Monet is so great that all the other painters ought to paint Monets'." Literature solely devoted to Monet began to appear in American periodicals in 1887. Paintings by Monet increasingly appeared in group shows in American commercial galleries and public exhibitions throughout the Northeast and Midwest, and one-artist exhibits of Monet's work began to be mounted in 1891, with a show at the Union League Club in New York, followed by one at the St. Botolph Club in Boston in 1892. Even before then, the work of Monet's American followers who had gathered in his home village of Giverny in 1887 had begun to appear in exhibitions in New York and Boston during the next several years.

A decade earlier, Mary Cassatt had joined the ranks of the French Impressionists, exhibiting with them in their fourth Parisian exhibition in 1879. She had previously studied at the Pennsylvania Academy of the Fine Arts in Philadelphia and then with a series of French academic and traditional masters, before a trip to Spain in 1872 where she painted a series of modern life subjects in Seville. These strongly tonal works, with their rich coloration and their bravura brushwork derived from Velásquez, were related to the earlier Spanish subjects of Edouard Manet and were not Impressionist, but they paved the way for the figure paintings she created under the influence of Edgar Degas, her mentor and long-time friend, with whom she began an association in 1877. One of the pictures she showed with the Impressionists in 1879 was condemned by a reviewer in the *New York Times* as "a dirty-faced female", who nevertheless recognized her relationship with Degas, and from then on Cassatt was identified as an advocate of Impressionism.

The following year, Cassatt began to investigate the theme of the mother and child with which she ultimately came to be primarily associated; it was a subject explored also by a number of other American expatriate women artists such as Alice Kellogg and Elizabeth Nourse, but only Cassatt was identified with the Impressionists. Like many of her French colleagues, she moved away from the free brushwork and varied chromaticism of that aesthetic during the 1880s, establishing a new formal emphasis upon drawing and pattern, in part derived from

her fascination with Japanese prints. From a well-to-do background, Cassatt was greatly influential upon wealthy American collectors whom she directed toward the work of Degas, Monet, and other French Impressionists, but her own paintings and pastels were not often on view in her native country until the 1890s, when the movement had already become popularized in the United States.

Cassatt's fellow-expatriate John Singer Sargent was also associated with the Impressionist movement in Europe, although more briefly, and in England rather than France. He had already established himself as an up-and-coming society portraitist when he settled in England in 1885, and that summer began to work out-of-doors in an Impressionist mode in the art and literary colony of Broadway in Worcestershire, during the summer and early autumn. Sargent is believed to have become acquainted with Claude Monet in Paris as early as 1876, but the full impact of Monet's aesthetics was not revealed in Sargent's summer painting until 1887, when he visited Monet in Giverny and also began to acquire a number of landscapes by his French colleague. Sargent's experiments with Impressionism are best identified with a series of depictions of artists painting outdoors in just the manner that he himself was engaged, and in pictures of young women lying in boats, walking along paths, and fishing, which mirror the similar treatment of such themes by Monet himself. Sargent's Impressionist canvases are relatively few, consisting of holiday work done in 1885-89, and they were seldom on view publicly, but the several examples such as *A Morning Walk* that he brought to the United States in 1890 were shown extensively that year, and undoubtedly supported the growing interest in Impressionism that was developing at the time. More specifically, Sargent influenced his younger Boston colleague Dennis Miller Bunker to explore Impressionist strategies in his outdoor landscape work during the summer of 1888, when Bunker was visiting Sargent in Calcot, on the Thames River. The short-lived Bunker brought this manner back to Boston that autumn, and though he died only two years later, the charismatic artist helped make Impressionism acceptable when he exhibited such work in exhibitions in Boston and New York, where his radical paintings attracted such prominent Boston patrons as Mrs. Jack Gardner.

The way was thus paved to some extent when the American contingent who had visited and worked in Giverny began to send Impressionist pictures back to exhibitions in the United States, or returned themselves and started showing their Giverny pictures in Boston and New York. The first group of Americans in Giverny arrived together in the summer of 1887, although several of them appear to have made brief visits there individually during the previous two years. These consisted of six young painters from the United States—Theodore Robinson, Theodore Wendel, John Leslie Breck, Willard Metcalf, Louis Ritter, and Henry Fitch Taylor—along with the Canadian artist William Blair Bruce. Most of them were art students in Paris, though they subsequently spent appreciable time in Giverny, painting scenes in the town and the local countryside, sometimes featuring the townspeople, and investigating aspects of color, light, and vigorous brushwork. As the Boston critic for the *Art Amateur* reported in October of 1887, "Quite an American colony has gathered, I am told, at Giverny . . . A

6 William Merritt Chase
7 Philip Leslie Hale
8 Theodore Robinson

few pictures just received from these men show that they have got the blue-green color of Monet's impressionism and 'got it bad'."

Presumably these artists, and those painters whom they in turn attracted to Giverny during the next several years, such as Dawson Dawson-Watson, Guy Rose, Lilla Cabot Perry, Henry Prellwitz, Theodore Butler, Philip Leslie Hale, Henry Howard Hart, and others, all came into some contact with Monet, but it seems likely that the French master was intimate with only a few of the Americans. Monet is known to have increasingly resented the growing presence of an art community in his peaceful village, and he was disturbed, too, over the amorous interest taken by several of the Americans in his future step-daughters, the three Hoschedé sisters; he successfully discouraged Breck from his pursuit of Blanche, but Butler did marry Suzanne in 1892, becoming the one permanent American member of the Giverny colony.

Breck remained in Giverny during the winters of 1888 and 1889, when many of his colleagues returned to Paris or the United States, and he seems to have profited from his contact with Monet almost more than any of his fellow-Americans, with the possible exception of Lilla Perry, suggesting that his initial reception was quite cordial. He was back in New England in the summer of 1890, and a show of his work held in November at the St. Botolph Club in Boston elicited a critical uproar over the avant-garde nature of his French scenes, which were recognized as reflecting Monet's aesthetic. Breck was back for the last time in Giverny during the summer and autumn of 1891.

Many of the American artists who visited and painted at Giverny in the late 1880s were Boston painters. Theodore Robinson, who has subsequently been acknowledged as one of the finest and most significant of the American Impressionists, was based in New York City, and it was he who established the strongest friendship with Monet. Monet, in fact, was reported in the press as the teacher of both Robinson and Breck, which was untrue, but he was certainly Robinson's mentor, and the closeness of their relationship is documented in the surviving volumes of Robinson's diaries. Robinson had settled in Giverny by 1888, and for the next four years spent the late spring, summer, and autumn there, returning to New York for most of the winter and early spring in order to participate in the major art activities there. Thus, it was in the spring of 1889 that he first showed his Impressionist Giverny scenes at the Society of American Artists, along with those of the still little-known Henry Fitch Taylor, at which time Robinson was acknowledged in New York City as the principal American adherent of Impressionism.

Robinson's still hesitant conversion to the Impressionist mode was announced in *La Vachère* of 1888, one of his few Salon-size canvases. The fluid brushwork and dappled sunlight do not disguise his traditional concern for peasant imagery, a heritage from the much-admired work of Jean-François Millet. The overlay of Impressionist strategies upon the activities of the working country folk remained a constant with Robinson's art during his Giverny years, and this amalgam can be seen also in the French paintings of his colleague, Dawson Dawson-Watson, who would later settle in America, becoming the leading exponent of that aesthetic in St. Louis.

Year by year, Robinson's painting became looser and more dashing, and his color sense increasingly brightened, though he continued to favor a contrasting spectrum of varied greens with violet and mauve tones, seldom indulging in the broad chromaticism of Monet. Sound draftsmanship remained a constant concern also; Robinson's diaries, written both in Giverny and later after his final return to the United States in December of 1892, reveal an artist constantly unsure of himself, revelling in the spontaneity of the new art and yet wishing to preserve the sound practices that he had so carefully nurtured in his Parisian studies. Indeed, this was a dilemma faced by many of the American Impressionists, who found it difficult to reconcile the academic traditions which they had pursued so diligently and for so many years in Parisian ateliers, with the new freedom implicit in the strategies of Impressionism. This is one reason why the work of some of these artists appears almost schizoid, with their figure painting maintaining the strong structural components of their formal training, and the landscape work, often done during the summers, reflecting their more avant-garde investigations.

Though Robinson would certainly have been aware of Monet's earlier serial images such as his Haystack sequence, he was particularly struck on his return to Giverny in the spring of 1892 with the first group of impressions that Monet had painted of the facade of Rouen Cathedral, and during the subsequent months, Robinson emulated his mentor with several landscape compositions repeated at different times of the day and in varying light and weather conditions. 1892 thus stands as perhaps the year of Robinson's greatest involvement with Impressionism, and certainly he seldom painted a more beautiful, full-color work than *La Débâcle.*

After returning to New York at the end of the year, Robinson settled into the art life of the city, frequently visiting his friend and fellow-Impressionist John Twachtman at his home in Greenwich, Connecticut. The following summer he taught out-of-doors classes for the Brooklyn Art School at Napanoch, New York. Though Robinson despised teaching, and appears to have been ill-suited to it, he produced that summer some of his freshest and most colorful American landscapes along the Erie and Delaware Canal. The following summer he taught at the School at Princeton, New Jersey, with less satisfactory results for his own art, but the works he painted at Cos Cob in 1894, while visiting Twachtman, are among his most beautiful, and some, such as *Boats at a Landing,* are his most abstract conceptions, reflecting the enthusiasm over Japanese prints which he shared at the time with Twachtman and J. Alden Weir. Robinson's early death in 1896 deprived American art of one of its finest Impressionists.

It was very soon after Robinson was recognized as New York's first native Impressionist in 1889 that he was joined in that distinction by Childe Hassam, a much longer-lived painter, and the artist most completely identified with the movement. Hassam was born in Dorchester, Massachusetts, and studied and made his reputation first in Boston; his New England heritage would later figure strongly in his art in his respect for early American traditions, a factor which was recognized by a number of the many writers who acclaimed his work. Hassam first went abroad in 1883, travelling throughout the European con-

tinent, but there appears no reference to any knowledge of the French Impressionists either in documentation or in his subsequent work. He emerged as a professional artist first in the medium of watercolor; he then began to paint strong Tonal oils of American landscape and farm scenes. His first major accomplishments, however, were in the realm of city- and townscapes painted in Boston and on Nantucket Island. These dramatic views of modern life, often involving modifying temporal conditions—rain, winter snow, twilight hours—were painted in a relentlessly objective, Naturalist mode. The theme of urban life viewed in regard and reacting to weather and time remained of central importance to Hassam's art, even after he surrendered to the color, light, and broken brushwork of Impressionism.

This occurred in 1887, probably soon after he returned to Europe in the fall of 1886, settling in Paris where he studied at the Académie Julian; his *Grand Prix Day,* one version of which is in the present exhibition, would seem to be a key work in Hassam's formal "conversion" to this then avant-garde style. But Hassam's Paris street scenes suggest further parallels with those of his French Impressionist contemporaries. His Boston pictures generally concentrate as much on the city's buildings and their fascinating spatial interplay with the avenues, parks, and squares as they do on the inhabitants. There is information to be gleaned about urban life from these pictures, but even more from his Parisian and later New York scenes, painted under the impact of Impressionism. These, too, often reflect wet weather; when he sent some pictures back to Boston for exhibition at Noyes, Cobb & Co., the writer for the *Boston Evening Transcript* advised the artist to "come in out of the rain."

Many of Hassam's city scenes, however, like *Grand Prix Day,* are painted in radiant sunshine, where the bright colors of costumes and parasols sparkle; Parisian flower vendors are featured in a good number of the pictures he painted during 1886–89, his longest European sojourn. While the city remained his principal theme, he and his wife summered outside of Paris at Villiers-le-Bel, where garden views, sometimes featuring Mrs. Hassam, allowed the artist to develop his landscape skills within the strategies of Impressionism.

On his return to the United States, Hassam settled in New York rather than Boston, devoting much of his talent to painting the metropolis during the autumn, winter, and spring. His summers were spent chiefly in New England, with the Island of Appledore, off the coast of New Hampshire and Maine, as his ultimate goal, though he passed through and occasionally painted in smaller towns along the way. His Appledore pictures, which constitute some of Hassam's finest work and at the same time most completely attest to his allegiance to Impressionism, reflect both the distinct topography and geological structure of the Isles of Shoals, and also often the devotion and gardening skills of Celia Thaxter, his island hostess, who was also a noted poet and writer. Though Hassam was not a prolific still-life painter, he created a number of beautiful formal depictions of flowers; the floral theme, however, surfaces even more brilliantly in the landscapes and garden scenes he painted in France and especially on Appledore.

Though Hassam continued to return to Appledore to paint during many of the summers that followed Thaxter's death in August of 1894, other New England towns often offered him greater inspiration—Gloucester, Newport, Provincetown, Cos Cob, and, from 1903 on, Old Lyme in Connecticut. Old Lyme had drawn artist-visitors from the mid-1890s on, and by 1899 it had begun to assume the reputation of an artists' colony, a center for American Tonalist landscape painting where it earned the epithet of "The American Barbizon." This identification, however, was short-lived, for Impressionism became the dominant aesthetic in Old Lyme with Hassam's first appearance there.

Hassam's own art, however, began to change in the late 1890s, taking on a new formal distinction with an emphasis upon stronger geometric construction in some of the work he painted early in 1895 on a visit to Cuba. This was combined with thicker impastos and an all-over decorative patterning of vivid brushwork in many of the pictures he created on his third trip to Europe in 1896-97, scenes painted in Capri, Rome, and Florence in Italy, and in Paris and Brittany in France, which suggest some contact with Post-Impressionism. These new decorative and somewhat anti-naturalistic tendencies surfaced in some of his Old Lyme work, though not consistently, and they characterize some of the landscapes he painted on his several trips out West in 1904 and again in 1908 when he visited his friend the amateur artist Colonel Charles Erskine Scott Wood. Hassam painted murals for the library of Wood's home in Portland, Oregon, and he accompanied his patron to the vast open reaches of the Malheur and Harney deserts, where Hassam essayed a new reductiveness which in turn reached its apogee in several seascapes he painted in 1911 off the coast of Appledore.

While Hassam travelled extensively, he maintained his studio at various locations in New York City, and continued to find the city fertile subject matter for his brush. In addition, his growing thematic versatility was amazing. The idyllic nude, sometimes monumental, at other times almost absorbed into a limpid landscape, increasingly became a highlight of his exhibitions from around 1900 on, and was a feature of his Portland murals. Though the theme of labor and industry is not usually associated with Impressionism, especially in American art, Hassam investigated such subjects in the country, in small New England towns, and in the city, depicting shipbuilding at Gloucester, wood cutters at Old Lyme, and New York urban construction, culminating in *The Hovel and the Skyscraper* of 1904, in the present exhibition.

Hassam's interpretation of New York itself exhibits fascinating change. Many, though not all, of his depictions of the late 1890s are intimate, close-up views of figures on the street, seen from ground-level, and they concentrate upon the display of genteel life. But toward the end of the first decade of the present century he began to reflect the excitement of the new skyscraper construction and the growth of the metropolis. This appears both in his city scenes and in his many pictures of stately, usually contemplative women placed in elegant, well-appointed, and somewhat hermetic rooms, an environment which offers quiet security and which is often contrasted with a window view from on high, looking out upon the exciting, tall buildings and the busy metropolis.

This "Window" series, which Hassam continued to paint

through the end of the 1910s, was enthusiastically greeted by critics, some of whom believed these pictures to have been the artist's most memorable, but many of the pictures today seem somewhat dated and contrived. Equally reflecting Hassam's elation with the city is the still much-admired "Flag" series of 1916-19, where the national banners, first of the United States alone and then of its Allies in World War I, bedecked Fifth Avenue during various celebrations and parades. These constitute Hassam's finest paean to the urban environment, combined with a fervent patriotic stance, with the great colored banners unfurled against the monumental buildings, and with tiny ideographs below signifying the throng of city dwellers.

At the same time, Hassam's travels did not lessen. He went abroad for the third and last time in 1910-11, visiting Spain, France, and England, and in 1914 he visited California; the relationship of his art to the emerging Impressionist movement on the Pacific coast awaits further investigation. In the winter of 1925 he travelled to the American South, visiting Baltimore, Maryland; Richmond, Virginia; Charleston, South Carolina; and Savannah, Georgia. In 1927 he went to southern California, stopping in New Orleans and in Texas and Arizona, and a year later he travelled to Annapolis, Maryland, and Williamsburg, Virginia. By this time, however, he had begun to spend almost half of each year in the resort and art colony of East Hampton on Long Island, which he first visited in 1898, and where he purchased a house in the summer of 1919.

Hassam's long life witnessed the rise of the American Impressionist movement, its popular and critical triumph, and its gradual decline in the face of a more vigorous urban realism and the impact of European Modernism. It was he whom the artist-critic Albert Gallatin characterized in January of 1907 in *Collector and Art Critic* as "beyond any doubt the greatest exponent of Impressionism in America."

In addition to Mary Cassatt, whose position in regard to the development of Impressionism in America was somewhat anomalous, the leading figures of the movement have traditionally been identified as Robinson, Hassam, Weir, and John Twachtman. All four were friends as well as colleagues, but Weir and Twachtman were especially close, travelling to Europe together in the early 1880s, and later sharing several two-artists exhibitions, teaching together, and living in Connecticut in close proximity. Their personal adaptations of the Impressionist aesthetic were also similar to some extent, but their background and training were radically different. Weir was brought up in an artistic household, his father having held the position of Instructor of Drawing—later Professor—for over forty years at the United States Military Academy at West Point; Weir's older brother, John Ferguson Weir, was also a noted American painter of the late nineteenth century, and the first and long-time Director of the School of Fine Arts at Yale University in New Haven.

Julian, or J. Alden Weir as he is generally known, followed the usual course of training undertaken by young American art students of the Post-Civil War generation, first taking instruction in New York City at the National Academy of Design and then going on to Paris. There, Weir entered the Ecole des Beaux-Arts in 1873 where his teacher was Jean-Léon Gérôme, who instilled in the young American a respect for and the prac-

tice of traditional academic strategies, with which Weir interpreted the popular theme of the Breton peasant. He was one of the few American artists in Paris during the 1870s who is known to have become familiar with the work of the French Impressionists, which, as we have seen, he likened to a "Chamber of Horrors." His own allegiance at the time and for many subsequent years was directed toward the work of the much-admired French Naturalist painter Jules Bastien-Lepage. On his return to New York in 1877, Weir quickly became identified with the contingent of young advanced-minded European-trained painters and sculptors involved with the newly founded Society of American Artists; for the next decade his own art centered upon portrait and figure work much of which reflected the friendship he had formed with Whistler in London on his way back from Europe, and also upon dark and dramatic floral still lifes.

As with a number of progressive artists in New York during the 1880s, Weir's gradual sympathy with Impressionist principles first developed with his exploration of the pastel medium, the intrinsic qualities of which led him toward freer handling of the medium and a lighter, more colorful palette. In his oil paintings, critics began to identify Weir as an Impressionist only in 1891. This became increasingly evident during the 1890s, especially in the scenes painted in the vicinity of his several Connecticut homes, at Branchville and Windham. Weir's approach to Impressionism is much more allied with contemporary Tonalism than is that of Hassam and many of their American contemporaries, often concentrating upon relatively pale variations of one or two hues. Bastien-Lepage's influence continued to be seen in the concern in many of these pictures with labor and farmwork, and in the allied theme of rural industry.

John Twachtman grew up not in the eastern United States but in Cincinnati in the Midwest, and like a great many of the young art students of that region he went abroad to study in Munich rather than in Paris. There he successfully adopted the radical manner of bravura, sometimes choppy, brushwork and strong light and dark tonal contrast which had been developed by the German painter Wilhelm Leibl and had been adopted by Twachtman's fellow-Cincinnatian, Frank Duveneck. Twachtman first practiced this style in 1877–78 on a trip to Venice with Duveneck and William Merritt Chase, and then back in the United States in both Cincinnati and New York.

On a trip to the Low Countries with Weir in 1881, Twachtman met Anton Mauve, the leader of the Hague School of Painters whose work reflected French Barbizon principles to some extent, and this encounter may have influenced Twachtman's conclusion the following year that he had carried the Munich manner as far as he could. In 1883 he was back in Europe for further instruction, this time at the Académie Julian in Paris; Twachtman's work of the mid-1880s constitutes his "second" manner—thinly painted, low-keyed landscapes characterized by a gray light and soft tonalities, pictures which have been identified as reflecting the influence of Whistler and also of Oriental art.

Twachtman was back in the United States late in 1885 or early in 1886; relatively little of his work of the next several years has been located, but by 1889 he had settled in Greenwich, Connecticut, and the following year he purchased a pro-

9 J. Alden Weir; 10 Willard Metcalf; 11 Childe Hassam;
12 Dennis Miller Bunker

perty there which would remain his home until his relatively early death twelve years later. It was there that he developed his third, "Impressionist" style, primarily devoted to landscape painting, the soft formlessness of which often confounded the critics, but which was greatly admired by his fellow artists. Of all the paintings of the American Impressionists, Twachtman's has been the most admired as especially individual in its poetic subtlety, and it remained so even during the 1920s and after when the movement went out of fashion.

Most of Twachtman's art derives from his own environment, the trees, brook, and waterfall on his property, his house and barn, and the garden he developed, occasionally peopled by his family. Though he painted such subjects repeatedly, at different times of the year and expressing different moods of Nature, Twachtman abjured scientific phenomenological study in order to express the beauty and harmony inherent in a scene as well as his personal empathy. Like Weir, he seldom employed the full chromaticism of Impressionism, and was often at his finest working with variations among the gentle whites of winter.

Once settled in Greenwich, Twachtman abandoned the peripatetic existence he had earlier led, though he did travel to paint Niagara Falls early in 1894 and in September of the following year go to Yellowstone in the Rocky Mountains. But even with such natural wonders his interpretations are distinctly personal ones. During the last several years of his life, from about 1900–02, a greater dramatic force reentered his art with more decisive brushwork, increased structure to his compositions, and the reintroduction of black, factors which are evident especially in the paintings he created during his summer visits to the art colony of Gloucester on the northern shore of Massachusetts during those years.

A few years after he had settled in Connecticut, Twachtman established a summer art school at the Holley House in Cos Cob, then actually a part of the town of Greenwich. During the rest of the year, he taught at the Art Students' League in New York City, but only out of financial necessity, and he had little sympathy for studio instruction. In his out-of-doors summer classes, however, he was very successful, and numbered among his pupils several, such as Ernest Lawson, who went on to establish significant careers, often practicing an Impressionist approach which reflected their teacher's manner. Twachtman's good friend Weir joined him in this endeavor in 1892, and the artistic ambience was further strengthened by occasional visits to Cos Cob during the 1890s by others of Twachtman's colleagues such as Robinson and Hassam.

Twachtman's summer classes were part of the tremendous development during the 1890s of institutionalized outdoor teaching, a pattern which had had its origins during the previous two decades. The most successful such instruction was that offered at the Shinnecock School of Art on the south shore of Long Island by William Merritt Chase, who started the school in 1891; it operated until 1902. The teachers of such summer classes were not always Impressionists, and the students they produced were not always confirmed in their devotion to outdoor painting or to Impressionist strategies, but this still avant-garde style was often a factor in and a result of such instruction. As a writer noted in the *Art Interchange* in July of 1894, "these Summer schools have exerted a powerful influence on the char-

acter of our painting . . . We no longer have any doubt that the modern eye has been developed to see color, movement, light and atmosphere . . . Out of this enlarged vision and abler technique of the Summer schools, will come the geniuses of the next period in our art."

William Merritt Chase became, in fact, the most significant art teacher in the United States in the late nineteenth and early twentieth century. In his painting, he gradually abandoned the dark and dramatic manner he had learned in Munich in the 1870s, and in the urban landscapes Chase began to produce in the city, first in Prospect Park, Brooklyn, in 1886, and subsequently in Central Park in Manhattan, the investigation of color and light applied to casual modern-day subjects ally his work with that of the French Impressionists, even earlier than that of Robinson and Hassam. And in the vibrant brushwork and color of his Shinnecock scenes of the 1890s, painted during the summers he was teaching his outdoor classes, Chase's canvases often took on the full range of Impressionist concerns. They are also among his finest pictures as well as some of the most beautiful produced by any American Impressionist.

Chase, in fact, not only paralleled Twachtman's involvement in outdoor teaching but also replaced the latter in 1905 as a member of The Ten American Painters. This was a group of painters who seceded from the Society of American Artists late in 1897 in order to exhibit together in small, carefully chosen shows, displaying works of high quality and stylistic affinity. The Ten American Painters have been characterized as a kind of academy of American Impressionism, but this was not strictly true even at the start. Thomas Dewing, for instance, was a Tonalist figure painter, Edward Emerson Simmons was primarily a muralist, and Munich-trained Joseph DeCamp was working in a dark, somber manner at the time. However, the dominant figures in the founding of The Ten—Hassam, Weir, and Twachtman—were leading artists among the Impressionist movement. The Society of American Artists had been the principal venue for American Impressionism from 1889 on, and subsequently Impressionism had been seen by the critics to have dominated some of the Society's annual shows. However, a conservative clique of more academically oriented painters had come to prevail at the Society since its progressive beginnings in 1877, and had begun to take a stand against Impressionism in the mid-1890s.

The Ten American Painters held their first annual exhibition in New York in the spring of 1898, and though the press at first deplored their secession from the Society, critics subsequently began to look forward eagerly to the carefully selected annuals which continued for twenty years. Many of the exhibitions went on for a second display in Boston; Philadelphia and Providence, Rhode Island, were each also home to several shows of the group, while in 1906–07 a travelling selection of pictures by The Ten toured the Midwest. Their final appearance was a retrospective held at the Corcoran Gallery of Art in Washington, D. C. in 1919.

Two other New York-based members of The Ten were Willard Metcalf and Robert Reid. Metcalf was one of the coterie of American art students who had descended upon Giverny in 1887, though he had made individual visits two years earlier. Though his Giverny experience introduced greater freedom and

breadth into Metcalf's painting, it was not until 1895, while painting in Gloucester, that the artist adopted the rich color range of Impressionism, and only in the early years of the present century that he became firmly committed to the strategies of that aesthetic. These he subsequently exercised in landscapes painted especially throughout New England: first in Boothbay in Maine in 1903–04; and subsequently in Old Lyme and Waterford on the Connecticut coast and around Falls Village in the western part of that state; around Cornish, New Hampshire; and around Chester, Vermont. Metcalf painted during all seasons of the year, but he was especially noted for his renditions of vividly colored autumnal landscapes and for his winter scenes. It was Metcalf especially among the Impressionists whom critics identified as having extolled the beauty of America.

While Robert Reid also painted an occasional landscape he was known chiefly as a figure painter. Having trained in Paris during the 1880s, he returned to the United States in 1889 and developed an artistic career often dominated by his involvement with extensive commissions for mural paintings and stained glass. Impressionist light and color was introduced in his work as early as his 1890 *Reverie* in the present exhibition, but the majority of his subsequent figure paintings are monumental images of attractive young women associated with flowers, sometimes with great masses of blooms. These were critically recognized in their own time as decorative conceptions when they appeared in the annual exhibitions of The Ten American Painters.

Three members of The Ten—Edmund Tarbell, Frank Benson, and Joseph DeCamp—were Boston artists, and all of them, like Reid, were specialists in figure and portrait painting. Impressionism in Boston became quickly identified with figural work, despite the initial impact made there by such landscape painters as John Leslie Breck; even the landscapist Edward Barnard achieved his finest pictorial statement in his *River Weeders,* a rare excursion into the theme of rural toil.

By the early 1890s, Paris-trained Edmund Tarbell became recognized as the leader of the Boston Impressionist contingent, and by 1897 these artists had become identified as "The Tarbellites" in an article published by the noted critic Sadakichi Hartmann in *Art News* in March of 1897. Tarbell first had established the basic characteristics of Boston Impressionism with his impressive *Three Sisters—A Study in June Sunlight* of 1890, acquired by Mrs. Montgomery Sears, one of Boston's principal art patrons, and the artist followed this up the following year with his even more monumental *In the Orchard.* Such paintings presented attractive young upper-class women in bright sunlight out-of-doors, garbed in attractive light-colored summer costumes, and shown free from the cares or even an awareness of the urban world. Tarbell's figures were admired for their healthy normality, a quality even more greatly associated with the work of his close friend and colleague Frank Benson, most of whose outdoor pictures were created at his summer home on the island of North Haven, Maine.

Though the work of Tarbell and Benson often offers startling similarities, Benson began to paint in an Impressionist manner out-of-doors somewhat later than Tarbell, beginning to do so just before the turn of the century; his figures are often

more active than Tarbell's and he painted in an even higher key, with his women and young children often dressed in sparkling white. The dominance in Boston of these two artists and their aesthetic was enhanced not only by the rapid appreciation and popularity of their work, but also by their involvement in teaching at the School of the Museum of Fine Arts in Boston, which they both joined in 1889, and where they continued until December of 1912. While the two painters may not have been dogmatic in their classroom instruction, a great many of the pupils who emerged from the school chose to portray similar subjects in a manner emulating the styles of Tarbell and Benson.

Another teacher at the Museum school, though not as closely associated either personally or aesthetically with Tarbell, was Philip Leslie Hale, who spent considerable time in Giverny in the late 1880s and during the 1890s, both before and after he joined the faculty in 1893. Hale's subject matter was similar to that of Tarbell, consisting of lovely, active young women assembled out-of-doors either in Giverny or in Matunuck, Rhode Island, at the home of his aunt, the artist-writer Susan Hale, but his style was quite different. It constituted one of the most radical aesthetics among the American Impressionists during the 1890s, with figures sometimes in an advanced state of dissolution and the scene saturated in sunlight which was interpreted in chrome yellow, with the colors often applied in a stippled fashion allied to that of the French Pointillists.

Hale's extreme interpretation of Impressionism confused the critics, and by the early years of the twentieth century he had retreated to a more modified and by then far more acceptable aesthetic, though lovely women outdoors remained a favorite theme. Hale's involvement with the teaching of traditional drawing may have helped to define this more conservative stance, as did his marriage in 1901 to one of Boston's finest and most sensitive draftspersons, Lillian Westcott Hale.

Probably the most significant factor in the realignment not only of Hale's art but that of almost all the Boston Impressionists was the new appreciation that developed for the art of the seventeenth century Dutch painter Jan Vermeer of Delft. Vermeer had been forgotten in the annals of art soon after his death, only to be rediscovered by European critics in the 1860s, but the early reflections of this revival began to appear in the United States only at the end of the century. It was Hale's publication in 1904 of a monographic study of Vermeer in the *Masters of Art* series that sparked the conscious emulation of Vermeer's subtle tonal contrasts and his sensitive handling of light, which Hale and his Boston colleagues adopted in their interpretations of refined women in sparse but elegantly painted interiors.

By the time Hale's monograph appeared (he would publish a much fuller one in 1913 which was revised and appeared posthumously in 1937), Tarbell had been moving away from the bright outdoor sunlight of his early Impressionist painting, and in *Girl Crocheting* of 1904 he painted his most thorough and influential tribute to Vermeer's art. The picture was unanimously greeted as a modern masterpiece, considered not only Tarbell's finest picture but even by some writers as the finest American painting of its time. Tarbell went on to paint numerous modifications of this subject, and many of his colleagues in

Boston created variations. Joseph DeCamp's *The Blue Cup* is one of the most beautiful and successful of these, an attractive housemaid examining a precious piece of fragile porcelain, the beauty of which also reflects her own. DeCamp was a Cincinnati artist who had trained in Munich, but after he settled in Boston in the mid-1880s, he became thoroughly integrated with the artistic community there.

This later Boston manner was particularly identified with Tarbell and his circle, and became identified as an aesthetic distinction of the Impressionist art of that city. Boston figure painting was critically discussed as characterized especially by extreme refinement, and concerned only with polite truths; the canvases were peopled with women leading quiet, uneventful lives, and marked by a quiet, gentle complacency. Technically, the imagery was handled with great finesse, with very palatable truths rendered with great care and accuracy. As the Ten American Painters continued to show together for twenty years, Impressionism gradually lost its role on the cutting edge of art in the United States. The paintings by these artists came to be viewed as increasingly conservative, dedicated to a concern for beauty and harmony while maintaining the highest standards of formal control, and the work of the Boston members of The Ten appear to have dominated many of the annual exhibitions of the group, not in numbers but in proficiency and quality.

By the time the Ten American Painters were at the height of their acclaim, Impressionism had become the dominant aesthetic across the United States, though in some regions, such as the South, relatively few artists adopted the style and few collectors patronized it. Not surprisingly, Impressionist artists could be found in large numbers in those colonies in which outdoor painting, sometimes allied with summer teaching, was practiced. This was certainly true at Old Lyme, Connecticut. There, after the appearance of Childe Hassam in 1903, many other artists, both summer residents and those that remained year-round, were inspired to create landscapes characterized by brilliant color, bright sunlight, and scintillating, broken brushwork, often in emulation of the work of Hassam and Willard Metcalf who were painting there. Other painters such as Edward Rook investigated Impressionist strategies more independently. Rook first visited Old Lyme in 1903, moved there in 1905, and gave up his New York City address in 1907. His Old Lyme landscapes are characterized by vivid, almost Expressionist brushwork and heavily encrusted pigments, and although he chose the same natural and man-made subject matter investigated by both Hassam and the earlier Tonalists in Old Lyme, there is no mistaking his very original artistry.

Another major art colony developed early in the twentieth century on the Delaware River around New Hope, Pennsylvania, much celebrated in exhibitions and among art writers of the time. The work of some of the leading painters who were active there, such as Edward Redfield, was often contrasted to the pictures of the Boston school, the New Hope artists being identified as more vigorous and even more "democratic" in their predominantly landscape art, compared with the aristocratic refinement of Boston figural painting. Many Pennsylvania landscapes, however, appear only tangentially related to Impressionism. Among the more original artists of the New

Hope group were Daniel Garber and Robert Spencer, the former equally a landscape and figure painter, and the latter the one major American Impressionist to devote his art to themes of social consequence. Garber's pure landscapes are often very decorative and patterned, utilizing an arbitrary and restricted color scheme; in his figural paintings, which often center upon members of his family such as his daughter, Tanis, such landscapes serve as a decorative foil for figures dramatically placed *contre jour,* offering exciting explorations of transparency and light. Spencer's pictorial interests were primarily architectural, and were devoted primarily to recording the mills, shanties, and tenements of New Hope workers, the implicit drudgery of which was formally relieved by the bright colorism and exuberant brushwork of quite orthodox Impressionism.

In the Midwest, the large art colony that grew up in Brown County, Indiana, beginning around 1907 attracted painters not only from that state, but from as far away as Buffalo, New York, and Salt Lake City, Utah. There was a large Chicago contingent from the start, one of whom was Carl Krafft. As the artistic population there became increasingly crowded, however, Krafft sought out an alternative venue of untrammeled beauty, and found his natural paradise in the Ozark Mountains of southern Missouri. There, in the early 1910s, he established the Society of Ozark Painters, made up of Impressionist-oriented artists from Chicago and St. Louis, of which he was President as well as one of the finest practitioners.

While there were Impressionist painters, of course, in Northern California also, the prevalence of the flat, Tonalist aesthetic identified as the California Decorative Style and especially associated with Arthur Mathews, the Director and dominant teacher at the California School of Design in San Francisco, appears to have inhibited the adoption of Impressionism there. The outstanding adherent of the movement from San Francisco was Joseph Raphael, but his was an expatriate career. Some years after studying with Mathews in the mid-1890s, Raphael was able to go abroad, painting dark, dramatic peasant genre in the Dutch art colony of Laren. It was only around 1912, when he moved to the Belgian town of Uccle, a suburb of Brussels, that Raphael adopted the bright hues of Impressionism, which he applied in large dabs of variegated color to interpretations of gardens and fields of flowers, in increasingly dynamic compositions. Raphael's work was greatly admired and was patronized in his native city, but he only returned to San Francisco in 1939, just before the outbreak of World War II.

Rook, Garber, Krafft, Braun, and Raphael were later followers of Impressionism than the original American adherents such as Robinson and Hassam, subscribing to the movement only in the twentieth century. As such, their work is tinged to some degree with greater purely formal, frequently decorative, and sometimes metaphysical concerns, often non-naturalistic and allied at least tentatively with various aspects of European Post-Impressionism. This would appear to have been a general development arising out of Impressionism, rather than an organized movement; there is no indication of any close communication let alone friendship among the painters mentioned as there had been among the Americans in Giverny, or that shared by Twachtman, Weir, Robinson, and Hassam at Cos Cob.

Raphael's activities in Belgium by no means constituted the

13 Frederick Frieseke

attractive women often engaged in intimate tasks in the boudoir. He favored even more placing his figures outdoors in a lush sun-filled floral environment which was cultivated by his wife. These scenes are almost always extremely decorative arrangements, the artist clothing his models in patterned garments and often accompanying them with colored parasols and patterned umbrellas. Among his most sensuous pictures are a series depicting the recumbent nude in a luxuriant landscape, dappled by sunlight.

Though Frieseke's preference for a garden setting suggests a relationship with the work of Monet, there is no evidence that the two artists were very close, or that Frieseke had established a relationship at all comparable with that which had existed between the French master and Theodore Robinson. Frieseke himself acknowledged rather his admiration for the painting of Pierre Auguste Renoir who was, like the American, much more of a figure specialist, and certainly Frieseke's figural and facial types often resemble Renoir's. The monumentality of Frieseke's women, his concern with feminine intimacy, and his fascination with the nude also relate his art to that of such contemporary Post-Impressionists as Pierre Bonnard.

Frieseke's presence in Giverny in turn attracted a great many other American artists, most, like himself, from the Midwest, whose style and subject matter also often mirrored his. These included Richard Miller, Lawton Parker, Edmund Greacen, Karl Anderson, and Guy Rose, identified by the American critics as belonging to the "Giverny Group", as well as several painters who arrived in Giverny in the second decade of the century such as Louis Ritman and Karl Buehr. Rose, from California, had first stayed in Giverny in 1890 and was a link between the earlier group of Americans there and those in Frieseke's circle.

Among those painters, Richard Miller was the other artist in addition to Frieseke to achieve a national and even international reputation. Miller was born in St. Louis, Missouri, and first studied there before attending the Académie Julian in Paris beginning in 1899. Miller appears to have adopted the higher color range and scintillating brushwork of Impressionism somewhat later than Frieseke, and he seldom abandoned academic strategies of figure construction to the extent that his colleague did. Miller became well known in France not only as an expatriate painter but also as a teacher, both in Paris and Giverny. After returning to the United States late in 1914, he joined his friend, Guy Rose, teaching for several years in Pasadena beginning in 1916, where his work appears to have had some impact upon Southern California art. By then, however, Impressionism had become enshrined as a style both dominant and historical at the Panama-Pacific International Exposition which was held in San Francisco in 1915. It had also by then lost its avant-garde identification in the face of the impact of European Modernism, which had first appeared in force in the United States at the Armory Show held in New York City early in 1913.

only continued preoccupation with the Impressionist aesthetic among American artists painting and living in Europe. This involvement was particularly identified with Giverny, where the American presence had remained strong; Theodore Butler, a close colleague of Robinson and Breck, had married one of Monet's daughters-in-law in 1892, and had permanently expatriated to Giverny, though he occasionally visited and continued to exhibit in the United States. Other American painters, and sculptors also, occasionally or even regularly travelled to the town and a number of them settled there for a considerable period of time.

The most significant of the Americans to reside in Giverny during the first two decades of the present century was Frederick Frieseke. He was a Midwesterner who was born in Michigan and studied at the Art Institute of Chicago before travelling to Paris for further training in 1898; by 1900 he had begun to frequent Giverny. Frieseke's earliest mature paintings are depictions of women in interiors, painted in a poetic, tonal mode related to the work of Whistler, who was one of his teachers. But within a few years he had adopted a brilliant color range which he applied not only to his paintings but also to his home, the interior and exterior of which figure in numerous of his pictures. Frieseke continued to paint interior scenes, usually of

THE PLATES

1
MARY CASSATT
(1844–1926)

MOTHER ABOUT TO WASH HER SLEEPY CHILD, 1880
39½ × 25¾ in.; 100,5 × 65,4 cm
Los Angeles County Museum of Art, Los Angeles, California
Mrs. Fred Hathaway Bixby Bequest

Mary Cassatt began to undertake the images of mothers with their children in 1880; the present work is thus one of her first such pictures and certainly one of the artist's most successful. It is with this theme that subsequent critics and biographers continued to align her art throughout her lifetime and afterwards. Like the theatre subjects which she had begun slightly earlier, Cassatt strikes a balance here between a concern for compositional structure and solid form, and the painterly expressivity which marks the most vital period of her involvement with French Impressionism. Thus, the two figures are quite volumetric, and the artist is at pains to contrast the projection of the mother's head forward, almost beyond the picture plane, in contrast to the tilting back of the child. At the same time, she delights in the broadly applied brushwork, more carefully delineating the heads and limbs of the two figures which are even outlined in black in some areas, while the paint is more freely to their white garments and the patterned wallpaper behind. The extended verticality of the format, also, accommodates the figures well and yet tends to align them with the picture plane, thus flattening the composition.

But Cassatt's primary interest here is in the characterization of the relationship of mother and child, and in the specific activity represented. Numerous writers, past and present, have defined this major component of Cassatt's oeuvre as an updating of the traditional theme of the Madonna and Child, but this seems on the visual evidence to be quite antithetical to the artist's intentions, although a few of her compositions have such traditional precedence. Some of Cassatt's contemporaries, including her fellow-expatriate Elizabeth Nourse, do seem to have transposed religious imagery into contemporary peasant genre, but Cassatt seems to have studiously avoided such an analogy.

Indeed, Cassatt appears to have gone out of her way to avoid such comparisons here, the child having none of the ideality and composure of established imagery, while the mother's averted face further lessens any formality. Cassatt convinces us that this is a domestic chore, though not an unwelcome one, as she contrasts the mother's upright pose and the strong intent of the her gaze, with the sprawled, relaxed image of the helpless, sleepy child, posed in a deliberately ungainly position that recalls Cassatt's *Little Girl in a Blue Armchair* (National Gallery of Art, Washington, D. C.) of two years earlier. The present work defines a modern life experience, in which awkwardness is a natural and refreshing projection. As one of Cassatt's American admirers wrote in 1914, "in painting children she has seen them somewhat differently from any other painter . . . Neither need you look for the idealized mother in this cheerily independent art."[1]

Mother About to Wash Her Sleepy Child was included in the *Exposition Mary Cassatt* held at the Durand-Ruel Galleries in Paris in November of 1893, and is believed to have appeared in the 1895 show held at the New York branch of Durand-Ruel, the first one-artist display of Cassatt's paintings in the United States.

[1] Elisabeth Luther Cary, "Painting Health and Sanity", *Good Housekeeping*, 58, February, 1914, p. 155.

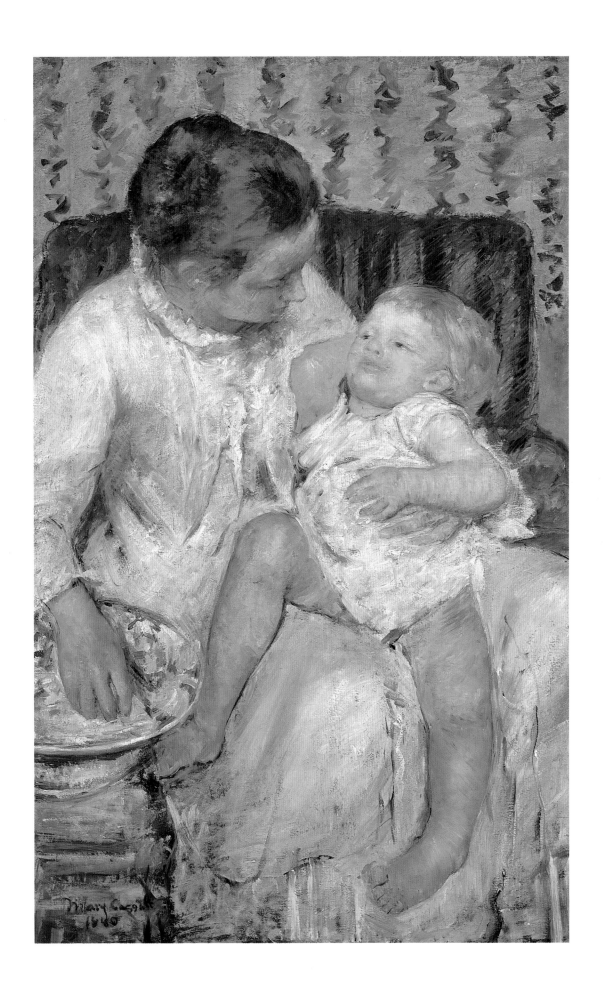

MARY CASSATT
(1844–1926)

SUSAN ON A BALCONY HOLDING A DOG, 1883
39½ × 25½ in.; 100,5 × 65 cm
Corcoran Gallery of Art, Washington, D.C.
Museum Purchase, Gallery Fund

Contrary to the usual estimation of Cassatt, the theme of the mother and child, though introduced into her art as early as 1880, did not dominate her painting until the following decade. *Susan on a Balcony Holding a Dog* is one of the finest of Cassatt's paintings from the period when she was most involved with Impressionist strategies. These include a strong consideration of light and color, studied in the outdoors, though not at the expense of abandoning accurate drawing and the strong structural concerns which she had pursued in her early study with artists such as Jean-Léon Gérôme and Charles Chaplin, and which had been reinforced through her association with Degas.

Cassatt's preferred model in the years immediately preceding this work had been her sister Lydia, but Lydia's increasing debilitation—she died in 1882—necessitated alternative options. Susan, who appeared in a large number of Cassatt's works of this period, may have been related to her longtime faithful maid and attendant, Mathilde Valet; her strong, unglamorous features are not dissimilar from Lydia's. Here, Cassatt has opted for a balcony setting popular in the contemporary work of her French colleagues, especially Gustave Caillebotte, who utilized it to contrast conditions of light and form indoors and out-of-doors, and also to explore eccentric spatial juxtapositions of near and far, up high and down below. Cassatt herself had chosen a balcony setting for one of her early Spanish pictures *On the Balcony During the Carnival* (Philadelphia Museum of Art) of 1872, and, actually, her immediately precedent Parisian theatre and opera images were also set in the upper tiers. Here, her interpretation is relatively more traditional than that of her Parisian associates, foregoing any concern for indoor space. Caillebotte emphasized his figures as urban onlookers; Cassatt deliberately ignores whatever Susan might chance to see beyond the iron railing. Nevertheless, the strongly modeled, quite monumental form of Susan is contrasted with the distant view of Parisian rooftops, very sketchily rendered, with the middle ground reduced to a blurred mass of green foliage. And the large, rounded form of Cassatt's model, in delicate, lavender and blue-tinted white costume, with her shape repeated in that of the wicker chair, is contrasted with the spindly rigidity of the black iron railing. Again, Caillebotte's railings were patterned and ornamental; Cassatt's are insistently utilitarian. Although outdoor pictures may account for almost half of Cassatt's oeuvre, her settings are usually quite anonymous, and this is a unique view of her adopted city, overlooking Montmartre from the family apartment at 13 Avenue Trudaine.

Whatever Susan's origins, she is presented here in elegant finery as an upper-class young woman, and in a domestic setting, reinforced by the pet she holds in her lap; this was Batty, one of Cassatt's Belgian griffons, temperamental animals to which the artist was devoted. Properly garbed and hatted, Susan wears gloves, perhaps in deference to the cool spring or autumn air, or possibly to avoid direct contact with the dog. The introspective, slightly melancholic expression is typical of many of Cassatt's images of single figures.

Like Degas and others, the rift within the ranks of the Impressionist coterie caused Cassatt to forego exhibiting in the seventh exhibition of the group in 1882, but she rejoined her associates Degas and Pissarro in participating in the eighth and last show, held in May of 1886, displaying seven pictures. *Susan on a Balcony Holding a Dog* is said to have been one of these,[1] but there is some question in this regard. The painting was entitled *Jeune fille à la fenêtre* and was lent by a "M. Berend." *Susan on a Balcony Holding a Dog* may more properly be seen as set before a railed window, but the picture is believed to have been owned by Cassatt until it was sold through Durand-Ruel in 1909. Gustave Geffroy reviewed *Jeune fille à la fenêtre* as a woman who "stands wearing a white straw hat enveloped in gauze",[2] but Susan is seated, and her bonnet is not distinguishable as a straw hat. Maurice Hermel noted "her hat [as] adorned with white gauze and pink silk",[3] but there is no pink silk visible on Susan's hat. And George Auriol found the subject "Indifferent to the people swarming below",[4] but there are no figures visible below, nor, in fact, is there any "below" at all.

Susan on a Balcony Holding a Dog appeared in the Cassatt exhibition held at Durand-Ruel Galleries in New York City in 1903, and subsequently in December of 1908 at the Second Exhibition of Oil Paintings by Contemporary American Artists, held at the Corcoran Gallery of Art, Washington, D. C. (the Corcoran Biennial), from which it was purchased by that museum the following year.

[1] Fine Arts Museums of San Francisco, *The New Painting Impressionism 1874-1886,* exhibition catalogue, San Francisco, 1986, p. 449.
[2] Gustave Geffroy in: *La Justice,* 26 May, 1886, quoted in: *The New Painting, op. cit.,* p. 449.
[3] Maurice Hermel in: *La France Libre,* 27 May, 1886, quoted in *The New Painting, op. cit.,* p. 449.
[4] George Auriol, in: *Le Chat Noir,* 22 May, 1886, quoted in: *The New Painting, op. cit.,* p. 449.

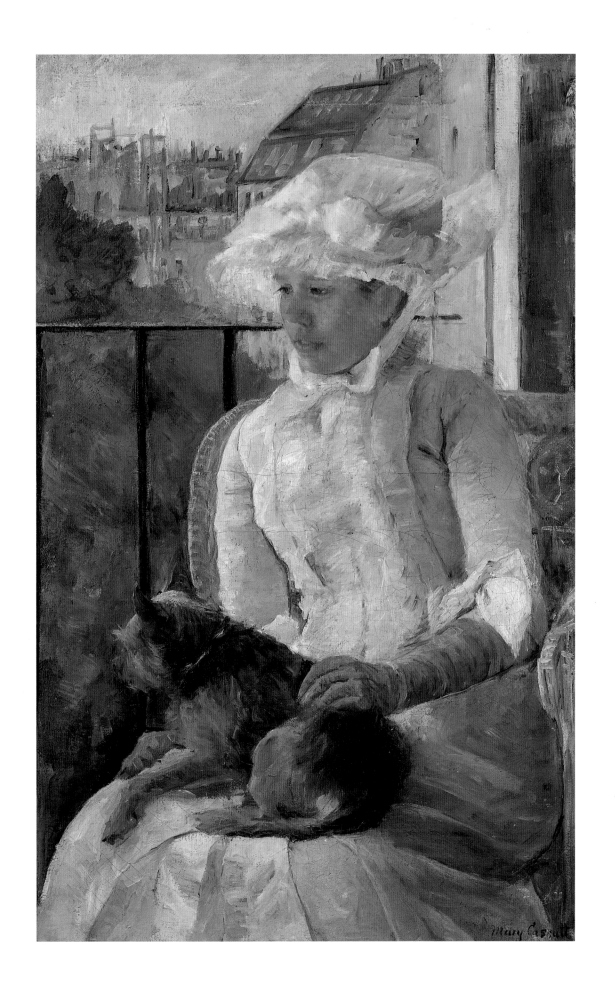

MARY CASSATT
(1844–1926)

BABY REACHING FOR AN APPLE, 1893
39½ × 25¾ in.; 100,5 × 65,4 cm
Virginia Museum of Fine Arts, Richmond, Virginia
Gift of an anonymous donor

While her art became increasingly devoted to the maternal theme, by the mid-1880s, Cassatt, along with many of her French Impressionist colleagues, was moving away from the dissolution of form in terms of loose, colored brushwork and began to reemphasize a strong concern for emphatic design. This direction in her painting was fostered also by her greater awareness of and fascination with the principles of Japanese art, especially after she attended an enormous exhibition of ukiyo-e prints held at the Ecole des Beaux-Arts in April of 1890, which led her, in her subsequent oils and graphics, to emphasize strong outlines, flat areas of color, and spatial compression. Without sacrificing her interest in presenting the figure out-of-doors in bright colors and rich sunlight, these qualities were abundantly evident by the early 1890s in such paintings as *Baby Reaching for an Apple*. (The painting has traditionally been dated 1893, but in a review of Cassatt's one-artist show in New York City in 1895, the critic noted that it was painted in 1892; as this information almost surely came from Durand-Ruel, it is probably correct.)[1]

This picture was included in Cassatt's first major one-artist painting exhibition, held at Durand-Ruel's Galleries in Paris in November-December of 1893, and it appeared again in the first significant showing of her paintings in the United States at the New York branch of Durand-Ruel in April of 1895. American critics were well aware of the change that had occurred in Cassatt's art, and they were not impressed; one wrote in 1893 that "For my part I liked Miss Cassatt better when she was more of an impressionist, ten years or so ago, and less of an extremist."[2] And when her pictures were on view in New York two years later, a reviewer noted that "In her earlier studies there seem to be a greater harmony of color and a softer envelopment of atmosphere, which is lacking in the more recent work. These last are frequently hard, crude, and have a tendency toward the brutal. Inharmonious masses of uncomplimentary color are brought side by side and shock the eye. A rude strength, at times out of keeping with the subject, is noticeable, and takes away in a measure from the charm of femininity."[3] The earlier comment is noteworthy also for suggesting a knowledge of Cassatt's paintings in 1893; until her New York show two years later, few oils had been on view in her native country, and American audiences were familiar only with her graphics. When Cassatt's gigantic mural was on view in the Woman's Building of the Columbian Exposition in 1893, a writer pointed out that "We have had but little opportunity of seeing her color work on this side of the water, so that her painting 'Modern Woman,' at Chicago, will form her first artistic introduction to many of us."[4]

The mural, which unfortunately disappeared subsequent to the close of the Exposition, was a modern-day allegory entitled *Young Women Plucking the Fruits of Knowledge and Science;* among Cassatt's easel pictures, *Baby Reaching for an Apple* is one of the closest in theme as well as in date. Here, however, woman reverts to her traditional role as progenitor and child raiser; she assists the baby in reaching for his goal, with the apple here a symbol not only of knowledge but also the future. While the mother, a columnar figure, is firm, strong, and supportive, and the infant (given its aggressive reach and determined mien, should we presume a *male* child?) is almost totally integrated within her form, with the outline of the left thigh continuing the curve of its mother's dress, her face is partially covered by that of her offspring. The child is dominant; its mother is presented as supportive, within a tightly packed ambience.

Formally, despite many intimations here of Cassatt's deep involvement with the principles of Impressionism, the flattened perspective and strong drawing is reminiscent of the work of Jean-Dominique Ingres, an analogy of which her mentor Edgar Degas surely would have approved. Achille Segard, in the first full-scale monograph on the artist published in 1913, discussed this work specifically, noting the existence of a similar color print, *Gathering Fruit*. He suggested that the hard linearity of the oil derived from the immediately preceding graphic work, a proposal confirmed by the reversal of the image of the mother and child from the precedent print and the drawing for it.[5]

Cassatt's New York exhibition in 1895 engendered a good deal of critical attention, including the earliest article in an American periodical exclusively devoted to her work. William Walton must have had *Baby Reaching for an Apple* in mind when he wrote of the paintings that: "In all of them may be felt that directness and vigor of presentation which has caused this lady to be claimed by the Impressionists; but hers is scarcely impressionistic painting as generally understood, vague as is that term. In all of them may be felt a certain sentiment, or charm, or poetry—something much more than mere good painting. The feeling of nature, of summer air and space, of the

(continued: on page 156)

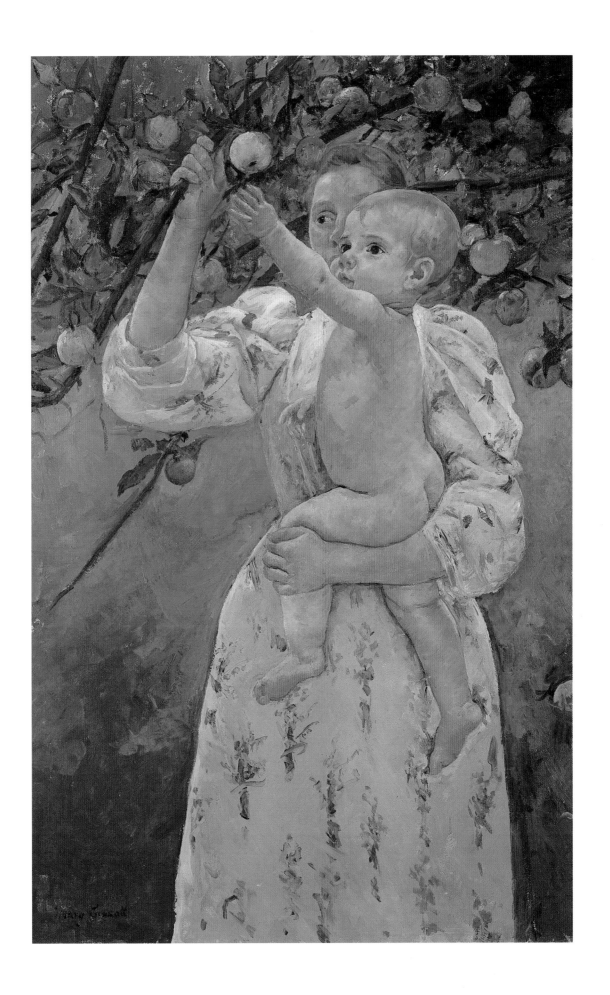

JOHN SINGER SARGENT
(1856–1925)

A MORNING WALK, 1888
26³/₈ × 19³/₄ in.; 67 × 50 cm
Private Collection

Along with Mary Cassatt, John Singer Sargent was one of the two most significant American expatriate artists to explore the aesthetic issues of Impressionism, and, like Cassatt, one of the earliest Americans to do so. Sargent's intense involvement with the formal issues of Impressionism was of relatively brief duration, but it produced a number of the artist's most beautiful and exciting paintings, and effected a good deal of influence upon the progression of that aesthetic in both the United States and Great Britain. Sargent first met Claude Monet in Paris in 1876, during his student years, but their relationship appears to have come to fruition over a decade later. By then, Sargent had transferred his residence from Paris to London, after the disastrous reception of his portrait of *Madame X* (Metropolitan Museum of Art, New York City) at the Paris Salon in 1884.

Taking a studio in London in July of 1885, Sargent continued to pursue his professional role as a society portraitist, but after a swimming accident in the Thames that summer, he recuperated among the colony of artists and writers at Broadway in Worcestershire. There he began his monumental *Carnation, Lily, Lily, Rose* (Tate Gallery, London), a figurative but non-narrative canvas which he completed back in Broadway the following summer and autumn; the picture was the great sensation of the Royal Academy exhibition of 1887. Sargent was acclaimed the arch-apostle of the "dab-and-spot school", and was acknowledged as a leading figure among the artists of the New English Art Club, who championed modern French aesthetic directions.

That same year witnessed the beginning of Sargent's increasing association with Monet; the two painters spent time together that spring in both Paris and Giverny, and that August Sargent acquired the first of four landscapes by Monet which he would ultimately own. Furthermore, while Sargent continued his primary pursuit as a portrait painter, his work during the summers of 1887–89, spent respectively at Henley-on-Thames; at Calcot, near Reading; and at Fladbury, seven miles from Broadway, constitute his fullest excursions into Impressionism.

It was especially at Calcot on the Kennet, a branch of the Thames River, where Sargent settled in June of 1888, that this investigation most closely approximated the aesthetics of his colleague Monet, and in *A Morning Walk* that exploration found its most complete expression. The work depicts Sargent's sister Violet carrying a parasol along the river, dressed in sun-speckled white. Here, Sargent has eliminated the neutral tones,

adopting a rich chromatic range and loose, sometimes broken, brushwork. Though Sargent projects a vision of loveliness—a beautiful woman in a verdant landscape—the painting is principally concerned with color and sunlight.

The work is also a homage to Monet, for it directly recalls that artist's two depictions of his future step-daughter, *Suzanne Hoschedé* (Musée D'Orsay, Paris), dressed in white and holding a parasol, painted at Giverny in 1886, which Sargent would certainly have seen on his visit there the following year. Yet, Sargent's canvas is more sober, and the differences between his work and those of Monet are telling. Sargent's free brushwork does not dissolve his figure in light and color to the extent that Monet's does. Equally significant, Monet adopts a worm's-eye perspective of Suzanne, who is silhouetted against the heavens, almost merging into the cloud patterns. Sargent chooses a bird's-eye view, firmly grounding Violet; indeed, no sky or clouds are directly visible, their blue and white colors only reflected in the flowing stream.

If *Carnation, Lily, Lily, Rose* was a pivotal work in the development of British Impressionism, so *A Morning Walk*, though less monumental, may have occupied a similar role in the United States. It was one of two Impressionist pictures that Sargent showed in America on his extended stay in his native land in 1890, and the only one to appear·in Boston, New York, Chicago, and Philadelphia (exhibited as *Summer Morning* in America). While French Impressionist paintings had been on view in the United States earlier in the decade, examples by American artists had only begun to be displayed in 1889, and these were almost all landscapes, not figure paintings. Thus, although Sargent's pictures often aroused critical hostility, and at best were greeted with equivocation, they were nevertheless recognized as replacing academic values and standards with modernist innovations, and, coming from the brush of an artist of international reputation, they could not be ignored.[2]

1 "The Royal Academy Exhibition", *Art Journal,* 26, June, 1887, p. 248.
2 For the reception of Sargent's Impressionist pictures, including *A Morning Walk,* in the United States in 1890, see my essay: "The Arch-Apostle of the Dab-and-Spot School: John Singer Sargent as an Impressionist", in Whitney Museum of American Art, *John Singer Sargent,* exhibition catalogue, New York City, 1986, pp. 132-145.

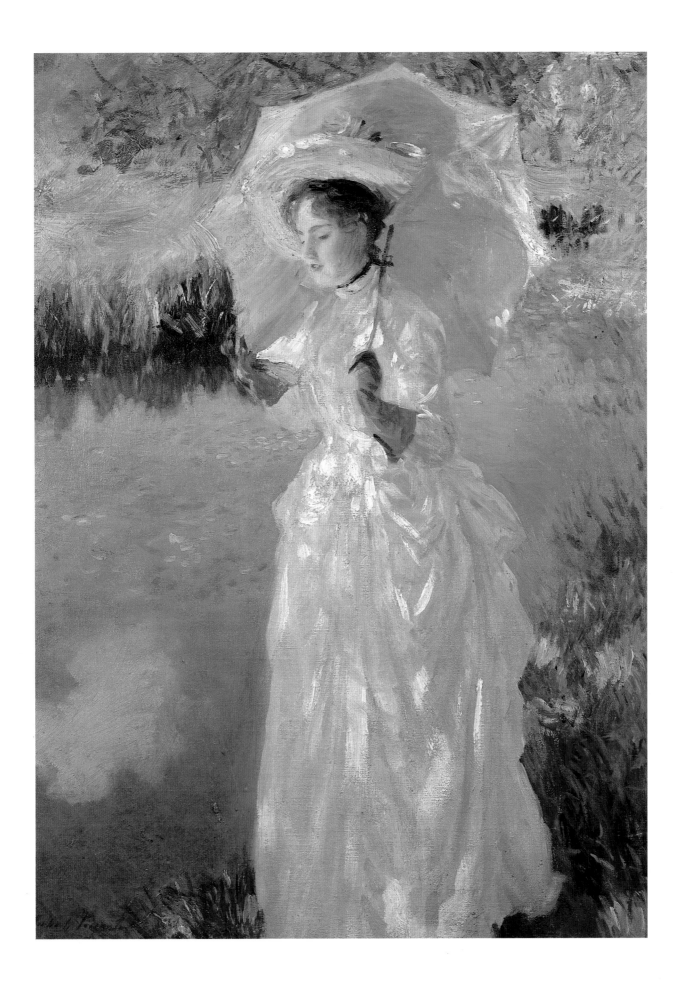

JOHN SINGER SARGENT
(1856–1925)

DENNIS MILLER BUNKER PAINTING AT CALCOT
ca. 1888
26¾ × 25 in.; 68 × 63,5 cm
Daniel J. Terra Collection
Terra Museum of American Art, Chicago, Illinois

Sargent spent the winter of 1887-88 back in his native United States, garnering important portrait commissions and establishing his reputation among wealthy art patrons of Boston and New York. During his visit, he met the attractive young Boston artist Dennis Miller Bunker, whom he invited to visit him in England the following summer. Like A *Morning Walk,* this depiction of Bunker dates from Sargent's summer of 1888 at Calcot, the period in which his involvement with Impressionism was at its height. The holiday work of that season and the summers of 1887 and 1889 are characterized by two themes, especially. One was that of lovely young women outdoors in the sunny landscape. The other subject which Sargent explored in those years was the artist at work; this theme, in fact, would continue to fascinate Sargent for the remainder of his career.

Though Sargent had essayed the subject of the artist painting out-of-doors even earlier, *Dennis Miller Bunker Painting at Calcot* is one of a trio of such pictures central to Sargent's Impressionist involvement. Probably the earliest of these is *Claude Monet Painting at the Edge of a Wood* (Tate Gallery, London), a work most likely dating from Sargent's visit to Giverny in the spring of 1887, though the picture has also been dated 1888 and even 1889. *Dennis Miller Bunker Painting* was followed by Sargent's record of his friend *Paul Helleu Sketching with his Wife* (The Brooklyn Museum), painted at Fladbury in 1889. These pictures must be seen not only as likenesses of Sargent's colleagues and testimonials to their friendships, but also as his response to and definition of the act of outdoor painting. That is, Sargent is pictorially explaining the very nature of the methodology in which he, himself, is indulging, and offering an endorsement of it.

Each of these three pictures offers a slightly different view of the artist at work. Monet is shown actively engaged in painting a landscape which is visible on his easel, a scene which echoes the Giverny landscape setting of Sargent's depiction. Helleu is applying his brush more delicately, compared to Monet's very assertive motion; his picture is not visible, however, with the canvas seen only from the rear. Bunker, however, is not at work. He stands back from his canvas, and his right hand—presumably his painting hand—is deep in his pocket. He has withdrawn from any activity and is ruminating—perhaps evaluating what he has already painted or trying to decide what he might be going to paint. He may also be distracted from work by the figure of Violet Sargent (the subject of *A Morning Walk)*, conspicuously placed by the river at the right. Bunker wrote from Calcot that "The youngest Miss Sargent is awfully pretty—charming. What if I should fall in love with her? Dreadful thought, but I'm sure to—I see it coming..."[1]

Or Bunker may have been genuinely anxious concerning the new, very modern aesthetic to which he was exposed by Sargent that summer. While he was excited about Sargent's spontaneous out-of-doors methodology, and would emulate it with great success on his return to Boston, he was also bewildered by it. We know of his perturbation from his letters to his patron Isabella Stewart Gardner and his friend Joe Evans; to the latter, for instance, he wrote that "I did not get anything done in these days. I've done nothing."[2] Bunker's previous landscape work had consisted of closely tonal, carefully delineated scenes reflecting his academic training. Subsequent to his visit to Calcot, Bunker adopted Sargent's looser brushwork, switching, as the author Hamlin Garland noted, "from 'the school of mud' to the school of the open air, and the use of primary colors."[3] Sargent's depiction of Bunker at Calcot, therefore, may reflect his young friend's perplexity as well as his involvement in *plein-air* painting at this significant moment in the careers of both artists.

[1] Bunker to Isabella Stewart Gardner, 25 June, 1888, Isabella Stewart Gardner Museum Correspondence, Archives of American Art, Smithsonian Institute, Washington, D. C.
[2] Bunker to Joe Evans, 11 September, 1888, Dennis Miller Bunker Papers, Archives of American Art, Smithsonian Institution, Washington, D. C.
[3] Hamlin Garland, *Roadside Meetings.* New York, Macmillan Press, 1930, p. 31.

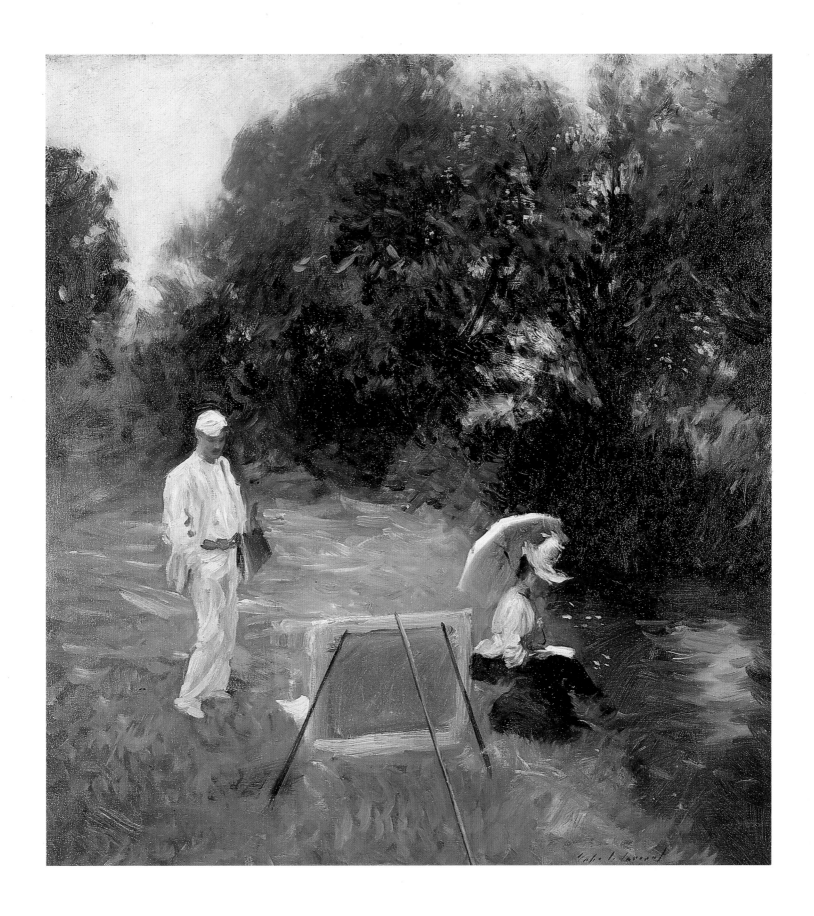

DENNIS MILLER BUNKER
(1861–1890)

WILD ASTERS, 1889
25 × 30 in.; 63,5 × 76,2 cm
Private Collection

New York-born Bunker entered the Antique School of the National Academy of Design in 1876 and studied with William Merritt Chase at the Art Students' League in New York City in the late 1870s. Bunker painted landscapes and genre scenes on Nantucket Island during the summers of 1881–82, before going on to Paris, where he entered the Académie Julian and also received instruction from Jean-Léon Gérôme at the Ecole des Beaux-Arts. There Bunker evolved a sensitive mastery of academic figure work and portraiture, but during his several years in France, he also investigated the landscape of Brittany, creating evocative, dramatic images of the town of Larmor in gray light and strong tonal contrasts.

Back in Boston in 1885, Bunker became a rising influence in the artistic community when he began to teach the life classes at the newly established Cowles School and at the same time attracted the attention of wealthy art patrons such as Mrs. Jack Gardner. The crucial influence on the last years of his abbreviated career occurred early in 1888 when he formed a friendship with John Singer Sargent, who had returned from England to America the previous autumn for a brilliant season of society portraiture in Newport and Boston; the two artists probably met at Sargent's first one-man exhibition held at the St. Botolph Club in Boston in January. In his holiday work during the three previous summers, Sargent had been investigating Impressionism, and he continued to do so in the summer of 1888 on his return to England, settling at Calcot, on the Thames near Reading. Bunker accepted Sargent's invitation to join him there, and when the young Boston artist returned to the United States, he had adopted Sargent's colorful, outdoor strategies in his landscape painting, though he clung strongly to academic traditions in his figural work.

Bunker's Impressionism found its most complete expression in the landscapes of gentle fields, brooks, and ponds painted in the summers of 1889 and 1890 in Medfield, Massachusetts. These were painted close to Bunker's boarding house in a meadow which he described as "a funny charming little place, about as big as a pocket-handkerchief with a tiny river, tiny willows and a tiny brook."[1] Though often brightly sunlit, many of these pictures are informed by a limited palette of yellow to blue greens. *Wild Asters* displays the richest chromatic range of any of Bunker's Medfield landscapes, the blue of the sky reflec-

ted in the swirling water, contrasting with the red reflections, fields of green grass, and the white flowers. The dynamics of these simple scenes are enhanced by an horizon that is high or, as here, eliminated entirely, so that the spatial plunge appears precipitous. This treatment is related to that explored by Sargent in such works as *The Morning Walk*, though the similarity of the two pictures is obscured by the dominant figure in the latter. Sargent-like also are the loose, long, and spikey brushstrokes which Bunker employed in *Wild Asters* and others of his Medfield landscapes. It must have been in the late 1880s that Edmund Tarbell called Frank Benson's attention to Bunker's brushstrokes, saying that "Dennis Bunker is making them out of fish-hooks these days."[2] These pictures, along with the work of several other painters just returning from Giverny in France, were the earliest American Impressionist pictures seen in Boston and New York.

Wild Asters appeared with a group of Bunker's work in the annual exhibition of the Society of American Artists held in New York City in 1890. Critical praise was reserved for his single figural entry, the lovely, quite academic *The Mirror* (Terra Museum of American Art, Chicago). However, many reviewers agreed with the writer in *Art Amateur* who noted that "the influence of the Impressionists is strongly shown in many of the landscapes", and Bunker was grouped in this category with Theodore Robinson, Theodore Wendel, Henry Fitch Taylor, and Childe Hassam.[3] One critic singled out *Wild Asters*, objecting to its chromatic intensity, noting that Bunker had "led a stream from some dye-shop through the flowery banks of a milliner's window."[4] The picture appeared again in the memorial exhibition of Bunker's work held at the St. Botolph Club in February of 1891.

[1] Quoted by R. H. Ives Gammell, *Dennis Miller Bunker*. New York, Coward-McCann, Inc., 1953, p. 56.

[2] Gammell, *Dennis Miller Bunker. op. cit.*, p. 65.

[3] "The Society of American Artists' Exhibition", *Art Amateur*, 23, June, 1890, p. 3; "Society of American Artists", *New York Daily Tribune*, 26 April, 1890, p. 7.

[4] "The Fine Arts. The Society of American Artists. (First Notice)", *Critic*, 3 May, 1890, p. 225.

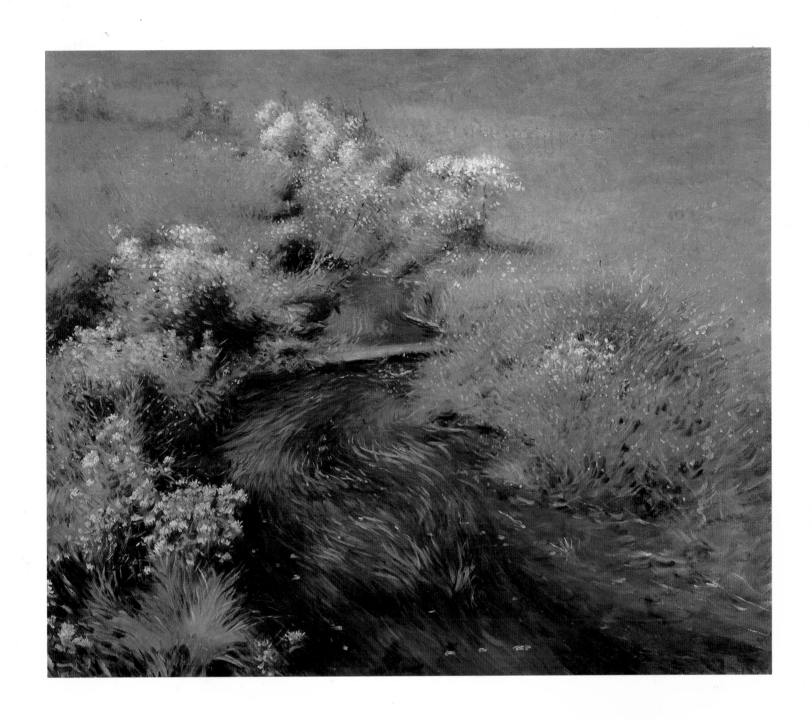

THEODORE ROBINSON
(1852–1896)

LA VACHÈRE, 1888
86³/₈ × 59⁵/₈ in.; 219,5 × 151,5 cm
Baltimore Museum of Art, Baltimore, Maryland
Given in memory of Joseph Katz by his children

Theodore Robinson first studied art in Chicago about 1870, probably at the Chicago Academy of Design, and then in New York City in the Life School of the National Academy of Design in 1874, and at the Art Students' League the following year. He was in Paris early in 1876, taking instruction from Carolus-Duran and Jean-Léon Gérôme. From the former he would have derived an inclination for a painterly technique, and from the latter a belief in the importance of flawless draftsmanship. Robinson's subsequent career reveals a consistent effort to reconcile these two artistic modes, applied to the large number of thematic concerns which he explored prior to his involvement with Impressionism. His earliest paintings reveal an interest in American rural naturalism, effectively, if sometimes awkwardly handled, related to the art of Winslow Homer, whose work he admired. He continued to essay such themes in the late 1870s and the 1880s, working both in France and in the United States, but he also painted idealized figures of young women, and in the mid-1880s he created a number of renderings of urban craftsmen in Paris.

From 1884 to 1892, Robinson resided primarily in France, though he spent most winters into early spring back in his native country. He was one of a group of seven painters—six Americans and one Canadian—who travelled together to Giverny in 1887, although Robinson may have visited there several years earlier; in any case, he was registered at the Hotel Baudy in Giverny from September 18, 1887 to January 4, 1888. Whether he met Claude Monet, who resided in the Norman village, in 1887 or as early as 1885,[1] Robinson was the artist of this group who formed the closest friendship with the French Impressionist, and one of those who followed Monet's lead in adopting Impressionist strategies. From 1888 to 1892, Robinson was to make Giverny his primary residence, and the majority of his pictures from these years were painted there.

Not surprisingly, however, many of the works painted during Robinson's earlier seasons in Giverny hold more completely to traditional forms than those he created in the early 1890s. From his French teachers, Robinson would have learned to respect the primacy of figure painting, and occasionally sought to render such images on a monumental, Salon-size scale. *La Vachère* is the most ambitious of all of these and the artist's largest located work; several smaller versions of this composition, with and without the cow, as well as studies of the heads of both figure and animal are known. The theme of a somewhat contemplative peasant woman was popular among both and expatriate artists in France, and abounded in the exhibitions of the Paris Salon, where this picture would be shown in 1889.

In Robinson's execution of this scene, the paint is applied very freely throughout most of the canvas, and flickering sunlight animates the composition. Nevertheless, both the young woman and the cow she attends are carefully drawn, and the shadows they cast within a shallow spatial niche are quite opaque. The monumentality of the figure is further enhanced by her uncompromising verticality and the picture's angular composition: the young peasant woman is shown in strict profile while the large cow is rigidly frontal. Robinson's color is certainly lighter and brighter than he had utilized in previous years when he often depended primarily upon the juxtaposition of neutral tones, but its scope is still limited here primarily to pinks and a range of greens. Actually, despite the close relationship that developed between Robinson and Monet, much of his figural work in Giverny, particularly in his early years there, is closer among the French Impressionists to the peasant imagery of Pissarro, whom Robinson is known to have met at Monet's home. And this picture may even be judged more in the tradition of the *plein-air* work of Jules Bastien-Lepage, so greatly admired by many American artists working in France in the 1880s.[2]

Robinson developed the theme of the "cow-girl" in a variant drawing and a poem "A Normandy Pastoral", which was published posthumously the year after his death.[3] After being exhibited in the Paris Salon of 1889, *La Vachère* was shown that year in the seventeenth Inter-State Industrial Exposition in Chicago. The picture subsequently reappeared in a frame shop, perhaps having been left there by the artist in lieu of some payment. It was acquired by William T. Evans of Montclair, New Jersey, probably the most important collector of contemporary American art at that time, specifically to donate the picture in 1906 to the Metropolitan Museum of Art in New York, but the museum subsequently deaccessioned the painting.[4]

[1] Pierre Toulgouat, "Skylights in Normandy", *Holiday*, 4, August, 1948, p. 67, states that Robinson accompanied Monet's friend, Ferdinand Deconchy to Giverny in 1885; Deconchy resided nearby at Gasny.
[2] Among others, the painter, Marsden Hartley likened Robinson's work to that of Bastien-Lepage; see his *Adventures in the Arts*. New York, Boni and Liveright, 1921, p. 77.
[3] Theodore Robinson, "A Normandy Pastoral", *Scribner's Magazine*, 21, June, 1897, p. 757.
[4] Florence N. Levy, "Theodore Robinson", *Bulletin of the Metropolitan Museum of Art,* 1, July, 1906, pp. 111–112.

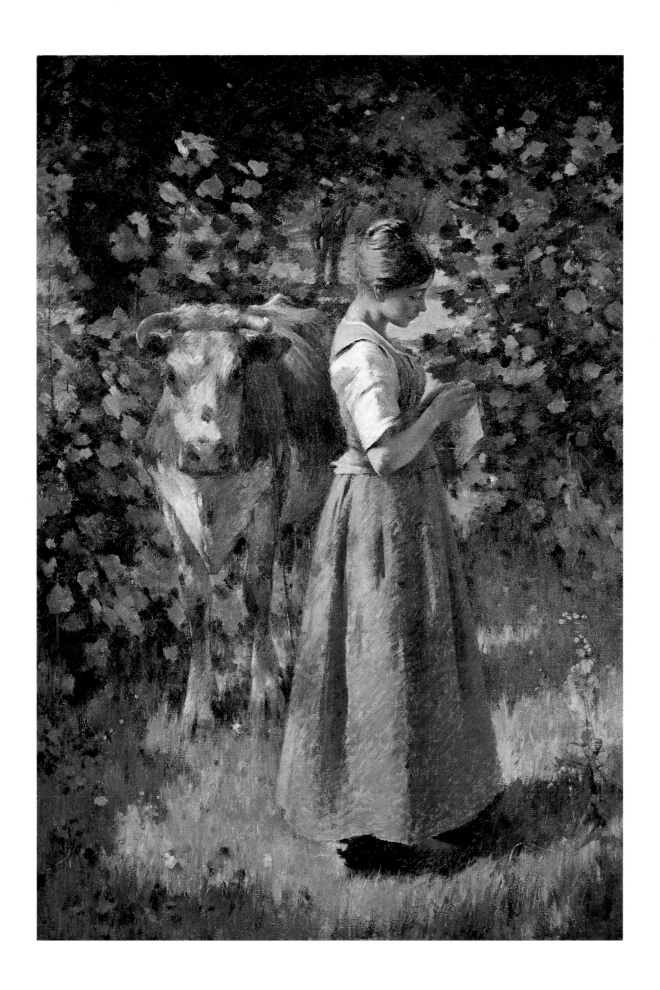

THEODORE ROBINSON
(1852–1896)

BIRD'S EYE VIEW OF GIVERNY, FRANCE, 1889
25¾ × 32 in.; 65,5 × 81 cm
Metropolitan Museum of Art, New York, New York
Gift of George A. Hearn

Between 1888 and 1892, the period in which Robinson spent half of each year or more in Giverny, he painted a series of landscapes from the hills above Giverny, looking down into the valleys, and focusing either upon the houses of the village, or on the Seine River and the distant town of Vernon. These pictures occasionally include figures but more often, as here, do not.

These works are among the most carefully structured of Robinson's paintings, and offer the impression of a disciplined environment, one that surely mirrors the sense of order that the artist sought in both his life and his art. Robinson uses here his favorite combination of pastel-like Impressionist colors, contrasting various tones of green with pinks and lavenders. The former expresses the natural environment , the latter defines man-made building structures. With his emphasis upon block-like shapes and the flat and angular planes of walls and roofs, Robinson supplies a strong geometric underpinning to his otherwise freely painted scene. The brush strokes also are applied in alternating directions, while the composition is based upon opposing diagonal axes of rooftops and tree-bordered land plots; the latter gradually retreat in the distance to a high horizon, a feature of many of the artist's Giverny landscapes. These are very orderly scenes, where spontaneity resides solely in the method of paint application. This strongly structural component in such works not only testifies to Robinson's effective academic training and his belief in sound draftsmanship, but has been interpreted as reflecting the impact upon him of the aesthetic concerns of the Post-Impressionists, above all those of Cézanne.

A *Bird's Eye View* was one of the first Impressionist pictures the artist exhibited in the United States, where it appeared initially in the twelfth annual exhibition of the Society of American Artists in New York in the spring of 1890, and then at the eighth autumn exhibition at the National Academy of Design that same year. The work was often overlooked at the Society, attention directed instead to Robinson's other entry in the show, *A Winter Landscape,* which won the Webb Prize of $300 that year. One exception was the writer for *The Nation,* who judged Robinson as the best of of those painters at the Society who revealed the influence of Monet. He found that *Bird's Eye View,* "with its clustered cottages seen in steep perspective, is most interesting in drawing, though a trifle flat and chalky in its attempt at color on a high key."[1]

More reviewers noticed the painting at the National Academy and wrote about it together with Robinson's *Girl with Watering Pots,* a figure piece. The writer for *The Critic* judged Robinson as "one of the few young men who have found salvation in the Impressionist gospel. He has made serious studies and he has not bade adieu to his artistic conscience, so that his freedom is not license, and he really gives the impression of out-of-doors air and sunlight. His 'Girl with Watering-pots' and 'Bird's eye View' over village and field are capital things in their way."[2] The critic for *Art Amateur* singled the work out as a successful example of Impressionist painting, for the "brilliantly natural effect of out-of-doors light and atmosphere",[3] and the writer for the *Independent* found the picture one of the most noteworthy landscapes in the exhibition.[4]

Bird's Eye View next appeared in the eighteenth annual Inter-State Industrial Exposition in Chicago in 1890, in the sixty-first annual exhibition of the Pennsylvania Academy of the Fine Arts in Philadelphia in January of 1891, and in the forty-fifth exhibition of the Boston Art Club in 1892. It remained in Robinson's possession on his final return to the United States at the end of 1892, and was displayed again in New York at the artist's first one-man show, held at the Macbeth Gallery in February of 1895. This exhibit then travelled to the Cotton States and International Exposition held in Atlanta, Georgia, that year, and to the museums in St. Louis in 1896 and Cincinnati in 1897. The painting was sold as *Bird's Eye View— The Valley of the Seine from Giverny* to the important New York collector George A. Hearn in the auction of the artist's estate held at the American Art Galleries in New York City on March 24, 1898; Hearn donated the picture to the Metropolitan Museum of Art in 1910.

[1] "Society of American Artists", *Nation,* 50, 8 May, 1890, p. 382.
[2] "The Fall Exhibition at the Academy", *Critic,* 14, 29 November, 1890,p. 285.
[3] "The Academy of Design", *Art Amateur,* 24, Jan., 1891, p. 30.
[4] Susan Hayes Ward, "The Autumn Exhibition at the National Academy", *Independent,* 18 December, 1890, noted that "the portraits of this room are more noteworthy than anything else, except it be the impressionistic 'Bird's-Eye View' and 'Watering Pots' of Mr. Robinson."

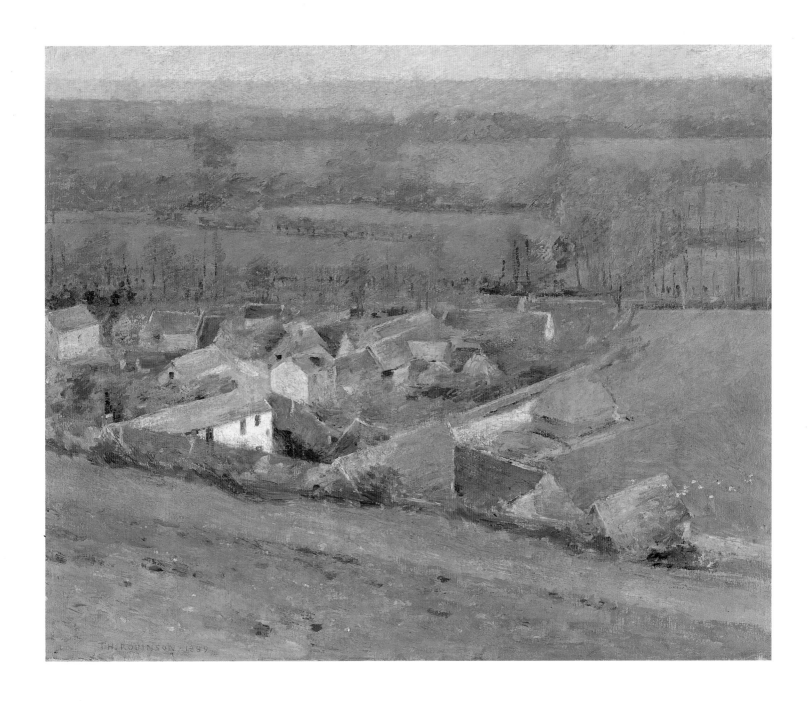

THEODORE ROBINSON
(1852–1896)

GATHERING PLUMS, 1891
22 × 18⅛ in.; 55,9 × 46 cm
Georgia Museum of Art, The University of Georgia, Athens, Georgia
Eva Underhill Holbrook Memorial Collection of American Art
Gift of Alfred H. Holbrook

The theme of the laboring peasantry had become increasingly popular in French art since the late 1840s, when it first began to achieve prominence in the work of Jean-François Millet, and it remained so at least through the 1880s, in the painting of not only French artists but also Americans working in France, finding their subject matter in the Breton and Norman countryside. Robinson had painted urban working figures in Paris in the mid-1880s, before he settled in Giverny, and subsequently the majority of his figural subjects were involved with aspects of peasant life. Robinson took the lead among a number of Americans working in Giverny who strove to effect a consolidation of traditional imagery with Impressionist strategies; Dawson Dawson-Watson is another artist painting there at the time who successfully wedded the old and the new. In this, Robinson's work diverged from that of his mentor Monet, and is closer to the art of Camille Pissarro, whom the American came to know on Pissarro's visits to Monet in Giverny. *Gathering Plums* bears a particular similarity to a large painting of Pissarro's on a similar theme, painted only five years earlier: *Apple Picking* (Ohara Museum of Art, Kuranshiki, Japan), which had been on view in Paris in 1886 and again in 1887, when Robinson could well have seen it.

Gathering Plums is one of the pictures in which Robinson has most successfully integrated this traditional theme with advanced aesthetic strategies. The color range here is especially brilliant, and the emphasis upon the blue-purple-red tones surely owes some inspiration to the colors of the nominal subject, the plums themselves. Color is divided in a structural way, also; the yellow-to-dark green leafage forms a tapestry-like pattern throughout the scene, a foil for the more structured forms rendered in warmer tones—the two peasant figures and the long ladders which anchor the composition.

Details are extremely blurred here—the faces of the figures are indistinct and no actual plums are visible—an effect somewhat similar to a photograph slightly out of focus. Actually, Robinson did depend upon photographic studies here, at least one of which is still extant. The relationship of Robinson's oil paintings to photographic sources has been perceptively studied by the late John I. H. Baur, who pointed out that the artist utilized photographs for preliminary compositional arrangements, but continued to paint on these pictures out-of-doors from the model.[1] And really, the forms in the photograph which relates to *Gathering Plums* are *more* blurred and light-struck than those in the painting itself.

[1] John I. H. Baur, "Photographic Studies by an Impressionist", *Gazette des Beaux-Arts,* series 6, 30, October-November, 1946, pp. 319–330.

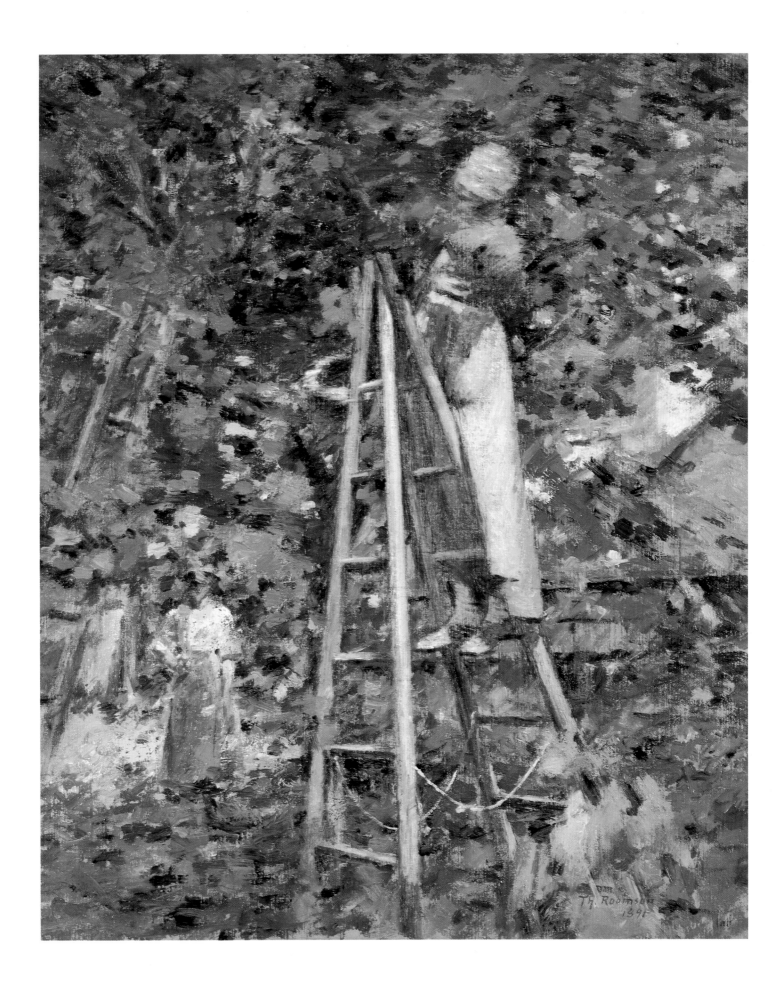

THEODORE ROBINSON
(1852–1896)

LA DÉBÂCLE, 1892
18 × 22 in.; 45,8 × 55,9 cm
Scripps College, Claremont, California
Gift of General and Mrs. Edward Clinton Young

From 1888, Robinson's mastery of the Impressionist idiom, along with his confidence in his own abilities to handle the strategies of the aesthetic, grew year by year, culminating in such beautiful and assured works as *La Débâcle*; the artist never painted a more lovely picture. The subject here is Marie, a model who often posed for Robinson, seated by the little bridge over the Epte River, which appears in other works by him; a view of the bridge from across the river in the opposite direction appears in *Père Trognon and his Daughter at the Bridge* (Terra Museum of American Art, Chicago), painted in 1891. Robinson noted in his diaries that Monet had come to visit him on August 15, and found *La Débâcle* "amusing."[1]

Though the vivacious brushwork imparts great spontaneity to the scene, the composition is very carefully orchestrated. The sandy colored roadway is actually a strong horizontal bisecting the scene, but the foreshortened iron bridge railing which parallels the road suggests a dynamic diagonal compositional axis, which is anchored in the right foreground by the upright figure of the seated Marie. The thrust into the left distance is enhanced by the emphatic gaze of the model in that direction, toward an undisclosed individual or event; this psychological "pull" is underscored by her grip of the bottom of the railing, as if she were holding fast to remain in the picture's foreground. The gentle enigma of the unseen object of her gaze, cut off by the left side of the canvas, is bolstered by the seemingly arbitrary cutting off of the trees at upper left and at the top of the picture, where the bottom of the sloping hillside replaces an horizon.

Robinson has carefully orchestrated the broken brushwork of green, brown, beige, and rust colored tones, which act as a field and a foil for the figure in her pink, blue and violet dress; against this, in turn, the bright yellow accent of the book she holds stands out. The title of the picture itself today adds further to the suggestion of mystery, for the viewer is intrigued as to the nature of the "debacle" implied, which appears unrelated to either Marie's calm or to the beauty of the scene. For contemporaries, however, there would have been no puzzle but rather instant recognition. *La Débâcle* was the title of the latest novel of Emile Zola, published that same year, which Marie is shown in the process of reading (Robinson himself read it during that summer, finishing it on August 3); thus the book was a literary work that was then *au courant* in Paris, New York, and obviously in Giverny. In the context of Robinson's painting, however, that identification, and the association with France's foremost Realist writer, imparted further modernity to the scene, a contemporaneity consistent with the Impressionist aesthetic in which the painting is rendered.

Robinson brought the picture back with him to the United States when he left Giverny in 1892, departing for America from Le Havre on December 3. He was no sooner settled into his New York studio on Fourteenth Street than the painting was sold to the major collector of modern American art John Gellatly. In his diaries Robinson recorded that Gellatly had visited him on December 19 and was shocked at the $400 price that the artist asked for the painting, but that, two days later, "Gellatly arrived early and took the canvas—Marie at the little bridge—at my figure—$400—wished me to 'keep shady'—not to tell anyone."[2] The work was exhibited in April of 1893 at the Society of American Artists; Robinson's increased assurance in the handling of broken color was noted by the critics of the exhibition, one of whom reported that the artist "seems to find it no longer necessary to hold pure colors apart, but blends them more one into another with increasing suavity."[3] The painting was coupled with William Merritt Chase's *The Fairy Tale* by the critic for the *New York Herald* as "two charming canvases of figures in landscapes."[4] Twenty years later, *La Débâcle* appeared on view again in New York City where it was one of five pictures by Robinson shown at the International Exhibition of Modern Art held at the 69th Street Infantry Armory.

[1] Theodore Robinson diaries, New York, 8/15/92, typescript, Frick Art Reference Library, New York City.
[2] *Ibid,* 12/19/92, and 12/21/92.
[3] "The Society of Artists", *New York Times,* 24 April, 1893, p. 4.
[4] "American Artists' Best Show of All", *New York Herald,* 15 April, 1893, p. 4.

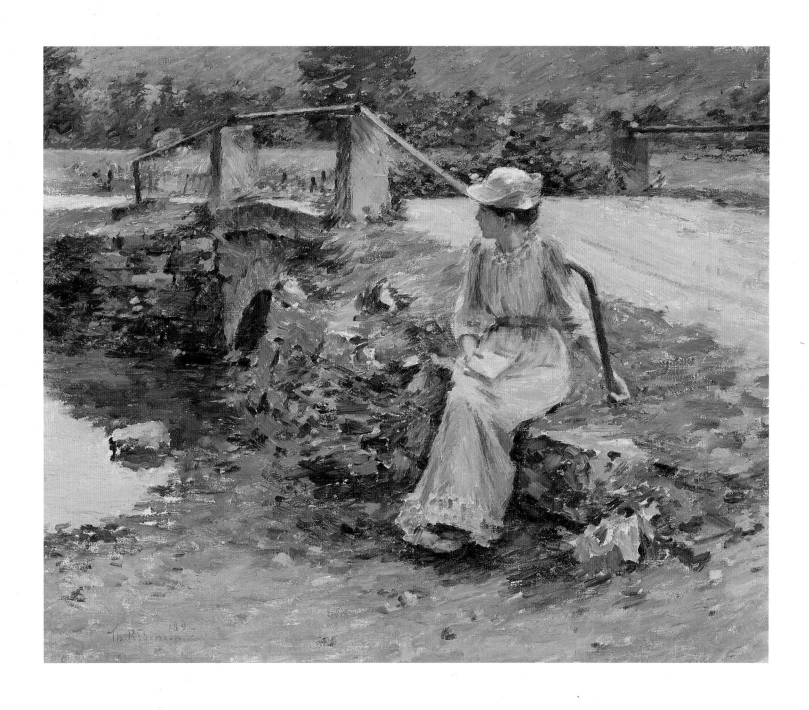

11
THEODORE ROBINSON
(1852–1896)

PORT BEN, DELAWARE AND HUDSON CANAL
(ON THE CANAL), 1893
18 × 22 in.; 45,8 × 55,9 cm
Thomas W. and Ann M. Barwick

Among Robinson's finest works painted in 1893, the first year after his final return from France, were those painted at Napanoch, New York, where he was teaching a summer session for the Brooklyn Art School. Though Robinson was not really sympathetic to the teaching experience, and resented the time lost in instruction as well as foul weather, he produced some of his most completely Impressionist work at the time, much of it along the Delaware and Hudson Canal. Such pictures give the lie to the suggestion that Robinson's work reverted to a more truly "American Realism" once he was no longer directly under the spell of Monet.

There are three known versions of this composition, but each is quite distinct. The largest is in the collection of the Pennsylvania Academy of the Fine Arts in Philadelphia; another, approximately the same size as the present work, is owned by the Nebraska Art Association in Lincoln, Nebraska. Continuing the serial tradition of Monet's Rouen Cathedral imagery, which had so impressed Robinson in Giverny in 1892 and had induced him to undertake several series of his own that year, the Nebraska picture shows the canal scene on a gray, overcast day, while the picture in Philadelphia as well as the present work are filled with sunlight and color.

Though Robinson was obviously attracted by the picturesqueness of the scene, as well as the rich light and atmosphere, neither the design nor the subject matter should be ignored. For all the spontaneity of Robinson's handling, the picture is carefully composed on a geometric grid, with a sharp horizon line dividing the picture into two equal zones of earth and sky. The lower half is bisected by the canal and its adjacent paths, along which the eye is carried back into the distance, with telegraph poles and buildings acting as receding spatial markers, the sweep tautly blocked by the red bridge, which is both perpendicular to the canal and parallel to the picture plane. Firm structure was becoming increasingly important to Robinson; the previous May he had noted in his diary that "I must make a big effort this summer for more completeness and grasp."[1]

The artist has transferred here his involvement in French peasant imagery to the rural environment of contemporary America. This was a functioning canal, and the activities of the canal workers were juxtaposed with those of Robinson's lady art students with their easels and white umbrellas. His class, in fact, was taken from one canal lock to another on these same barges, which were towed by the horses along the side paths visible in the picture. One reviewer of the summer endeavors noted that "the canal men are kindly interested in the progress of art and aid it when they can by pointing out 'the fresh greens' and 'tender purples' within sight. This artistic vernacular has become so common that the very drivers stop their horses to point out 'pretty bits' to the aspirants for artistic glory."[2]

On the Canal was included in Robinson's first one-man show, held at the Macbeth Gallery in New York in February, 1895, the only one-man display held during his lifetime; the exhibition subsequently went to Atlanta, Georgia, for the Cotton States and International Exposition in 1895; the St. Louis Museum of Fine Arts, in St. Louis, Missouri, and the Fort Wayne Art School in Fort Wayne, Indiana, both in 1896; and the Cincinnati Museum Association in Cincinnati, Ohio, in 1897. Still unsold, it was purchased by the important New York collector Samuel T. Shaw at the Robinson estate sale held at the American Art Galleries on March 24, 1898. Shaw was a major collector of Robinson's work and purchased seven pictures at the estate sale; he appears to have owned more paintings by Robinson than by any other artist. These, including *On the Canal,* together with Robinson's *In the Sun,* which had won the Shaw Purchase Prize at the Society of American Artists in 1892, were exhibited as part of the Shaw Collection at the Lotos Club in New York in April, 1904.

Later, the picture was the subject of much praise by the painter and writer Eliot Clark, one of Robinson's great admirers. After noting that the artist had shown "that where there is air and sunshine there is also infinite material for the painter", Clark introduced this work: "here we see the brilliant coloring of a clear summer day, with flying clouds, an effect typical of our Eastern States but seldom seen in northern France. Robinson has rendered it with unerring accuracy and an almost primitive frankness. It has the unaffected and uncultivated simplicity of American landscape, but the artistic eye has observed the beauty of the commonplace and characterized it in a masterful manner. The wooden fence, the telegraph-poles, the red bridge, the simple farmhouses have been made elements of a picturesque pattern which at the time was thought very unbecoming and unconventional."[3]

[1] Theodore Robinson Diaries, May 13, 1893, typescript, Frick Art Reference Library, New York City.
[2] "Women and Their Interests. Artists Afield", *New York World,* 8 August, 1893, p. 11.
[3] Eliot Clark, "Theodore Robinson A Pioneering American Impressionist", *Scribner's Magazine,* 70, December, 1921, p. 768.

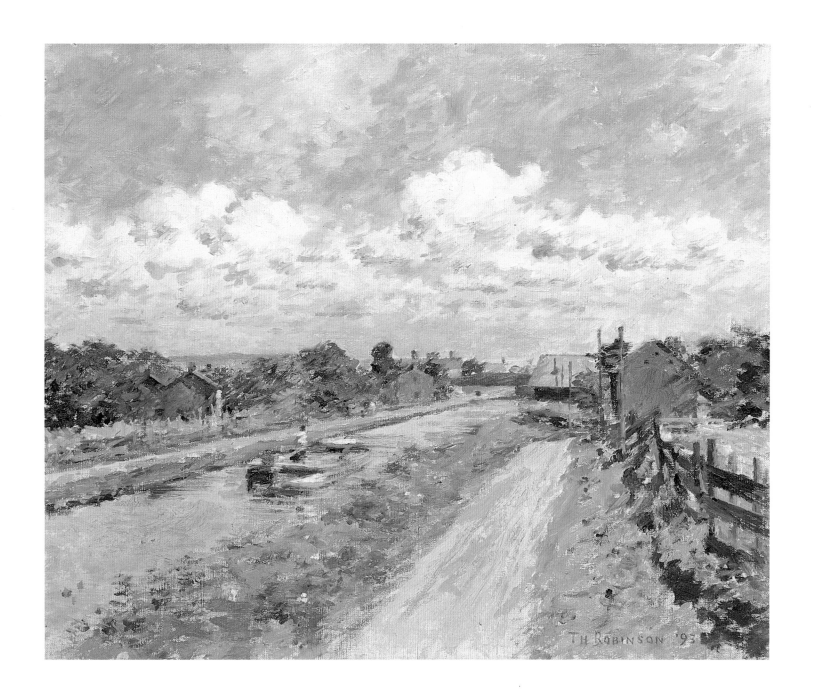

THEODORE ROBINSON
(1852–1896)

BOATS AT A LANDING, 1894
18½ × 22 in.; 47 × 56 cm
Mr. and Mrs. Meyer P. Potamkin

Among the most successful works that Robinson produced after his final return to the United States at the end of 1892 are those painted while visiting with his friend and colleague John Twachtman, who was living in Greenwich and teaching nearby in Cos Cob, Connecticut. The most admired of these are the group of pictures which Robinson painted at the boat yard and the Riverside Yacht Club in Cos Cob, which he first began on a visit early in June, 1894, and which continued to occupy him into July.

Among the masterworks of this series are such traditionally composed scenes such as *Low Tide, Riverside Yacht Club* (Mr. and Mrs. Raymond J. Horowitz), *Low Tide* (The Manoogian Collection), and *The Anchorage, Cos Cob* (William Marshall Fuller Collection). More striking and radical in design is the near abstract *Boats at a Landing*, one of the most severely devised of all of Robinson's compositions. This picture is rigidly constructed on a grid of horizontals, composed of the pier, the bows of the small boats, and the parallel land formations extending off into the river channel at the right, all of which are balanced by the repeated verticals of the masts. While normal spatial recession is maintained, these elements also effect a strong two-dimensional surface design, abetted by the high horizon line which returns the viewer's gaze toward the picture plane. The sunlit coloration of bright yellows balanced by the blue of the water also asserts a careful equilibrium between naturalism and an arbitrary abstraction.

One source for the radical nature of Robinson's conception here is evident in his diaries: the intensity of the artist's interest in the aesthetics of Oriental art, and especially of the Japanese print, an attraction which he shared at the time with Twachtman and Julian Alden Weir. While Robinson may have become drawn to the general interest in things Japanese even earlier, his fascination with Japanese art was certainly aroused on a visit to Greenwich on October 31, 1893. In his diaries he noted Twachtman's enthusiasm for a Japanese exhibition he had recently seen at the Museum of Fine Arts in Boston, while acting as best man at Weir's wedding in that city. Subsequently, the diaries record a viewing of Japanese art in New York with Weir on November 30, where Weir was "enthusiastic over some old Japanese prints"; there, Robinson, too, admired the artistry of Oriental arrangement, and the "extraordinary delicacy of tone and color." He noted in his diaries on December 10 a discussion of Japanese art with Twachtman and Henry Fitch Taylor, a fellow-Impressionist from his years in Giverny.

The enthusiasm for Japanese art on the part of Robinson's close friend Weir was especially noteworthy in the ensuing months. On January 6, 1894, he wrote about Weir's depiction of a nude girl with cats in a Japanese manner, and on February 11 he noted Weir's acquisition of some Japanese objects. Five days later, Robinson and Weir visited a Japanese exhibition at Boussod, Valadon and Co., where Robinson acquired a Japanese print, and the next day he observed that "my Japanese print points in a direction I must try & take; an aim for refinement and a kind of precision seen in the best old as well as modern work, the opposite pole to the slap-dash, clumsy . . . sort of thing." And on April 8, Robinson attended a dinner party at Weir's home, joining Twachtman and the Japanese importer Heromichi Shugio for a discussion of that country's art.[1] Japanese-inspired refinement and precision was triumphantly realized several months later in *Boats at a Landing*.

There is surprisingly no record of an exhibition of this work before the artist's untimely death early in April of 1896. Except for the presence of a group of his Cos Cob paintings in the only one-man show held during his lifetime, which took place in February of 1895 at the Macbeth Galleries in New York City, Robinson seems to have chosen not to exhibit his Cos Cob pictures; the single exception was the appearance of *Low Tide, Riverside Yacht Club* in the autumn 1894 exhibition of the National Academy of Design. The favorable reception of this painting, which one reviewer deemed the "best shore piece in the collection", suggests that *Boats at a Landing* would also have been highly lauded.[2]

[1] References to Robinson's interest in Japanese art and the inspiration of Japanese aesthetics can be found in the typescript of the Theodore Robinson Diaries (1892-96), Frick Art Reference Library, New York City.

[2] "The Autumn Academy", *Evening Post*, 13 December, 1894, p. 5. See also "The Fine Arts The Autumn Exhibition at the National Academy of Design", *The Critic*, 22, 15 December, 1894, p. 417.

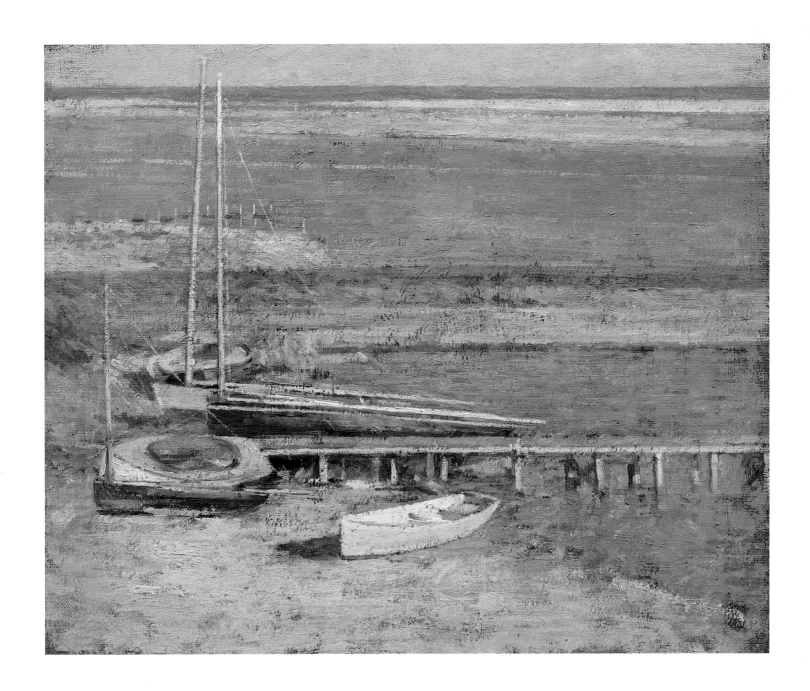

13
JOHN LESLIE BRECK
(1860–1899)

GARDEN AT GIVERNY, 1890
18 × 21⁷/₈ in.; 45,7 × 55,5 cm
Daniel J. Terra Collection
Terra Museum of American Art, Chicago, Illinois

Breck was born at sea off the Pacific island of Guam and was raised in Massachusetts; he studied in Europe, first in Munich in 1878–81, and then in Antwerp in 1882, before entering the Académie Julian in Paris in 1886. The following year he was one of a number of American and Canadian artists, including Theodore Robinson and Willard Metcalf, who visited Giverny in the summer.[1] This was crucial to Breck's ensuing career; under the influence of Claude Monet, he appears to have been one of the first Americans to adopt the loose, broken brush-work and high-keyed colorism of Impressionism. It seems likely also that Breck, more than any of his colleagues, championed not only this new aesthetic but also the attractions of Giverny as a summer art colony; it was Breck who induced Dawson Dawson-Watson to join the artists in Giverny in June of 1888. This attachment to Giverny was also personal, for Breck was captivated by Blanche Hoschedé, Monet's stepdaughter-to-be; however, though Breck remained in Giverny from 1888 until 90, the French painter effectively discouraged the liaison. Some of Breck's Giverny pictures were brought back to Boston in 1889 by the artist's colleague Lilla Cabot Perry and attracted attention when they were seen in her studio.

Soon after Breck's own initial return to Boston in 1890, he enjoyed a one-artist show of his work at the St. Botolph Club, an early exhibition of paintings by an American Impressionist. In the ensuing decade, before Breck's untimely demise in 1899, he was briefly in California in 1891, back in Giverny that year and again in 1894, in Kent in England in 1892, and in Venice in 1897, but Boston remained his base, where he was a leader among the avant-garde landscape painters. He had a second one-man exhibition in 1893, this time at J. Eastman Chase's Gallery, a third at the St. Botolph Club in 1895, and a memorial show at the Club in 1899.

It was the writer Hamlin Garland who described the works he viewed in Lilla Perry's Boston studio as "a group of vivid canvases by a man named Breck, [which] so widened the influence of the new school . . . I recall seeing the paintings set on the floor and propped against the wall, each with its flare of primitive colors—reds, blues, and yellows, presenting 'Impressionism,' the latest word from Paris."[2] Garland may well have encountered just such pictures as the present *Garden at Giverny*, which is said to depict a section of Lilla Perry's garden, near Monet's home. Breck was primarily a landscape painter, both in America and abroad, but he also created a number of dazzlingly colorful flower garden pictures. The inspiration for these most likely lies in Monet's own predilection for this theme, but it proved a strong attraction for a great many of the American Impressionist painters who, like Breck, painted both formal and informal gardens.

Seven or eight of the fifty paintings Breck exhibited in his 1890 Boston show were garden pictures, almost surely painted in Giverny, as were most of the landscapes he displayed; one work, in fact, was entitled *M. Monet's Garden.* Breck's exhibition evoked considerable passion among both the Boston and New York critics, some of whom championed Impressionism while others violently denigrated the movement. Generally, the garden pictures were among those to which the critics were most receptive; one reviewer, for instance, found that "the garden scenes are delightfully unconventional."[3] Another writer, after characterizing Breck as a "radical Impressionist" and objecting to much of his landscape work, wrote that: "On the other hand the flower pictures are charming in their intense gaiety. A painting of hollyhocks is luscious in its harmonious richness. Some of the detached bits of flower-beds and garden scenes play an enchanting staccato melody to the eye."[4] Here, the characteristic density of Breck's painted surfaces, with their uniformly heavy impastos, correspond to the impenetrable thickness of the mass of flowers themselves, as solidly geometric as the distant building behind them.

[1] One of the more reliable accounts of the original American presence in Giverny was provided by Breck's brother, the musician, Edward Breck, who, with their mother, accompanied the group of artists to Giverny. See: Edward Breck, "Something More of Giverny", *Boston Evening Transcript*, 9 March, 1895, p. 13.

[2] Hamlin Garland, *Roadside Meetings.* New York, Macmillan Press, 1930, pp. 30-31.

[3] "Fine Art Notes", *Boston Morning Journal*, 22 November, 1890, p. 2.

[4] "The Fine Arts", *Boston Sunday Herald*, 23 November, 1890, p. 12.

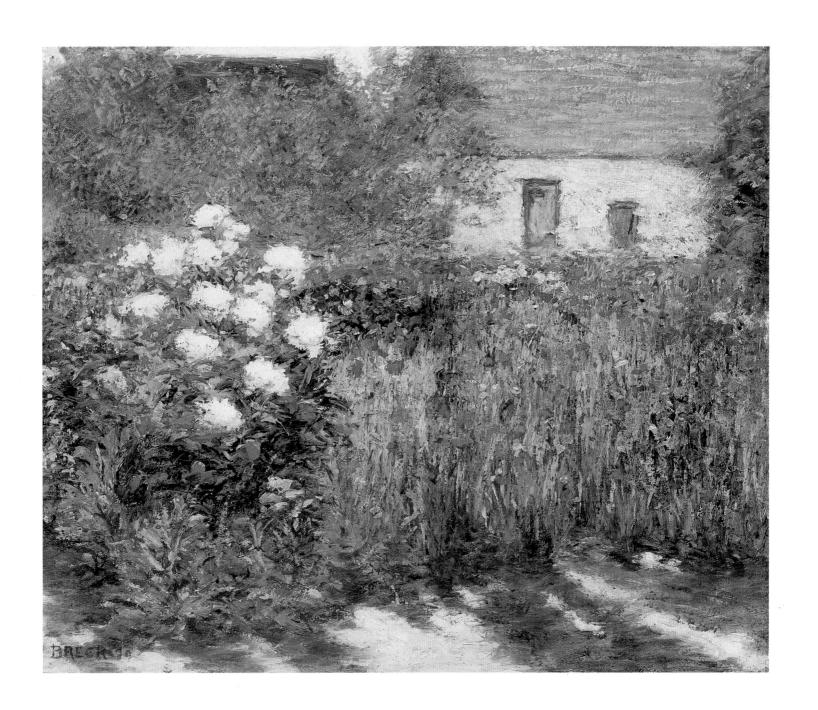

DAWSON DAWSON-WATSON
(1864–1939)

HARVEST TIME, ca. 1891
34 × 50½ in.; 87 × 128,2 cm
Pfeil Collection

Dawson Dawson-Watson was an English-born artist, the son of the illustrator John Dawson-Watson; he studied with the American expatriate Mark Fisher before seeking further instruction in Paris in 1886. Two years later he met John Leslie Breck who had first visited Giverny in 1887, and who induced Dawson-Watson to join him the following June. Dawson-Watson planned on staying in Giverny for two weeks; he ended up spending five years, as he related in one of the most reliable accounts of the development of the Giverny art colony.[1] While in Giverny in 1891, Dawson-Watson became involved with a number of other American artists including Thomas Meteyard and Theodore Earl Butler, Monet's stepson-in-law, and the writers Bliss Carman and Richard Hovey, in publishing a small, hand-printed magazine, the *Courrier Innocent.*

In 1893, Dawson-Watson came to America as Director of the Hartford Art Society in Hartford, Connecticut; after returning to England in 1897 for four years, he was in Quebec, Canada, in 1901, and he established a summer home and school in Scituate, Massachusetts, where his colleague Meteyard lived. Subsequently, Dawson-Watson was briefly affiliated with the Byrdcliffe art colony in Woodstock, New York, but after exhibiting at the Louisiana Purchase Exposition in St. Louis in 1904, he settled in that city, becoming one of the St. Louis' leading exponents of Impressionism, while establishing an arts and crafts school at Brandsville in the Missouri Ozark mountains. In 1914, he began to visit San Antonio, Texas, eventually dividing his residency between St. Louis and San Antonio.

Very few of Dawson-Watson's paintings have yet come to light; this is true even from his long periods of activity in Missouri and Texas. Several monumental depictions of the French peasantry from about 1890, however, suggest that at that time the artist sought to effect a balance between academic standards of sound draftsmanship and careful rendering of space and perspective, with a new chromatic sensibility derived from Impressionism. In such pictures, winter scenes are replete with blue and purple shadows and, as here, a summer rendition of harvesting is ablaze in bright sunshine, while dark, neutral tones are banished. Dawson-Watson's brushwork, too, became pro-

gressively looser, though even in *Harvest Time* that freedom is selective. Thus, the figures are quite carefully delineated while the field and the stacks of hay are vigorously brushed on to the canvas. Structure, too, is strongly maintained, the distant row of village houses and the plots of ground on the sloping hillside above them all being delineated in careful, geometric segments.

For all the brightness of the scene and the rich colorism of typically Impressionist purple shadows, garments, and rooftops, the theme here still conforms to the traditional interpretation of the hardworking Norman peasantry. The figures, men and women, are bent over in heavy labor, all of them integrated with the field in which they toil. Their lives as well as that field are circumscribed by the path at the right and by the distant wall, below which the figures sink in rather plunging perspective. The hillside and the far buildings also weigh down the composition, and the horizon line is almost non-existent, so that there is virtually no area of sky to relieve this earthbound composition. Dawson-Watson and Theodore Robinson would seem to be the two Americans painting in Giverny who most retained allegiance to the traditional theme of the working peasantry, one which Monet himself generally avoided. This painting is probably similar to several Giverny agrarian scenes which Dawson-Watson exhibited in a group show at the St. Botolph Club in January of 1894, along with paintings by Edmund Tarbell, Frank Benson, Philip Hale, Joseph DeCamp, and by Lilla Perry, who owned a rendering of Giverny haystacks by Dawson-Watson which was in that show. Perry's picture was also one of several of Dawson-Watson's agrarian scenes of Giverny which were then shown in New York at the sixteenth exhibition of the Society of American Artists, where critics acknowledged Dawson-Watson as a member of the contingent of American Impressionists.[2]

[1] Dawson Dawson-Watson, "The Real Story of Giverny", in: Eliot C. Clark, *Theodore Robinson His Life and Art.* Chicago, R. H. Love Galleries, Inc., 1979, pp. 65–67.
[2] "Landscapes and Portraits. Exhibition of the Society of American Artists", *New York Tribune,* 25 March, 1894, p. 5.

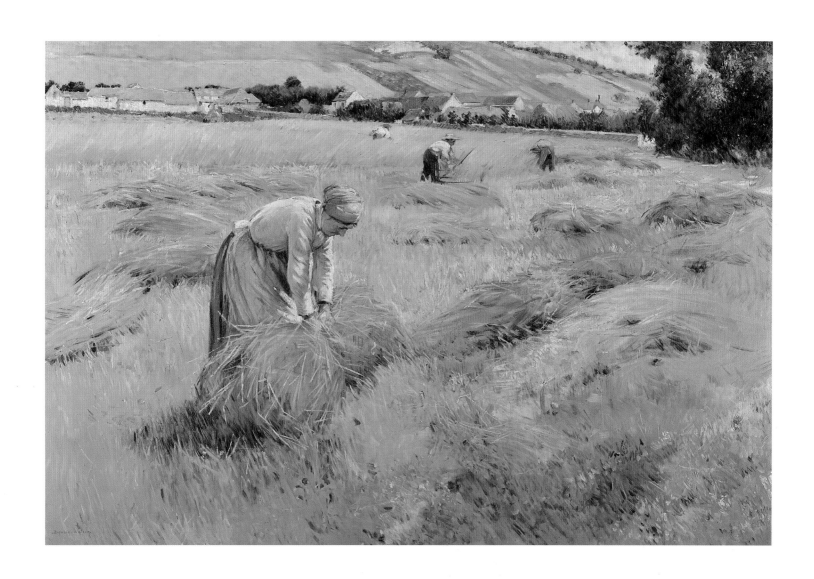

CHILDE HASSAM
(1859–1935)

GRAND PRIX DAY, 1887
24 × 34 in.; 61 × 86,5 cm
Museum of Fine Arts, Boston, Massachusetts
Ernest Wadsworth Longfellow Fund

By the beginning of the twentieth century, Childe Hassam had come to be considered by many the leading American exponent of Impressionism. He was an enormously successful painter, who had an active career of over fifty years, and the variety and innovation in his art was far greater than that of most of his contemporaries. Born in Dorchester, Massachusetts, he trained in Boston and came to the fore first as a painter in watercolors in the early 1880s. He then established his reputation as a masterful painter of contemporary urban street scenes, very possibly influenced by the work of such artists as Jean Béraud and Giuseppe de Nittis, whose pictures he very likely saw on his first journey to Europe in 1883. Hassam's early oil paintings, including his initial masterpiece *Rainy Day, Columbus Avenue, Boston* (Toledo Museum of Art) of 1885, are painted with close, dark tonal values applied to the strongly silhouetted buildings as well as pedestrians and street traffic vehicles, all plunging forward along the broad avenues of Boston, much in the manner of his European contemporaries.

If Hassam appears to have remained ignorant of the Impressionist aesthetic subsequent to his first trip to Paris, his second visit, which lasted three years, witnessed his selective adoption of the strategies of that movement, which found its most triumphant expression in his *Grand Prix Day* of 1887, a scene situated near the Place de l'Etoile. Like his earlier Boston pictures, this is a dynamic street scene, but now the view is informed by rich colorism, brilliant light, and vibrant brushwork. However, the full Impressionist mode is visible primarily in the range of trees of the Champs-Elysées. In contrast, the street itself is rendered in a flat, "glare" aesthetic, reflecting the rich sunlight, while the figures, carriages, and horses are quite academically depicted, indicative of his study at the Académie Julian at the time.

In addition, however, and despite the spontaneity and freshness of Hassam's perception, this is not a randomly selected moment. The artist has chosen a day of great sporting and social significance, the running of the great international horse race for three year olds, at Longchamp, in the Bois de Boulogne, on the last Sunday in June, and the accompanying parade of carriages in which the rich and famous of Parisian society were to be seen. Paris is fully acknowledged in the monumental mansarded building at the right and especially the partial view of the Arc de Triomphe at the left, which identifies not only the city but its grandest avenue. The carriages are packed on the street, coursing in both directions, a play of scintillating hues established by the contrast of the multi-colored parasols of the ladies

and the gentlemen's black top hats. The sidewalk, too, is dense with pedestrians. Even the empty foreground acknowledges the recent passing of another vehicle, from which a single red flower has been lost, about to be trampled upon by the brilliantly rendered pair of contrasting white and brown horses. The composition is quite untraditional; the emphatic diagonals of the stream of carriages, with the most prominent moving forward without any barrier, establishes great empathy with the viewer. The picture has the immediacy of an instant photograph, an effect abetted by the cropping at the right of the row of trees, and at the left, the carriages and the Arc de Triomphe.

While *Grand Prix Day* may call to mind the pictures of the horses, spectators, and carriages at Longchamp by such French Impressionists as Manet and Degas, the emphasis here upon the fashionable pageantry in the center of the city, rather than at the track, still recalls the work of Béraud and de Nittis. All of these artists, in fact, however, share with Hassam the modern vision of the spectacle; that is, such paintings not only depict a social procession, but they are about the observation of an event deliberately ostentatious. The present work, though a finished painting in itself, was also preparatory for a larger version (New Britain Museum of American Art, New Britain, Connecticut). That painting, in its more consistently flecked brushwork and greater chromatic intensity, displays more completely the strategies of Impressionism, though it is perhaps a somewhat less sensitive evocation of La Belle Epoque; it won for Hassam a bronze medal at the Paris Salon in 1888. Hassam sent the present picture back to Boston early in 1889, where it was exhibited as *The Champs Elysées, Day of the Grand Prix,* at Noyes, Cobb & Co., in March. Critics of the show noted modifications in Hassam's latest work from the cityscapes of his earlier Boston years. One wrote: "These pictures were nearly all painted in Paris, and they show a change of key at least, and also of theme from previous work. He gives, it is true, some street scenes, but he does these sufficiently well to justify frequent recurrence to so attractive and envied a subject. He shows us the Paris streets, both wet and gay, but the bright, light tones prevail in the collection. Indeed, the whole effect of the pictures is cheerful … Mr. Hassam has found out many attractive corners of Paris … picturesque angles of the boulevards."[1] The artist, himself, returned to this country later that year.

[1] Undated clipping from the *Boston Sunday Herald,* Childe Hassam Papers, Smithsonian Institution, Washington, D. C.

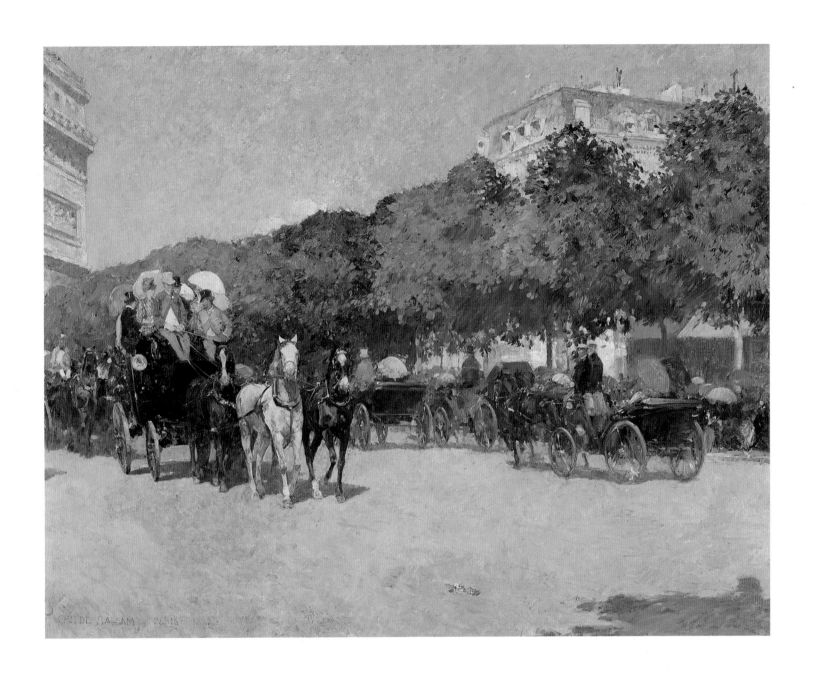

16
CHILDE HASSAM
(1859–1935)

WASHINGTON ARCH, SPRING, 1890
27¹/₈ × 22¹/₂ in.; 68,9 × 57,1 cm
Phillips Collection, Washington, D.C.

Hassam returned to the United States in the autumn of 1889 after three years of studying and painting in and around Paris; he settled in New York City, rather than in Boston where he had previously lived and trained. In both Boston and Paris Hassam had established himself as a specialist in the painting of urban scenes, and he reaffirmed this position in New York. Though many of his city scenes of the 1890s now utilized the still innovative aesthetics of Impressionism, it was as the leading interpreter of New York City that he first came into public prominence. Some of these views, including a number of renderings of Union Square, are panoramic scenes from on high, but others, such as his superb *Washington Arch, Spring,* emphasize Fifth Avenue and the more elegant sections of the city viewed frontally and from street level. Hassam's studio at 95 Fifth Avenue was near both the Arch and the Square.

It is amazing the amount of city life that Hassam is able to encompass in this canvas. An elegantly dressed lady of obviously good breeding is the most prominent, seen here on her morning rounds, walking along next to well-tended flowering garden patches which border the stoops of the brownstone row homes. Behind her, several top-hatted gentlemen promenade down the Avenue, along with a nurse pushing a perambulator and taking her charge for an early outing; the strong shadows cast by the sun in the East indicate the early time of day. Hassam establishes here an immaculate sense of order and neatness. The spacious sidewalk opens up broadly, spreading out over the entire front plane; this is bordered at the left by a row of trees, budding in spring sunlight. A sense of consistent growth and renewal is present even in the contrast of the four mature trees in the middle ground, behind which are several younger ones, while in front is a thriving sapling. Off the curb is an amusing contrast of a dark liveried carriage and a street cleaner in a spotless white uniform, engaged in his morning chore of sanitizing the avenue, thus further emphasizing the immaculate nature of elegant, upper-class New York. It should be noted, however, that the quality of life in this area around Washington Square had declined in the previous several decades; this downturn had only recently been reversed and Hassam's introduction of the busy street cleaner is emblematic here of that change.

Behind this compositional grouping of diverse figures, out for a morning promenade, looms the sparkling architectural mass of the Washington Arch, designed by the great architect Stanford White, and erected in wood in 1889, the year previous to the painting, built to commemorate the centenary of George Washington's inauguration. Thus, despite its tradional, classical form, it was a recent, modern construction; painted white at the time to simulate stone, it was replicated in actual stone three years later. It thus recalled the Arc de Triomphe that figured in Hassam's great *Grand Prix Day* of 1887 (Museum of Fine Arts, Boston). Yet, Hassam noted that "the thoroughfares of the great French metropolis are not one whit more interesting than the streets of New York."[1]

What is equally significant here are those aspects of city life which are omitted. There is no sign of squalor or confusion, of the lower classes or of any class distinctions. There is no chaos; figures do not move at discordant angles, nor are there any inharmonious chords of color. Indeed, nature is in full accord with the tone of satisfaction and good living that Hassam has established, with rich sunlight infusing and illuminating this scene of city life. The month is May, as was acknowledged in the exhibition of the picture as *Fifth Avenue and the Washington Arch in May,* when it was shown at Doll & Richards Gallery in Boston in February, 1895, and again at the St. Botolph Club in November, 1900, shown then as *Washington Arch, May.* Even nocturnal security is hinted at, with the long, strong shadow of a street lamp streaking across the sidewalk.

Once established in New York, Hasssam was acknowledged as "a brilliant painter, a sort of Watteau of the Boulevards, with unlimited sparkle and gaiety, movement and animation. He suggests a crowd well; he gives you the color of the streets and the tone of the city."[2] The earliest significant article on Hassam, published in 1892, was entitled "Mr. Childe Hassam on Painting Street Scenes", in which the artist recalled that the great French painter and teacher Jean Léon Gérôme had advised his pupils to "go into the street and see how people walk."[3] A year later, the artist illustrated a perceptive study of Fifth Avenue, written by one of the most astute art critics of the time, Mariana van Rensselaer. Using Hassam's *Washington Square, Spring* as an illustration, she noted that it was with the Square that "the real Fifth Avenue begins."[4]

[1] A. E. Ives, "Mr. Childe Hassam on Painting Street Scenes", *Art Amateur,* 27, October, 1892, p. 117.
[2] [William] Howe [Downes] and [Frank] Torrey [Robinson], "Childe Hassam," *Art Interchange,* 34, May, 1895, p. 133.
[3] Ives, *loc. cit.*.
[4] M.G. van Rensselaer, "Fifth Avenue with Pictures by Childe Hassam," *Century,* 47, Nov., 1893, pp. 5–18, esp. pp. 6, 10.

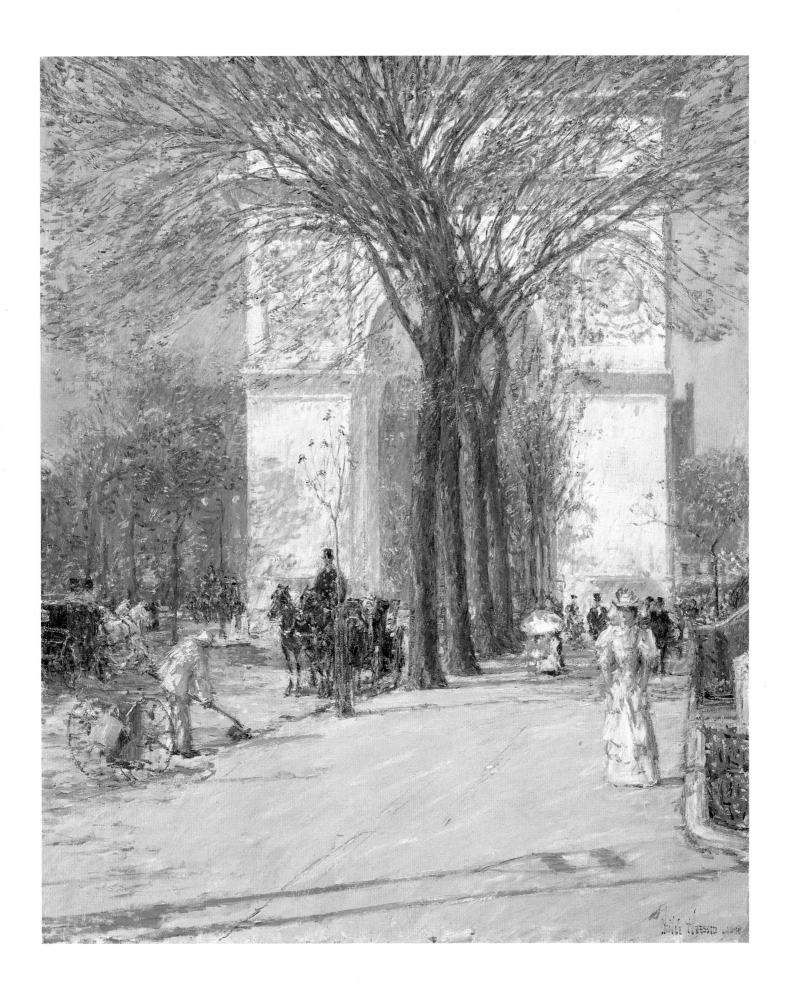

17
CHILDE HASSAM
(1859–1935)

THE LITTLE POND, APPLEDORE, 1890
16 × 22 in.; 40,6 × 56 cm
Art Institute of Chicago, Chicago, Illinois
Friends of American Arts Collection and Walter M. Schulze
Memorial Collection through Exchange

Hassam is believed to have first visited the island of Appledore, one of the Isles of Shoals off the coast of New Hampshire and Maine, in the summer of 1884, even before his decisive trip to Europe two years later. This was the home of his pupil Celia Thaxter, a poet and essayist of note, who established there an attractive, informal summer salon for artists and writers. Hassam was the most noted painter to execute an extensive body of work on Appledore; especially fine are those pictures he painted during the summers of 1890 to 1894, before Thaxter's much-mourned death in August.

In these paintings, Hassam exploited fully the Impressionist strategies he had developed in Paris in the late 1880s—the rich colorism, the interest in bright sunlight, and the vivid, sometimes rather ragged paint application. These qualities were especially appropriate to the wild flower garden that Thaxter cultivated on Appledore, and which was one of the great attractions there, in works which recall the depictions of poppy fields which Claude Monet had painted during the previous decade and a half. In his pictures, however, Hassam also emphasized the unique topography of Appledore—the irregular configurations of the low-lying granite outcropping, seemingly "floating" on the clear blue ocean waters. Though usually figureless, these paintings are paeans to natural beauty and, by extension, to human pleasure and contentment, in their clear skies, the calm waters, and the colorful foliage.

The flower pictures are perhaps the best known of Hassam's Appledore works, but he painted the landscape there in a variety of moods, from blazing light and color to somber moonlight views. *The Little Pond, Appledore* is one of the most sedate and subtle of this group of paintings. Hassam has effected a marvellous balance between the clear, unbroken, horizontal plane of the sky which occupied over half the picture, and the extremely varied land mass below. The foreground consists of long grasses, interspersed with wild roses and flowering white bushes, all richly rendered. Flat purple-gray rock formations, separated by low-lying green foliage, occupy the middle ground and extend out into the ocean, geological forms distinctive to the island

which appear to have fascinated Hassam in his many renderings of them. Between the two planes is the pond, scintillating with rippling blue, red, and purple tones, in contrast to the calm evenness of the sky.

Hassam's Appledore paintings were first exhibited at Doll & Richards Gallery in Boston in February of 1891, and then at the thirteenth annual exhibition of the Society of American Artists in April of that year, and they continued to appear at that venue through 1894. In addition, a group of these pictures were displayed at the eighth annual art exhibition of the St. Louis Exposition and Music Hall Association, also in 1891. The critics noted the vivacity of these landscapes, and their reflection of the growing Impressionist strain in American landscape painting, but many found their colors crude and even implausible, and objected to their vigorous brushwork, and their lack of traditional compositional strategies and tonal considerations of light and shadow. They appeared to some reviewers to lack theme and purpose; one wrote that "We would not undervalue Mr. Hassam's recent open-air studies . . . A painting that is a painting purely can have merit and charm, but the public demand for a picture rather than for a 'note' or 'an arrangement,' for a composition rather than for a fragment, is logical and right."[1] It was only around 1894 that some of the critics began to accept the novelty of Hassam's Appledore scenes; the writer for the *New York Herald* that year judged that "Childe Hassam's 'An Island Landscape—Evening,' is an impressionist masterpiece."[2] Hassam himself must have been aware of the modernity of these renderings of sparkling bits of nature, for none of his early Appledore pictures appeared in the exhibitions of the more conservative National Academy of Design.

[1] "Society of American Artists", *New York Daily Tribune*, 8 December, 1892, p. 7.
[2] "Splendid Show of the Society", *New York Herald*, 10 March, 1894, p. 7.

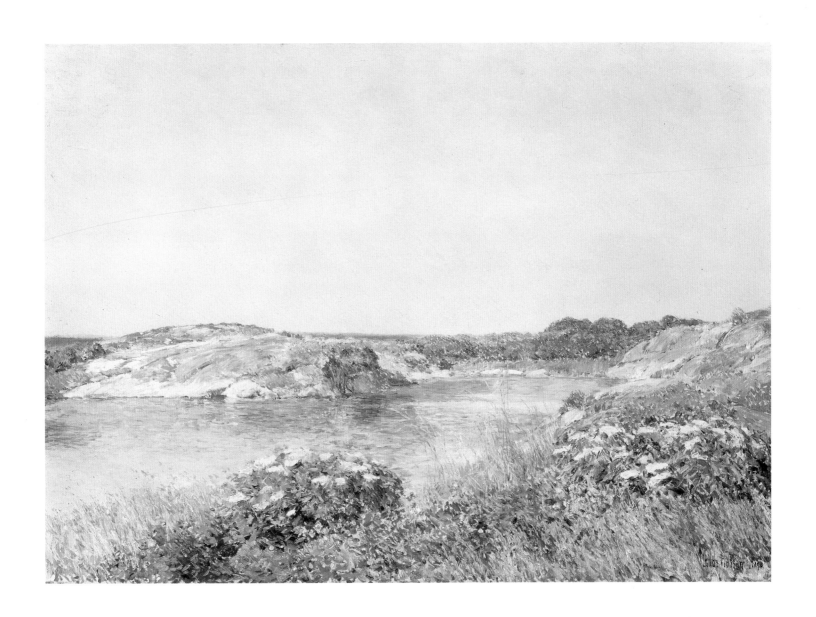

18
CHILDE HASSAM
(1859–1935)

FIFTH AVENUE AT WASHINGTON SQUARE, 1891
22 × 16 in.; 56 × 40,6 cm
Thyssen-Bornemisza Collection, Lugano

Fifth Avenue at Washington Square would seem to depict the identical section of the same block featured in *Washington Arch, Spring,* painted the previous year. A smaller picture, it is also less panoramic and more intimate, with greater concentration on the figures and vehicles, which appear larger and more individualized. Much of the same "cast of characters" appears in both; the foremost individual is an elegant woman, and behind are children and a nurse, while further back, men and women are promenading. It is a heterogeneous crowd of people, agreeably busy on the urban thoroughfare, a subject that held great appeal to the artist. He noted the year after this picture was painted that "There is nothing so interesting to me as people. I am never tired of observing them in everyday life, as they . . . saunter down the promenade on pleasure. Humanity in motion is a continual study to me."[1]

Again it is morning, for the shadows are cast toward the right from the sun in the East, although it is a later hour and the shadows are neither as elongated nor as dark. It is also later in the year, judging by the full, green leafage of the trees, and the need for a parasol; the light, too, appears even more golden and warmer. If *Washington Arch, Spring* was painted in May, this is probably a scene in June. By now, the street cleaners have come and gone and, instead, the streets are more heavily trafficked; carriages follow one upon another and a bus can be seen in the background with several figures alighting. In general, there is more activity, and Hassam has correspondingly utilized different, sometimes more informal strategies. Some figures—the nurse, and the girl with a hoop—move at an angle to the main perpendicular axis of the composition; the others walk both toward the foreground and toward the rear, unlike the uniform forward motion in the earlier picture. One man, in casual clothes rather than a top hat, walks his dog; even the shadows of the trees are more busy and amorphous, lacking the severity of those in *Washington Arch, Spring.* Hassam's brushwork is, if anything, even more feathery and animated in this slightly later painting.

The lower classes and the poor are likewise totally omitted from *Fifth Avenue at Washington Square.* Washington Square and lower Fifth Avenue had been the center of upper-class society in the mid-nineteenth century, and after some decline, were undergoing a "renaissance" at this time, which is celebrated in this group of Hassam's paintings. Mariana van Rensselaer noted: "I am ready to affirm that Washington Square has thus far led a reasonably conservative life. So, too, it has been with the lowest part of the avenue and its adjacent streets . . . They are not the fashionable streets they were in my childhood; but 'good people' still live in them, and the number is now increasing again year by year, desecrated dwellings being restored within and without, and a belief steadily gaining ground that, whatever may happen a little farther up the avenue, this quarter-mile stretch will remain a 'good residence neighborhood'."[2]

The most obvious difference between the two canvases, one that almost obscures their identical setting, is the omission here of the Washington Arch. Presumably, the present work was painted when the temporary wooden arch had been removed and before the permanent replacement was erected in 1892. The omission of the arch generates greater intimacy in the present picture, and makes the work more a truly "urban landscape" than a "cityscape".

[1] A. E. Ives, "Mr. Childe Hassam on Painting Street Scenes", *Art Amateur,* 27, October, 1892, pp. 116–117.
[2] M[ariana] van Rensselaer, *Century,* 47, November, 1893, p. 10.

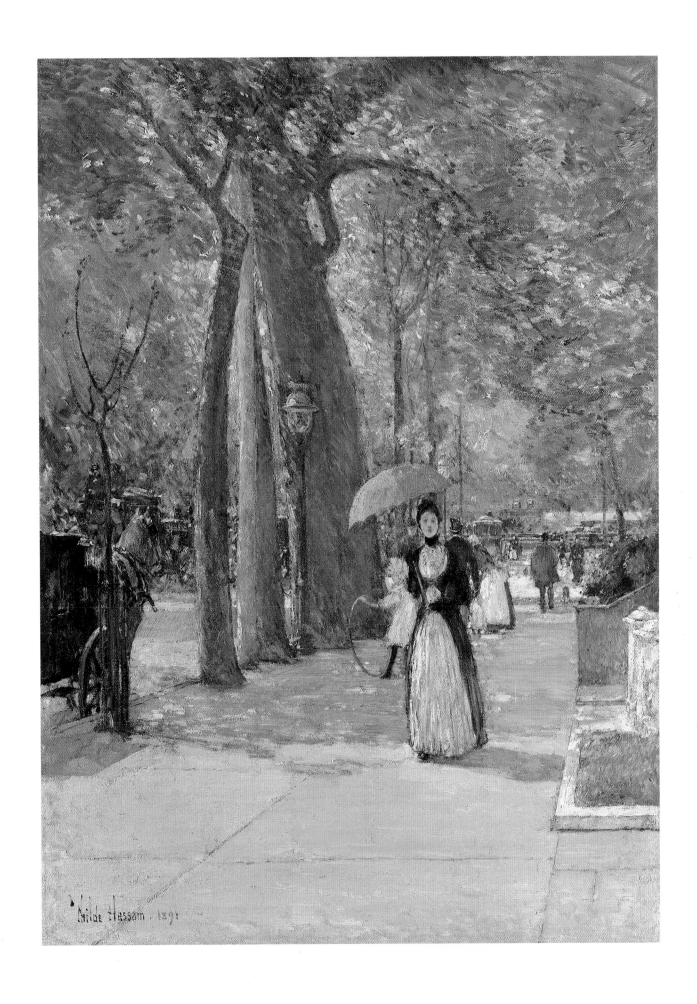

CHILDE HASSAM
(1859–1935)

PIAZZA DI SPAGNA, ROME, 1897
29¼ × 23 in.; 74,3 × 58,5 cm
Newark Museum, Newark, New Jersey
Gift of the Misses Lindsley

Late in 1896, Hassam went abroad for the third time, travelling to Italy, France, and England. He was an established Impressionist master now, rather than the tyro he had been when he went to Paris a decade earlier, and his purpose was not to study further, but to travel and paint exotic motifs. In Italy, he visited Naples, Posillipo, Rome, Capri, and Florence; the best known of his Italian subjects are the several depictions of the Spanish Stairs he created during his month in Rome in January of 1897, including the present example and one in the collection of the Los Angeles County Museum of Art.

New strategies developed in Hassam's art in 1897, undoubtedly due in part to the examples of contemporary painting which he encountered in Europe. Foremost was his handling of paint, which became much more expressive compared to the delicate touch he had exhibited in such pictures as *Washington Arch, Spring* and *The Little Pond, Appledore*, both of 1890. Here, the paint is laid on very thickly, in long, broad strokes of contrasting hues; there is great emphasis upon light, but it is conveyed, not in terms of scintillation, but rather of reflection in the white and yellow paint, and the rich azure sky. At the same time, there is increased concern for structure and a new dynamism infused into Hassam's composition also; the point of view is taken from some distance down the Scalinata, the Spanish Stairs, with forms and space diminishing precipitously both up and back, the group of packed figures at the top squeezed between the receding balustrade at the left and the curved wall at the right. The stairs themselves are emphatically defined, and seem to cascade down to meet the viewer abruptly, though the eye is pulled back into the composition by the peasant women, several of whom are almost duplicates of one another, and are seen mounting the stairs. The entire cast of characters here, in fact, consists of contadini in native costume; there are no tourists, and no middle-class. There are also no males; Hassam has chosen to identify the scene with old Rome, and to emphasize the picturesque, since the women's costumes were more decorative and especially more colorful than those worn by men.

Hassam's Italian pictures did not have a great deal of public exposure in the immediate years after they were painted, nor did they figure in the various commercial gallery and museum retrospectives that the artist enjoyed during the 1920s, as did, for instance, the Parisian and Brittany scenes he painted on the same European trip. Soon after he returned to New York City, he was one of the ten painters who seceded from the Society of American Artists and who organized The Ten American Painters, and that group, henceforth, became one of his primary New York venues. It was with The Ten that Hassam exhibited several versions of his depiction of The Spanish Stairs. One appeared under that title in the first annual exhibition of The Ten, which opened at the Durand-Ruel Galleries in New York at the end of March, 1898, and went on to the St. Botolph Club in Boston in late April; another, entitled *Down the Spanish Stairs*, was shown in the second annual exhibition at the Durand-Ruel Galleries in April of 1899.

A recurring problem in analyzing the critical reaction to Hassam's paintings was his consistent repetition and near-repetition of titles; lacking illustrations in reviews, it becomes almost impossible to be certain which version of a subject was displayed in a given exhibition. One reviewer of the 1898 show of The Ten noted the increased modernity of Hassam's recent works; he pointed out that "They seem to have been painted with a desire to indulge in some assertion of radicalism."[1] In general, though, *The Spanish Stairs* itself evoked little reaction; his Florentine view of a bridge across the Arno was probably the most admired of his foreign scenes in that display. *The Spanish Stairs* was praised by one reviewer who found the picture "deliciously amusing," while another noted the artist's preference for architecture in his seven entries, and judged that "his fashion of putting light and air into *The Spanish Stairs, Pont-Aven*, and *The Arno* cannot be bettered..."[2] *Down the Spanish Stairs, Rome*, shown in 1899, received a good deal more acclaim than its predecessor, and was generally judged the finest of his four offerings that year.[3] It would seem to have been similar to *Piazza di Spagna*, judging by a description in the *Mail and Express*, where the picture was also admired for its "feeling in the composition for width and spaciousness, for the beauties of color and light and air, for the work as a whole rather than some one technical feature in it."[4] One writer noted that "Mr. Childe Hassam did better in his Roman street scene than in his pictures of bathers", referring to two pictures of nudes that he also displayed.[5]

[1] "The American Painters", *World*, 3 April, 1898, p. 14.
[2] "The Fine Arts", *Boston Evening Transcript*, 27 April, 1898, p. 16; "Fine Arts", *Independent*, 7 April, 1898, p. 443.
[3] "Ten American Painters", *Artist*, 25, May-June, 1899, p. vii.
[4] "Art Notes", *Mail and Express*, 5 April, 1899, p. 4.
[5] "The Fine Arts: Exhibitions", *Critic*, 34, May, 1899, p. 461.

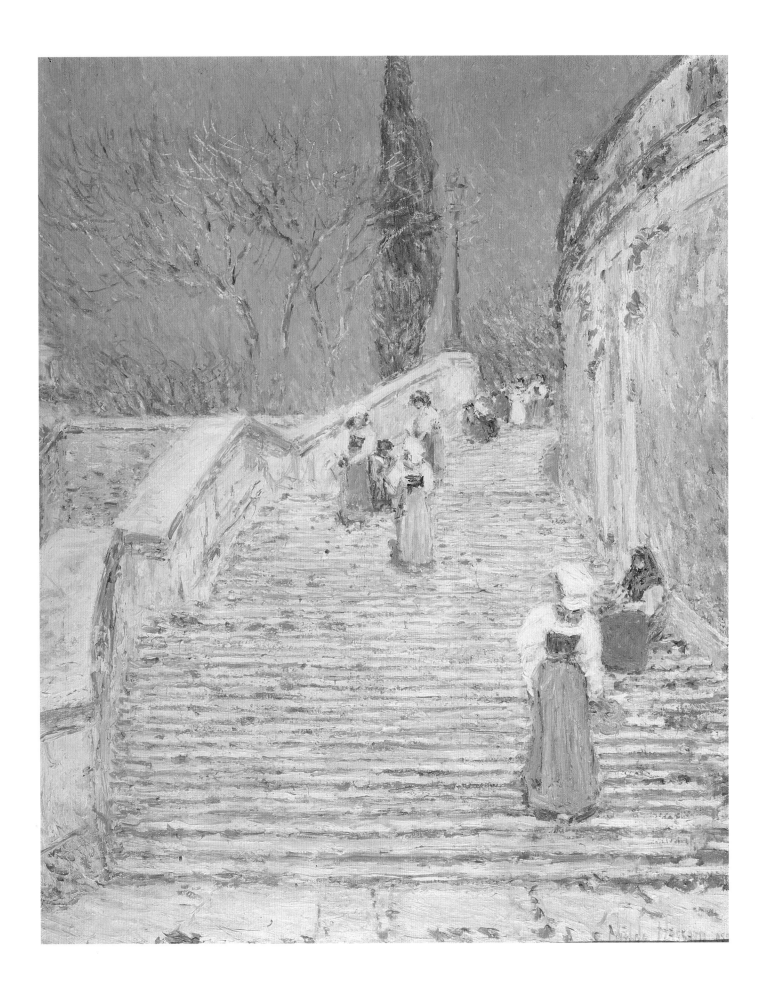

CHILDE HASSAM
(1859–1935)

GLOUCESTER HARBOR, 1899
24½ × 22½ in.; 62 × 57 cm
Pfeil Collection

Hassam is known to have visited and painted in Gloucester, Massachusetts, as early as 1890, but his summer work for the next few years was done chiefly at Appledore; it was only after Celia Thaxter's death on that island in August of 1894 that the artist began to spend substantial parts of the summers at other resorts and art colonies elsewhere in New England. He returned to Gloucester in 1894 and made numerous visits thereafter; his season there in 1899 appears to have resulted in some of his finest renderings of a New England town. He was, of course, not alone in choosing to paint at Gloucester; from the late 1870s the community had increasingly appealed to artists, and by the 1890s it had become a popular colony for artists, a number of whom also held summer art classes there.

Hassam's Gloucester pictures are basically extremely faithful to their subjects. In *Gloucester Harbor,* for instance, painted from Banner Hill in East Gloucester, the buildings can be precisely identified, from the residence in the foreground at 245 Main Street, to the City Hall clocktower in the far distant center, and next to it the spire of the First Baptist Church. The promontory in the center is Rocky Neck, with the chimney of the Marine Railways power plant rising prominently. The small boats in the water are in that part of the harbor known as Smith's Cove.[1] Yet, such works are more than a compilation of specifics. Hassam was genuinely devoted to his New England heritage, and these paintings of Gloucester, Newport, and other small, old towns are paeans to and affirmations of a tradition which he upheld, and which he interpreted in the most advanced aesthetic then being practiced in the United States.

Here, Hassam celebrates the joyousness of the scene, the sense of order and tranquility which he discovered in Gloucester, and the harmony between man and nature. Though the town is built up neatly, the artist choosing a vantage point from which each band of settlement recedes parallel to the picture plane, and while industry is not denied, there is nothing discordant here; even the boats are almost all pleasure crafts, with little recognition of the fishing industry that we see in John Twachtman's almost contemporary Gloucester scene, *Bark and Schooner.* Ernest Haskell summed up Hassam's achievement in pictorially defining the essence of the town: "Before I had seen Hassam's pictures, it seemed a fishy little city, now as I pass through it I feel Hassam. The schooners beating in and out, the wharves, the sea, the sky, these belong to Hassam. Just as one cannot go to Venice and be very far from Whistler."[2]

Numerous of Hassam's paintings were shown and/or are today known with the title *Gloucester* or one very similar; the present example, however, may be identified through an illustration in *Harper's Weekly* as the work which appeared in March of 1900 at the Durand-Ruel Galleries in New York City in the third annual exhibition of The Ten, and which was then shown in Boston when the display went on to the St. Botolph Club in April. This was one of the most acclaimed paintings which Hassam ever showed with that group, the reviewer in *Harper's Weekly* noting that it "added one more to his brilliant series of city subjects."[3] Another writer agreed, finding it "a worthy companion to the other brilliant city studies of this painter. Its composition is so interesting; the impression of space as well as of masses of houses and shipping is suggested in a masterly way and the purity of color and sense of light and free air are admirable."[4]

The critic for the *Sun* found the picture "a brilliant little piece of sunlight with the most radiant of summer atmospheres enveloping the town and harbor."[5] And Royal Cortissoz in the *New York Daily Tribune,* hitherto a strongly adverse critic of Hassam, found the painting "delightfully handled. The diverse elements in the composition seen from a height, are thrown into a perspective that is not only correct, but fruitful of a pictorial impression, and the light which floods the scene is rendered with unimpeachable accuracy. In this picture Mr. Hassam seems at last to be the master of those impressionistic ideas over which he has inadequately fumbled for so long a period."[6]

1 Gail Stavitsky, "Childe Hassam" in Museum of Art, Carnegie Institute, *Directions in American Painting 1875-1925 Works from the Collection of Dr. and Mrs. John J. McDonough,* exhibition catalogue, Pittsburgh, 1982, p. 36.
2 Ernest Haskell, in Nathaniel Pousette-Dart, compiler, *Childe Hassam.* New York, Frederick A. Stokes Company, 1922, p. viii.
3 "Third Exhibition of the 'Ten American Painters'", *Harper's Weekly,* 44, 14 April, 1900, p. 338.
4 "Third Annual Exhibition of Ten American Painters", *Artist,* 27, May, 1900, p. xxviii.
5 "Art Notes", *Sun,* 20 March, 1900, p. 6.
6 [Royal Cortissoz], *New York Daily Tribune,* 17 March, 1900, p. 2.

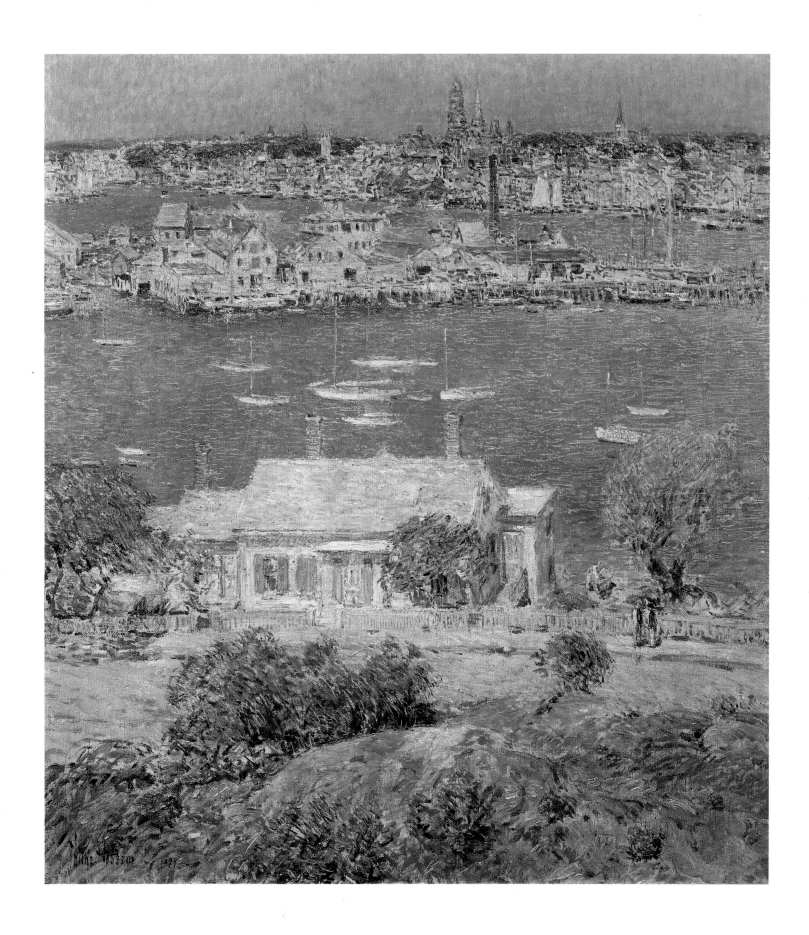

21
CHILDE HASSAM
(1859–1935)

THE HOVEL AND THE SKYSCRAPER, 1904
34¾ × 31 in.; 88,3 × 79 cm
Mr. and Mrs. Meyer P. Potamkin

The Hovel and the Skyscraper reflects Hassam's ongoing concern with the appearance and the dynamics of New York City, but he approaches the subject here in a manner very different from his earlier views near Washington Square. The present scene is situated uptown, off Sixty-seventh Street where Hassam had just established his studio at the time, and right near Central Park, which is seen over the construction work. In a sense, the picture is a metaphor of Hassam's own urban art, one which had then been moving away from the more traditional areas of the city with often smaller buildings, in favor of skyscrapers, which would subsequently be featured in his New York Window series and in his Flag pictures, both painted during the 1910s.

In addition to Hassam's well-identified involvement with the depiction of cities, however, he was also much more concerned with themes of work and labor than is usually acknowledged, subjects which ally his art with that of the artists of the contemporary "Ashcan School." Sometimes this was rural labor, as in Old Lyme, or that in smaller towns, such as shipbuilding at Gloucester and Provincetown, but workers in the metropolis did not escape his scrutiny. *The Hovel and the Skyscraper* is the most monumental testament to this interest.

Here the scene is situated from on high, probably taken from the artist's studio, overlooking a panorama of the city; the winter weather furnished Hassam with a rich tonal contrast between the snow laden park and the dark forms of the pulleys and other construction devices. The title suggests one significant contrast implicit in the scene, though in fact the picture is about neither a hovel nor a skyscraper, just between the old and the new. The latter referred to the building of a new parish house for a church on the corner of West Sixty-eighth Street and Central Park West, while the "hovel" was the low-slung old riding stables at the West Sixty-seventh Street entrance to Central Park.[1] Perhaps the artist introduced the term "skyscraper" in his title both to refer to the unprecedented growth of the city at the time, as well as to suggest its seemingly limitless expansion; and the "hovel" may have been meant to call to mind the shantytown that had previously existed in this area of New York City, which had been gradually replaced during the last several decades. Hassam introduces here a pictorial symbol especially favored by Impressionist painters of the modern cityscape, the steam pockets which, as Wanda Corn has perceptively noted, "hung like banners over New York, still known worldwide for its clean air and unsooted white facades! Having become an emblem of the city, steam clouds continue to hang over the cubist cityscapes of [John] Marin and [Max] Weber in the next decade."[2]

At the same time, the picture balances the uncompromisingly solid and geometric forms of man-made urban structures in both the foreground and far distance, with the soft, feathery landscape of the extensive park—man and nature, each dominant in their own realm. A few tiny riders on horseback canter through the park, while in the foreground four workers go about their chores unconcerned about their precarious perch. And on Central Park West, an amazing catalogue of spidery figures are visible: a single pedestrian walks north; two women walk south, one pushing a perambulator; a man walks a dog; and in the street is a street cleaner and an ice wagon. In all, a composite mass of the city's dwellers.

1 Donelson Hoopes, *Childe Hassam,* New York, Watson-Guptill Publications, 1979, p. 62.
2 Wanda M. Corn, "The New New York", *Art in America,* 61, July-August, 1973, p. 81.

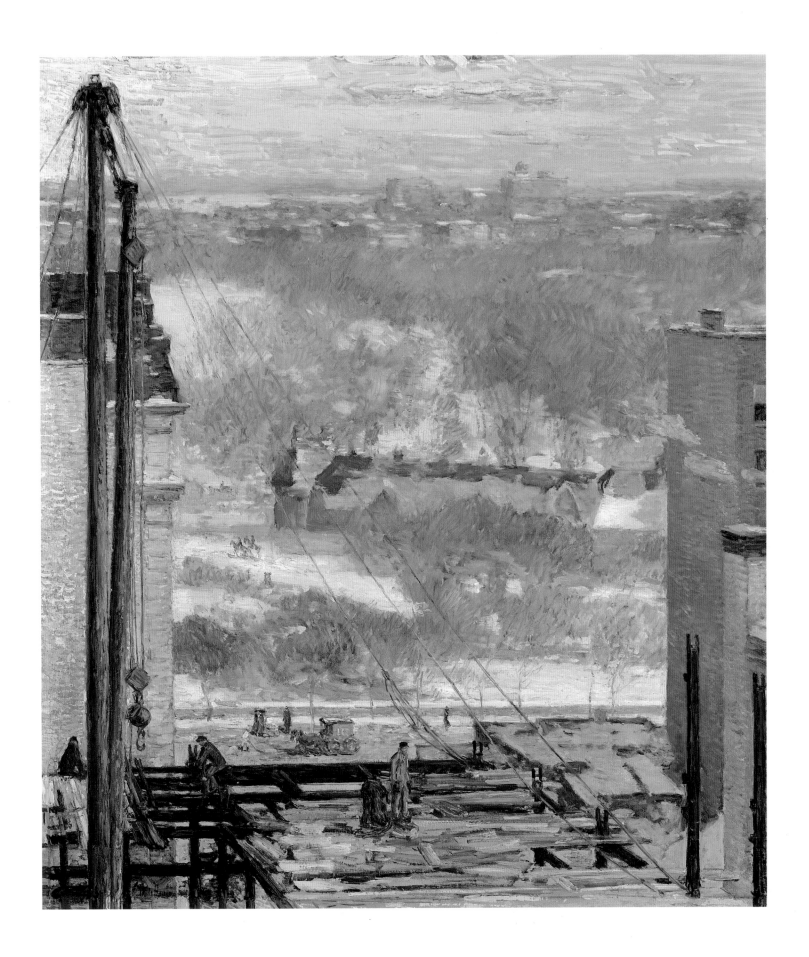

CHILDE HASSAM
(1859–1935)

CHURCH AT OLD LYME, CONNECTICUT, 1905
36¼ × 32¼ in.; 92 × 82 cm
Albright-Knox Art Gallery, Buffalo, New York
Albert H. Tracy Fund

It may well be that the archetypical American Impressionist image is one of the numerous representations by Hassam of the Congregational Church at Old Lyme, Connecticut, a series of images he painted between 1903 and 1906. Old Lyme had been visited by American artists in the mid-1890s, but it was only in 1899 that it began to assume its place as one of the major artists' colonies in the United States. At that time, it became a bastion for late-Barbizon and Tonalist painting, especially of landscape, but with the appearance there of Childe Hassam in the summer and autumn of 1903, and then of Willard Metcalf, the dominant aesthetic of Old Lyme began to reflect Impressionist strategies, with some of the Tonalists converting to a more colorful and light-filled mode, and others moving away; Hassam continued to visit Old Lyme through 1912. Certainly, Hassam cannot be credited completely for this transformation, but as a well established artist working with a style so popular among collectors and critics, he at least played a major role.

Hassam, and the Old Lyme painters who emulated him, devoted a good deal of their attention to those pictorial icons, both natural and man-made, which were especially associated with Old Lyme. These included the abundant hedges of mountain laurel, the distinctive bow bridge across the Lieutenant River, and especially the church pictured in this work by Hassam. The Congregational Church symbolized the New England, Puritan heritage from which Hassam had sprung and which seemed to encompass the strongest traditional values of the nation, in addition to its obvious religious role. It was also a striking visual motif, its brilliant white form reflecting the light of the heavens, and surrounded by the golden leafage of a grove of slender elms and the dense greens of the shorter evergreens, both of which echo the thrust of the church while the elms also bow in obeisance toward it.

Hassam painted the church numerous times, in bright daylight and in evening light, sometimes from a slight distance, at other times close up; on the canvas here he even recorded the day and month of the year in which he painted the church—October 17, 1905—suggesting the significance of accurate naturalistic observation to the artist. While hardly so extensive, and never exhibited as an ensemble, one of Hassam's biographers, Adeline Adams, has noted that "What the Rouen Cathedral was to Monet, the New England meeting-house was to Hassam." And Adams went on to quote Hassam's recollection of the boyhood church in his native Dorchester, Massachusetts, a memory evoked by the similar structure in Old Lyme, the artist referring to these buildings as "masterpieces of architecture",

and noting that "All unconsciously I as a very young boy looked at this New England church, and without knowing it, appreciated partly its great beauty as it stood there against one of our radiant North American clear blue skies."[1] These images took on even greater poignancy after the church was razed by fire on July 2, 1907, though it was subsequently rebuilt.[2]

The first version of this subject by Hassam (private collection, California) appeared in the Seventy-third Annual Exhibition of the Pennsylvania Academy of the Fine Arts in January of 1904, and then in mid-March with The Ten American Painters at the Durand-Ruel Galleries in New York City. The present variation of the *Church at Old Lyme* was originally shown in the Eighty-second Annual Exhibition of the National Academy of Design in New York in March of 1907. There it was the subject of an extended encomium in *The Nation* by the painter-writer Frank Fowler who wrote: "An exquisite example of modern 'seeing' is 284, The Church at Lyme, by Childe Hassam, a simple composition, spacious, calm-compelling, marked by taste in its well-disposed masses. Rising from substantial base to slender steeple, the church cuts the canvas, suggests the completing proportions, and gives the air of fragile altitude while conforming to an unstudied pattern of much distinction. This much for the design. The color is of a quality that might be found in some rare Persian tile, or better, in the opalescent air of a late summer day with the hint of autumn stirring among the branches of immemorial elms. This . . . makes a picture that touches, perhaps, the high-water mark of sensitive vision and achievement in the exhibition. It is in essence a phase of consecrated New England, and becomes art through a sustained and intelligent presentation of 'the splendor of the true'."[3]

Church at Old Lyme subsequently appeared in the *Ausstellung Amerikanischer Kunst* in Berlin and Munich in 1910, one of the most important surveys of American painting ever to be shown abroad, and then in numerous retrospectives of Hassam's work held during the 1910s and 1920s.

[1] Adeline Adams, *Childe Hassam*, New York, American Academy of Arts and Letters, 1938, p. 90.

[2] For information on Hassam in Old Lyme, including his pictures of the church, see the essay by Kathleen M. Burnside in Florence Griswold Museum, *Childe Hassam in Connecticut,* exhibition catalogue, Old Lyme, Connecticut, 1988, pp. 12-17.

[3] Frank Fowler, "Impressions of the Spring Exhibition", *Nation,* 84, 28 March, 1907, p. 298.

CHILDE HASSAM
(1859–1935)

LOWER MANHATTAN
(BROAD AND WALL STREETS), 1907
29¾ × 15½ in.; 75,5 × 39,5 cm
Herbert F. Johnson Museum of Art, Cornell University, Ithaca, New York
Willard Straight Hall Collection
Gift of Mrs. Leonard K. Elmhirst

Throughout his long career, Hassam devoted his considerable talents to the depiction of the urban scene, and he was especially fascinated by the changing aspects of New York. No more telling contrast could be identified in his art than that between the idyllic tranquility of *Washington Arch, Spring* of 1890, and *Lower Manhattan,* painted almost two decades later. Rather than the low viewpoint chosen for the earlier scene, Hassam has positioned the observer high up among the tall buildings looking down Broad Street. His concern here is far more than the merely topographical. He sought to pictorialize the dynamics of the modern metropolis, embodied in the tall skyscrapers that defined the nation's financial center. Their soaring verticality is abetted by the extremely narrow proportions of the picture—almost twice as long as it is wide.

This is primarily "The New New York," as defined in the book of that title by the art writer and critic John Van Dyke published in 1909; in fact, Van Dyke's illustrator was the noted printmaker Joseph Pennell, who in 1904 had produced an etching of *The Stock Exchange* almost identical in subject with Hassam's oil. The Exchange, the pedimented building at the left with a white marble facade of Corinthian columns, was a modern building, a very recent structure, completed in 1903. Beyond the Exchange is the Gillender Building with a cupola. But Hassam also contrasts the new classicism of the Exchange with the old, for in the distance is seen part of the Doric portico of the Sub-Treasury Building on Wall Street, originally completed in 1842 as a customs house. Built on the site of the colonial city hall, it was here that George Washington was inaugurated as the first President of the United States; in 1907 it was the depository for gold and silver bullion. And the great crowd in the street was the outdoor Curb Exchange, brokers who had no place on the Stock Exchange.

The picture is thus replete with historic, architectural, and financial associations. The sunlight sparkles upon these majestic structures, gleaming joyously in a pink and blue tonality, contrasted with the hundreds of tiny, dark figures below, moving around almost like ants on the shadowed street and sidewalks. What the French novelist Paul Adam noted of Pennell's work is equally conveyed in Hassam's painting: "In these buildings, the face of America is concentrated. To erect donjons of 25 stories to superimpose business offices therein, to exalt above the city the omnipotence of money as the tower of the feudal castle was exalted of yore above the surrounding country— what exact and happy symbolism is this! Our ignorance has

fondly maintained, hitherto, that the Yankee possesses no personal art. Here is the refutation."[1]

From what vantage point Hassam set about to record this view is not known; it is also possible that Hassam did not experience this scene firsthand but, like another Impressionist before him Theodore Robinson, utilized photographs. Indeed, both the composition and viewpoint of *Broad and Wall Streets* is strikingly similar, though not identical, to a well known Brown Brothers photograph of this subject taken about 1905, only a year or so before Hassam created this picture.[2] As a meaningful pictorial identification of the nation's financial center, this soaring view down Broad Street assumed iconic status, and in the same decade was painted by Colin Campbell Cooper (unlocated) about 1904, and was also recorded by the famed photographer Alvin Langdon Coburn in 1910. Indeed, Hassam's possible relationship to photography awaits investigation.

Hassam exhibited this painting, as *Broad and Wall Streets,* in the Eleventh Annual Exhibition of The Ten American Painters at the Montross Gallery in New York City in March of 1908. The critics seized upon this striking and unusual work, and it was one of the most admired of all the pictures he ever showed with this organization. One noted that "Childe Hassam, who usually wanders in groves and dells inhabited by nymphs and lambs, has been to Wall Street. One of the most striking of the pictures he shows is the cañon about which men pile up dollars or capitalize their conversation, as seen by the impressionist."[3] Another commented that "The painter has given an impression of the asphaltic Eldorado. A slight mist obscures the features of the amateur golden fleece hunters. We cannot recognize any of the magnates of our acquaintance, but we do feel the soul of the quarter."[4]

In one of three reviews in which he praised the picture, the artist-writer Arthur Hoeber called Hassam "the pictorial historian of our city," noting that he had "wandered down with the bulls and the bears, to the domains of frenzied finance . . . A dexterous performance this, and so charmingly done, the architecture being suggested in an appetizing way, and the street full of rushing mankind."[5] Joseph Chamberlin called the work "a noble picture of the scene in front of the Stock Exchange, in which not the hustle and hard superficiality of the city is represented, but its depth, its strong solemnity, its majesty."[6] And the noted art writer Charles de Kay found the painting "un-

(continued: on page 156)

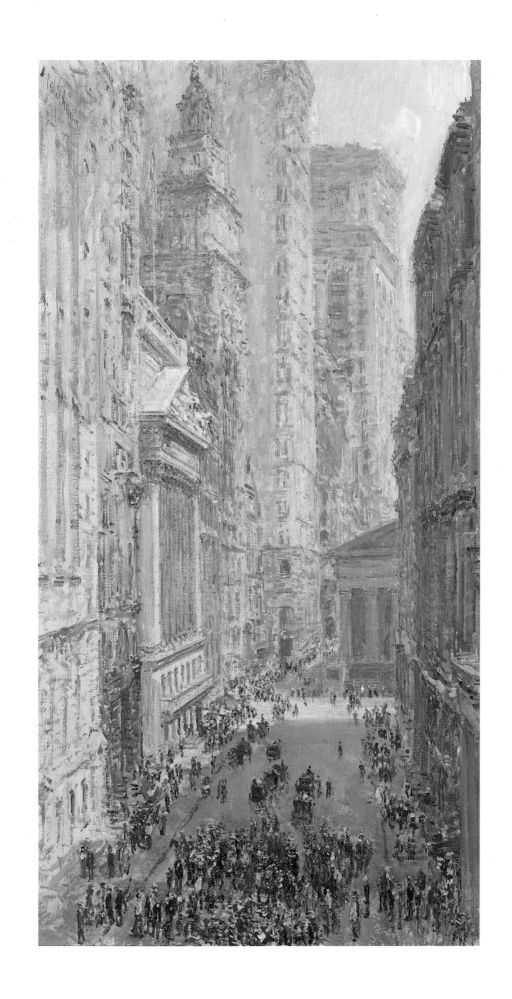

CHILDE HASSAM
(1859–1935)

ALLIES DAY, MAY 1917, 1917
36¾ × 30¼ in.; 93,5 × 77 cm
National Gallery of Art, Washington, D.C.
Gift of Ethelyn McKinney in memory of her brother,
Glen Ford McKinney

Of all the American Impressionists, Childe Hassam not only enjoyed the longest active career, but he was also the most innovative; the originality and variety of his oeuvre remains underrecognized. This was never more richly demonstrated than in his much-admired Flag series, a group of about thirty pictures painted between 1916 and 1919, depicting the national flags of the United States and her World War I allies, unfurled along Fifth Avenue and its neighboring streets. One writer believed that, in Hassam's entire career, "The most daring effort was to paint the Flags. No one had ever painted flags before, so now when one thinks of flags one thinks of Hassam's flag pictures. These pictures were not garish affairs but were filled with the poetry of patriotism. He made the Flags symbols of his heritage."[1]

Hassam conceived the series on viewing the celebration of Preparedness Day on May 13, 1916, a demonstration in support of the nation's armed forces with an enormous parade and decorations on Fifth Avenue. Hassam stated that "There was that Preparedness Day, and I looked up the avenue and saw these wonderful flags waving, and I painted the series of flag pictures after that."[2] The most immediate precursor for these works lay in Hassam's *July Fourteenth, Rue Daunou* of 1910 (Metropolitan Museum of Art, New York City), painted in Paris on Bastille Day, July 14, on Hassam's last trip to Europe, with the gaily colored patterns of the French flags seen from on high, above the crowds of pedestrians and carriages in the street below. And, in turn, these works may owe a debt to the painting by Claude Monet of *The Rue Montorgueil, Festival of June 30, 1878* (Musée d'Orsay, Paris), a picture depicting hundreds of flags unfurled in celebration of the Fête de la Paix, which Hassam would have had the opportunity to see when it was on exhibit at the Galerie Georges Petit in Paris in the early summer of 1889.

Both of these paintings were inspired by patriotic celebrations, and this is even more true of Hassam's Flag series; they are the artist's very genuine response, first to the American revulsion against German aggression, and then to America's participation in the common cause of the War and its attendant victory. The same month that Hassam painted *Allies Day, May 1917,* he donated a number of pictures to be sold for the benefit of a War relief fund.[3] The patriotic stance implicit in the series was recognized by contemporary critics; one noted that "Never has there been a more marvellous street decoration and never a more brilliant recording of it in picture form . . . Such

was our Fifth Avenue and such again are the great canvases painted by Childe Hassam in honor of this historical emblematic gathering together of friendly nations."[4] At the same time, the flags offered the artist a marvellous motif in which to exploit the sunlight, color, and pattern concerns of the Impressionist and Post-Impressionist modes, these great banners contrasted with tiny ideographs of figures on the streets below, and combined with his increasing fascination with the great urban canyons of contemporary New York City.

The paintings differ among themselves greatly in their iconographic and formal strategies. The Stars and Stripes of the United States are usually featured, and in the earliest paintings of the series, such as *The Fourth of July, 1916* (ex-Christie's, New York City) and *The Avenue in the Rain, 1917* (The White House, Washington, D. C.), the United States flag is the only one visible, repeated over and over again. In some works, such as *Avenue of the Allies: Brazil, Belgium, 1918* (Los Angeles County Museum of Art), the flags, buildings, and figures are rendered in an especially sketchy manner; *Allies Day, May 1917* is one of the most firmly drawn and precisely executed of the series. It is also one of the few taken from a viewpoint high up, which emphasizes the largeness of the flags and the massiveness of the buildings, while diminishing the significance of the crowd below.

Allies Day, May 1917 was one of the first of the flag pictures created after the United States entered World War I, early in April of 1917. More specifically, the work honored the visit of the Allied war commissioners of England and France to the United States, and the celebration in May of Anglo-French-American cooperation; Hassam dedicated this painting "to the British and French nations commemorating the coming together of the three peoples in the Fight for democracy."[5] In their massiveness, the flags act as unifying elements in the composition as well as symbols of both national and international solidarity. In the first two planes of flags, those of the three allies are carefully grouped, though that of the United States looms largest. Elsewhere over Fifth Avenue, the flags are distributed more randomly, with these strong colored patterns placed mostly on the East side of the Avenue, facing the gleaming diverse buildings of the city at the left; most prominent is Saint Thomas's Episcopal Church in the middle distance, and beyond, the University Club, the Gotham Hotel, and the Fifth

(continued: on page 156)

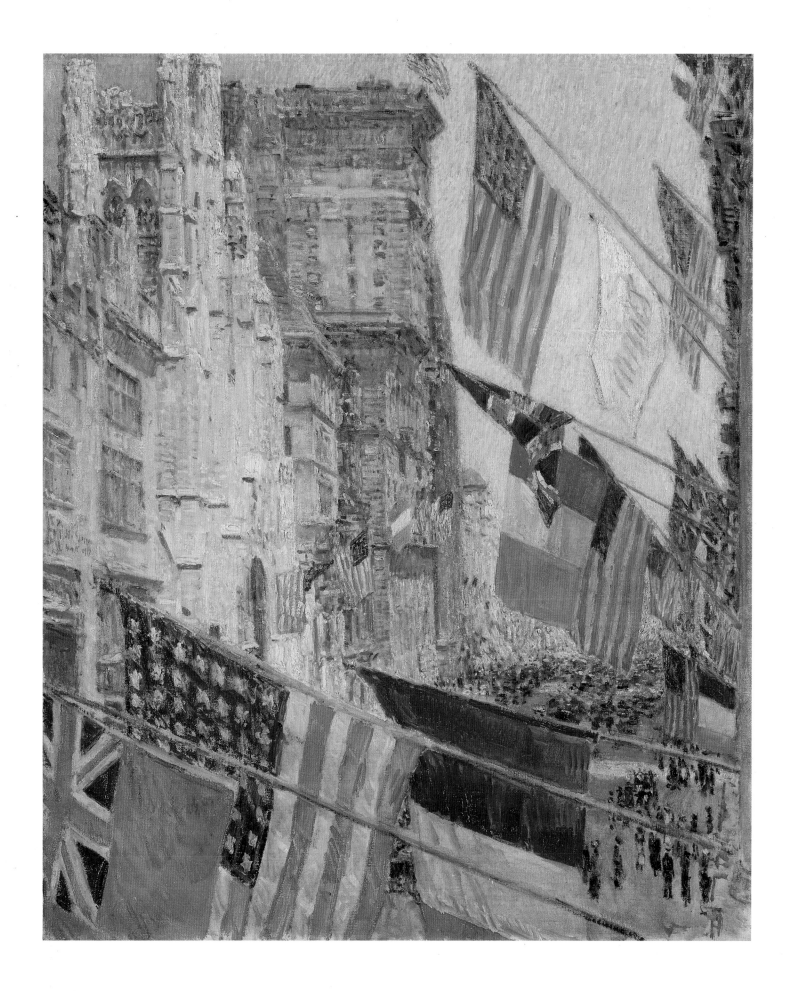

JULIAN ALDEN WEIR
(1852–1919)

THE RED BRIDGE, 1895
24¼ × 33¾ in.; 61,5 × 85,5 cm
Metropolitan Museum of Art, New York, New York
Gift of Mrs. John A. Rutherford

The Red Bridge is J. Alden Weirs most renowned painting and certainly one of the finest works of his career. Weir's first encounter with the Impressionist aesthetic occurred while he was studying at the Ecole des Beaux-Arts in Paris in the mid-1870s; his reaction to the group's third exhibit was one of total revulsion. Although on his return to New York in 1877, Weir immediately became associated with the newly formed Society of American Artists, and soon became a standard bearer for the more progressive art community, advising the collector Erwin Davis to purchase several major works by Edouard Manet. It was only around 1890 that Weir's own painting began to reflect Impressionist strategies of broken brushwork and a high color key.

At first this was evident more completely in his landscape subjects; many of his figural works, some painted indoors and marked by a gentle poetic revery, were often more Tonal. The majority of Weir's major canvases were painted in rural Connecticut, where the artist maintained two country homes, one in Branchville in the Western part of the state, and one at Windham in the Northeast. While there is little difference between the landscapes and village themes that Weir painted in both locales, a number of the most important pictures the artist painted in Windham reflect an interest in juxtaposing industrial structures with rural scenery, a theme which Weir introduced in 1893 in the important series of paintings of the thread mills at Willamantic, the major urban community in the vicinity of Windham.

The Red Bridge is another such conception, depicting a new iron bridge that replaced a picturesque covered structure spanning the Shetucket River. In her biography of the artist, his daughter recalled Weir's initial dismay over the loss of the older landmark; he then realized the inherent beauty of the contrast of the vivid red underpainting of the rigidly geometric structure and its rippled reflection in the river, with the verdant, sun-dappled beauty of surrounding Nature.[1] Despite its modernity, echoed in the single telephone pole beyond the bridge in the upper left, the skeletal appearance of the roofless ironwork expresses a certain fragility and sense of incompleteness, as the trees and cloud-filled sky appear visible through its open structure.

A concern with work and industry, rare in American Impressionist painting, is part of the artistic legacy which Weir inherited from Jules Bastien-Lepage, the French artist of peasant themes whom he enormously admired; so also is the rather even light and the consistent, low intensity of the chromatic scale which Weir introduces here. But of equal impact is the reflection of Weir's new found admiration for the aesthetics of Oriental art, seen especially in the flattened composition, the high horizon, and the decorative, cropped forms of tree trunk and branches in the foreground, with the contrast among them of swinging curvilinear shapes at the left and the series of uprights at the right. Weir, along with his colleagues Robinson and Twachtman, became especially excited about Japanese prints which he began to collect, beginning in 1893. This enthusiasm was perhaps sparked by the experiences of their good friend and colleague Robert Blum, who returned from two years in Japan in August of 1892, and by exhibitions of Japanese prints which Weir and his associates could have seen at the Columbian Exposition in Chicago and at an exhibition at the Museum of Fine Arts in Boston, both in 1893.

Weir first exhibited this painting (as *Iron Bridge at Windham*) in the spring, 1896 annual exhibition of the National Academy of Design. The reviewer for *Art Interchange* judged the work "very striking," and noted that "it is abreast of the times in its scientific study of light . . ."[2] The writer for the *Evening Post* was especially fulsome: "Mr. Weir is quite happy and, indeed, very acute in his refinement of so commonplace a subject . . . It is not 'picturesque' enough or sharp enough in color or shadow for the average person, but its very accord of tones has been its charm to Mr. Weir. And how delicately yet firmly he has knit these tones together, giving the planes of the picture, the value of each note without violent contrast, the placid drift of the river, the drawing of the trees in the foreground. To produce an effect of 'forcing' some one feature is an antique accomplishment that began with Rembrandt; to hold a picture together and produce one single effect with it is a modern method of working that Mr. Weir seems to understand very well."[3]

[1] Dorothy Weir Young, *The Life & Letters of J. Alden Weir*, New Haven, Yale University Press, 1960, p. 187.

[2] "The Seventy-First Academy Exhibition", *Art Interchange*, 36, May, 1896, p. 115.

[3] "The Spring Academy", *Evening Post*, 1 April, 1896, p. 9.

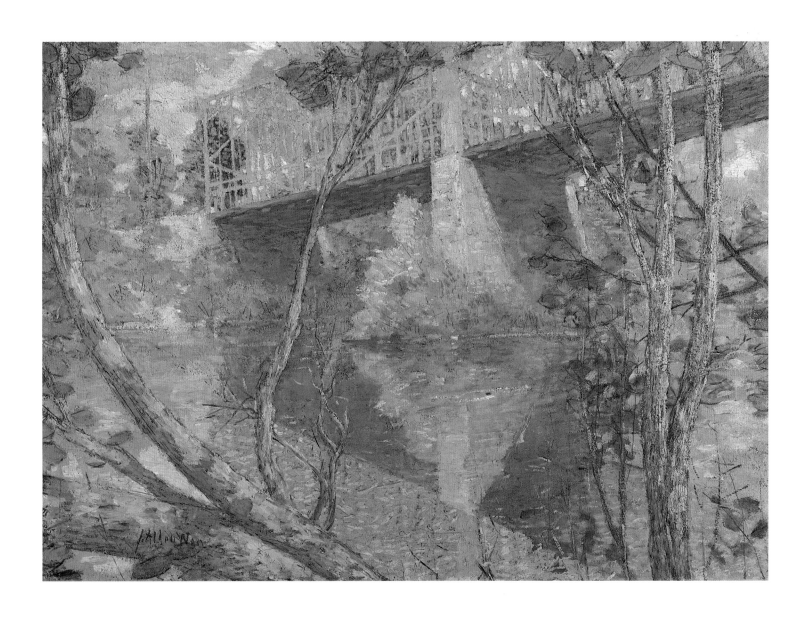

JULIAN ALDEN WEIR
(1852–1919)

BUILDING A DAM, SHETUCKET, 1908
31¼ × 40¼ in.; 79,5 × 102 cm
The Cleveland Museum of Art, Cleveland, Ohio
Purchase from the J.H. Wade Fund

Like *The Red Bridge,* the present work was painted near Weir's summer home in Windham, Connecticut, again a scene on the Shetucket River which flows near that village and the larger industrial town of Willamantic. Similar to *The Red Bridge* also, *Building a Dam, Shetucket* is a rare Impressionist work concerned with industrial activity.

Even more than in the earlier picture, Weir's modern forms of industrial equipment are absorbed in a paean of nature's beauty, rather than presented in stark contrast, or as a violation of the land. Industrial activity is confined to the middle distance, the drilling silhouetted against dense foliage, while its dark uprights repeat the strong verticals of the grille of trees in the foreground. The wisp of blue smoke spirals gently up to merge with the much more intense blue of the sky, and repeats the tones of river water in the lower left foreground. Nature appears curiously undisturbed by the activity which is, in any case, benign; the structure is probably the Scotland Dam near Weir's Windham home, created in 1907–09 to insure the inhabitants of the region, including the artist and his family, an adequate supply of energy; the structure remains operative today by the Connecticut Light and Power Company.[1]

Weir's technique is seen here at its most Impressionist, the artist applying his brushwork in short, staccato-like strokes, and creating an all-over pattern on the surface of the picture which somewhat negates deep spatial recession. So does the intensity of the dominant green tones, as strong in the distance as in the foreground, and far more so than the gentler colors of *The Red Bridge.* Typical of Weir also is the reliance on a single dominant hue, varied from yellow- to blue-green, and contrasted with more neutral tones, especially the light tawny ground of the middle distance.

The picture was shown in New York City in the thirteenth annual exhibition of The Ten American Painters held in March of 1910. For the critics, however, *Building the Dam, Shetucket* was overshadowed by Weir's nocturnal landscape *The Hunter's Moon* and a figure subject *The Flower Girl.* Royal Cortissoz, however, found *Building the Dam, Shetucket* a work of extraordinary merit, and James B. Townsend in *American Art News* judged that picture, along with Weir's *Sumach* as "the most charming outdoor studies imaginable."[2] Weir himself thought very highly of this work; he observed in a letter written early in 1911 to his close friend the Portland, Oregon, art patron Charles Erskine Scott Wood that "It is very decorative, and seems to me to have an equal charm of color," noting also that his fellow-artist Albert Pinkham Ryder believed it to be one of Weir's best pictures. The painting was about to be seen in Weir's one-artist display at the St. Botolph Club in Boston which opened on January 16, 1911, and later that year, *Building a Dam, Shetucket* was exhibited in a show of Weir's work at the Albright Art Gallery in Buffalo. Weir subsequently offered the picture as a gift to Wood the following year.[3]

[1] Harold Spencer, "Reflections on Impressionism, Its Genesis and American Phase", in William Benton Museum of Art, The University of Connecticut, *The Artist and The Landscape,* exhibition catalogue, Storrs, 1980, p. 61.

[2] R[oyal] C[ortissoz], "Art Exhibitions. Some New Pictures by the Ten American Painters", *New York Daily Tribune,* 29 March, 1910, p. 9; James B. Townsend, "Annual Exhibit of 'The Ten'", *American Art News,* 8, 26 March, 1910, p. 6.

[3] Letters from Weir to Wood of January 13, 1911, and March, 1912, quoted in Dorothy Weir Young, *The Life & Letters of J. Alden Weir.* New Haven, Yale University Press, 1960, pp. 230, 241-42.

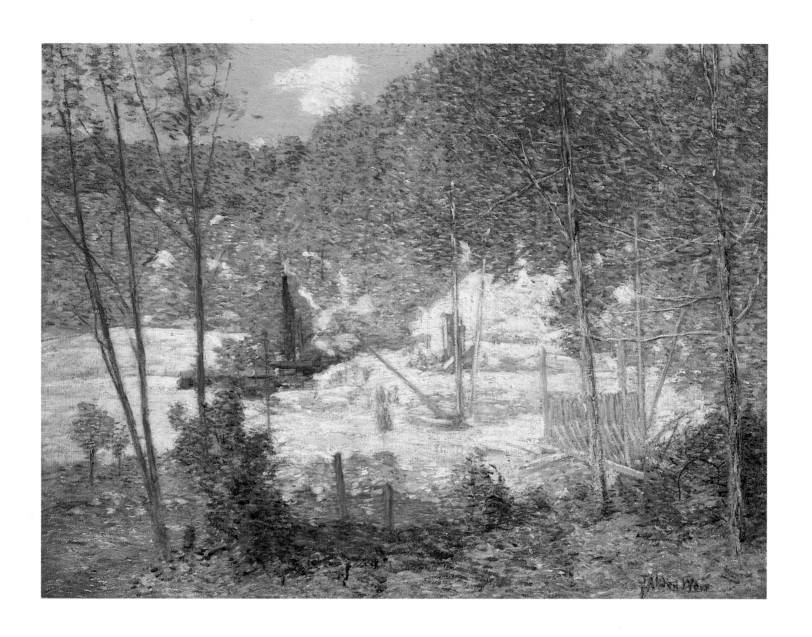

JOHN TWACHTMAN
(1853–1902)

ICEBOUND, ca. 1889–1900
25¼ × 30⅛ in.; 64 × 76,5 cm
Art Institute of Chicago, Chicago, Illinois
Friends of American Art Collection

Born in Cincinnati, John Twachtman studied there at the McMicken School of Design before he travelled abroad in 1875 for further instruction in Munich, the goal of many Midwestern Americans, including his fellow-Cincinnatian, Joseph DeCamp. Twachtman returned to America in 1878, bringing with him a style informed by the dramatic tonal contrasts, the rich, dark blacks, and the bravura paint handling that was characteristic of the progressive Munich manner. These were applied to landscapes back in Cincinnati and to New York harbor scenes, but by 1882, Twachtman had decided that he had exploited these strategies as far as he could, and the following year he returned to Europe, this time to study at the Académie Julian in Paris. In his work of the mid-1880s, the Munich manner was replaced by a close-hued Tonal approach applied to scenes along the French coast which suggest the combined impact of Whistler, Puvis de Chavannes, Oriental art, and the painters of the Hague School in Holland.

When Twachtman returned to America in the winter of 1885–86, his art was still unaffected by Impressionism; his activities during the following several years are little documented. Though he spent some time during the winter of 1886-87 in Chicago, he appears to have begun his association with the area around Greenwich, Connecticut, in the summer of 1886, moving to a property there on Round Hill Road in the fall of 1889, which he purchased early the following year. It is the work of the ensuing decade that reflects Twachtman's "conversion" to Impressionism, and marks his most distinct contribution to American art.

During his years in Greenwich, the great proportion of the artist's canvases were drawn from scenes on his own property, the natural beauty of the hemlock pool, Horseneck Brook, and the waterfall there; the house and barn, to which he made additions; and the garden he cultivated. He painted many of these scenes repeatedly, though without the intent of compiling the data of serial imagery achieved by Claude Monet with such themes as the Haystacks or the many renditions he created of the facade of Rouen Cathedral. Twachtman, rather, was motivated by his pleasure in his environment and the joy of home and domesticity in which he delighted. He painted his surroundings in all seasons of the year, but winter was certainly his favorite, and he became the finest specialist in the winter landscape of his time. He wrote to his friend J. Alden Weir from Greenwich in December of 1891 that "We must have snow and lots of it. Never is nature more lovely than when it is snowing.

Everything is so quiet and the whole earth seems wrapped in a mantle . . . All nature is hushed to silence . . ."[1]

Icebound is one of the finest and best known of these winter pictures. Its exact date within the context of Twachtman's Greenwich paintings is not known, since the artist almost never dated his works, and his exhibition titles are confusing at best, since more than one picture often shared the same designation. It has been suggested that *Icebound* is one of the earliest of these paintings, the picture of that title (actually *Ice-bound*) exhibited late in May in the Second Annual Exhibition of American Oil Paintings at the Art Institute of Chicago.[2] But this now seems to be too early a date, not only for the style of the painting but also for the locale depicted; the work, which represents a scene on his Greenwich property, would have to have been created in the winter of 1888-89, before the artist had actually moved there. In fact, *Snowbound,* the title by which the picture had hitherto been known until the suggestion of its 1888-89 date arose, may be more correct and appropriate, for the water in the brook appears more liquid than frozen. The work may be the picture entitled *Snowbound* or *Snow-bound,* exhibited in the annual exhibition at the Pennsylvania Academy of the Fine Arts in December, 1895, and in two of Twachtman's one-artist shows held in 1901, first at the Art Institute of Chicago in January, and then in March at the Durand-Ruel Galleries in New York City.

Judging by contemporary critical comment, Twachtman would seem to have developed his very subjective approach to Impressionism about 1890, for there was no suggestion of his alliance with the movement in the reviews of the sale of work painted by Twachtman and his good friend J. Alden Weir held at Ortgies and Company in New York in February of 1889, while he had achieved such an identification by March of 1891 with his one-artist exhibition at Wunderlich Galleries. Winter scenes, it should be noted, appeared in both displays, so that his attraction to that theme had been established by 1888-89. The source for Twachtman's emergence as an Impressionist remains unclear. It may have been due in part to the visits of his friend Theodore Robinson, back for the winters of 1888-89 and 1889-90 in the United States from Giverny, France, where he had come under the influence of Monet. And the impact of Twachtman's own previous exploration of pastel painting with its attendant high colorism and sparkling freedom cannot be dis-

(continued: on page 157)

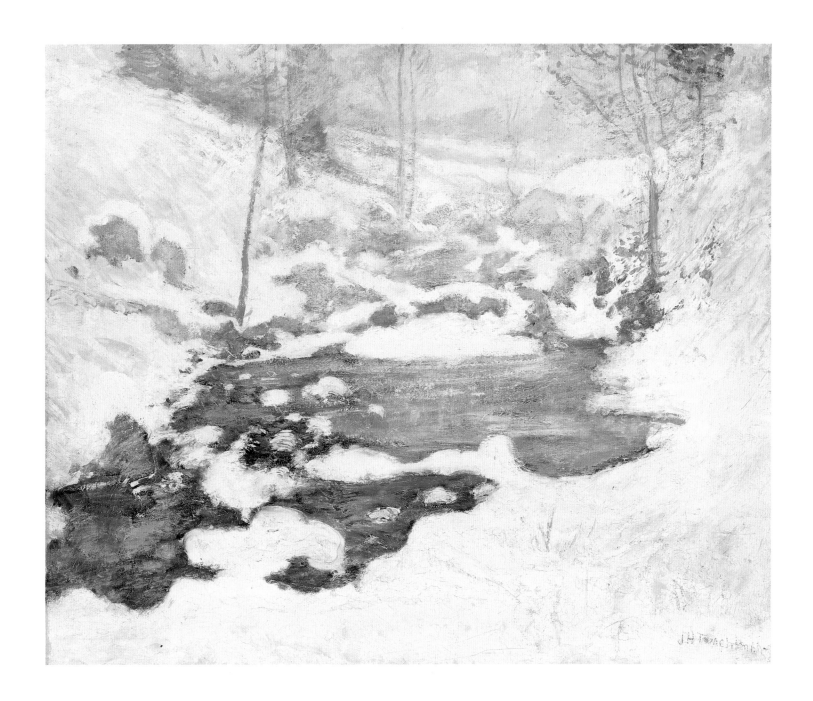

JOHN TWACHTMAN
(1853–1902)

WINTER HARMONY, 1890's
25¾ × 32 in.; 65,5 × 81,5 cm
National Gallery of Art, Washington, D.C.
Gift of the Avalon Foundation

Twachtman's *Winter Harmony* depicts much of the view of the hemlock pool on his Greenwich, Connecticut, estate that he also rendered in *Icebound*. Both would appear to have been painted within a year or two of each other, and perhaps at the same period of early winter, also, for in both the trees still retain the remnants of their russet leafage. Yet, a comparison of the two pictures demonstrates Twachtman's changing interpretations of the landscape—*his* landscape—and the different moods which he found that nature could evoke.

While the forms in *Icebound* are defined in thick, coarse paint, the brushwork in *Winter Harmony* is more flowing and relatively more smooth, or at least its texture is more fine. Likewise, though in both pictures the white of the snow constitutes the dominant tone, there is more color and a greater variety of it in *Winter Harmony*, and the overall feeling is warmer, with the emphasis upon those violet tones which critics had come to associate with Impressionism, rather than the colder blues featured in *Icebound*.

The more "brushy" application of paint, and the unifying violets, project greater atmospheric haze in *Winter Harmony*, a Whistlerian lyricism which adds to the picture's poetry. This is abetted also by the softer treatment of snow which at times merges with the flowing water, rather than the strong whip-like silhouette dividing water and embankment in *Icebound*. The slender trees in the latter canvas look more frail; such trees are more numerous in *Winter Harmony* and appear more upright. The result is a more geometrically ordered composition, the pool appearing circumscribed by these verticals. And the water in *Winter Harmony* flows sufficiently gently that in its rippled patterns can be discerned the reflections of some of the trees. Here, Twachtman's fascination with slow-moving, flowing water within a snowy landscape suggests the possible influence of the work of the Norwegian Impressionist, Fritz Thaulow. Thaulow was a specialist in both this motif and winter scenery;

his painting is known to have had a good deal of impact upon that of a number of American painters after it became well known and well patronized in the United States during the 1890s, some of it on view at the Columbian Exposition in Chicago in 1893. The Norwegian artist's pictures, however, always dealt with more material aspects of natural phenomena than did Twachtman's, and he did not infuse them with such lyrical suggestiveness.

No record of a picture with the title of *Winter Harmony* is found in the many records of exhibitions of Twachtman's work held in his lifetime or even after, which suggests that it is a later, "assigned", designation. The work may well have appeared on view in the 1890s and/or early 1900s under a different title, possibly one of the many pictures shown as *Brook in Winter* or *Reflections in the Pond*, for instance; it seems unlikely that the artist would not have made sure to display a painting of this quality and size. Lisa Peters has suggested, in fact, that *Winter Harmony* may be one of the pictures which Twachtman showed in his 1891 solo exhibition in New York. This work, one of a number to which the artist assigned the title *Hemlock Pool* over the years, was praised by one critic, who believed that "the exquisiteness with which its values are rendered would alone make it a great landscape painting, but there is added to it that indescribable something which is the spirit of woodland winter."[1]

[1] Lisa N. Peters, "Twachtman's Greenwich Paintings: Context and Chronology", in: National Gallery of Art, *John Twachtman Connecticut Landscapes*", exhibition catalogue, Washington, D. C., 1989, p. 27, quoting the writer of "The World of Art: An Impressionist's Work in Oil and Pastel— Mr. J. H. Twachtmann's [sic] Pictures", *New York Mail and Express*, 26 March, 1891, p. 3

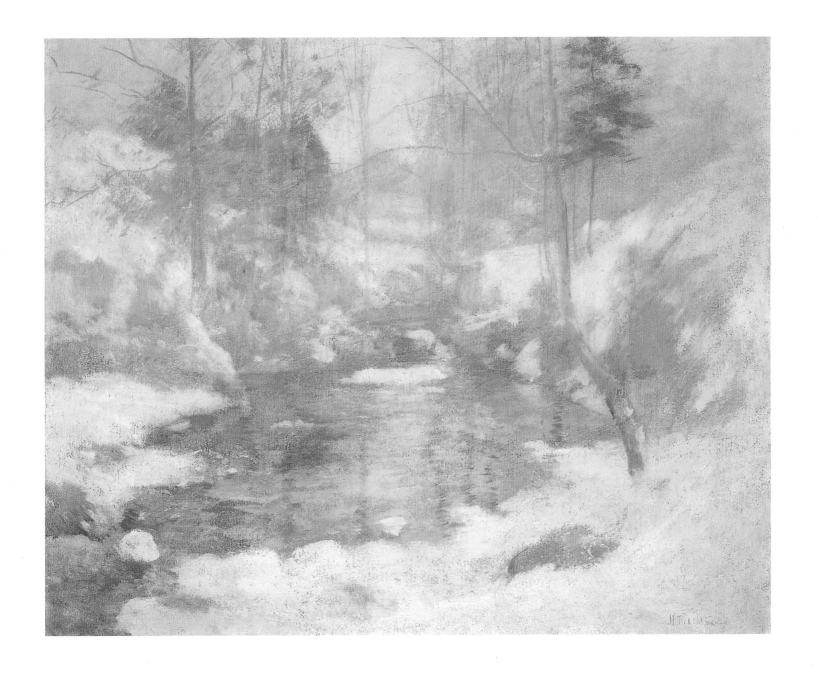

29
JOHN TWACHTMAN
(1853–1902)

LAST TOUCH OF SUN, ca. 1893
25¹/₈ × 29⁷/₈ in.; 64 × 76 cm
Manoogian Collection

From 1889, when he rented a house on Round Hill Road in Greenwich, Connecticut, which he then purchased over the next several years, his home became the center not only of John Twachtman's personal, but also his pictorial world.[1] Twachtman painted the house in all conditions of weather and seasons of the year, though winter remains his favorite period for his architectural subjects as for his pure landscapes. In *Last Touch of Sun,* he contrasts the geometry of the building and the outlying uprights of the bird house, posts, and slender trees, with the soft, amorphous bank of deep snow, observed during early evening when the sun casts long blue shadows, and this is juxtaposed with the purple tones of the solid elements in the picture. Though he taught at the Art Students' League in New York City, Twachtman lived year-round in Greenwich, and over the years he extended the house, adding a second dormer to one wing, and building a large portico in front. The successive changes to the building are clearly visible in the many pictures in which the house is central, and indeed, these occasionally offer some validity to the approximate dating of particular pictures which are otherwise notoriously difficult to pin down, since the artist seldom dated his work.

Last Touch of Sun (originally exhibited as *The Last Touch of the Sun*) would thus have been painted relatively early in the 1890s, for none of the changes to the building have yet appeared. This is, however, a rare case where there is external evidence as well for suggesting that the picture was painted in the winter of 1892-93. Twachtman, as most artists, tended to exhibit his latest works in the major exhibitions in which he participated, and *Last Touch of Sun* first appeared in the two-artist show he shared with his friend J. Alden Weir at the American Art Association in May of 1893. At the same time, the Association held a second two-man show of the French painters Claude Monet and Albert Besnard, and the two exhibits were intended to be judged together. The displays were quite different: the Frenchmen showed far fewer works than the Americans, who also included varied media: Weir displayed etchings as well as oils, and Twachtman both oils and pastels.

Reviewers recognized all four painters as exponents of Impressionism but they distinguished between the national approaches. Some found the work of the Americans preferable; the writer for the *New York Sun* felt that Twachtman and Weir

"looked with soberer eyes. There is none of the splendid, barbaric color that distinguishes the works of the Frenchmen."[2] Others, such as Alfred Trumble, the editor of the *Collector,* otherwise no champion of French Impressionism, denigrated the Americans: "When you turn around among the Weir and Twachtman pictures, you seem to be looking at Monet, at Sisley, at Bastien Lepage, through a fog, which washes out the force and substance and leaves the shadow. The mannerisms are all here. But the virile power is not. It is the ghost of something else . . ."[3]

Among the paintings shown by Twachtman, *Last Touch of Sun* would seem to have been especially admired, however. Almost certainly the writer in the *Art Amateur* was referring to this work when he wrote that "One of Monet's pictures is of his house in a garden of sunflowers; two are of haystacks; and Mr. Twachtman seems to have taken a hint of this preference for commonplace subjects made beautiful by light, and has given us several views of his house (more picturesquely situated, it is true) in summer and in winter. His snow scenes, with blue shadows are the most charming things he has done."[4] Another writer may have had this work in mind also when he stated that "Mr. Twachtman's winter and snow scenes are among his happiest efforts."[5] *Last Touch of Sun* was subsequently owned by the great American industrialist and philanthropist Andrew Carnegie, after being shown at the second annual exhibition at the Carnegie Institute in Pittsburgh in November of 1897, and the sixty-seventh annual exhibition at the Pennsylvania Academy of the Fine Arts, in January of 1898.

[1] The most complete discussion of the house was written by Alfred Henry Goodwin, "An Artist's Unspoiled Country Home", *Country Life in America*, 8, October, 1905, pp. 625–630.
[2] "A Group of Impressionists", *New York Sun,* 5 May, 1893, p. 6
[3] "Impressionism and Impressions", *Collector,* 4, 15 May, 1893, p. 213.
[4] "French and American Impressionists", 29, June, 1893, p. 4.
[5] *New York Sun, loc. cit.*

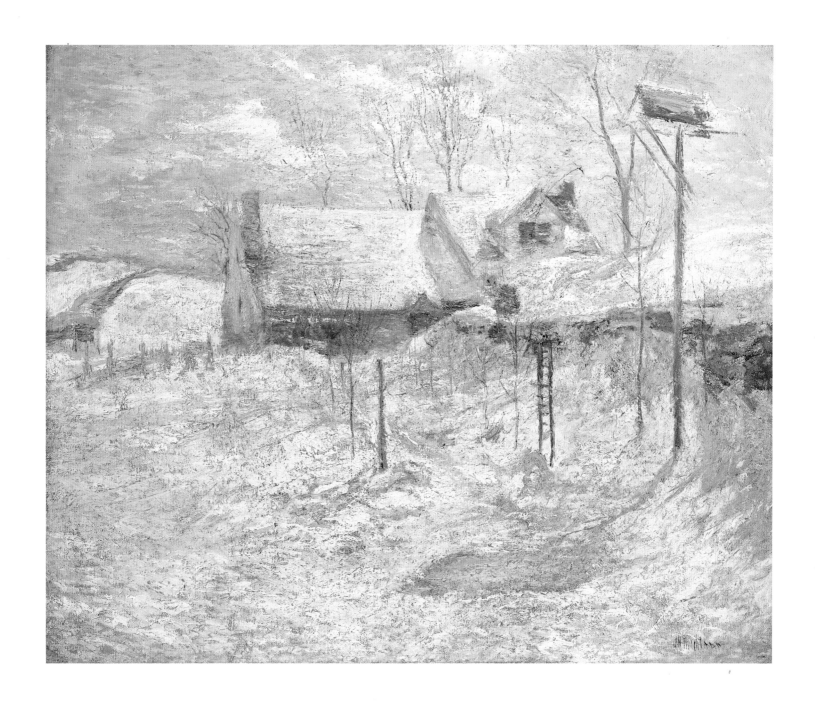

JOHN TWACHTMAN
(1853–1902)

MEADOW FLOWERS, early 1890's
33¹/₁₆ × 22¹/₁₆ in.; 84 × 56 cm
Brooklyn Museum, Brooklyn, New York
Caroline H. Polhemus Fund

Until recently, John Twachtman has been considered almost solely as a landscape painter, in the context of the Impressionist movement, and it is true that his figural and floral works are relatively few. Yet, he received a good deal of critical acclaim for his rare excursions into those themes, and they are essential for the full understanding of the man and his art, which was so completely devoted to and an expression of his love for the complete environment at his Greenwich, Connecticut, home.

The floral work, mostly still-growing plants, nature studies, and garden pictures—he is known to have painted only one formal bouquet—may number in total no more than about thirty-five examples painted in both pastel and oil; though there are records of about sixty such pictures, many have similar or identical titles, and probably represent the same works shown at different occasions. They would appear to divide into three fairly distinct groups, painted sequentially, though there was undoubtedly some overlap; Twachtman's disinclination for dating his work makes the establishment of a chronology extremely frustrating. The artist had painted several garden scenes in oils during his stay in France in the mid-1880s, but it was first in the medium of pastel that Twachtman produced his earliest significant body of outdoor floral and nature studies. One such picture, *Wild Flowers*, appeared in the auction he shared with J. Alden Weir in February of 1889 in New York, even before he settled in Greenwich that autumn. But subsequently, he undertook a series of pastels of wild flowers and the related subject matter of weeds and herbs that grew on his property, fragile growths recorded spontaneously out-of-doors, as part of his total Greenwich experience. Many of these pictures appeared in his one-man exhibition held in March of 1891 at the Wunderlich Gallery in New York.

A group of paintings depicting these same themes were displayed a little over two years later at the exhibit Twachtman shared, again with Weir, in May of 1893 at the American Art Galleries, but while some pastels were included, he had begun by then to interpret such nature studies on a larger scale, in oils. One of these depicted *Tiger Lilies* (probably the work in The Potamkin Collection), and the other *Golden Rod and Wild Aster*, which may well be the painting in our exhibition, now known as *Meadow Flowers*, both of them pictures most likely painted, therefore, in the summer or fall of 1892. Twachtman may well have been engaged in creating the present work when he wrote to Weir in September of 1892 that "The foliage is changing and the wild-flowers are finer than ever. There is

greater delicacy in the atmosphere."[1] Other oil paintings of similar subjects known from records of subsequent exhibition include *Pink Phlox, Willows and Golden Rod*, and *Marigold*. However, as Twachtman's life became increasingly domesticated in the mid- and late 1890s, and as he became involved with improvements to his house and property, he appears to have abandoned the wild-growing plants on his estate and turned to more orderly arrangements of cultivated flowers, often in conjunction with the rendering of his family within the setting of his home.

The subject of the still-growing plant and flower was hardly original by ca. 1890, having been promoted in the writings of the English aesthetician John Ruskin at mid-century, though Twachtman's painterly sketchiness was completely antithetical to Ruskin's emphasis upon precise botanical accuracy. Childe Hassam painted a series of renderings of Celia Thaxter's wild flower garden on the island of Appledore in the early 1890s, contemporary with Twachtman's work, but though a seemingly random planting, this was a garden, and thus a more cultivated floral setting; though Hassam interpreted it with great spontaneity, he was still careful to define the garden's relationship to the configuration of the island landscape. In *Meadow Flowers*, Twachtman's composition fills the entire canvas, thrusting the flowers toward the picture plane, and appearing as an extension of a larger, all-encompassing mass of blossoms, which almost engulf the viewer. The delicately colored pigments are laid on extremely broadly; the artist achieves a very dry surface appearance by utilizing a medium that allowed him to drag his brush with heavy paint, and at the same time avoid the more traditional shiny surface. Such a technical procedure imitates the effects Twachtman had previously achieved in pastel chalks, but now with greater density and monumentality.

Under its present title, *Meadow Flowers* was sold sometime before 1908 by the artist's widow to the important patron of American painting, William T. Evans. The Evans collection was auctioned in 1913, and that year the picture entered the collection of the Brooklyn Museum, which lent the painting to the important display of Twachtman's works at the Panama-Pacific International Exposition of 1915. During his lifetime and after, critics wrote admiringly of Twachtman's florals and nature studies, though their words of praise were even more often directed at the pastels than such oils as the present work. But

(continued: on page 157)

JOHN TWACHTMAN
(1853–1902)

THE WHITE BRIDGE, ca. 1900
30 × 25 in.; 76,2 × 63,5 cm
Memorial Art Gallery, University of Rochester, Rochester, New York
Gift of Mrs. James Sibley Watson

Sometime in the mid-1890s, Twachtman began to make extensive improvements to his home and to the grounds of his Greenwich, Connecticut, property, adding a dormer window and an imposing portico to the house, changes which are visible in some of his paintings and assist in their dating. Likewise, he established a garden, and built a decorative bridge over the brook that ran through his property, just down from the pool featured in *Icebound* and *Winter Harmony*. The bridge is also central to a series of the finest pictures that he painted in the last six or seven years of his career, most of which are entitled *The White Bridge;* in these works, the bridge is highlighted both as a testament to Twachtman's pride in and love for his estate, and as a beautiful aesthetic feature in its own right. The date he built the bridge is not recorded; he exhibited a picture entitled *The Bridge* in two shows in 1896, but one entitled *The White Bridge* did not appear until the annual exhibit of the National Academy of Design which opened early in April of 1897, which suggests that the bridge was constructed during the summer or autumn of the previous year.

In the versions of this subject in the collections of The Art Institute of Chicago and The Minneapolis Institute of Arts, the bridge is viewed broadside, and shielded by the branches and foliage of slim hemlock trees, the leafy pattern of which is contrasted with the geometric latticework of the bridge railing. In the present example, the bridge is seen almost straight on, so the railing pattern is minimized, while the structure itself is more clearly in focus and dominates the composition. The white of the bridge is deeply tinged with the blues and violets characteristic of Impressionist practice, and these colored forms are, in turn, reflected in the gently flowing brook. They contrast with the broadly brushed greens of the foliage on either side of the stream, which run the gamut of variations of that color from deep- to yellow-green. The paint is laid on more vigorously than any other version of this subject, and this, together with the bold chromatic contrast and strong sense of design, suggest that it may be the latest rendering of the bridge, perhaps dating even from the early years of the present century. Reviews of earlier exhibitions held in 1897 and 1898 which included paintings of the bridge referred to them as delicate and filmy, adjectives not applicable to the present work. The verdant foliage and bright, rich sunlight suggest that the painting was created in May or June; this is indicated also by the title *White Bridge, Spring,* under which the picture was exhibited in the Twachtman exhibition held at New York's Lotos Club in January of 1907.

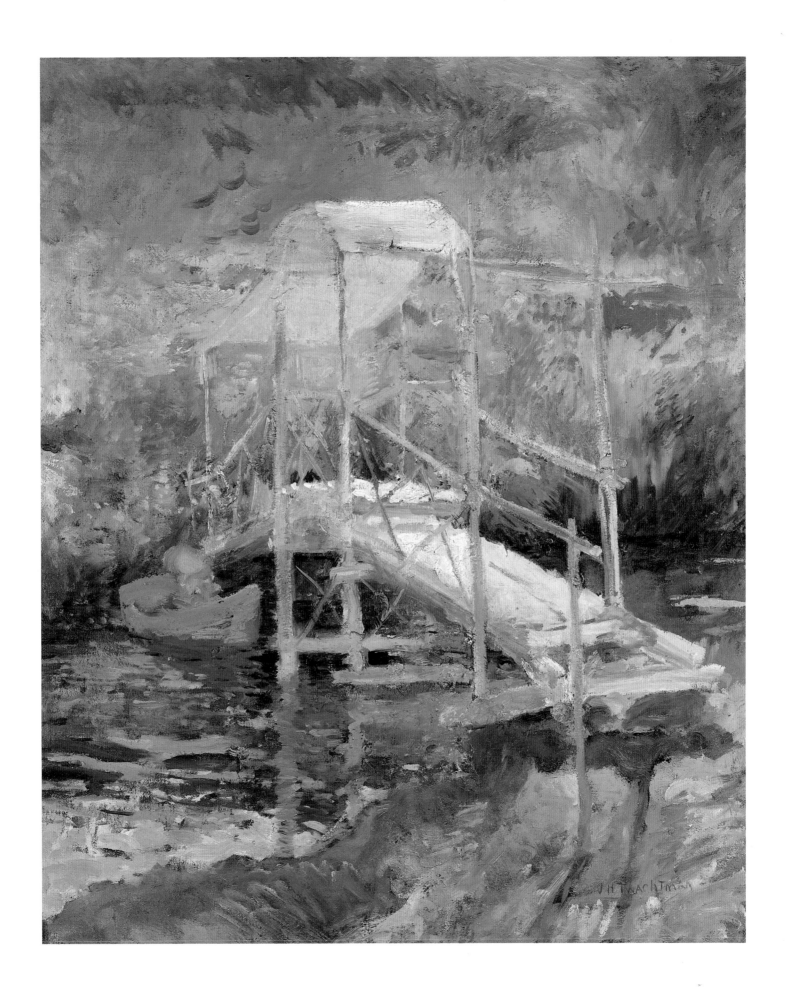

JOHN TWACHTMAN
(1853–1902)

HORSESHOE FALLS, NIAGARA, ca. 1894
30¼ × 25⅜ in.; 77 × 64 cm
Parrish Art Museum, Southhampton, New York
Littlejohn Collection

In the winter of 1893-94, Twachtman was invited for a visit by Charles Cary, a prominent doctor and teacher in Buffalo, New York, at which time the artist created a series of views of Niagara Falls. Twachtman had painted waterfalls before, most notably depictions of Horseneck Falls on his own Greenwich, Connecticut, property. These, however, were close-up views of a private, secluded bit of nature, while Niagara was America's grandest phenomenon, one celebrated in paint by almost every nineteenth century American landscape painter from Thomas Cole and Frederic Church to George Inness. The majority of earlier painters had emphasized the grandeur of the Falls, and their panoramic breadth, some requiring two different views to encompass all its majesty. Twachtman, typically, relinquished these possibilities in favor of a more intimate viewpoint from below Niagara, which still capitalized upon the sense of spectacle, while emphasizing the rushing power of the Falls seen close at hand. This was not in itself innovative; a British amateur, Captain James Erskine, painted the Falls from below as early as about 1784 (Public Archives of Canada, Ottawa), and the American professional John Trumbull had chosen a similar vantage point in 1808 in his *Niagara Falls from Below the Great Cascade on the British Side* (Wadsworth Atheneum, Hartford), though, with distorted perspective, he combined this with a panoramic scene of great depth and breadth. Other notable views of the Falls from below include one by Regis Gignoux, a winter scene of 1847 (United States Senate, Washington, D.C.), and a lost version by Frederic Church. Gignoux's painting of 1847 was one of the first to utilize the vertical format, a choice that had first been essayed by Alexander Wilson in an engraving that appeared in the *Port-Folio* magazine in March of 1810. Yet, there is no need to assume Twachtman's familiarity with the Wilson print or even the Gignoux oil painting in his choice of format and viewpoint.

The interpretation that Twachtman has chosen is an artistic one, emphasizing sensations of color and paint, with the great waters translated into the vibratory aesthetics of Impressionism. Twachtman appears to have painted about six versions of *Niagara,* and while the basic subject is repeated in each, the chromatic range, the weather conditions, and possibly even the seasons, vary widely. Some, such as the present example and that in the New Britain (Connecticut) Museum of American Art, are true winter scenes, but the white of the ice is greatly modified by glowing blue color which infuses the water and mist. Other examples of *Niagara* by Twachtman represent the falls in warmer weather, infused with myriad colors; among the finest of these are the pictures in the Horowitz collection and the National Museum of American Art, Washington, D.C. The *Niagara* paintings vary in regard to paint application also; the last named example is extremely sketchy, while the picture in the present exhibition is one of the more highly finished versions, with some of the flowing water turned to stalactites of ice.

The decision to paint such spectacular scenery was an unusual one for an artist who preferred the personal and the intimate in landscape. While it may be that this choice was the result of a commission, there appears no documentation that Charles Cary actually ordered or possessed any versions of *Niagara* though he did own a *Niagara Gorge* by Twachtman.

On July 1, 1894, Theodore Robinson, then staying at Cos Cob, called upon Twachtman at Greenwich, who showed his friend several of his *Niagaras.* Robinson commented on "one square one 30 × 30" very good. One, on the river, is pretty— too much like a Monet";[1] this last may be Twachtman's *Pier on Niagara River,* shown at the Society of American Artists' seventeenth annual exhibition in March of 1895. There is no indication in Robinson's diaries as to whether the *Niagara* he viewed was painted on the spot or perhaps reconstituted from sketches in Greenwich. The affinity to the painting of Claude Monet that he discerned is especially noticeable in the more colorful versions of Niagara. Twachtman enjoyed renewed exposure to Monet's work in March of 1893 when he and Weir showed their work together in New York in an exhibit at the American Art Association, at which time the galleries also housed a two-artist display of paintings by Monet and Albert Besnard.

It is likely that most of the series were created in a short period of time, early in 1894. Twachtman exhibited *Horseshoe Falls, Niagara—Afternoon* at the National Academy of Design annual exhibition that year at the beginning of April; two *Niagaras* at the Society of American Artists in March, 1895; a *Niagara Falls* in the annual exhibition of the Pennsylvania Academy of the Fine Arts in 1895; another painting of that title appeared at the National Academy annual exhibition in 1898; and a *Niagara* was shown in March of 1900 at the third annual show of The Ten American Painters, held at the Durand-Ruel Galleries, an exhibit which then travelled to the St. Botolph Club in Boston the following month. Unfortunately, neither

(continued: on page 157)

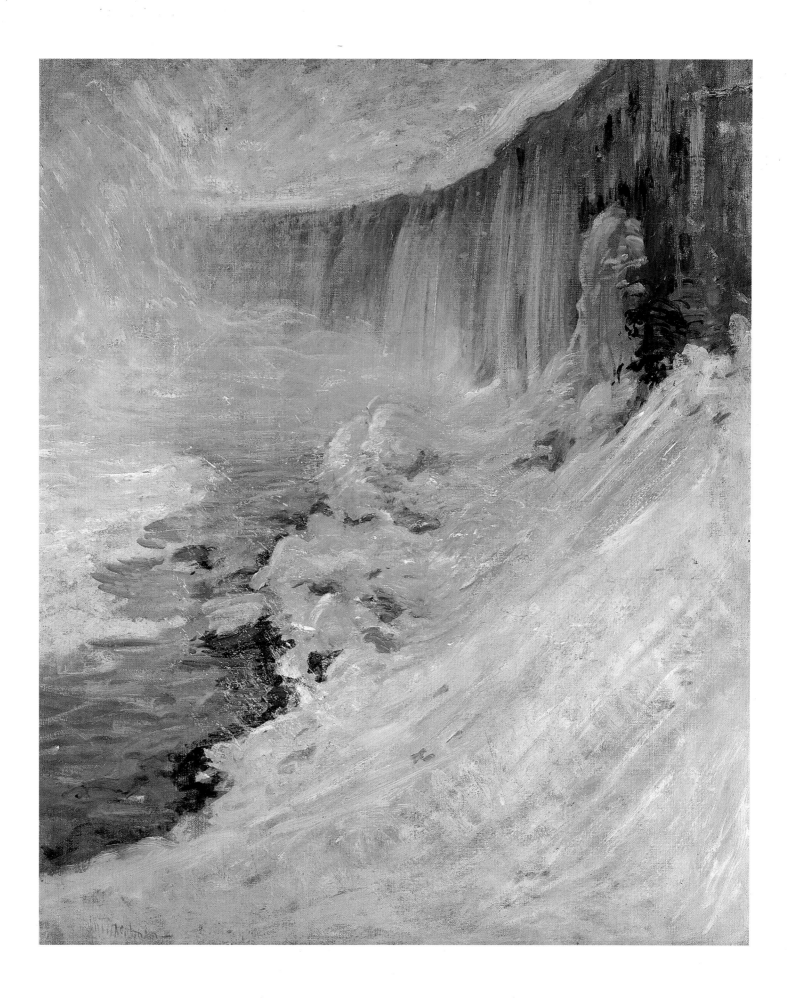

33
JOHN TWACHTMAN
(1853–1902)

MORNING GLORY POOL, YELLOWSTONE, ca. 1895
29¾ × ½ in.; 75,5 × 62 cm
Private Collection

While visiting Dr. Charles Cary in Buffalo in the winter of 1893-94, Twachtman was introduced to Major William A. Wadsworth, a wealthy resident of Geneseo, New York, who commissioned the artist to travel to Wyoming to paint scenes at Yellowstone National Park; presumably, Wadsworth had been impressed by some of the renderings Twachtman had made of Niagara Falls during his Buffalo visit. The artist was at Yellowstone in September of 1895; the particulars of the commission are not recorded, such as the nature of the subjects and the number of pictures that Wadsworth requested; certainly, the artist painted additional works which he kept for exhibition and sale. Wadsworth is known to have owned at least four Yellowstone paintings by Twachtman, which he lent to a Twachtman exhibition held at the Albright Art Gallery in Buffalo in March of 1913.

Like Niagara, the various natural phenomena at Yellowstone had been rendered earlier by painters more concerned with featuring the panoramic vastness and the spectacle of Western scenery; Thomas Moran is the artist most associated with views of Yellowstone scenery, beginning in 1872. Twachtman chose to depict several subjects at the Park: he painted distant views of the canyons, encompassing the largest amount of territory; he concentrated more closely upon the waterfalls; and he focused in especially upon the Yellowstone pools.[1] He wrote to his patron from the Park that "We have had several snowstorms and the ground is white—the cañon looks more beautiful than ever. The pools are more refined in color but there is much romance in the falls and the cañon."[2] Twachtman was seeking the dramatic and the beautiful, but he eschewed the more bizarre rock formations and the geysers, the kind of unusual phenomena that attracted Moran, Albert Bierstadt, and other painters at Yellowstone.

Twachtman must have painted at a great rate, for numerous examples of all three subjects are located and others are known from exhibition and auction records. Of these, the waterfalls are the most conventional; the canyon pictures have not fared well by critics, but with their strong and rugged compositions, they appear due for reappraisal. The pools, however, such as his several versions of the *Emerald Pool,* and here *Morning Glory Pool, Yellowstone,* have always been admired; Twachtman appears to have painted about four or five pool pictures. In these, the artist focused directly upon the basins and their steaming, misty waters, with little concern for their placement within the overall topography of the Park. These are among the most abstract paintings of Twachtman's career, alive with the sinuous outlines that the artist also emphasized in such Greenwich paintings as *Icebound,* and glowing with the beautifully luminous, jewel-like greens and blues of the algae and water of the hot springs. It was especially with the pools at Yellowstone that the artist could gratify his involvement with Impressionist color and concern for light, combined with patterned shapes.

While Twachtman did exhibit some of his paintings of Yellowstone Falls in his lifetime, there are no records of his showing any of the pool pictures. And when one of these was auctioned in the Twachtman estate sale in March of 1903 at the American Art Galleries in New York, it may be significant in regard to current public taste that the painting brought a good deal less than works of comparable size created at Greenwich and Gloucester. Eliot Clark wrote the most moving tribute to these pictures. Clark felt that Twachtman had "failed to humanize the Yellowstone, or to bring to it that human emotion which might do so, but he brought back some splendid bits of colour from its jewelled pools and radiant waterfalls . . . Twachtman was not impressed by . . . elemental power; nor did he attempt to express it. He is more purely sensuous in his perception."[3]

[1] Lisa N. Peters, "Twachtman's Greenwich Paintings: Context and Chronology", in National Gallery of Art, *John Twachtman Connecticut Landscapes,* exhibition catalogue, Washington, D. C., 1989, pp. 32–35.

[2] Twachtman, Grand Canyon Hotel, Yellowstone National Park, Wyoming, 22 September, 1885, to Wadsworth, Wadsworth Family Papers, College Libraries, State University of New York, College of Arts and Sciences, at Geneseo.

[3] Eliot Clark, *John Twachtman.* New York, privately printed, 1924, p. 51.

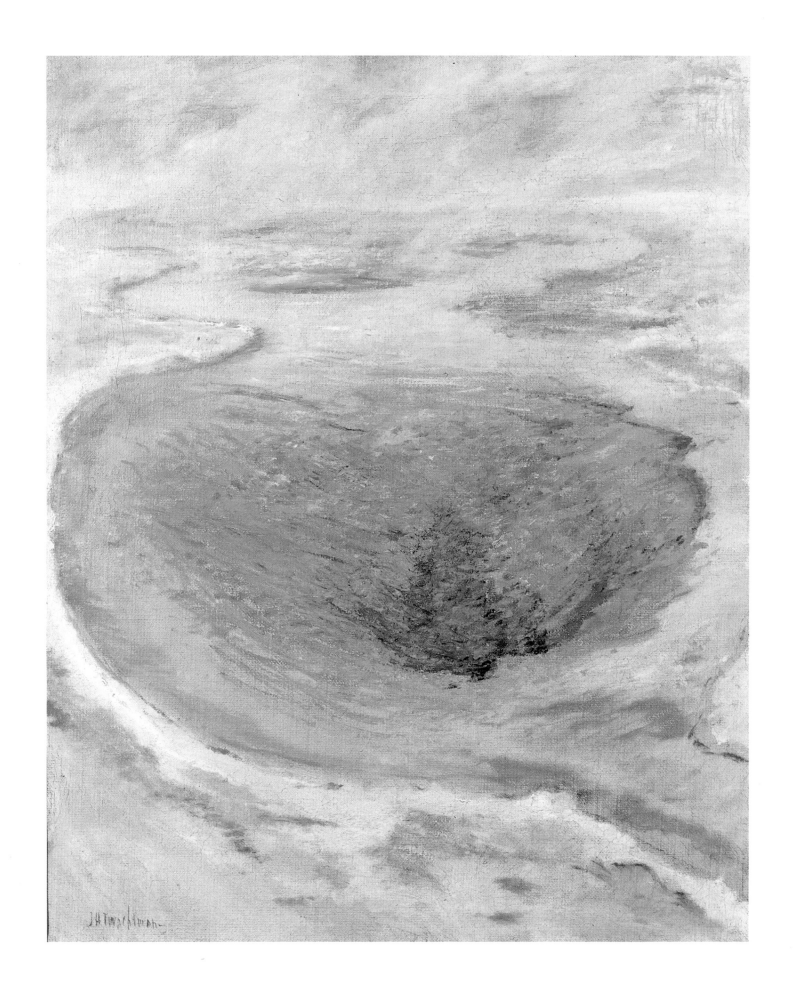

JOHN TWACHTMAN
(1853–1902)

BARK AND SCHOONER (ITALIAN SALT BARK), 1900
25 × 25 in.; 63,5 × 63,5 cm
F.M. Hall Collection
Sheldon Memorial Art Gallery
University of Nebraska, Lincoln, Nebraska

Sometime in the late 1890s, Twachtman replaced the evanescent effects which usually dominated his landscapes with more vigorous paint application and stronger color contrasts, even reintroducing the rich blacks of his Munich years. Though the works of this last period of the artist's life have been designated as his "Gloucester Years," referring to the paintings he created during the summers of 1900-02 which he spent in that Massachusetts coastal resort and artists' colony, this altered aesthetic surely was in force in the pictures he painted during the rest of the year in Greenwich and Cos Cob as well. Nevertheless, the best known of these late works are those done at Gloucester, of which *Bark and Schooner* is one of the finest. Critics were aware of the changes that had taken place in Twachtman's aesthetics in these years; a writer for the *New York Herald Tribune*, perhaps their art reviewer Royal Cortissoz, noted in Twachtman's obituary that "of late years his ideas underwent a clarifying precess; his hand became firmer as his vision became more acute, and in the paintings of this period he showed that he had travelled far from the uncertainties of his earlier experiments. His work became stronger in design, more attractive in color and more delicate in atmosphere. At the same time his art increased in personal force."[1]

Much of Twachtman's attention at Gloucester was given over to the active fishing and shipping that was a mainstay of the town's economy, painting the ships and wharves of the harbor. In referring to the artist's Gloucester pictures, Eliot Clark, Twachtman's first biographer, noted that "Harbors and shipping seem always to have held a vague fascination for the painter."[2] The larger ship, alongside the wharf, was a three-masted Italian bark which brought salt for fish processing; these vessels figure in many of the paintings created by artists working at Gloucester in the late nineteenth and early twentieth centuries.

These three summers were very productive for Twachtman and presumably very stimulating ones, for he rejoined a group of his early Munich colleagues, most notably his mentor Frank Duveneck, and his former fellow-student Joseph DeCamp, all three originally from the Cincinnati area. In his Gloucester paintings such as *Bark and Schooner*, the more sinuous shapes that figure in Twachtman's earlier paintings are replaced by strongly geometric forms, emphasized here in the long horizontal beams of the vessels and their rigid perpendicular masts. The

direction of the artist's vigorous brushwork reinforces this structural emphasis, as does the square format of the picture, all directed toward achieving a strong architectonic impression, which is relieved, however, by the contrast of the austerity and severity of the shapes of the boats with the marvellous fluidity of their reflections in the rippling water.

Though the painting has gone under both titles *Bark and Schooner* and *Italian Salt Bark,* it was originally exhibited as *Italian Barque* in the one-artist show of Twachtman's work held in January of 1901 at the Art Institute of Chicago; the picture, therefore, must have been painted during the artist's first summer at Gloucester in 1900. In anticipation of the Chicago exhibition's travelling to Columbus, Ohio, a writer for a Columbus newspaper noted of Twachtman's pictures that it was the "very quality and strength of the brushwork that keeps them graceful and charming... Every brushmark tells, his knowledge of drawing and technique enable him to paint rapidly and directly."[3] The critic thus acknowledged the new forces that had come into play in the work of Twachtman's last years and may have had this picture in mind when writing the review. Twachtman's art was especially appropriate for Columbus, Ohio, and not only because he was a native of that state. One of the city's most notable painters at the time was Albert C. Fauley, who also summered at Gloucester, and in August of 1900 he participated with Twachtman in an exhibition of recent work by the art colony held at the Rockaway Hotel in East Gloucester; the Twachtman exhibition was, in fact, held in Fauley's Columbus studio early in February of 1901, this painting presumably included. Fauley's paintings appear quite dependent upon Twachtman's example, and he concentrated upon harbor and dock scenes, and especially on salt barks and other ships, similar to those in *Bark and Schooner.* Twachtman himself referred to this picture as "the best thing I ever painted."[4]

[1] "John H. Twachtman", *New York Herald Tribune*, 9 August, 1902, p. 8.
[2] Eliot Clark, *John Twachtman*. New York, privately printed, 1924, p. 51.

(continued: on page 158)

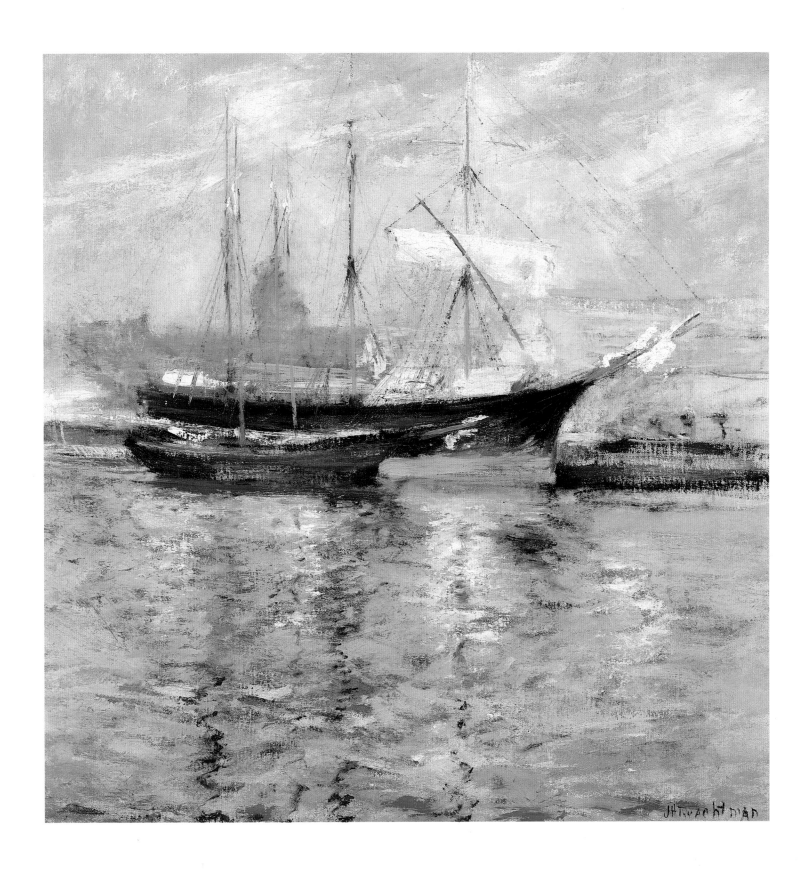

JOHN TWACHTMAN
(1853–1902)

OLD HOLLEY HOUSE, COS COB, ca. 1901
25 × 25 in.; 63,5 × 63,5 cm
Cincinnati Art Museum, Cincinnati, Ohio
John J. Emery Fund

By 1892, several years after he moved to Greenwich, Twacht-man established a summer school nearby in Cos Cob that was headquartered at the Holley House hostelry; it is believed that the artist may have boarded in Cos Cob, and possibly at the Holley House, as early as 1886, even before he settled in Green-wich three years later. Started about the same time that William Merritt Chase began his more famous Shinnecock Summer School of Art on Long Island, Twachtman's establishment also became well known. In addition, some artists, including friends of Twachtman's such as Theodore Robinson, came and stayed at the Holley House quite independent of the school, and Twachtman himself painted and stayed there during periods when the school was not in session including during his favorite season of winter.

Old Holley House, Cos Cob is probably the best known of Twachtman's several renditions of the house itself, painted toward the end of his career; at much the same time he also painted a number of exceptionally fine views looking away from the house across the Mianus River. Twachtman is known to have stayed at the House during much of the winter of 1901-02, and since *Old Holley House* was not included in any of the one-artist exhibitions held of Twachtman's paintings in New York, Chicago, and Cincinnati in 1901, it is likely that this picture had not yet been created. Furthermore, the work is il-lustrated and discussed in a letter from the artist to his son writ-ten in the winter of 1901.[1] While a good deal of scholarly atten-tion has been given lately to the works Twachtman painted at Gloucester during the last three summers of his life, 1900-02, he obviously continued to be active during the rest of the year at Greenwich and Cos Cob, and the pictures painted there share with the Gloucester works similar strategies, which differ from the paintings of the previous decade.

Though *Old Holley House, Cos Cob* continues the artist's preference for the winter subject and utilizes the lush blue and purple tones so prevalent in Impressionism, there is a new di-rectness in Twachtman's handling, with the paint laid on *alla prima,* and with more boldness, which has been discussed as a reemergence of a number of the strategies of his early Munich work. The artist even reintroduced black into a number of his last pictures, here in the strongly accented tree at the left. At the same time, there is also a reinforced commitment to structure and design, an emphasis here upon the geometry of the Holley House itself, its horizontal and vertical components, and the rectangular patterning of doors and windows. Twachtman re-corded this scene on a square canvas, a shape he especially preferred and utilized, and one that reinforces the geometry of the composition, providing a further sense of stability. In one obituary, a writer summed up Twachtman's late achievements noting that his "ideas underwent a clarifying process, his hand became firmer as his vision became more acute, and in the paintings of the period he showed that he had travelled far from the uncertainties of his earlier experiments. His work became stronger in design, more attractive in color and more delicate in atmosphere. At the same time his art increased in personal force."[2] *Old Holley House, Cos Cob* is one of more than thirty works by Twachtman that were once owned by William T. Evans, the great collector of American art; Evans appears to have acquired the picture about 1906.

[1] Lisa N. Peters, "Twachtman's Greenwich Paintings: Con-text and Chronology", in National Gallery of Art, *John Twachtman Connecticut Landscapes*, exhibition catalogue, Washington, D. C., 1989, p. 47, f.n. 96.

[2] "John H. Twachtman", *New York Daily Tribune,* 9 August, 1902, p. 8.

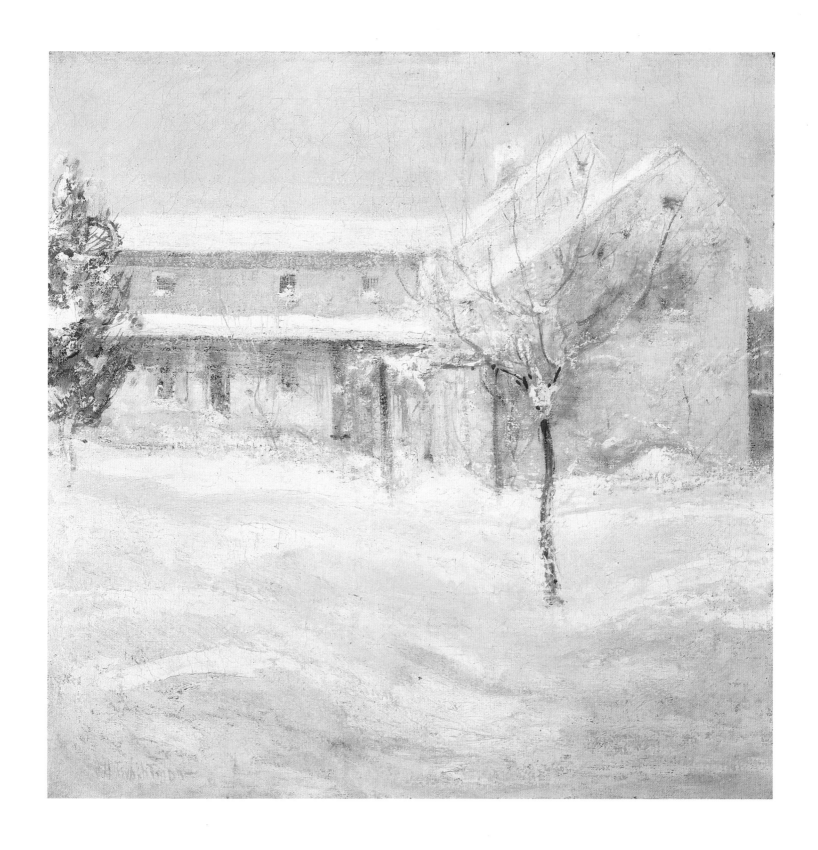

WILLIAM MERRITT CHASE
(1849–1916)

IN THE PARK: A BY-PATH, 1890–1891
14 × 19³/₈ in.; 35,5 × 49 cm
Thyssen-Bornemisza Collection, Lugano

William Merritt Chase was an Indiana-born, Munich-trained painter, who returned to the United States in 1878, settling in New York City, where he soon became a leader among the younger, European-trained generation of artists. It is arguable that the earliest pictorial manifestation of Impressionism to take place in the United States is the series of park scenes painted out-of-doors by Chase from 1886, first in Prospect Park, Brooklyn (Chase married in 1886 and the couple first lived in Brooklyn), and then, from 1889, in Central Park in New York City. (At the time, Brooklyn was an independent community and did not become a borough of New York City until 1898.) While Chase did not then adopt the full divisionist brushwork of Impressionism, a hallmark of that aesthetic, among his primary concerns was the investigation of sunlight, and his facture in these pictures is broad and free. The theme of contemporary urban life, seemingly chosen at random and presented spontaneously, is also characteristic of the work of his French contemporaries, among whom park scenes were quite common, though Chase's paintings always maintain a great sense of decorum, and often focus, as here, upon small children and maternal concern.

By November of 1886, when Chase first exhibited a group of these park scenes in a major one-artist show at the Boston Art Club, he was well aware of the achievements of the French Impressionists. He had featured a significant group of their work late in 1883 in the Pedestal Fund Art Loan Exhibition (to raise funds for construction of the pedestal of the Statue of Liberty in New York Harbor). The crucial display of French Impressionist painting, sent over to New York by the Parisian dealer Paul Durand-Ruel, had taken place in April of 1886 at the American Art Association. It was this exhibit, and its accompanying critical notoriety, which made the American public aware of the true nature of Impressionism, and this attention must have sustained the direction that Chase's art was taking in the painting of such outdoor scenes as *In the Park*.

Chase's park pictures—those painted in Central Park even more than the earlier Prospect Park scenes—were admired by both critics and fellow artists, especially after a substantial group of them were displayed in his one-man show of over seventy pictures, held within the art display at the Inter-State Industrial Exposition in Chicago in September 1889. When another group were on exhibition prior to an auction at the Fifth Avenue Art Galleries in March of 1891, a writer praised

these "park subjects which during the past two or three years have brought Mr. Chase into a popularity greater than he had ever earned before. In the parks of Brooklyn and New York he has found subjects which, although so close at hand, none of our other painters had appreciated . . ."[1] *In the Park*, probably painted in June of 1890, was singled out in 1891 by Charles de Kay as representing "one of those sections of rough rock-work which give character to many nooks and corners of the Park at the same time that they serve a useful end. Here, again, the ever-present nurse and child recall the purposes for which Central Park and many another park of New York have been established."[2]

In this picture, Chase's vigorous brushwork not only animates the scene, but creates a fascinating contrast between the giant rough boulders of the wall, and the small child in delicate finery, whose helplessness is accentuated by her isolation on the exaggeratedly broad and swiftly diminishing pathway. This spatial treatment was a common motif in Chase's outdoor pictures; the emphatic perspective was discussed by him in a talk in 1890, the year this picture was probably painted: "About the very best lecture that I ever had was once when I stood at the back of a railroad-train and saw a track running to a point away from me—and I never have forgotten it, and I have seemed to see things diminish in the distance so ever since."[3] The path terminates, however, in the watchful figure of the nurse/mother—diminutive, but featured by the touches of bright red pigment in her costume. Though one might read the scene as a metaphor of the child's path of life toward adulthood and beyond, the Naturalist proclivities of Chase and his contemporaries would seem to disaffirm such considerations, which would have been more appropriate to an earlier period.

Chase was also the first painter to make sustained use of Central Park as an appealing and interesting pictorial motif, though the park had been developed two decades earlier and T. Addison Richards had produced a series of twenty-one miniature painted views of the new park by 1860. De Kay noted that "the distinction of being the artistic interpreter of Central Park, and of Prospect Park, Brooklyn, has come to Mr. Chase very naturally."[4] These parks provided urban dwellers with havens of nature in their midst, and artists with an alternative to the traditional painting-grounds of the Hudson River School.

(continued: on page 158)

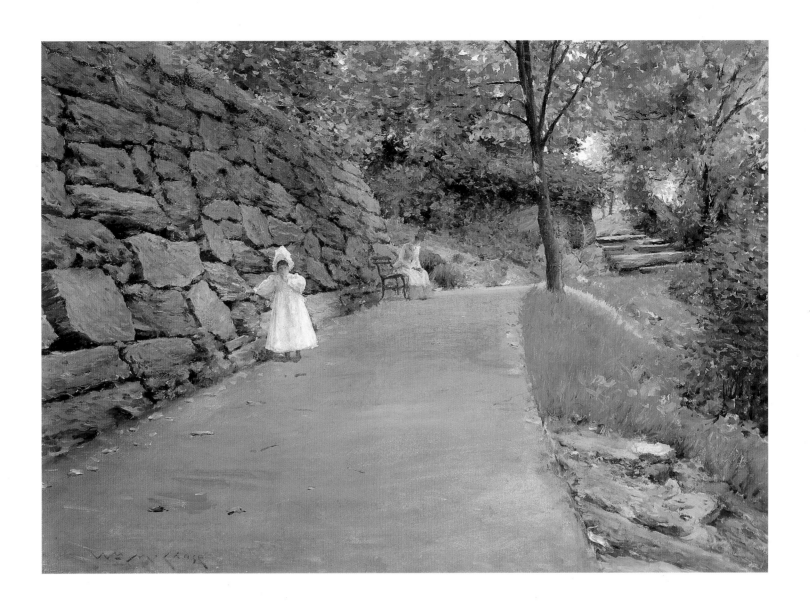

WILLIAM MERRITT CHASE
(1849–1916)

THE NURSERY, 1890
14³/₈ × 16 in.; 36,5 × 40,5 cm
Manoogian Collection

While most of Chase's paintings done in Central Park in 1890 feature the lawns, pathways, and lakes of this great natural resource of New York City, *The Nursery* is more specifically situated in an area between Harlem Lake and the Upper Reservoir; the land had been originally designated for an arboretum, but when this proved to be impractical, it was turned into a nursery.[1] Chase exhibited the work at the thirteenth annual exhibition of the Society of American Artists in April of 1892 under the title *A Visit to the Garden.*[2] In writing about Chase's Central Park pictures, Charles de Kay referred to this picture specifically, and he noted the nursery as "a spot seen from the cars of the Hudson River Railroad, little frequented save by those who live near East 100th Street."[3] The area was still quite far from the increasingly northward evolution of the city's residential quarters, but Chase may have been attracted to the subject by the opportunity to combine the renderings of flowers with elegant female figures. Having chosen to paint the scene in the month of June, when the seedlings cultivated in the cold frames had developed and been transplanted to beds and urns throughout the park, Chase, ever the Realist, depicts the nursery with its paucity of flowers and visitors. Yet, out of a nominally mundane scene, he created a vivid pictorial achievement. As one writer noted the following year, "Mr. Chase is sometimes named as being, before all, a masterly technician. This he is, but to the painter's hand he adds the painter's eye, the eye which when it sees a thing that it wants to paint sees it as a picture, and not as a mere object of study."[4]

Actually, given Chase's increasing proclivity during the 1880s toward bright colors in brilliant sunlight, it is perhaps surprising that flowers do not figure more in his oeuvre. He is known to have told his students that flowers were very difficult to paint, and he may have also thought them a subject that was too conventionally "pretty". Here, they are present chiefly in the bouquet held by the principal figure, presumably unlike another park picture *Flower Beds,* which was described as a "veritable little marvel of bright yet exquisitely harmonious tints."[5] The flowers that are shown in *The Nursery* are little more than ideographs, consisting of colored brushwork rather than identifiable blooms. The dominant red in the bouquet echoes the color of the side of the building at the left, which sends a strong diagonal plunge deep into space, repeated by the cold frames and even the watering pail at the right. Three figures, in radically diminishing size, act as spatial markers in this regression, the third so small as to be almost indistinguishable.

The viewer therefore focuses both on the distant plane of leafy trees, seen against a bright sunlit landscape, and upon the foreground figure, seated and holding the bouquet. The pose is a common one in Chase's pictures painted in both Central Park and, earlier, in Prospect Park, Brooklyn. Here, she anchors the composition and at the same time projects the age-old alignment of lovely women and beautiful flowers. The sparkle of color and sunlight are enhanced by the vivacity of Chase's brushwork—broad strokes for the whites of the women's garments, shorter and more broken for the foliage, with the features and gloved hands of the principal figure, and the geometry of the building at the left rendered fairly tightly.

What Chase has accomplished here is a superb combination of genres—the urban landscape and the study of a genteel woman. It is a work that must have seemed both very modern (in both technique and subject) and very attractive to contemporary viewers. The seamy side of the city is completely shunned, and the young lady is not only comely but extremely well-garbed, and though she walks on dirt paths, may rummage through plant boxes, and handle flowers, she is in immaculate white, a symbol of purity. De Kay believed that there should be hundreds of New Yorkers who enjoyed the Park, and who "would like a picture recalling this or that spot, particularly if the artist were clever and distinguished", such as Chase. And he hoped then that Chase would continue to essay such scenes, "for his pictures of Central Park, while they ought to be popular by reason of circumstances, have all the possibilities he may demand for the painting of fresh natural subjects under the changes of light and shadow out-of-doors, and for the treatment of the human figure in a bright, unhackneyed fashion."[6]

[1] Henry Hope Reed and Sophia Duckworth, *Central Park: A History and a Guide.* New York, C. N. Potter, 1972, p. 133, quoted by Ronald G. Pisano in National Gallery of Art, *American Paintings from the Manoogian Collection,* exhibition catalogue, Washington, D. C., 1989, p. 140

[2] "Society of American Artists", *New York Times,* 26 April, 1891, p. 5.

(continued: on page 158)

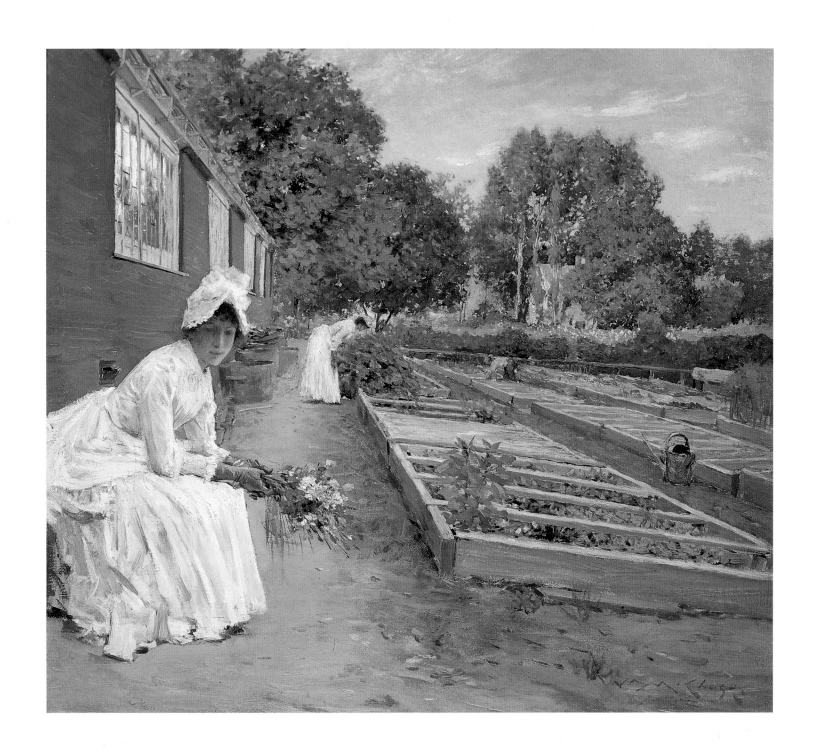

38
WILLIAM MERRITT CHASE
(1849–1916)

THE FAIRY TALE, 1893
16½ × 24½ in.; 42 × 62 cm
Mr. and Mrs. Raymond J. Horowitz

The culmination of Chase's involvement with the strategies of Impressionism—the concern with color and light interpreted with scintillating brushwork, applied to informal modern-day scenes—can be found in the pictures that the artist painted while conducting his out-of-doors summer school at Shinnecock, on the south shore of Long Island. Chase appears to have gone out there in 1890, and the following year opened the school, which he ran through 1902. Though not the first such institution in the United States, it became the most famous, and many of the country's leading artists of the twentieth century took instruction there. Likewise, though not all the painters who emerged from the school adopted the Impressionist style, the nature of the instruction and Chase's own paradigmatic work of the period encouraged that approach.

If his Shinnecock pictures encompass Chase's finest years of Impressionist painting, *The Fairy Tale* is perhaps the most noteworthy and best known of these canvases. Here even the technique is extremely close to orthodox French Impressionism, though Chase's aesthetic as well as his subject matter is especially akin to the style of the "pre-Impressionist" Eugene Boudin. This picture was painted in 1892 and was highlighted the following year in one of the many published essays describing and promoting the activities at the summer school. After commenting on some of Chase's work of the previous year, John Gilmer Speed noted that "Of all the landscapes, there is one that is particularly notable, and to my mind entirely satisfactory... The foreground is the same grass and heather before spoken of, and sitting in this a lady and a child—the lady in white with a pink hat and the child in pink with a white hat. An open parasol lies beside them, and this, too, is pink and white. In front of the two figures, which are not merely sketched in, but finished with care and nicety as to details, is a scrub oak that seems, because its foliage mingles with the heather and grass, more like a clump of bushes than a tree. Beyond and in the distance is the Peconic Bay, with a cluster of bath-houses, and still beyond is Robbin's Island. Over all is a cloudless summer sky. No one could give any idea by mere description of the poetic beauty of this lovely picture..."[1]

Speed had remarked about Chase that "summer vacation is his busiest and his happiest time, and upon the work then done he not infrequently finds his inspiration for the remainder of the year," and noted also that "the advantage of living in such a place is that all an artist has to do is to take out his easel and set it up anywhere, and there in front of him is a lovely picture."[2]

This suggestion of informality in both the landscape and the figures, with the scene appearing casual and unorganized, is a major factor in the picture's appeal. His wife and their second child, Koto, enjoy the pleasures of unrestrained nature, the verdancy of which is represented by the scrub oak before which they bask, while the rich sunlight and good weather are conveyed by the parasol and the clear blue sky respectively. That Chase thought especially highly of this work is suggested by its inclusion in *A Study,* another picture reproduced by Speed in his article, which represents his wife Alice sitting in the artist's studio in front of *The Fairy Tale,* already elaborately framed. The composition, a "picture-within-a-picture," is itself a fascinating juxtaposition of portrait and landscape, of an indoor and outdoor conception, a painting about painting and the artist's life.

Nevertheless, the composition is more calculated than first appears. The two figures, along with the parasol, form a stable, pyramidal group in the center of the picture, united in the white and warm salmon tones which contrast with the greens and blues of their natural surroundings. The bright salmon-pink tones are themselves symmetrically arranged triangularly. Chase reveals here the poetry in that contrast, along with the harmony between the vigorously rendered landscape and the more delicate figures. The relatively small picture projects a vast, unending landscape, with the flattened shoreline in the distance and the broad, cloudless expanse of sky; while the bathhouses in the distance, identified in the same salmon colors as the foreground figures, implies security and further human presence. *The Fairy Tale* expresses the epitome of the sophisticated late nineteenth century urban artist's relationship with nature, the antithesis of his predecessor's worship of raw wilderness as the ultimate embodiment of a spiritual presence.

The Fairy Tale was first exhibited, under the title *A Sunny Day,* in February of 1893 at the sixteenth annual exhibition of American paintings held at Gill's Art Galleries in Springfield, Massachusetts. Subsequently, under its present title, it was one of three Shinnecock landscapes shown in New York two months later at the fifteenth annual exhibition of the Society of American Artists, of which Chase was the President. In reviewing the display at the Society, the critic for the *New York Herald* found that "a fit introduction to the landscapes and marines will be two charming canvases with figures in landscapes by

(continued: on page 158)

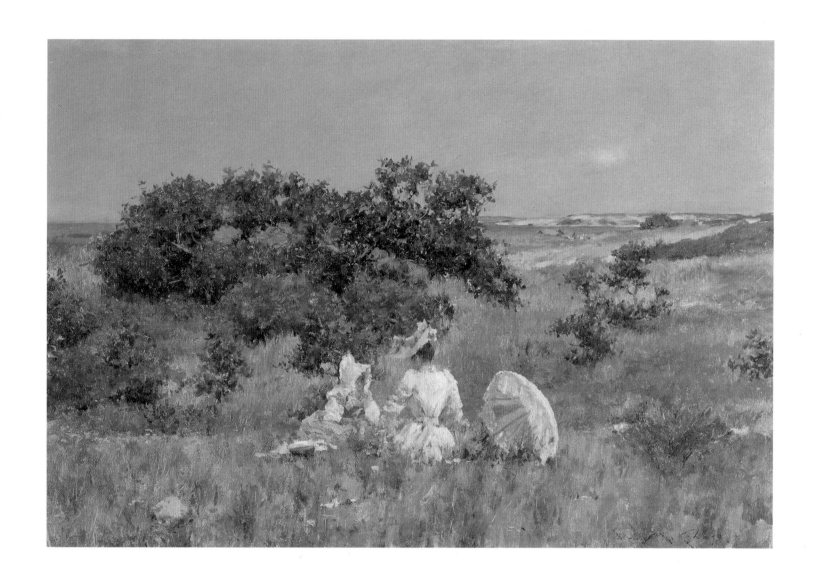

WILLIAM MERRITT CHASE
(1849–1916)

SHINNECOCK HILLS, ca. 1893–97
17½ × 21½ in.; 44,4 × 54,6 cm
Thyssen-Bornemisza Collection, Lugano

While the majority of Chase's landscapes painted at Shinnecock during the 1890s feature figures, usually of his wife and children, there are a number such as *Shinnecock Hills* in which they are absent. Most of these pictures share with the figural ones the exploration of bright sunlight and rich painterly effects which convey the artist's delight in the environment he had chosen for his combined summer activities of teaching and painting. And human presence is at least implied in this scene also, by the path running from the left side up to the horizon, and the fence posts which parallel it part way.

Nevertheless, there is a purposeful sense of emptiness and loneliness in such a picture. This is strengthened by several formal strategies which Chase adopted in his outdoor work at Shinnecock. In most of these works, the foreground is usually painted with more freedom than the more distant areas, so that the foliage and hillocks at the horizon appear quite sharp and clear, reinforcing the sense of vacantness. Likewise, Chase generally featured a fairly high horizon, offering great depth for visual exploration of the landscape, augmented by the path along which the viewer metaphorically travels, meeting no one. The open-ended composition, too, with no impediments to lateral expansiveness in both directions beyond the edges of the canvas, adds further to the suggestion of emptiness.

Though Chase does not appear to have dated any of his Shinnecock landscapes, it has been suggested recently that these somewhat more mood-inducing and introspective scenes are generally later than the sparkling paeans to contentment such as *The Fairy Tale* of 1892, and that they may date from the middle of the decade.[1] In fact, the present work may be a reverse image of another picture, also titled *Shinnecock Hills* (National Museum of American Art, Washington, D. C.), which is dated around 1895 and depicts the beginning of the roadway, with the fence posts at the right.

Without a salient feature in the scene, and lacking the appearance of any figures, the question arises as to Chase's motivation for painting this picture and others like it. Most likely, he was drawn to such endeavor by his enjoyment of the variegated colors of the low-lying grasses and the contrast of this relatively "busy" foreground with the more empty field further in the distance. He may have wished also to demonstrate that even the most casual and unprepossessing subject could serve for a splendid work of art at the hands of a master painter; that the creative process was its own intrinsic *raison d'être* and far more significant than felicitous subject matter. Such pictures as *Shinnecock Hills* substantiate the comment made by John Gilmer Speed in discussing Chase's summer activities that "all an artist has to do is to take out his easel and set it up anywhere, and there in front of him is a lovely picture."[2]

[1] Nicolai Cikovsky, Jr., "Impressionism and Expression in the Shinnecock Landscapes: A Note", in National Gallery of Art, *William Merritt Chase Summers at Shinnecock 1891-1902*, exhibition catalogue, Washington, D. C., 1987, pp. 31-37.

[2] John Gilmer Speed, "An Artist's Summer Vacation", *Harper's New Monthly Magazine*, 87, June, 1893, p. 8.

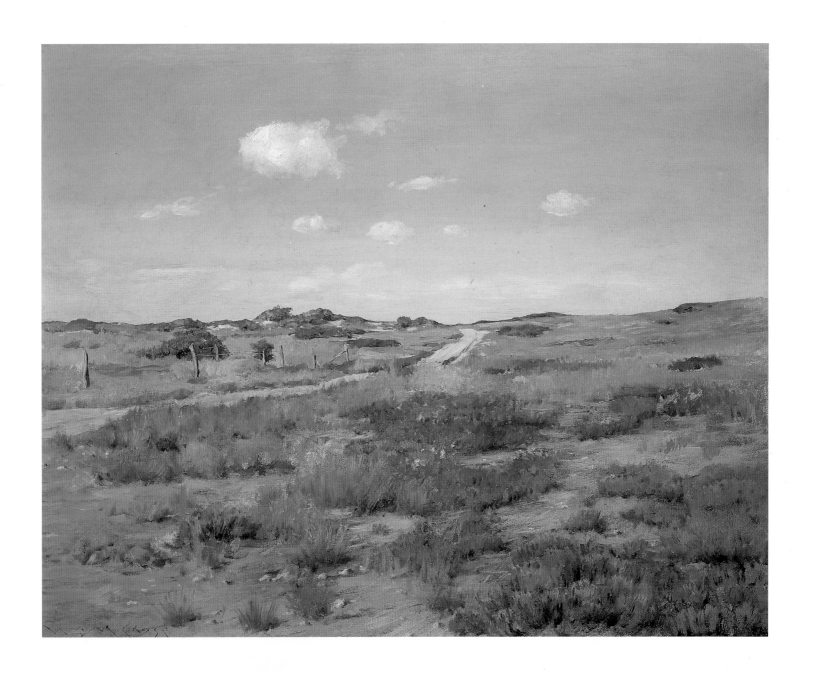

WILLARD METCALF
(1858–1925)

GLOUCESTER HARBOR, 1895
26 × 28¾ in.; 66 × 73 cm
Mead Art Museum, Amherst College, Massachusetts
Gift of George D. Pratt

Massachusetts-born Willard Metcalf studied in Boston and established his reputation as an illustrator for his contributions to a series of articles on the Zuni Indians of Arizona, published in *Century* magazine in 1882–83. He then went to Paris to take instruction at the Académie Julian, spending his summers in a host of art colonies in France and England. Metcalf appears to have been one of the first Americans to visit Giverny, his presence there being recorded in 1885, and he was part of the group of artists from the United States and Canada who descended upon Monet's home village in 1887. His activities there and his visit to North Africa in the winter of 1886–87 may have been responsible for Metcalf's increased concern with the effects of light as well as greater breadth in paint handling, but his work of this period reflects little of the chromatic range of Impressionism nor any suggestion of divisionist dissolution of form. By December of 1888, the artist was back in America, where he held a one-artist show at the St. Botolph Club in Boston the following March, at which the critics recognized his modernity.

The years immediately following Metcalf's return to the United States are imperfectly documented, though his attention was taken primarily by illustration, portraiture, and teaching. He soon settled in New York City, but for the rest of his career the great majority of his pictures were painted throughout the New England states, with which region he became especially associated; indeed, it was Metcalf whom the critics especially found to have "Americanized" the Impressionist style. The artist's involvement with Impressionism first appeared in a series of pictures he painted during the summer of 1895 at Gloucester, Massachusetts, the best known of which was *Gloucester Harbor,* which won the Webb Prize in the eighteenth annual exhibition of the Society of American Artists in New York City the following spring. Metcalf showed six paintings at the exhibit, five of which were Gloucester subjects.

Critical reaction to Metcalf's success at the Society was mixed, many of the reviewers judging *Gloucester Harbor* as lacking in sentiment and too clever and too sketchy to have deserved the award; several noted that a similar work by Hassam had won the same prize in 1895.[1] Even Metcalf's friend and colleague Theodore Robinson noted that the artist had "a brilliant but superficial exhibit of Gloucester things" at the Society.[2] Royal Cortissoz, the critic for the *New York Daily Tribune,* was one writer who judged Metcalf's work positively, finding *Gloucester Harbor* "a vigorous study . . . in which there is abundant light playing through an attractive scheme of color and illuminating what is in every way a sincere, authoritative interpretation of nature."[3] Cortissoz went on to become Metcalf's greatest champion, authoring several monographic articles on the painter. Although in 1896 the reviewers did not yet specifically associate Metcalf with Impressionism, he was surely included in the observation that "those of our younger painters who follow more or less closely Mr. Claude Monet and the French Luminarists have had things pretty much their own way at the Eighteenth Annual Exhibition of the society . . ."[4] Ironically, this would be the last time Metcalf would exhibit with the Society, and at the end of the following year he would join Hassam, Twachtman, Weir, Benson, Tarbell, Reid, DeCamp, and two other painters in seceding from that organization and founding The Ten American Painters. *Gloucester Harbor* was acquired in 1896 by Samuel T. Shaw, the noted New York art patron and founder of the Shaw prize at the Society of American Artists, who lent it that December to the sixty-sixth annual exhibition of The Pennsylvania Academy of the Fine Arts.

The rich colorism and loose facture of *Gloucester Harbor* are not dissimilar from Childe Hassam's work of the 1890s, and Hassam in fact did spend some of the summer of 1895 in Gloucester, so the possibility of the influence of the more established Impressionist upon Metcalf's development should not be overlooked. Years later, Hassam claimed credit for this breakthrough at Gloucester in Metcalf's artistic development, noting "I got Metcalf to go there and start his work. It was the beginning of his success."[5] At the same time, Metcalf's Impressionism is selective; the foreground is rendered with vibrant brushwork, but the plane of bright blue water upon which attention is centered is unbroken, and it acts as a solid foil for the irregular shapes of buildings, piers, and boats. The block-like forms of the buildings on the distant shore and even the preference for lavender-grey rooftops recall Theodore Robinson's treatment of the houses in Giverny painted in the late 1880s when he and Metcalf were working together. But Metcalf has combined these influences to create a distinct pictorial identification for this quintessential New England coastal town, at once an active fishing village, a joyous tourist resort, and an artist's haven.

(continued: on page 158)

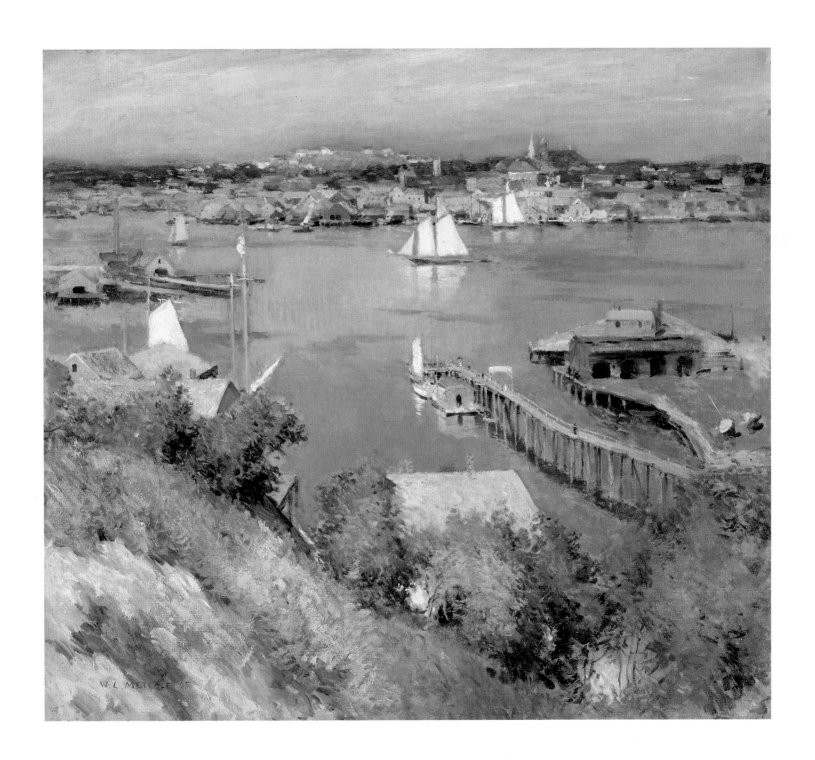

WILLARD METCALF
(1858–1925)

THE POPPY GARDEN, 1905
24¹/₈ × 24¹/₈ in.; 61 × 61 cm
Manoogian Collection

Perhaps too much has been made of Metcalf's "renaissance", the year he spent in Maine in 1904, after which he became fully identified with the Impressionist movement. He had, after all, painted richly chromatic works such as *Gloucester Harbor* in 1895, and two years later participated in the founding of The Ten American Painters, a group which, at the time, was identified predominantly with that aesthetic. As such, his "renaissance" should probably be recognized more as a personal triumph than as an artistic breakthrough, although the landscapes painted in Maine that year reflect a pretty thorough commitment to Impressionist strategies.

This is true also of most of his work done during the summers of 1905, 1906, and 1907 at the art colony of Old Lyme, Connecticut, one of the major centers committed to Impressionism. Old Lyme began to attract artists in increasing numbers beginning in 1899, but these earlier painters were working in a basically Tonal mode, a derivation from the impact of Barbizon landscape painting in America. The artistic character of the colony changed fairly abruptly after the appearance of Childe Hassam in Old Lyme in the summer of 1903, with some of the Tonalists turning to a more broken facture and brighter colors, and others moving away. Metcalf visited Old Lyme early that summer also, but his significant association with the colony began in 1905, when he settled there in early May at Florence Griswold's house, where most of the visiting summer artists boarded, remaining until November. (Her home was referred to at times as "The Holy House", a parody of its Cos Cob, Connecticut equivalent, The Holley House, a subject often painted by John Twachtman, who taught there.) Metcalf became a mainstay of the Old Lyme colony for the next several summers.

The artist is known to have painted almost thirty works during his first summer in Old Lyme in 1905, including *The Poppy Garden*. The picture is actually a fairly unusual work for him; although gardens and fields of flowers were especially popular among the American Impressionists as is evident from the present show, it was not a motif explored to any great degree by Metcalf as it was, for instance, by his colleague Hassam or by the local Old Lyme painter Edward Rook. Generally, Metcalf preferred more sweeping landscapes; he is known to have painted only two formal floral still lifes, and his excursions into outdoor flower painting are rare, occurring principally during these summers in Old Lyme. Like Hassam and Rook, he did essay the groves of laurel that grew there abundantly, and several paintings of flower gardens were painted in Old Lyme, of which *The Poppy Garden* is the best known; the picture is believed to have been painted in the garden of his colleague, the Old Lyme resident artist Clark Voorhees, or possibly that of Florence Griswold. The motif itself is one made famous by Claude Monet; the best known of Monet's poppy field paintings (Museum of Fine Arts, Boston) was on view in New York City in the spring of 1886, but Metcalf was then in France. However, he may well have come to know similar works by the French master in Paris or Giverny. More immediately, the series of paintings of Celia Thaxter's poppies in her wild flower garden on Appledore, painted in the early 1890s, were well known through exhibition in New York and in reproduction in Thaxter's book *An Island Garden*, and some of these are especially close in design to Metcalf's picture. The decorative nature of this work is enhanced by the square format which Metcalf adopted, a shape which tends to center the composition on the picture plane and to minimize spatial depth and breadth; Metcalf, in fact, painted more square pictures than almost any of his colleagues, as indicated in the present exhibition.

Metcalf's Old Lyme canvases appeared in exhibitions in New York early in 1906, first at a one-artist display at Fishel, Adler and Schwartz Gallery in February and then at the eighth annual show of The Ten American Painters, held at the Montross Gallery in March; *The Poppy Garden* was one of the six pictures he exhibited there. By and large, the critics concentrated their attention upon Metcalf's more spacious landscapes rather than his two pictures of poppies and laurel. Royal Cortissoz was again the exception here, noting that with "the dainty 'Poppy Garden' and the radiant 'Mountain Laurel' he fills us with the sense of the truth and freshness of nature and captivates us with his clear and animated way of saying what he has to say."[1]

[1] [Royal Cortissoz], "Art Exhibitions", *New York Daily Tribune,* 21 March, 1906, p. 7.

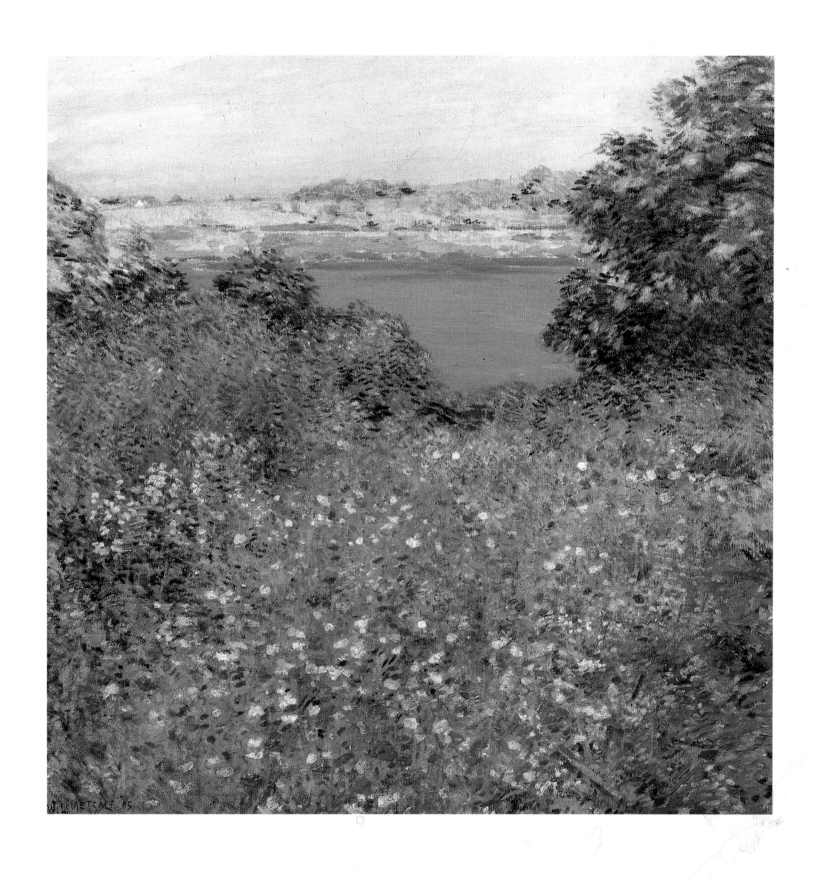

42
WILLARD METCALF
(1858–1925)

OCTOBER, 1908
26 × 29 in.; 66 × 73,6 cm
Museum of Fine Arts, Springfield, Massachusetts

More than almost all his Impressionist colleagues, Metcalf is usually regarded as solely a painter of the New England landscape, with little interest during his mature years in portraiture, in figure painting, or in floral work. A significant, if partial exception to this, however, was his exploration of the subject of old, often historic buildings, placed, of course, in landscape settings. He first appears to have concentrated upon such objects in the wake of the enormous critical and financial success which he achieved with his 1906 *May Night*, a Tonal and nocturnal view of the Florence Griswold house in Old Lyme, which led not only to a host of imitations by his colleagues in Old Lyme, but also to his own involvement for the next several years in the painting of "moonlights", nighttime landscapes centering on old buildings. Metcalf, in turn, may have been inspired to essay such architectural subjects by the success of Hassam's sequence of renderings of the old Congregational Church in Old Lyme which he began in 1903, this constituting Hassam's American response to Monet's famous Rouen Cathedral series.

But, of course, not all Metcalf's pictures of buildings were nocturnal scenes, given the artist's proclivity for the rich sunlight and bright colors of Impressionism, and his growing concern with seasonal considerations. One of the finest of such more colorful renditions is *October*, painted in 1908 on Leete's Island, Connecticut, a depiction of Peletiah Leete's house, "decorated" with a rich pattern of purple shadows cast by the tall trees upon the sunlit white walls. Metcalf had not returned to Old Lyme in 1908, but after residing much of the summer in Maine, he spent six weeks that fall at Leete's Island near Guilford, Connecticut, a guest of Judge Calvin Leete. *October*, one of four paintings that resulted from that visit, is one of the most colorful in Metcalf's oeuvre. He capitalized on the bril-

liant fall foliage, contrasting the two large trees, one with red and the other with russet leaves, and comparing their airy leafage rendered in broken Impressionist brushstrokes, with the solid saltbox of the Leete home. A joyous drama takes place here between nature's exuberant, ever-changing forms and man's foursquare, enduring creation, the one so colorful, the other in neutral white. Metcalf carefully defines the scene as a rural setting, rather than a townscape, with attention given to the haystack at the right, before which scatter a group of chickens. The Americanness which critics identified with Metcalf's New England painting is especially evident in the respect and admiration he evinces for these architectural mementos of the national heritage.[1]

October appeared in a one-artist show of Metcalf's work held at the Montross Galleries in New York City in January of 1910. The picture was highly appreciated. The critic for the *New York Times* described it as "an arrangement of color that might have been a strident horror, but instead is the tenderest of warm harmonies. Not only the color is delightful, but the intimate detail of the scene, the chickens pecking at the ground in front of the haystack, the suggestion of the farmyard in the background, the delicate drawing of the house itself, half hidden by the trees, are eloquent of a vision that has observed sympathetically and remembered with singular accuracy."[2]

[1] See the discussion of these pictures by Elizabeth de Veer in Elizabeth de Veer and Richard Boyle, *Sunlight & Shadow The Life and Art of Willard L. Metcalf.* New York, Abbeville Press, 1987, pp. 83-93.

[2] "Metcalf Paintings on View", *New York Times,* 4 January, 1910, p. 7.

106

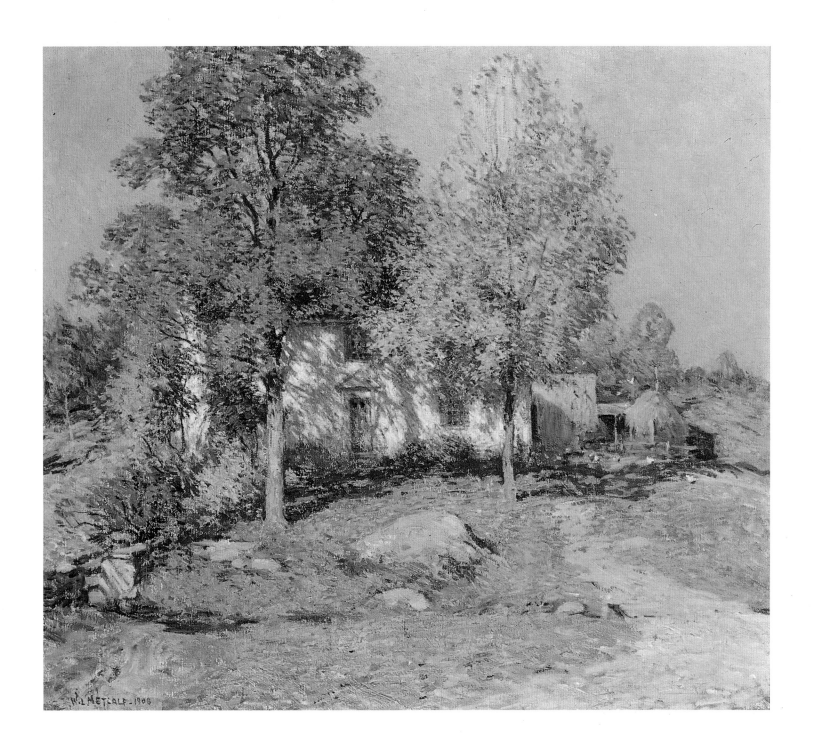

WILLARD METCALF
(1858–1925)

THE WHITE VEIL, 1909
24 × 24 in.; 61 × 61 cm
Museum of Art, Rhode Island School of Design, Providence, Rhode Island
Gift of Mrs. Gustav Radeke

Although Metcalf had painted winter scenes at least as early as 1906, it was on his first visit to Cornish, New Hampshire, in February and March of 1909 that the artist began to establish his reputation as a master of this landscape genre, assuming a role and recognition previously held by his deceased friend and colleague John Twachtman. Metcalf's champion, the critic Royal Cortissoz, believed that only he and Twachtman "could so consummately capture the beauty of a snowy day."[1] Cornish had developed as a major colony of artists in the mid-1880s, after the sculptor Augustus Saint-Gaudens established his home and studio there in 1885. Saint-Gaudens was deceased by 1909, but many artists and writers remained, and it proved an ideal environment, offering social amenities as well as striking motifs for the *plein-air* landscapist. Hitherto, Metcalf had specialized in spring, summer, and autumnal scenes; winter obviously imposes special hardships for outdoor work. Even though some artists had homes there for year-round living, Old Lyme was emphatically a summer art colony. While painters also were generally active in Cornish during the summers, its more diverse constituency, which included writers and architects, would seem to have made it especially agreeable for Metcalf's winter visits, and he ultimately painted more landscapes there than any other artist.

Among the most beautiful of Metcalf's Cornish scenes of 1909 is *The White Veil,* or rather, both versions of *The White Veil*; a slightly larger replica of the present picture, also painted that year, is owned by The Detroit Institute of Arts. In these works, Metcalf has carried over the basically Tonal aesthetic that had earlier predominated in the nocturnal pictures he painted at Old Lyme in 1906, substituting the overall soft white hue for the dark blues and greens that predominated in *May Night* and its successors. Violet and lavender tonalities, often a hallmark of Impressionist identification, are subtly infused here among the foliage and along what appears to be a stone fence in the distance. Metcalf also exploits a harmonious contrast between the more dramatic evergreens and the leafless deciduous trees, the branches of which create a decorative fan-like pattern against the gray sky. *The White Veil* offers an especially gentle and poetic vision, the flecked brushwork of Impressionism serving as an ideal strategy for the depiction of falling snow, forming the "veil" of the title, which in turn identifies the work as truly an out-of-doors painting, rather than a studio concoction. But even Metcalf's colleagues among the American painters of winter, such as Twachtman, appear to have avoided the actual recording of falling snow; the artist's achievement with *The White Veil* may have partially inspired Guy Wiggins to adopt this as his specialty about a decade later, though Wiggins applied this motif of falling snow to the urban winter scene. The stillness and solitude associated with winter are projected here by Metcalf with great success.

The result of Metcalf's first Cornish winter was initially seen in New York at the twelfth annual exhibition of The Ten American Painters, where the present version of *The White Veil* was shown as the artist's sole contribution, vying with Joseph DeCamp's *The Blue Cup* as the star of the show. The picture was greeted with much enthusiasm by the critics, one of whom wrote that "Metcalf has never shown a finer canvas than *The White Veil.*"[2] One writer, who began his review by praising *The White Veil,* described it as a picture "of delicacy and poetry, of subtle values well expressed, and a sense of nature admirably conveyed," and another called the picture "a strong winter landscape which runs the lamented Twachtman very close."[3] With his mastery of the winter landscape, Metcalf had completely defined his role as the interpreter of New England in all of its seasons.

[1] Royal Cortissoz, "Willard Leroy Metcalf", in *Commemorative Tributes of the American Academy of Arts and Letters, 1905-1941.* New York, 1942, p. 181; the eulogy was originally published in 1927.
[2] "Gallery Notes", *New York Times,* 22 March, 1909, p.7.
[3] "Art and Artists", *Globe & Commercial Advertiser,* 19 March, 1909, p. 6; James B. Townsend, "Annual Exhibit of The Ten", *American Art News,* 20 March, 1909, p. 6.

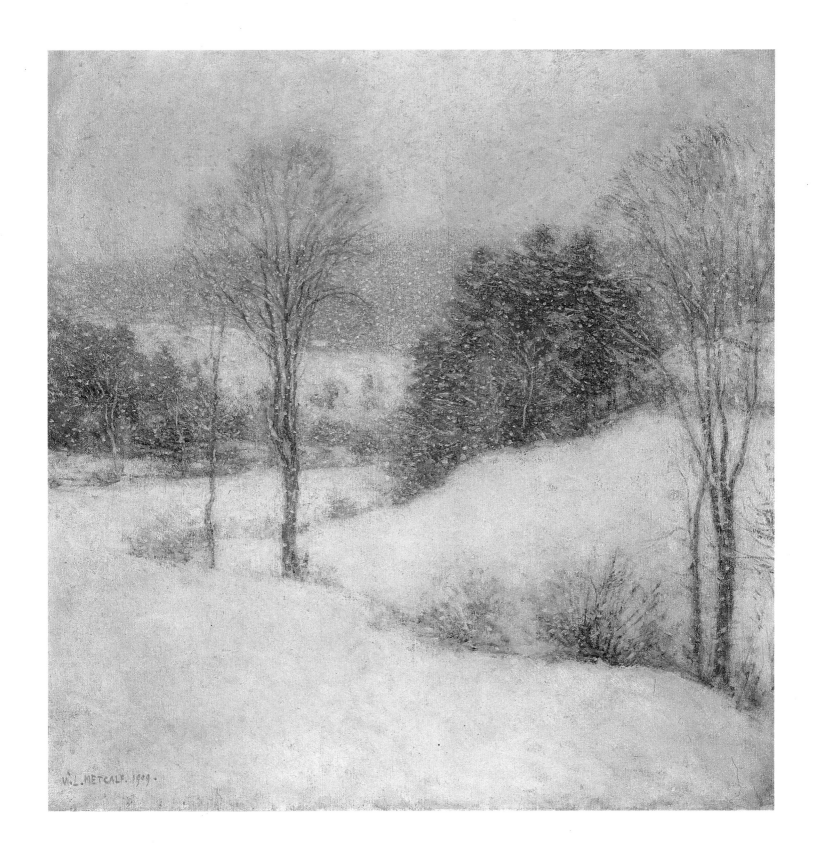

WILLARD METCALF
(1858–1925)

CORNISH HILLS, 1911
35½ × 40 in.; 90 × 101,5 cm
Thomas W. and Ann M. Barwick

Following his first visit to Cornish early in 1909, when he painted *The White Veil,* Metcalf returned there in 1911 and then during the next several winters, and was back sporadically thereafter through 1920. The 1911 sojourn was especially felicitous, almost surely in part because this was the artist's wedding trip with his new bride, the former Henriette McCrea. In any event, that winter proved an exceptional season of many outstanding paintings not the least of which was his monumental *Cornish Hills.*

Cornish Hills is one of the grandest of Metcalf's landscapes, painted while visiting the architect-painter Charles Adams Platt in Cornish. The view is of Blow-Me-Down Pond and, in the background, Dingleton Hill; the foreground is land adjacent to Platt Road, and on the steep bluff behind the pond are the house and barns of Charles Beaman. Beaman had originally encouraged the sculptor Augustus Saint-Gaudens to settle in Cornish in 1885, and thus was instrumental in the founding of the Cornish art colony.[1]

If the Impressionism of *The White Veil* is tempered by Tonalist considerations, *Cornish Hills* is more precisely drawn and more firmly constructed than most Impressionist painting, the artist relinquishing here almost any suggestion of broken brushwork. Impressionist identification lies principally in the concern for sunlight and the telltale blue shadows, which color and dramatize the broad blanket of white snow in the foreground. In the distance, the hills rise majestically almost to the top of the canvas, the white snow now becoming a foil to the dark range of rich evergreen trees, while these large natural forms are contrasted with the tiny houses nestling in the valley below.

Cornish Hills was one of two works Metcalf exhibited with The Ten American Painters at their fourteenth annual exhibition held in March of 1911 in New York City. It was well received by the critics, Charles Henry Dorr in the *World* calling the picture "the finest landscape in the group."[2] One writer stated that "Mr. Metcalf's hills in winter have the ponderous mass and the crisp delineation of the season's eager, nipping air"; another called the picture "a magnificent landscape, nobly proportioned and with rare beauty of light and color"; and this was echoed by a third writer who deemed the picture "a magnificent structure, nobly proportioned and veiled with a singularly pure beauty of color and light."[3]

The critic for the *Evening Mail* described the painting as "A superb winter picture . . . There is a purple-topped mountain in the distance, up which climb the snow-covered pastures and the patches of pine woods. There is a glistening lake at the base of the mountain and a foreground of gentle beauty."[4] Robert Macbeth analyzed Metcalf's achievement in painting snow in some detail: "the artist shows us that snow is not always the same kind of white; we are shown snow under various conditions, broken up beneath the trees on the hillside, smooth and undisturbed on the level plain, shaded by the evergreens and also by the clouds, and we feel with Metcalf the very different aspect of the white mantle under such varying conditions."[5]

[1] Information from William A. Shurtcliff, courtesy of Elizabeth de Veer.
[2] Charles Henry Dorr, "American 'Ten' Make Fine Show with Paintings," *World,* 26 March, 1911, p. M7.
[3] "In the Galleries," *International Studio,* 43, April, 1911, p. lxxii; "Exhibitions at the Galleries," *Arts and Decoration,* 1, May, 1911, p. 300; "Fourteenth Annual Exhibition of the Ten American Painters at the Montross Galleries," *New York Times,* 26 March, 1911, part 5, p. 15.
[4] "The 'Ten Painters' Once More," *Evening Mail,* 22 March, 1911, p. 8.
[5] R[obert] W. Macbeth, "Secessionists Exhibit in New York," *Christian Science Monitor,* 1 April, 1911, p. 15.

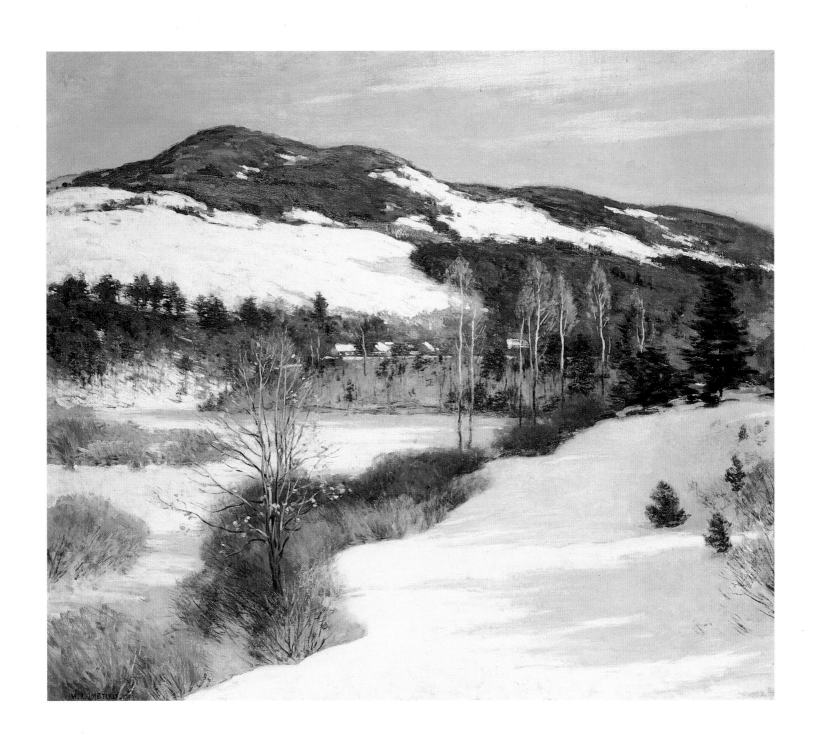

ROBERT REID
(1862–1929)

REVERIE, 1890
11⁷⁄₈ × 20¹⁄₈ in.; 30 × 51 cm
The Manoogian Collection

Reid studied at the school of the Museum of Fine Arts in Boston from 1880-84, a classmate of Edmund Tarbell and Frank Benson, with whom he would later become associated as one of the leading American Impressionists, joining them as a member of The Ten American Painters when that Impressionist-oriented group was formed in 1897. After a brief period of study at New York's Art Students' League early in 1885, Reid made the inevitable trip to Paris for advanced study, summering at Etaples where he began to produce academically oriented pictorial dramas of the lives of French fisherfolk.

Reid returned to the United States in 1889, settling in New York City. In 1892 he began a successful involvement with mural painting, and few easel pictures by him are known from the early and middle 1890s, before he turned to the large, decorative images of attractive young women enmeshed in a floral setting which would become his forte. *Reverie,* painted only a year after his return from France, indicates his abrupt turn away from narrative and his allegiance to idyllic out-of-doors imagery which also began to be investigated by his Boston colleagues at the time. The present work was originally entitled *Summer* and was first exhibited by Reid in the annual exhibition of the Society of American Artists in April of 1891.[1] *Summer,* presumably the same canvas, was again shown by Reid in November of 1891, this time at the Union League Club.

In May of the previous year, soon after his return to New York, Reid contributed to the final exhibition held at the galleries of Wunderlich and Co. in New York of the Society of Painters in Pastel, a group which included the most Impressionist-oriented young American artists, many of them recently back from France. Reid's earliest association with Impressionism was probably made at this time in regard to his pastel *Afternoon Sunshine,* depicting a peasant woman and child resting.[2] The New York critics continued this identification in regard to the pictures he exhibited at the Society of American Artists and the Union League Club during the 1890s; his *Summer Sunshine,* shown at the Club in 1891, was noted as "the best work of his that we have seen; but, nevertheless, we wish we need not count Mr. Reid among the young men who have been bitten by the Impressionist tarantula."[3]

More specifically, the patchy brushwork, dappled sunlight, and bright but somewhat restricted palette of *Reverie* suggests a kinship with the paintings of Theodore Robinson, who had become recognized as the foremost American convert to Impressionism with the paintings he showed with the Society beginning in 1889. No connection between Reid and Robinson at this time has yet been adduced, however. In this picture, Reid quietly introduces a strong structural component underlying his casual and sketchy presentation. The young woman in pink is positioned in a strongly demarcated cube, defined by the vertical trunks of three birch trees, which appear to stand guard in a natural sanctuary. The empty stillness of the scene is accentuated by the vacant bench at the left, presumably similar to that on which the central figure sits. *Reverie,* or *Summer,* is probably the loveliest of all of Reid's work known today.

[1] The picture is described in the review of the exhibition that appeared in the *New York Times,* 26 April, 1891, p. 5: "'Summer' is the figure of a young woman in straw hat and pink dress reading with her back against the bole of a white birch".

[2] "The Pastel Exhibition", *Art Amateur,* 23, June, 1890, p. 4.

[3] "The Pictures at the Union League Club in New York-Second Notice", *Studio,* 6, 17 January, 1891, p. 57.

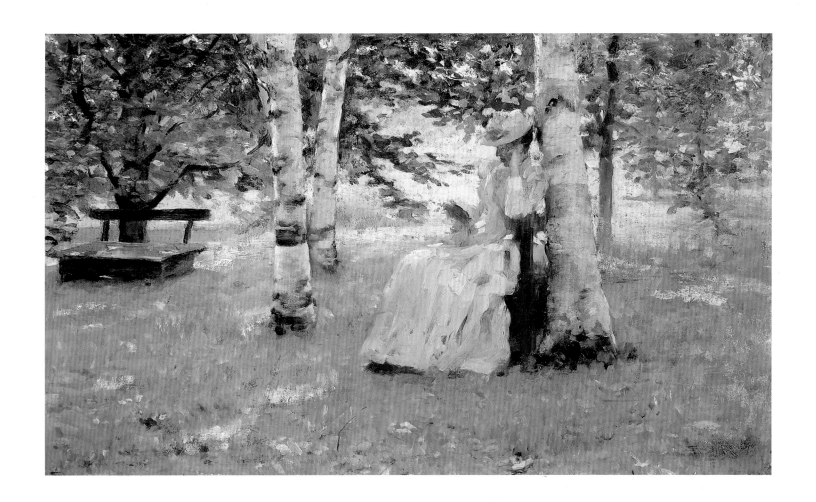

EDMUND TARBELL
(1862–1938)

THREE SISTERS – A STUDY IN JUNE SUNLIGHT, 1890
35$^{1}/_{8}$ × 40$^{1}/_{8}$ in.; 89 × 102 cm
Milwaukee Art Museum, Milwaukee, Wisconsin
Gift of Mrs. Montgomery Sears, Boston

Despite the slightly earlier investigation and public presentation of Impressionism by a number of Boston landscape painters such as Dennis Miller Bunker and John Leslie Breck, this new aesthetic of color and light became identified in that city during the 1890s with the achievements of a group of figure painters. The earliest and most significant of these was Edmund Tarbell, whose leadership was recognized by 1897 when the art writer and critic Sadakichi Hartmann coined the term "The Tarbellites" in reference to this group.[1] Hartmann was referring to the collective preference by Tarbell and his colleagues for the interpretation of attractive, upper-class young women and/or children, placed either in outdoor garden environs or in elegant interiors. In the former, Impressionist strategies of bright color and dappled sunlight were utilized, while in the latter glowing lamp- and firelight were explored, the artists never sacrificing the academic principles of figure structure which they had learned in the ateliers of Paris and Munich.

Frank Benson and Joseph DeCamp were two others among the artists to whom Hartmann was referring, but Tarbell was recognized as the leader of the group, and their Impressionist approach was assured longevity when, in 1889, he and Benson assumed their long-lasting positions as the most significant teachers at the School of the Museum of Fine Arts, perpetuating their aesthetic through another generation. Tarbell had earlier studied at the School before going to Paris in the summer of 1884 and entering the Académie Julian; he returned to Boston in 1886, establishing himself first as a painter of dark and dramatic, firmly constructed portraits.

Three Sisters of 1890 was Tarbell's earliest significant announcement of his involvement with outdoor figure painting. Though the Impressionist pictures exhibited in Boston in the late 1880s may have contributed to Tarbell's turn to Impressionism, these were primarily landscapes, and cannot fully account for this new direction in his art. It is more likely that the appearance of John Singer Sargent's *A Morning Walk* (retitled *A Summer Morning*) at the St. Botolph Club in Boston in late January of 1890 may have triggered a response by Tarbell, who also was represented in that show with a *Portrait,* and his dark *Violinist,* painted the previous year.

Tarbell's *Three Sisters* invokes comparison with multi-figured compositions by Pierre Auguste Renoir, but there is an elegance and reticence here which departs radically from the more earthy compositions of the French Impressionists, and

Tarbell has defined his subject as sibling and maternal. Formally, too, the enclosed garden setting of dense foliage, and the strong structural elements of the chair and the wooden garden bench further confine the symmetrical, inward grouping of the three women in fashionable dress, "protecting" them from outside intrusion. The sitters here are the artist's wife Emeline, holding their child Josephine, and Emeline's sisters.

The picture was an immediate success, acquired by Mrs. Montgomery Sears, one of Boston's major art patrons, after it first appeared at the St. Botolph Club in late December of 1890 and then in a two-artist show Tarbell shared with Benson at Chase's Gallery in Boston early in March of 1891. Boston critics referred to the work as "wonderful" and "masterly". In a letter published in the *Boston Post,* Desmond Fitzgerald, a great champion of Claude Monet, described the picture as "solidly painted, overflowing with sunlight and in perfect harmony of color", and he concluded that the picture "will always mark a progressive step in art in Boston".[2]

Following its second Boston showing, Mrs. Sears lent the painting to the sixty-sixth annual exhibition of the National Academy of Design in New York City. There it was well received by a number of the art magazine critics who acknowledged Tarbell's innovative aesthetic. The writer for the *Art Amateur* reported that Tarbell had "succeeded well with a more difficult problem . . .; it is among the best of the recent 'plein-air' pictures"; and the reviewer for the *Art Interchange* found the work "brilliantly warm and less chalky and brittle than these 'effects' usually are."[3]

Several newspapers reported more ambivalent reactions to the painting. The writer for the *New York Times* admired its dazzling hues, but objected to the lack of proper spatial definition and convincing figural structure, concluding that "there is such a thing as being too brilliant." And the reviewer for the *Sun* noted that many visitors derided or condemned the *picture,* startled at the bright colors "massed and streaked on the canvas". But this writer noted, too, that some sat down and absorbed "the spirit of the painting. They forget the paint and enjoy the June sunlight. It is in the green background, in the gay hats and dresses of the women, in the green and purple shades reflected on the white features; it revels in the glowing cheeks of the women, and pervades every inch of canvas."[4]

(continued: on page 159)

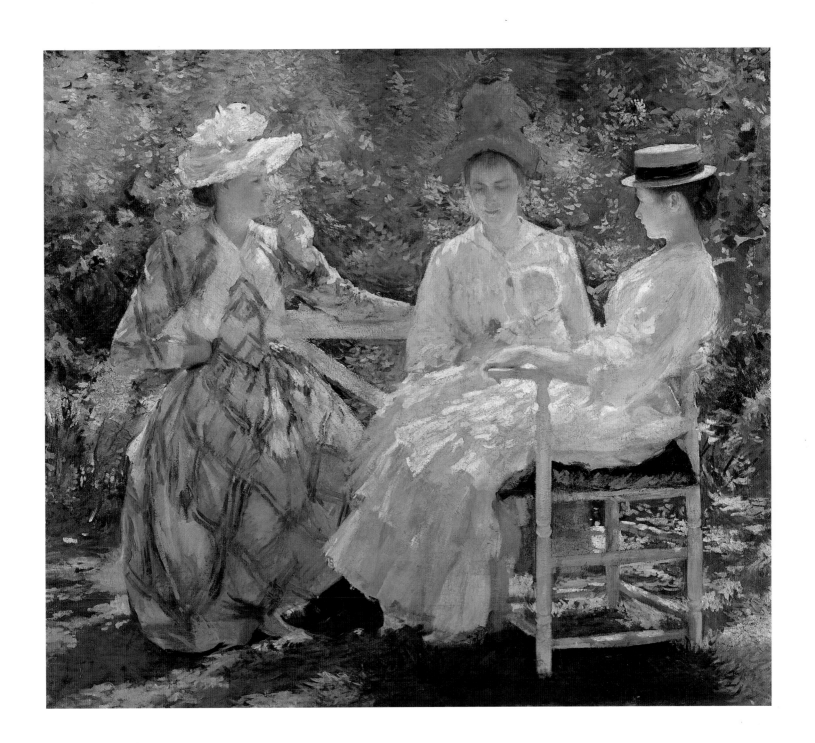

EDMUND TARBELL
(1862–1938)

IN THE ORCHARD, 1891
60¼ × 65 in.; 153 × 165 cm
Private Collection

Tarbell followed up the Impressionist identification he had established with his *Three Sisters* of 1890 with *In the Orchard* of the following year, his most monumental Impressionist canvas and the one that subsequently came to exemplify Boston Impressionism. His wife and her sisters, who featured in the earlier canvas, appear to be present here also, joined by a fourth woman, her back to the viewer, and a young man (a brother of Mrs. Tarbell) in a summer outfit. Although still a proper and polite gathering in comparison to somewhat similar Impressionist pictures by Pierre Auguste Renoir, the work is not only more peopled, but more casual than *Three Sisters*. The women are less formally garbed, three of them bareheaded, and the composition is more open, with the figures in more varied poses. Unlike the single exchange among the three sisters in *June Sunlight*, the communication among the five men and women *In the Orchard* is more complex. The seated woman seen from the rear would appear to be speaking, engaging the attention of the figure directly facing her, who is seated on the red bench. The latter's companion on the bench turns her head toward the speker, but her body is inclined toward the woman standing at the left, suggesting that she has newly turned her attention to the women at the right. The standing figure, in turn, appears to be attracted rather toward the young man, whose gaze returns her interest. Nevertheless, the artist has maintained a certain rectitude, placing the four women within an imaginary circle, and the male figure outside and beyond it.

Tarbell's brushwork has also become looser and more broken, and he has adopted more completely the chromatic range associated with Impressionism. Shadows are less intense and less opaque; those that play over the white dress of the standing woman at the left mix blues, pinks, and purples, rather than the darkening grays employed the previous year. Yet the artist still maintains academic underpinnings, not only in the solid figural modelling, but in the geometric pattern of enframing trees, the bright red garden bench, and the white rush-seated chair which had occupied a similar place in the 1890 composition.

Tarbell repeated the exhibition pattern of *Three Sisters*, showing *In the Orchard* at the St. Botolph Club in 1891, and then at the National Academy of Design in New York in 1892; it is significant of the growing similarities of the annual shows of the Academy and the rival Society of American Artists that neither of Tarbell's ground-breaking works were displayed at that once more avant-garde showplace. *In the Orchard* carried

off the honors at the National Academy, as stated in Clarence Cook's *Studio*. Tarbell's identification with Impressionism was complete, with the critic for *Art Amateur* calling the painting "the most successful picture in the new manner," while Royal Cortissoz, writing in the new Montreal-based *Arcadia*, noted that the artist had "emulated Claude Monet without being strained or obviously imitative". Probably the reviewer for the *New York Daily Tribune* best defined both the nature of Tarbell's success and the current degree of acceptability of the new aesthetic when he wrote that "there is nothing violent about Mr. Tarbell's impressionism," and that the picture was "a remarkably temperate illustration of the application of impressionistic principles to the solution of a difficult open-air problem."[1]

In the Orchard was one of three paintings by Tarbell which appeared in the Art Gallery of the Columbian Exposition in Chicago in 1893, and was one of the most fully Impressionist pictures by an American painter at the Fair. At that time, Boston's leading art critic William Howe Downes called the work "one of the most remarkable paintings that American art can boast of", but his admiration was based more upon interpretation than technique. Downes believed that "nothing could be livelier, more festive, more cheerful, than this glimpse of wholesome jollity, of strong and sumptuous color, of summer, and youth and freedom from dull care, of wreathed smiles, and sweet sunshine."[2] *In the Orchard* was discussed in one of a series of dialogues on contemporary painters between Downes and George Torrey Robinson that were published in *Art Interchange* in 1894-95. The writers compared Tarbell's two Impressionist masterworks; Downes noted that *Three Sisters* "makes you squint and blink, they are so saturated with sunbeams," while *In the Orchard* was "the best picture of its class that I have seen . . . It is natural, easy, gay, and a charming effect of color and light."[3] For Downes, Tarbell epitomized those artists for whom "light and color are enough in a painting". And the accolades which accrued to *In the Orchard* from American writers were echoed by the Parisian critic S. C. de Soissons on a trip to the United States in 1894, calling Tarbell "one of the most talented artists" in the country, and *In the Orchard* "one of the most remarkable" paintings exhibited in Chicago.[4]

(continued: on page 159)

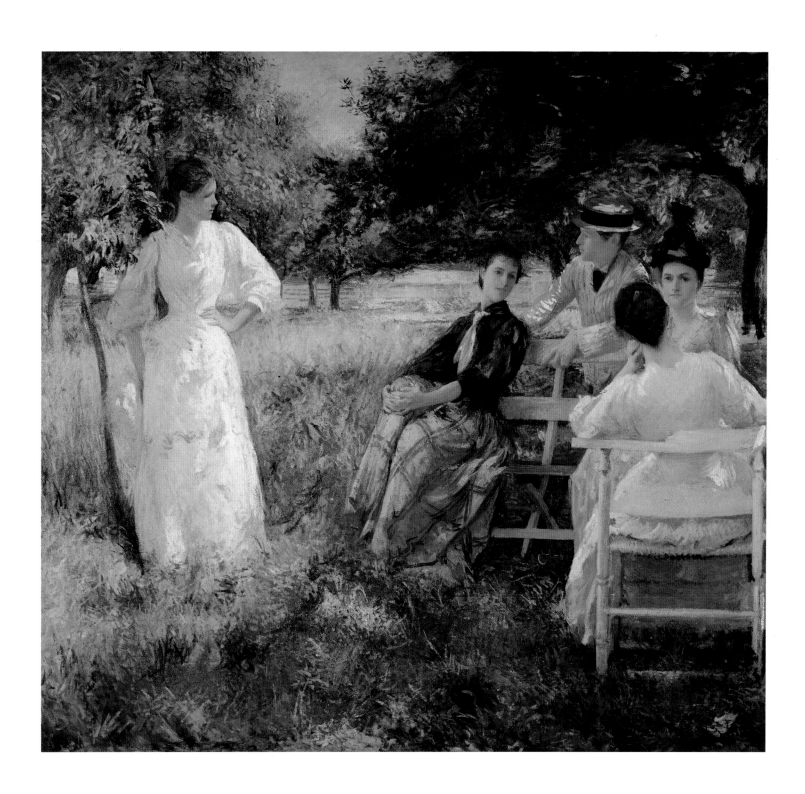

EDMUND TARBELL
(1862–1938)

GIRL CROCHETING, 1904
30 × 25 in.; 76 × 63,5 cm
Canajoharie Library and Art Gallery, Canajoharie, New York

On its first appearance in the eighth annual exhibition of the Ten American Painters, held first in New York City and then in Boston, *Girl Crocheting* was immediately recognized as Tarbell's outstanding achievement, and the picture became the lodestar for the later figure paintings by the Boston Impressionists. The work signalled the turn to a more conservative and more classic formal interpretation, away from heightened colorism and flashy brushwork, one that concentrated upon subtle effects of indoor illumination within a close tonal range, and often emphasizing a neutral coloration. Critics quickly perceived this as an updated homage to the Dutch seventeenth century "little masters" and, above all, to the painting of Jan Vermeer.

The Vermeer revival originated in France in the 1860s in the writings of Thoré-Bürger, but an American response did not occur until the artist-writer Philip Hale published his study of Vermeer in the *Masters of Art* series in 1904, simultaneous with the production of Tarbell's ground-breaking work.[1] (Hale was to produce a more comprehensive study of Vermeer in 1913, which was revised and enlarged posthumously in 1937.) Vermeer-like in Tarbell's picture is the contemplative woman in a sparse interior, illuminated by the graduated light from a source visible at the picture's edge. The geometry of the room's architecture is emphasized, reinforced by the furniture, and by the pictures on the wall. Several of the paintings by Vermeer which Hale reproduced in 1904 bear particular kinship to *Girl Crocheting*: the similar activity in Vermeer's *The Lace-Maker* in the Louvre, Paris; the self-absorbed restraint of Vermeer's *Young Woman Reading a Letter* in the Rijksmuseum in Amsterdam; and the Oriental ceramic on the table in Vermeer's *The Lady with the Pearl Necklace* in the National Gallery in Berlin. Furthermore, much of Hale's study is given over to excerpts from earlier writings on Vermeer, most of which emphasize the Dutchman's mastery of light effects, and at the same time focus upon the sensation of vibration in his pictures, an inherent quality of Impressionist painting. The success of *Girl Crocheting*, combined with the impact of the Vermeer revival, led numerous other American figure painters, especially in Boston, to explore this aesthetic; one of the most famous and successful results is Joseph DeCamp's *The Blue Cup*.

Nevertheless, Vermeer is not the only artistic force at work here. Tarbell's own copy of Velásquez' *Portrait of Pope Innocent X* (original in the Galleria Doria Pamphili, Rome) is prominently hung in the center of the wall, testifying to Tarbell's expressed admiration for the subtle tonalities and brushwork, and objective stance of the great Spanish master. Indeed, the artist has created a careful balance and contrast between Velásquez' seated figure posed on a diagonal toward the right, and Tarbell's own model absorbed in her crocheting, facing in an opposite direction.

The picture also reflects the Colonial revival in America, in the simple, large gate-legged table with its polished top, while a further implication of the past is present also in the Gothic revival chair in which his model sits. These identify an ongoing cultural heritage but, at the same time, suggest the acquisitions of a collector (in this case the artist himself), as do the Oriental objects—the Japanese prints on the wall, and the shining blue and white ceramic. These denote exquisite taste, all the more refined because of the relative austerity of the setting, where each "choice" object can be individually identified and admired. Likewise, the artist is careful to define the genteel and demanding task with which his model is involved; Guy Pène du Bois noted that the figures painted by the Boston artists "never do things and are never found in places outside of the province of the lady. They sew—not shirts—read and write letters, finger the finest of grand pianos, ride, or are caught behind Venetian blinds in dainty negligee." Du Bois saw the women in these pictures as "not more important than the Chippendale chair, the waxed floor, the mahogany, the blue and white porcelain."[2]

Subsequent to its initial New York and Boston showings in 1905, *Girl Crocheting* was purchased by the sculptor Bela Lyon Pratt, who lent it to numerous exhibitions, again at commercial galleries in those cities, as well as in museum annuals or one-artist shows in Worcester, Massachusetts, Philadelphia, and Washington, D. C.. The picture was a prize winner at the Art Institute of Chicago in 1907 and at the International Exhibition of Contemporary Painting held at the Carnegie Institute in Pittsburgh in 1909. It was in the latter year that the artist-critic Kenyon Cox published what is probably the most fulsome tribute to *Girl Crocheting*, acknowledging its inspiration in the work of Vermeer, while praising the series of similar pictures that Tarbell had subsequently produced. After referrring to the artist's earlier works such as *June Sunlight* and *In the Orchard*, Cox noted that Tarbell "had experimented with various forms of *plein-air* painting and was a notable virtuoso with the brush.

(condinued: on page 159)

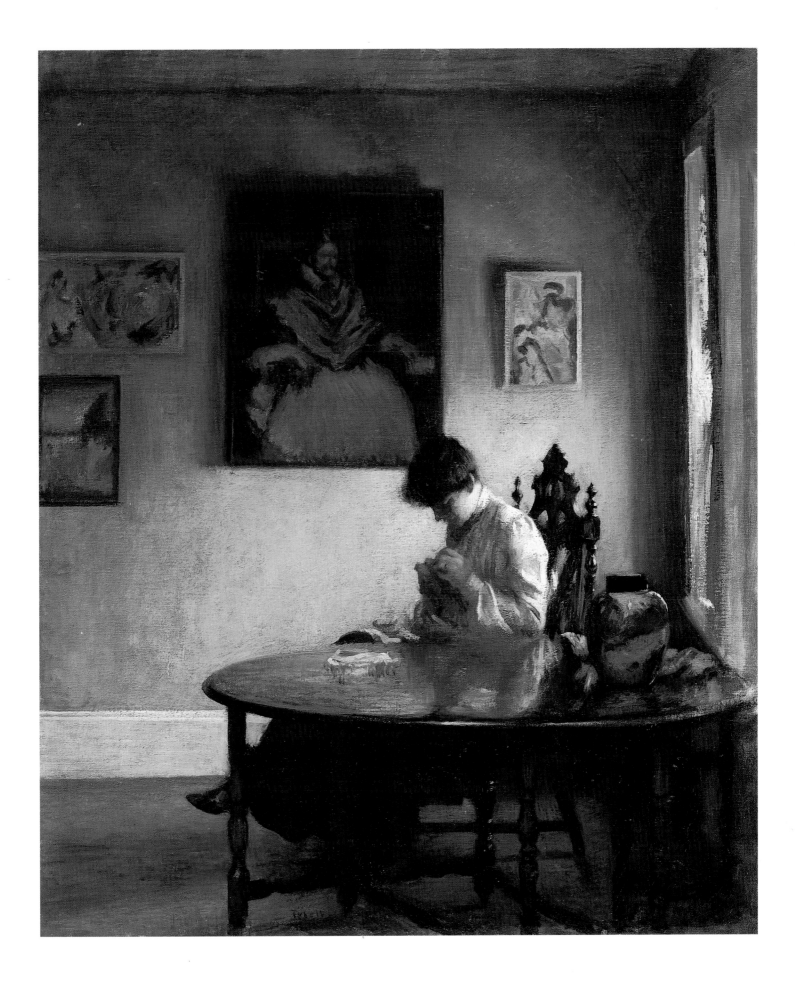

FRANK BENSON
(1862–1951)

THE SISTERS, 1899
40 × 39½ in.; 101,5 × 100,3 cm
IBM Collection, Armonk, New York

Benson was born in Salem, Massachusetts, which remained his home throughout his life. In 1880 he entered the school of the Museum of Fine Arts in Boston, to which he returned as an instructor in 1889, after having studied in Paris from 1883-86. At the Museum School, Benson was associated with Edmund Tarbell, a former classmate, and the two artists often exhibited together and were closely associated in the critical press as the leaders of the "Boston School". During the 1890s, however, while Tarbell was investigating color and light in his outdoor pictures, Benson established a reputation primarily as a studio painter of sympathetically rendered women and children in interiors, sometimes with dramatic effects of fire- and lamplight.

Only in the summer of 1898 did Benson turn to the rendering of images of his children out-of-doors, with *Children in the Woods* (private collection) painted in New Castle, New Hampshire. Here, for the first time, the artist adopted the lighter tonalities and broken brushwork of Impressionism. Returning to New Castle the following summer, Benson painted *The Sisters*, a representation of his daughters Elisabeth and Sylvia. A milestone in the artist's career, Benson has fully realized his identification as an Impressionist painter, and revealed his distinctive approach to outdoor work. The sobriety of his previous figural renderings has given way to an exuberant joyousness, formally expressed in sparkling sunlight and the brilliant, variegated chromatic range of white and pink costumes, yellow sunlight, and bright blue skies and water. The healthy vigor of the children is expressed in their dynamic poses, especially that of the younger Sylvia, and is echoed in the vigorous brush strokes and the suggestion of blowing wind. While the figures are rounded and solid, the artist brings them close to the picture plane with the strongly sloping ground plane, and the high horizon line stretching across above Sylvia's head. These are associated with the dynamic modern strategies implicit in the adoption of a nearly square canvas, and also relate to the aesthetics of Oriental art, then influencing so many Western artists. Oriental also is the thrust of the several delicate tree branches, cut off by the top edge of the picture, and again pulling the scene forward.

The Sisters was Benson's first great success, a prize winner at a series of major shows including the Paris International Exposition of 1900, the Pan-American Exposition in Buffalo in 1901, and the Louisiana Purchase Exposition in St. Louis in 1904. The painting was also shown at the Carnegie International Exhibition held in Pittsburgh in 1899, at the retrospective of Benson's work held at the St. Botolph Club in Boston in 1900, and in New York in the annual exhibit of The Ten American Painters in 1901. A Boston writer viewed the picture as the culmination of the artist's years of labor: "To this blossoming of his art has Mr. Benson worked steadfastly through his career; and as we look back we can trace with ease the successive steps that led in a logical order from the beginnings up to 'The Sisters'."[1] In New York *The Sisters* was greeted by the critics as "an unusual achievement" and "perhaps the most satisfactory painting" in the show.[2] One reviewer was rapturous: "These are veritably children: healthy, natural types, spontaneously represented; fresh, happy, lovable. What a joyousness of sunshine, and buoyancy of bracing air; how invigorating the free play of brushwork and purity of color and, as well, the knowledge and subtle craftsmanship displayed!"[3] Another writer judged the picture "charmingly spontaneous and fresh in color, as well as treatment, and bids defiance to the pessimism and eroticism so prevalent in all forms of art just now."[4]

The Sisters established the qualitative standards and set the tone for the rich colorism and dazzling light of Benson's future outdoor work, most of which would be painted on North Haven Island, Maine, where he began to summer in 1900. Thematically also, *The Sisters* was integral to the series of paintings begun by Benson a few years earlier, which depict some or all of his four children, and one sees them maturing over the years in these outdoor pictures, their healthy robustness mirrored in radiant nature.

[1] "The Fine Arts: Mr. Benson's Exhibition at the St. Botolph Club", *Boston Evening Transcript*, 13 January, 1900, p. 15.

[2] "The Art World," *Commercial Advertiser,* 19 March, 1901, p. 6; "The Ten Landscape Painters", *Art Interchange*, 46, May, 1901, p. 106.

[3] "Around the Galleries", *Sun,* 20 March, 1901, p. 6.

[4] B. F., "Pictures of 'The Ten'", *Evening Post*, 20 March, 1901, p. 4.

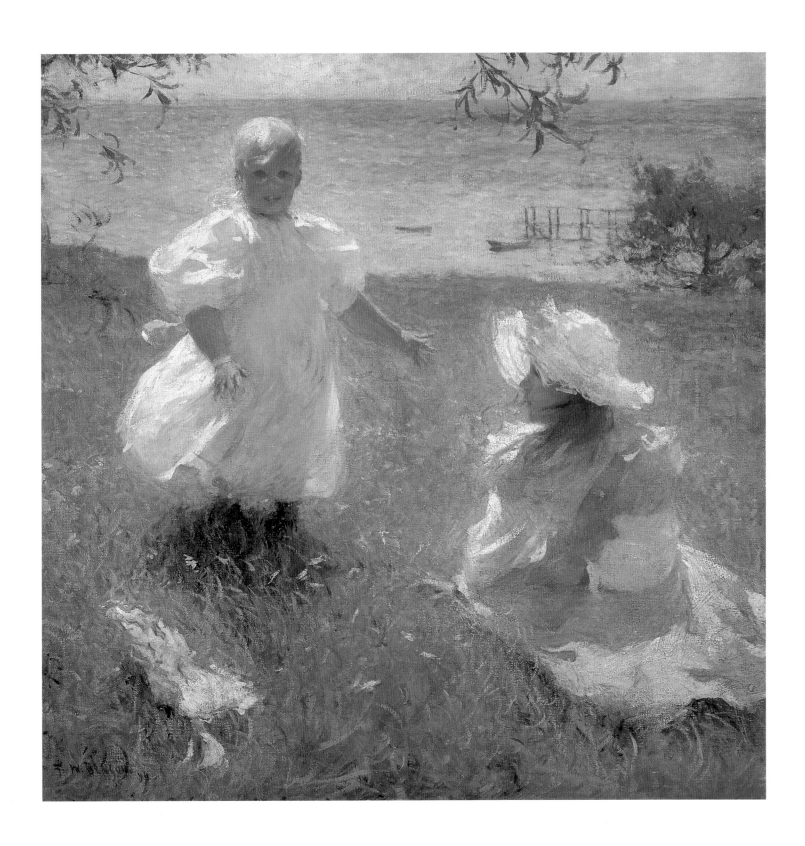

JOSEPH De CAMP
(1858–1923)

THE BLUE CUP, 1909
50½ × 41½ in.; 128,2 × 105 cm
Museum of Fine Arts, Boston, Massachusetts
Gift of Edwin S. Webster, Laurence T. Webster, and Mrs. Mary M. Sampson
in memory of their father, Frank G. Webster

Like John Twachtman, Joseph DeCamp was born in Cincinnati, Ohio, and, as with so many young artists of that heavily German-populated city, both studied in Munich after their preliminary training at the McMicken School of Design in their native town. DeCamp enrolled in the Bavarian Royal Academy in 1878, while studying during the summer under the American Frank Duveneck in the village of Polling, and he subsequently followed Duveneck to Venice and Florence, before returning to Cincinnati in 1883. Finding little reception for his work, he settled in Boston in 1884 and taught at the school of the Museum of Fine Arts there from 1885-89; after leaving that institution, he began to teach in 1903 at the Massachusetts Normal School in Boston,where he stayed for the rest of his career.

Only tangentially can DeCamp be classified as an Impressionist; the strategies of that style are far more evident in his comparatively rare landscapes than in his portrait and figure work. These last constitute the greater part of his existing oeuvre, but any analysis of DeCamp's achievements is hampered by the disastrous loss of so much of his earlier painting in the Harcourt Street Studio Building fire in November 1904. Much of what remains of DeCamp's production consists of sensitive, academic portraits, the most notable of which depicts Theodore Roosevelt (Harvard University Portrait Collection, Cambridge, Massachusetts), the twenty-sixth president of the United States, whom the artist painted in 1908.

In both his landscape and figure painting of the beginning of the present century, DeCamp seems to have begun to abandon the smooth surfaces and strong chiaroscuro that characterized such slightly earlier pictures as his *Magdalene* and *Woman Drying Her Hair* (both in the Cincinnati Art Museum). He was moving toward more scintillating brushwork and brighter colorism, influenced in his landscape work by exposure to the later art of Twachtman and Duveneck, whom he rejoined in Gloucester during the summers of 1900-02, and in his figure painting through participation with fellow-Bostonians Edmund Tarbell and Frank Benson in the exhibitions of The Ten American Painters. However, the loss of so much of his production in the 1904 fire coincided with the discovery of and enthusiasm for the work of the Dutch seventeenth century master Jan Vermeer by DeCamp's Boston colleague Philip Hale, and the emulation of Vermeer's subtle, quite tonal painting by Hale, Benson, and above all, Tarbell in his ground-breaking *Girl Crocheting*.[1] DeCamp quickly followed suit with a series of images of lovely young women in interiors, his images more carefully rendered and more intensely colored than those of Tarbell and Benson, placed in settings with less filtered light and atmosphere. Of these, *The Blue Cup* was and remains the most acclaimed.

DeCamp created a subtle, harmonious balance of solid form and empty space in this masterwork, the shadowed still life of delicate porcelains on a low, flat table in the lower left anchoring the composition, while the viewer's eye travels up a long diagonal to focus on the exquisite cup held in the upper right by the lovely young woman. Though this figure wears an apron, and therefore suggests a working maid, she appears extremely refined and is neither cleaning nor dusting, but rather admiring the translucency of the precious object. The cup, along with the rest of the porcelains on the table, connotes not only the contemporary passion for collecting and owning Oriental *objets d'art*, but also conveys both affluence and gentility.[2] Thus, the activity depicted is aesthetic rather than laborious, just as the picture itself is conceived as a work of art, rather than a reportorial document. And even among the more rarified harmonies of these later, Vermeer-inspired productions of the Boston artists, light here remains a principal concern; in one sense this picture is about light which not only illuminates the scene but passes through the delicate blue cup holding the attention of the principal subject. Finally, one should recognize a preoccupation of so many of the Boston painters of this period with images of lovely women—the conception of the attractive young lady herself as an object of rare beauty, no less than the object that she holds. There is thus a curious kinship between her and the cup she admires, for the viewer is invited to appreciate *her* in much the same way and for the same reasons.

The Blue Cup was DeCamp's only submission to the twelfth annual exhibition of The Ten American Painters, held in 1909 at the Montross Gallery in New York City, a show which subsequently moved on to the Copley Gallery in Boston. Almost all the critics had words of praise for the painting; one New York reviewer judged the work the "star" of the exhibit, describing the figure as splendidly drawn and posed, and finding the still life of objects on the table remarkable.[3] In Boston, Philip Hale reviewed the painting and found that DeCamp had "quite surpassed himself".[4] The picture appeared on public view again in a show of DeCamp's work held at the St. Botolph Club in

(condinued: on page 159)

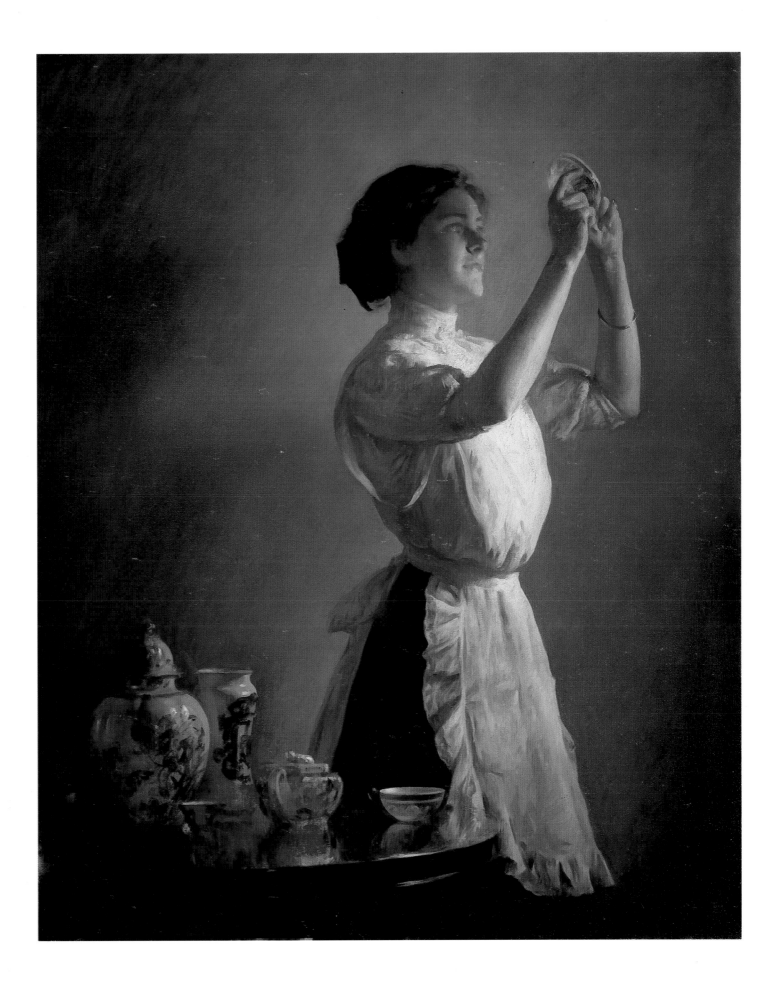

PHILIP LESLIE HALE
(1865–1931)

GIRLS IN SUNLIGHT, ca. 1897
29 × 39 in.; 74 × 99 cm
Museum of Fine Arts, Boston, Massachusetts
Gift of Lilian Westcott Hale

A Boston figure painter of the late nineteenth century, Philip Hale is one of the most distinct of American Impressionists. Thematically, his work conforms to the subject matter preferred by Edmund Tarbell and his colleagues—images of attractive, upper-class young women in sunlit landscapes, but Hale's technique was very much his own. By suffusing his scenes in a dominant yellow tonality in which the figures seem almost to dissolve and from which a glowing radiance seens to emanate, he creates a pantheistic world where his dematerialized women and nature appear as one. Hale advised his students, in fact, to bring "plenty of chrome yellow no. 1. It is well to anticipate the yellow fever."[1] Hale's painting would appear to be almost as consonant with contemporary European Symbolism as it is with Boston Impressionism, and his almost pointillist technique was one also adopted by a number of the Symbolist artists. While the strategies which Hale developed were aimed primarily toward achieving extreme effects of vibrating light, a goal of many Impressionists, Hale's writings of the early 1890s confirm his awareness of both Neo-Impressionism and Symbolism. His description of Divisionism in a review of a Neo-Impressionist show held in Paris in the winter of 1893, that "in certain effects, as in brilliant sunlight, it suggests luminosity in a way which no other method does",[2] suggests his own adoption of this aesthetic.

Hale studied at the Boston Museum School and then at New York's Art Students' League before travelling to Paris early in 1887 to study at the Académie Julian. In 1888 he joined Theodore Robinson, John Leslie Breck, and Dawson Dawson-Watson among other American artists in Giverny, and presumably there first began to investigate the strategies of Impressionism under the influence of his colleagues, and of Claude Monet whom he also knew and visited. Except for 1890, which he passed at the home of his aunt Susan Hale at Matunuck, Rhode Island, Hale spent the summers from 1888-93 at Giverny. Hale's radical formal approach to Impressionism is documented as early as his Rhode Island summer of 1890, and it is sometimes difficult to determine whether such scenes were painted in France, or in the United States, where he began in 1893 a long career of teaching at the School of the Boston Museum, while also teaching and painting during the summers at Matunuck from 1894. Hale wrote to a colleague from Amer-

ica in 1895 that he had gone "très Impressioniste," and that he was trying to pitch his paintings a "little lower than my Giverny things but higher than my last year's work."[3] *Girls in Sunlight* is indeed "très Impressioniste", a Matunuck picture which would seem to date from the mid-1890s when the impact of Oriental design was particularly strong in the work of many of the American Impressionists. It can be seen here especially in the flat patterning of leaves which are abruptly cropped at the lower border of the painting.

Hale's radical Impressionist technique startled American critics, especially when his work was seen in his first one-artist show at the Durand-Ruel Galleries in New York in December of 1899. One critic found his pictures "neither harmonious or agreeable," and commented that "the yellow girls rambling, or lolling, or disappearing in nebulous phantasy are *outré;* all work is experimental."[4] That this reference was to *Girls in Sunlight* is indicated by a second review, also quite negative, which describes the picture in more detail: "At present the sunshine in which he evidently prefers to work completely overwhelms him, taking possession of his canvases so blatantly that neither landscape forms nor the human figure can pretend to any serious weight . . . The four girls rambling in a meadow with the sun beating down upon them . . . are surrounded by a kind of aureola of lemon yellow . . ."[5]

This more extreme phase of Hale's art does not seem to have survived the 1890s, and in the following decade he turned to a more academic stance, which continued to include depictions of lovely ladies, often in a floral environment. This change was conditioned partly by his activity as a teacher of drawing at the School of the Museum of Fine Arts in Boston, and partly by the influence of his wife, the talented artist Lilian Westcott Hale, one of the finest draftswomen of her time, whom he married in 1902. In addition, Hale, almost as much an author and art critic as a painter, was instrumental in inaugurating the Vermeer revival in America in his writings from 1904 on. The impact of Vermeer upon the art of his Boston colleagues such as Edmund Tarbell *(Girl Crocheting)* and Joseph DeCamp *(The Blue Cup),* with their turn to more structured compositions and a more muted palette, was reflected also in Hale's own later painting.

(continued: on page 160)

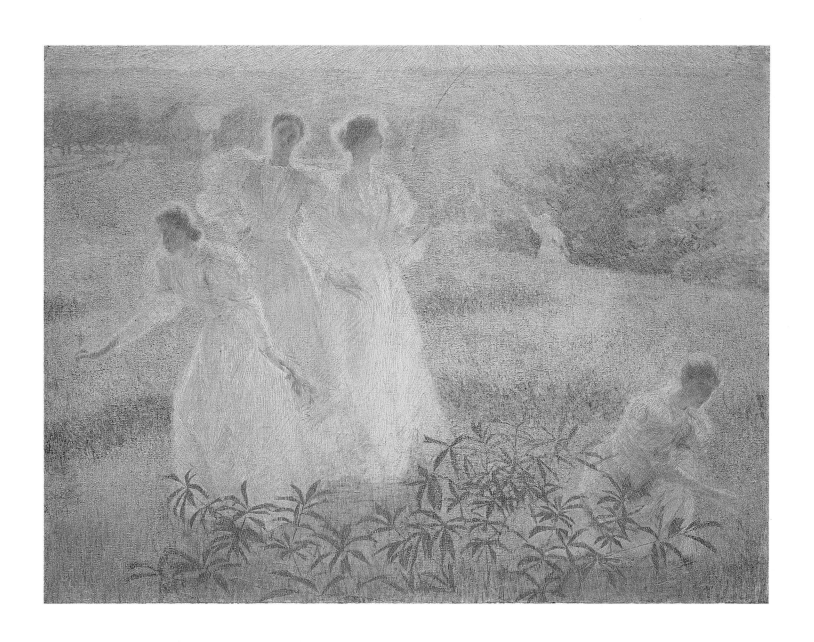

EDWARD H. BARNARD
(1855–1909)

RIVER WEEDERS, ca. 1893
40 × 60 in.; 101,5 × 152 cm
Pfeil Collection

Barnard is probably one of the least-known painters in the present exhibition, but in his lifetime he was a respected member of the greater Boston art community.[1] He was born in Belmont, Massachusetts, and first studied to be an architect at the Massachusetts Institute of Technology from 1872-74. He subsequently turned to a career as a painter, influenced by William Morris Hunt and studying first with John B. Johnston in Boston, and then for four years at the School of the Museum of Fine Arts in Boston beginning in 1877; in 1886 he went to Paris where he entered the Académie Julian and then became a student of Raphael Collin. Barnard began to exhibit at the Paris Salon in 1888, and had decided to pursue portrait painting, until his last winter in Paris.

It was in the winter of 1888-89 that Barnard attended an exhibition of the work of Claude Monet, probably that held in February at Boussod, Valadon and Company, and found the inspiration for his subsequent career; previously, he had seen a few examples of Monet's paintings but found them rather queer. On his return to Boston in July of 1889 he was confirmed in his pursuit of landscape, though he continued to paint an occasional portrait and also decorated a church in Salem, Massachusetts.[2] Barnard lived in Boston until he returned to the family home in Belmont in 1901, but many of his landscapes were painted in Plymouth and Chatham, Massachusetts, Ogunquit, Maine, and in Mystic, Connecticut, where Charles Harold Davis, a close friend and fellow-art student from Barnard's Paris days, had settled.

River Weeders was painted in Mystic, which Barnard first visited in 1892, and where he decided that "the atmosphere along the Connecticut shore is better for painting than any place I have found."[3] The picture was first exhibited (as *River Weeders—Mystic, Conn.*) at the Boston Art Club in 1894 and therefore probably dates from the previous summer, and certainly no earlier than 1892. It appeared again in December of 1894 in the annual exhibit at the Pennsylvania Academy of the Fine Arts, in Boston at the South End Free Art Exhibition in April of 1895, and then (as *River weeders, Connecticut*) in the Annual Exhibition of Oil Paintings and Sculpture by American Artists held at the Art Institute of Chicago in October of 1895. The picture (as *River Weeders, Morning*) gained an honorable mention at the Tennessee Centennial Exposition held in Nashville in 1897, and appeared the following year at the Trans-Mississippi and International Exposition in Omaha.

Barnard may not have been a very prolific painter. Though he was active in Boston art circles and a member of the Boston Art Club, much of his time was given over to teaching art at Bradford Academy (now Bradford College) in Bradford, Massachusetts, a seminary for young women, which he joined in 1892, continuing to 1903. In addition, he may have suffered from increasingly poor health, and he died at a young age. *River Weeders* was probably the best known of Barnard's pictures during his lifetime and the only one at all familiar today. The picture is an outdoor scene, concentrating upon the coastal inlets of the Connecticut shoreline which appealed to Barnard so much, and which he painted in a gentle but consistent Impressionist style with small, broken brushstrokes and a high color key, eliminating the neutral tones.

The outstanding feature of the picture, and the most unusual one, is the prominence of the figures and their role as laborers; their activity was described: "From rivers near the sea the grass is dredged, to be used in enriching the neighboring fields."[4] While the working peasantry was a popular theme among both European artists and American expatriates during the 1870s and 1880s, and was interpreted in Impressionist strategies by some Americans painting in Giverny in France around 1890, it was an infrequent theme among the American Impressionists back in the United States. When the work was shown at the South End Free Art Exhibition in Boston in 1895, the catalogue listed Barnard as "An American follower of Monet"[5] (the French Impressionist, whose works were by then well known in Boston, was represented in that show by three paintings, along with work by Barnard's first teacher John Johnston and his early mentor William Morris Hunt). Impressionism appears to have been so completely identified with beautiful landscapes and scenes of joyous leisure that themes of toil may have seemed unsuited to that aesthetic.

While *River Weeders* undoubtedly records a specific scene which the artist witnessed, Barnard has superimposed a strong geometric structure of parallel horizontal and diagonal axes. This, together with the rather pale Impressionist palette, and the anonymity of the foreground weeder—rendered in a good deal of detail but with his features carefully shielded by a broad-brimmed hat—suggest a curious kinship with a number of contemporary Italian artists, who also adapted the Impres-

(continued: on page 160)

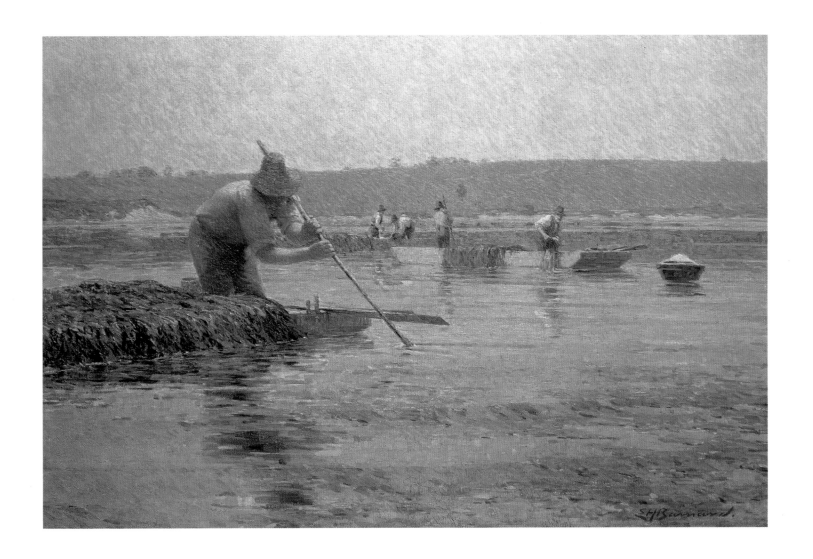

EDWARD F. ROOK
(1870–1960)

LAUREL, ca. 1905–07
40¼ × 50¼ in.; 102 × 127,5 cm
Fine Arts Collection of the Hartford Steam Boiler Inspection
and Insurance Company Hartford, Connecticut

In the early years of the twentieth century, the village of Old Lyme, Connecticut, became one of the outstanding art colonies in North America. Painters had first begun to congregate there in 1899, practicing a Barbizon-inspired Tonalist aesthetic, but the appearance in Old Lyme of Childe Hassam in 1903, followed by Willard Metcalf, immediately turned Old Lyme into a stronghold of Impressionist practice, and this remained the dominant aesthetic for several decades.

While Hassam and Metcalf were the most renowned artists to work in Old Lyme, numerous other painters of more local reputation began to summer there from 1903 on, and others came to live there all year round. While some were attractive followers of American Impressionist artists of national repute, Edward Rook was probably the finest and most original painter whose career is solely associated with that colony. Rook spent the greater part of the 1890s studying in Paris and painting tonal, often nocturnal, scenes in Brittany. He returned home around 1898; he first visited Old Lyme in 1903 and two years later moved there permanently, at the same time participating in the annual exhibitions held there at the end of each summer.

The exact origins of Rook's turn to Impressionism is unclear, though a series of pictures he painted on a visit to Mexico in 1901-02 suggest that he had already moved away from the close tonalities of his French work, and had invested his painting with a vigor that carried it to an Expressionist threshold. This dynamic technique, combined with a very gritty, encrusted brushwork, is what sets Rook's paintings apart from the more lyrical pictures painted by many of his Old Lyme colleagues. Furthermore, since the expression of strength and energy was among the major motivations for his work, rather than the colorful sweetness of much American Impressionist painting, he did not enjoy the popularity accorded to many of his contemporaries by patrons and critics. And since Rook was financially quite well off, he had little need to seek out a New York gallery or to participate extensively in national exhibitions, remaining more a "painter's painter," and a local artist of rare ability.

While Rook occasionally created exceptionally beautiful floral still lifes, he was primarily a land- and seascape painter. Two subjects engaged his attention especially. One was a local landmark, Bradbury's Mill Dam, which afforded the artist the opportunity to paint the vivid, swirling waters flowing down from the dam. The other was the abundant hedges of mountain laurel which grew in the neighborhood, a plant that was also the Connecticut state flower. Both Hassam and Metcalf painted noteworthy renderings of the laurel, as did a number of Rook's more local colleagues, but none of them invested the flower with the combination of strength and beauty that were the hallmarks of Rook's art. The lavender-white flowers seem individually to burst forth amidst their green surroundings, while they group massively, as solid in formation as the rock at their right which mirrors their shape. The bank of flowers plunge forward, while receding behind is a brilliant, sunlit landscape of verdant trees and rolling hills topped by distant houses, along the banks of the Lieutenant River.

Rook belonged to a later generation of American Impressionists than many of the artists in the present show, and his work reflects to some degree a more decorative and less naturalistic phase of the movement. Thus, he presses his major forms up against the picture frame, contrasting them with the outlying landscape, and all but eliminating a middle distance. Likewise, Rook's *Laurel* is not solely the result of his immediate response to the scene, for it was reported to have taken several years to complete and was thus, at least in part, a studio picture. It was noted that when the laurel wilted, Rook replaced it with cotton balls.[1]

Laurel has probably the most distinguished exhibition history of any of Rook's pictures. It would seen to have been completed by 1907 or early 1908, for in the latter year the picture was shown in March at the annual exhibition of the National Academy of Design in New York City, and again in late May at the Fifteenth Annual Exhibition of American Art at the Cincinnati Art Museum. Two years later the picture won a prize at the *Carnegie International* and was also shown in late summer of 1910 at the Lyme Art Association. *Laurel* was shown at the International Exposition in Rome in 1911, was the only Old Lyme painting included in the Anglo-American Exposition held at Shepherd's Bush in London in 1914, and won the artist a gold medal at the Panama-Pacific International Exposition in San Francisco the following year.

[1] Florence Griswold Museum, *Edward F. Rook 1870-1960 American Impressionist,* exhibition catalogue, essay by Diane Petrucha Fischer, Old Lyme, Connecticut, 1987, p. 14. Ms. Fischer's monograph is the most complete study of Rook's art to date.

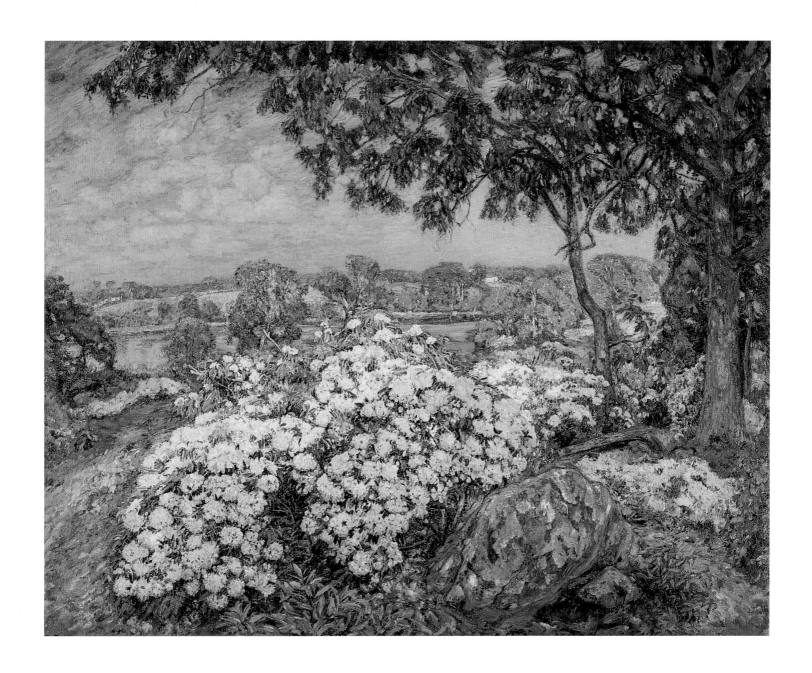

ROBERT SPENCER
(1879–1931)

WHITE TENEMENTS, 1913
30 × 36¼ in.; 76 × 92 cm
The Brooklyn Museum, Brooklyn, New York
John B. Woodward Memorial Fund 25.761

Robert Spencer was one of the few American Impressionists who consistently embodied in his work the social concerns more associated in the United States with the "Ashcan School", a group of primarily New York-based artists of the first decades of the twentieth century, whose art often reflected the lives of the lower classes in a metropolitan setting. These painters, such as John Sloan, George Luks, and Robert Henri, rejected the aesthetics of Impressionism as too delicate and lovely for the strong urban dramas which they depicted, and they replaced the aesthetic of "art for art's sake" with a belief in "art for life's sake."

Along with Daniel Garber, Spencer was one of the most significant and individual of the Pennsylvania Impressionists who were based in and around New Hope, on the Delaware River. It was his achievement to effect a reconciliation of Impressionist artistic strategies with a thematic preference for the lives and activities of the local mill workers, along with the mills that employed them and the tenements which housed them. Thus, while figures appear frequently in Spencer's pictures, they are often subordinated to architectural structures, which not only constrict their way of life, but form strong, structural masses which project stability and monumentality in his compositions. The buildings were actual cotton, silk, and grist mills in New Hope, such as William Maris' silk mill, and Richard Heath's grist mill, but Spencer stated his indifference to the actual purpose of the structure: "I don't care whether the building is a factory or a mill; whether it makes automobile tires or silk shirts. It is the romantic mass of the building, its placing relative to the landscape and the life in it and about it that count."[1]

This is especially true of *White Tenements,* perhaps the artist's masterpiece. The severe, unadorned, central structure is seen from the back, with wooden sheds and projections, and a lot of hanging laundry before it, deliberately establishing a very unglamorous scene. Spencer's dealer Frederic Newlin Price perceptively identified the significance of such scenes: "A backyard . . . is the intimate side of life, the half dressed side, where beings are themselves. Backyards are genuine, unpretentious . . . To Spencer castles are not half so romantic as are factories or mills or tenements . . . Every workman, every year leaves some impression of himself or itself, and how rich in this sort of thing is an old tenement, each succeeding family leaving its mark, until the very structure becomes human and fits into the moods of the town. A massed building against the sky with a river or a canal at its foot . . ."[2] Price's comments were made in response to the question put to Spencer by his colleague Joseph DeCamp: "Why do you paint back-houses? Why not castles?"[3]

Here, in *White Tenements,* a small figure in the foreground is slightly bent over and appears to be working; his presence humanizes the scene and establishes a sense of scale, but he is nevertheless dwarfed by the enormous building which obstructs any further view into the distance, looming up ominously. Though the building is the home of workers, the bare walls and small, dark windows suggest an almost prison-like habitation. The viewpoint is from below, so that the picture is "read" through a progression of parallel planes rising almost to the top of the canvas, while the rigidity of the scene is reinforced by its formal, frontal symmetry.

Nevertheless, Spencer has alleviated the potentially oppressive aura here by using the flat plane of the building to reflect the rich sunlight, and he introduces the sparkling, broken brushwork of Impressionism, especially manifest in the mottled blue sky and the bright green grass and other foliage along the bank of the river or canal in the foreground. The emphasis upon horizontal compositional elements—the flat rooftops and the tranquil bank along the water—is repeated in the direction of the brush strokes in the sky, all of which impart a sense of calm and harmony. The colors are bright and cheerful also, the blues and greens offsetting the more drab neutral tones which often dominate Spencer's works.

Spencer appears to have been influenced in the thematic direction taken in his art by Robert Henri, with whom he studied at the New York School of Art from 1903-05, while his stylistic mode may derive from William Merritt Chase, his other teacher at the School. But perhaps Spencer's most important instructor was Daniel Garber, with whom he studied during the summer of 1909 while living in Point Pleasant, Pennsylvania; by 1912 Spencer had settled in New Hope, where he remained for the rest of his life. *White Tenements* won the Inness Gold Medal when Spencer exhibited it at the eighty-ninth annual exhibition of the National Academy of Design in New York City in 1914, where one critic described it as a "tribute to the poetry and mute appeal of factory life".[4] The next year *White Tenements* was shown in the 110th annual exhibition of The Pennsylvania Academy of the Fine Arts in Philadelphia.

(continued: on page 160)

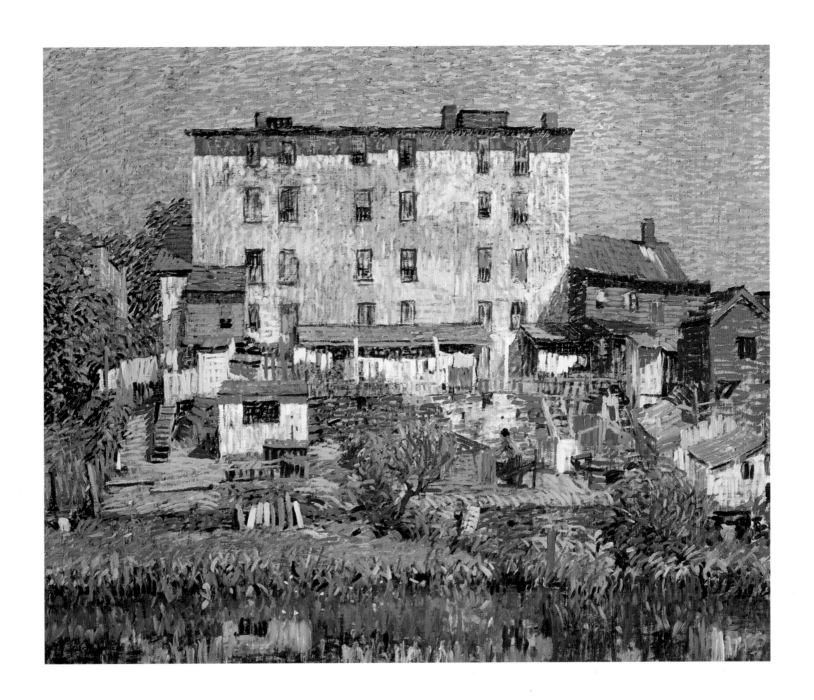

DANIEL GARBER
(1880–1958)

TANIS, 1915
60 × 46¼ in.; 152,5 × 117,5 cm
Warner Collection of Gulf States Paper Corporation
Tuscaloosa, Alabama

Though the vivid, raw winter scenes of Edward Redfield are generally considered to constitute the quintessential theme of the Pennsylvania Impressionists, a number of these artists, working in and around New Hope, Pennsylvania, in the early twentieth century produced work of great variety and tremendous quality. Daniel Garber may have been the most versatile and talented among them, a painter who worked in several landscape modes and almost the only one who was also a figure specialist, a theme to which he turned around 1909, concentrating upon images of his wife and two children. Indeed, this depiction of his daughter *Tanis* may constitute not only Garber's masterpiece, but certainly the finest known figural work of any artist of the school.

Garber was born in Indiana and studied at the regionally important Art Academy of Cincinnati in 1897, before attending the Darby Summer School outside of Philadelphia in 1899-1900; it may have been there that he first became inclined toward Impressionism, being drawn particularly to the work of J. Alden Weir, though he is said to have admired Weir even in his youth. At the same time, he was enrolled at the Pennsylvania Academy of the Fine Arts, where in 1905 he received the Cresson travelling fellowship. Going first to England, and then to Italy and to Paris, Garber returned to Philadelphia in 1907, assuming a teaching post at the Philadelphia School of Design for Women and, in 1909, at the Pennsylvania Academy, where he remained until 1950. Also in 1907, he established his studio in Lumberville, north on the Delaware River above New Hope. It was at this time that his art reached its maturity and within a few years he had begun to gain national prominence.

In his landscape work, centering on views along the Delaware River, Garber's style varied from more straightforward naturalism, often directed toward the representation of the quarries across the river in New Jersey, to more decorative scenes in bright colors and glistening sunlight. Similar landscape effects characterize the backdrop against which Tanis stands in the open doorway of Garber's Delaware Valley studio. The dotted and stitch-like brushstrokes contribute an aesthetic construct to the scene, as does the arbitrary choice of colors ranging from yellow-greens to intense blues. A Post-Impressionist fascination with decorative patterning unites Garber with other painters of his generation such as the Chicago artist Carl Krafft and the Californian Maurice Braun.

The same color scheme extends to the figure of Tanis herself, her golden hair contrasted with her blue-bordered skirt and the predominantly blue shadows of her diaphanous white dress. Impressionist painters, not surprisingly, were intrigued by transparent materials which allowed sunshine to penetrate—veiling, hammocks, parasols—but no American was ever quite as successful as Garber is here in achieving such radiant transparency. Backlighting is the key to Garber's unusual conception, sunlight filling the garden and passing through the young girl's smock, while creating the sharp profile of her head, and casting transparent shadows on her lovely face.

Yet while aesthetic concerns are paramount here, cognitive interpretation is not ignored. A number of American artists of this period evinced a preference for positing a figure, often in profile, between the indoors and the outdoors, half in the light and half in the shade, though seldom on so monumental a scale as here, nor do such works usually achieve such a psychologically meaningful statement. Although the artist restrains any visual comment on his affection for his ten-year-old daughter, she is shown poised between her present state of childhood and young womanhood. This passage from youth to maturity is echoed not only in the sensual penetration of her garment by sunlight, but also in her pose—isolated and erect, yet with a certain tentativeness in the imperceptible sway of her body, which leans slightly on the door handle she holds, as well as in the casual downturn of her head.

The present work is the most monumental of a number of paintings Garber created of his daughter at this time. *Tanis* was highly acclaimed when it was exhibited in the 1915 winter exhibition of the National Academy of Design in New York City. There it won the Altman Second Prize for the second-best figure painting by an American artist; this was an award newly established that year. (Garber had previously won the Julius Hallgarten First Prize at the Academy in 1909.) One writer pointed out that "few men have had the success that he has had with the picture of his little daughter Tanis standing at the doorway in full sunlight, while the sunbeams stream through the green leaves and her hair with a luminescence which suggests stained-glass itself".[1] Another, in discussing Garber's achievements in both landscape and figure work, excepted this picture from his generalizations, noting that "the famously good *Tanis*, however, a portrait of a child in the sunshine against an outdoor background, withdraws from classification to enter class".[2] Garber followed up on the success of *Tanis*

(continued: on page 160)

CARL KRAFFT
(1884–1938)

THE MYSTIC SPELL, ca. 1915
46 × 43 in.; 117 × 109 cm
Ms. Barbara B. Millhouse

Carl Krafft was one of the finest Midwestern landscape painters of the early twentieth century, many of whose major works were inspired by the scenery of the several art colonies which he joined. The most active of these was that established in and around Nashville in Brown County, Indiana; there, artists not only native to the state but from as far distant as Buffalo and Salt Lake City came during the summers to paint, including a large contingent from Chicago. Ohio-born Krafft, who studied in Chicago, was one of these, arriving in 1908, but he subsequently went searching for more untrammeled, wild, and romantic vistas. After reading Harold Bell Wright's popular and influential novel of 1907 *The Shepherd of the Hills,* Krafft settled upon the Ozarks in Southern Missouri in the summer of 1912; the following year, joined by a number of like-minded painters from Chicago and St. Louis, he founded the Society of Ozark Painters, of which he became President.[1] By the mid-1920s, however, Krafft had left the Ozarks in pursuit of more novel scenery.[2]

Krafft's Ozark pictures were painted throughout that mountain region. He first explored along the banks of the Gasconade River in the south-central part of the state and around Hollister and other towns on the White River in Taney County in the southwestern Missouri Ozarks. In 1916 he ventured to the Arcadia Valley, around the towns of Arcadia and Pilot Knob in southeastern Missouri. Krafft maintained studios in both Hollister and Arcadia, and painted in the Ozarks not only during the summers, but also captured the joyousness of autumn, and visited the region in the dead of winter.[3]

At their finest, as in *The Mystic Spell,* Krafft's pictures maintain a magnificent balance between a sense of the pictorial beauty and breadth of the Ozarks, and a fantasy of rich Impressionist color and patterned decoration, seen here especially in the contrast between the natural trellis of hanging vines and branches, and the repeated clumps of large trees rolling back into the distance. Krafft likened the landscape in the Ozarks to a miniature Switzerland, with the effect even more beautiful because of the incomparable coloring of the scenery.[4]

Krafft's work here bears particular comparison with another regional scene *California Valley Farm* of San Diego's Maurice Braun. Both painters utilize similar Post-Impressionist strategies, and in both pictures the viewer is positioned high up in the foreground, with a broad panoramic sweep extending below into the far distance. Yet each artist carefully demarcates his particular region. Braun's valley was a lush agrarian one, with crisscrossing bands of fertile land establishing an ordered sequence from frontal plane to background. Krafft's Ozarks are far more wild, and the vista falls immediately and precipitously off into dense, prismatic forest land which separates the foreground from the distant village. *The Mystic Spell* was shown in the painter's first one-man museum exhibition which opened at the Art Institute of Chicago in September of 1920.

[1] The only monograph on this still little-known painter was written by his daughter: Lal (Gladys Krafft) Davies, *Carl R. Krafft An Artist's Life.* New York, Vantage Press, Inc., 1982; for Krafft in the Ozarks, see "Art Notes", *Chicago Daily Journal,* 5 May, 1916.

[2] C[larence] J. Bulliet, "Artists of Chicago Past and Present No. 38 Carl Rudolph Krafft", *Chicago Daily News,* 9 November, 1935.

[3] Lena M. McCauley, "A Painter Poet of the Ozarks", *Fine Arts Journal,* 10, October, 1916, pp. 465-72.

[4] "2 Chicago Artists on Way to Ozarks", *St. Louis Republic,* 10 October, 1915.

MAURICE BRAUN
(1877–1941)

CALIFORNIA VALLEY FARM, ca. 1920
40 × 50 in.; 101,5 × 127 cm
Joseph L. Moure

Maurice Braun was one of the finest of California's Impressionists, an artist who is regionally renowned, but still little-known beyond the southern part of that state. Hungarian-born, Braun grew up and studied art in New York City before establishing himself in San Diego in 1909 or 1910. At the same time, he moved away from his previous concentration upon portrait and figure work, and turned toward landscape, inspired not only by new aesthetic responses conditioned by the beauty of Southern California, but also by his growing religious impulses.

Even before he left for California, Braun had been attracted by the doctrines of Theosophy, a movement which had established strong headquarters at Point Loma on the northern edge of San Diego, or "Lomaland" as it came to be known. The spiritual leader of that community was Katherine Tingley, who had set up a strong arts and crafts movement and an art academy there, but she encouraged Braun to remain devoted to pursuing his artistic impulses in the city itself; Braun only moved near to the Theosophist community on Point Loma in 1924. Nevertheless, Braun's expansive landscapes, sometimes including figures and in any case projecting a smiling, natural beneficence in which man's place is securely established in total harmony with the landscape, can be interpreted as projecting his Theosophist beliefs. Nature's inexhaustible variety within that harmony is another feature of many of Braun's finest canvases, the artist often unveiling a broad panorama which stretches from deep valleys to high hills and mountains across a vast stretch of terrain. He himself stated that "the immensity of the open spaces [of Southern California] are themselves an inspiration."[1]

Braun remained one of Southern California's leading painters, though he did work for several years in the early 1920s in the Connecticut artists' colonies of Silvermine and Old Lyme. In San Diego, Braun founded the San Diego Academy of Art in 1912 (or possibly in 1910, according to school brochures), the earliest art school in the city, and was associated in 1915 with the founding of the San Diego Art Guild, of which he was the second President in 1917-18.[2]

While the outward manifestations of the artist's pictures such as *California Valley Farm* are marked by Impressionist strategies of rich sunlight, bright, prismatic colors, and scintillating brushwork, the stylized, repeated shapes and the integrated colorism throughout the scene suggest studio painting rather than outdoor work. Compositions as here are also carefully organized, where the thin verticals of the sparsely leafed trees on either side open up to the rhythmic curve of much more dense and sponge-like, low-lying foliage which gently curves back into space. The magnificent but somewhat unreal palette, the patterned forms, and the reemergence of structural expression not only in the rocks and mountains but in the solid buildings of the valley farm suggest a Post-Impressionist direction taken by many early twentieth century American landscape painters, more conservative and very different from the dominant expressivity of European Post-Impressionism.

In other words, work such as Braun's may be seen as a union of latter-day Impressionism with elements of European Symbolism, though without the latter's esoteric, enigmatic, and often erotic concerns; like Symbolist art, however, it is not Naturalistic. Symbolism was the dominant aesthetic mode of the Point Loma artistic community; Braun himself stated that "Landscape should not be taken too literally. It is what we visualize and the interpretation we give the phantasy of our mind that counts."[3] Again, he noted that "I do not believe in taking a landscape literally. Landscape impresses me as being poetry. I get more of the truth of the scene portrayed by including the phantasy of the inspiration the surroundings afford."[4]

[1] Maurice Braun, "Theosophy and the Artist", *Theosophical Path*, 14, January, 1918, p. 14.

[2] The most recent and complete discussion of Braun is Martin E. Petersen, "Maurice Braun Master Painter of the California Landscape", *Journal of San Diego History*, 23, Summer, 1977, pp. 20-40.

[3] "Maurice Braun, Landscapist", *Western Art!*, 1, June, July, August, 1914, p.27.

[4] Quoted in Jon de Lack, "Maurice Braun of San Diego and His Aesthetic Landscapes", *Society,* p. 14; undated article in author's collection, courtesy of Martin E. Petersen.

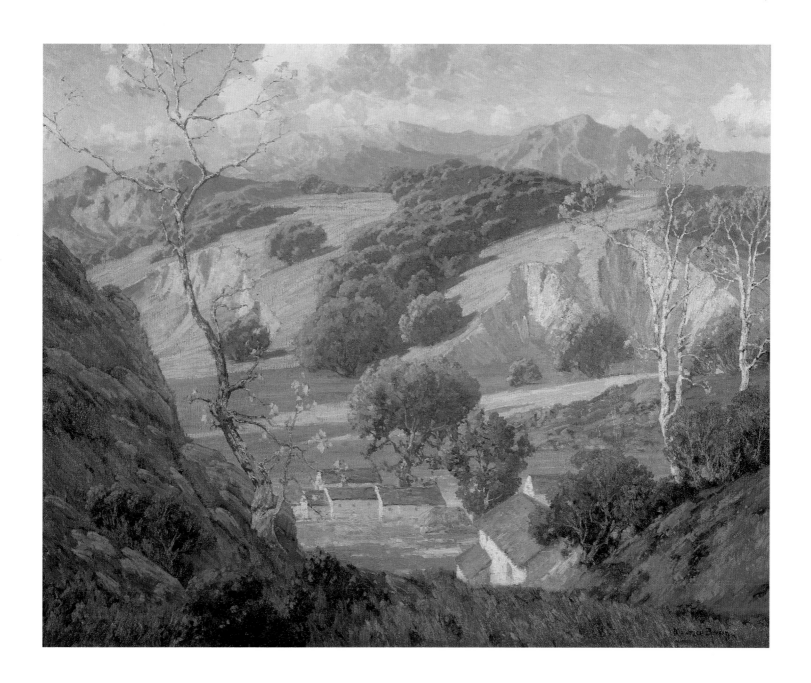

JOSEPH RAPHAEL
(1869–1950)

THE GARDEN, ca. 1913–15
28¼ × 30¼ in.; 72 × 77 cm
John H. Garzoli, San Rafael, California

Joseph Raphael from San Francisco was the most brilliant and original Impressionist painter from Northern California, but he was essentially an expatriate. After studying at the California School of Design (which became affiliated with the University of California and changed its name to the Mark Hopkins Institute of Art during the period that Raphael was a student), he went to Paris in 1903 for further instruction at the Académie Julian, and soon began dividing his time between Paris and the art colony in Laren in the Netherlands. Most of his work during this decade consisted of powerful renderings of the Dutch peasantry, but after a visit home in 1910 in connection with a show at the San Francisco Institute of Art, Raphael turned increasingly to landscape painting and even more after he moved to Uccle, a suburb of Brussels, in 1912. At about this time, or perhaps a year or two earlier, he abandoned the dramatic Tonal manner of his earlier work for a bright chromatic range of colors applied in a divisionist approach which straddles the line between Impressionism and Post-Impressionism. Raphael remained in Europe, living in Belgium and then in Leiden in The Netherlands after 1929, until war broke out a decade later; he spent the last years of his life back in San Francisco. He had maintained his connections with that city through the patronage of local collectors and by periodically contributing works to exhibitions there, winning a silver medal at the Panama-Pacific International Exposition in 1915; his paintings were also shown periodically at the Helgesen Galleries in San Francisco.

The cause of the seemingly abrupt change in Raphael's art has not been identified. He was already quite mature even when he went to Europe, and was over forty when he became associated with Impressionism; he would certainly have had many previous opportunities to study the work not only of Monet, but also of the latter's successors among the Post-Impressionists. It may be, however, that his move to Belgium not only increased such opportunities but also encouraged him to adopt such strategies, for Belgium, far more than Holland, had been especially receptive to the work of Seurat and the Pointillist movement. Raphael may have been referring to paintings such as this in letters to his patron Albert Bender of San Francisco, written from Uccle. On July 12, 1911, he wrote: "I am working now outdoors, rather modern luminous portraits, and I am going to send out a half dozen heads, that we must dispose of."[1] In January of 1912 he noted to Bender: "With my work I have

experimented and really studied and progressed not in the way of doing big things (it's not in me) but in the outdoor work."[2] On July 22 of that year he wrote that: "Here I work every day, landscape. I'm painting the four points of the compasss, the hottest sunny days preferred. It's like California."[3] Perhaps *The Garden* was a result of the work that summer.

The Garden represents the first stage of Raphael's involvement with the color and light of Impressionism, while the paint is laid on in bright, thick touches of color, an enlarged version of the divisionist technique of the Pointillists. Raphael's compositions in these works of around 1912-15 are quite reductive, with often a single path, diminishing in width toward the distance, offering the primary evidence of three-dimensional depth. Otherwise, the colors lie on the face of the canvas, forming a near abstract design; this emphasis upon the painting's surface is augmented by both the high horizon and the near square shape of the picture, which lessens the suggestion of either depth or breadth. *The Garden* won the Emanuel Walter Purchase Prize at the annual exhibition of the San Francisco Art Association in 1916.

Fields of flowers and gardens, a major theme of Raphael's pictures of this period, were a subject prevalent among Impression ist painters internationally. Especially associated with Claude Monet and his famous gardens in Giverny, the theme was tremendously popular with many American Impressionists as well. In this work, Raphael makes no attempt to reproduce the textures and even little of the actual form of the flowers, merely approximating them in the colors and the size and shape of his brushwork. A range of trees separates the foreground from the middle distance, but these, too, are suggested only by their darker tones and the nature of the brushstrokes. Raphael subsequently carried his vivid use of paint even further, developing an art that combined characteristics of Impressionism, Post-Impressionism, and Expressionism in a unique and effective blend.

[1] My thanks to the artist's daughter, Johanna Sibbert, for her asssistance, and specifically here in regard to the Raphael-Bender correspondence.

[2] Raphael to Albert Bender, January, 1912, Special Collections, Mills College Library, Oakland, California.

[3] Reference courtesy of Johanna Sibbert.

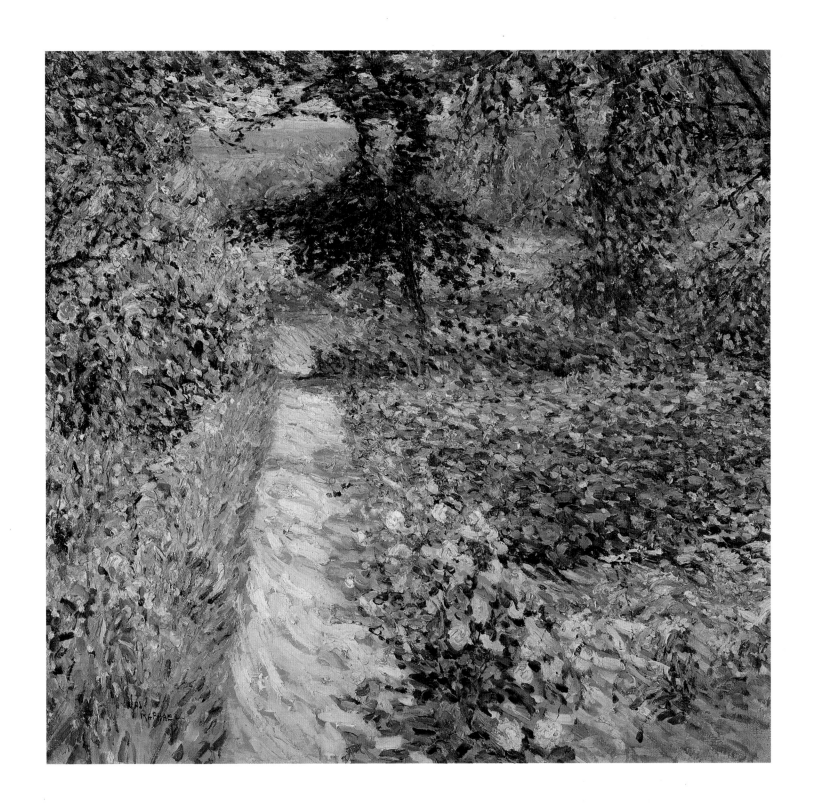

ERNEST LAWSON
(1873–1939)

HARLEM RIVER, ca. 1913–15
40⅛ × 50 in.; 102 × 127 cm
The Manoogian Collection

Ernest Lawson is one of the younger painters in the present exhibition and, to some degree, heir to an Impressionist heritage that had already been established in the United States. Canadian-born, Lawson's most significant instruction was taken with John Twachtman at the Art Students' League in New York in 1891 and, probably more productively, with Twachtman and J. Alden Weir the next summer at Cos Cob, Connecticut. Lawson remained devoted to Twachtman, and his painting reveals his indebtedness to his teacher both in his preference for winter scenes and in his adaptation of many of the older artist's strategies—the free brushwork, the scumbled paint, and the abundant use of white. In 1893 Lawson continued his studies at the Académie Julian in Paris, and, while working at Moret-sur-Long, met the French Impressionist painter Alfred Sisley, who abetted the direction that Lawson's art was taking.

After two more years of study in Paris from 1896-98, the artist returned to New York City and settled in Washington Heights. During the following decade he became associated with "The Ashcan School" or "The Eight", a group of eight painters who held an exhibition of their work at the Macbeth Galleries in February 1908, which resulted in a great deal of notoriety. These artists were primarily devoted to exploring and recording the down-to-earth appearance and activity of contemporary urban life. As a landscape specialist, Lawson's art was somewhat distanced from the main thrust of Ashcan School painting, but he shared their concepts in expressing the beauty of the unpicturesque urban landscape along the shores of the city's Hudson, Harlem, and East rivers. His painting came to represent the modern urban scene and, as such, it was as far removed from the rural poetry of Twachtman's Connecticut landscapes, as those were from the sublime scenes of the Hudson River School. Lawson's modernity was identified by his representation with the Daniel Gallery, one of the bastions of modern art in New York City, during the 1910s.

Harlem River, especially, was the subject of many of Lawson's finest pictures, such as the present work, very probably painted after the artist had moved from northern Manhattan and was living in Greenwich Village. While topographical identification is not Lawson's primary motivation, the scene is a record of the mixture of urban development and natural setting which is featured in so many of his paintings, and the massive structures across the river in the Bronx are recognizeable monuments. At the left is the Veteran's Hospital, no longer standing, while the twin-towered building at the right is Webb's Academy and Home for Ship Builders, on Sedgewick Avenue.[1]

Lawson's rough paint quality, referred to as "crushed jewels" of color, was particularly effective in projecting the flow of the water.[2] The pigments are laid on very broadly in the foreground, more delicately on the opposite shore, and there is also a chromatic contrast between the richer, darker tones in the foreground and the paler ones in the distance. Against this landscape setting, the artist's draftsmanship in defining the small tug boat and the propped up signboard at the left is actually quite careful. The boat, especially, imparts a liveliness to the scene which is truly an early twentieth century urban landscape, with large buildings alternating with still open tracts of land. It was in the middle years of the 1910s that Lawson achieved a good deal of acclaim; one writer predicted that "Some day this man will be generally recognized as one of the greatest landscape painters produced in this country and no collection will be complete without a Lawson, as to-day the indifferent of yesterday vie with one another for the possession of a Twachtman or a Theodore Robinson."[3]

[1] I want to acknowledge my appreciation here to Christopher Gray, Office for Metropolitan History, New York City.
[2] The reference to "crushed jewels" is attributed to the influential art critic James G. Huneker by Lawson's later dealer F. Newlin Price. Price, "Lawson of the 'Crushed Jewels'", *International Studio,* 78, February, 1924, p. 367.
[3] *Camera Work,* 38, April, 1912, pp. 38-39, quoting from J. Nilsen Laurvik in the *Boston Transcript.*

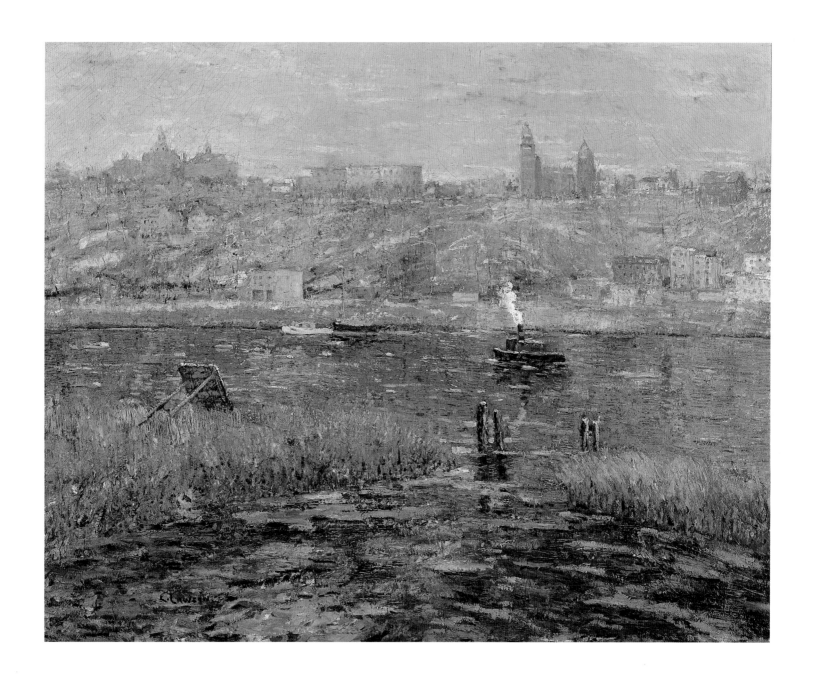

FREDERICK FRIESEKE
(1874–1939)

LADY IN A GARDEN, ca. 1912
32 × 25¾ in.; 81 × 65,4 cm
Daniel J. Terra Collection
Terra Museum of American Art, Chicago, Illinois

The substantial American presence in Giverny, the French village where Claude Monet resided from 1883, can be documented from 1887 through the decade of the 1910s. Though there was much overlap, one can perceive three separate groups of artists. There was the first contingent, including Theodore Robinson, John Leslie Breck, and Dawson Dawson-Watson, who arrived in the late 1880s and who quite quickly began to assume some of the strategies of Impressionism. In the 1890s, a more academic and classically oriented group arrived, centering around the painter-sculptor Frederick MacMonnies and his wife Mary Fairchild MacMonnies, and which included the muralists Will Low and William De Leftwich Dodge; these are not included in the present exhibition. And then, at the beginning of the present century, a new influx of Americans arrived, the most significant of whom was Frederick Frieseke.

Frieseke came from a small town in Michigan, and studied at the Art Institute of Chicago as well as in New York before travelling in 1898 to Paris, where he entered the Académie Julian. Frieseke also received some instruction from Whistler in Paris; his earliest paintings are Tonalist images of women in interiors, not unlike some of the work of that great American expatriate. Frieseke began to summer in Giverny as early as 1900 and, starting in 1906, rented the house near Monet's that had earlier been occupied by Theodore Robinson. Nevertheless, Frieseke would seem to have had relatively little contact with Monet and, among the French Impressionists, his stated preference was for the painting of Pierre Auguste Renoir.

Unlike that of their predecessors, the art of Frieseke and his colleagues centered upon the figure of woman in intimate, if characteristic situations; pure landscape painting held very limited appeal. Rather than Robinson's emphasis upon the working peasant, Frieseke's women were generally situated in a domestic environment, and here the artist's stated preference was the flower garden. Rather than the orchard or the vegetable garden to which the earlier artists had been partial, Frieseke favored a colorful, decorative setting, one where, as here, he could play off the variegated color patterns of the floral blooms with that of the geometric design of the costume worn by the woman set in their midst.

The inspiration to emphasize the flower garden derives, of course, from the extensive gardens that Monet himself had developed at Giverny, and which were not in place in the late 1880s; however, it seems unlikely that Robinson and his colleagues of that earlier period would have been drawn to such subject matter in any case. Though his art centered upon the figure, Frieseke maintained the Impressionist interest in light and sunshine, directed especially toward the garden setting. As he stated in an interview published in 1914, "It is sunshine, flowers in sunshine, girls in sunshine, the nude in sunshine, which I have been principally interested in for eight years . . . I know nothing about the different kinds of gardens, nor do I ever make studies of flowers. My one idea is to reproduce flowers in sunlight . . . to produce the effect of vibration . . . If you are looking at a mass of flowers in the sunlight out of doors you see a sparkle of spots of different colors; then paint them in that way."[1]

This is exactly what Frieseke has done in *Lady in a Garden.* There is no botanical concern expressed here; it would be difficult to identify the different kinds of blooms which surround the standing figure, except perhaps by their colors and the length of brushstrokes. Yet the artist's spontaneity conceals careful organization; the lower portion of the garden consists of a bank of long, vertical strokes, out of which the woman seems to emerge, the black stripes of her dress continuing the long, flowing upward lines of the garden. She is symmetrically surrounded on each side by pink-blue-purple blossoms, echoing her facial skin tones, but her head is silhouetted against a dense profusion of very different and contrasting colors, where yellows and blue-green predominate. The last named color actually identifies not flowers, but the painted shutters of Frieseke's home, where his joyous chromatic response found further expression. Frieseke and his wife remodeled the house in which they lived in Giverny, painting it bright yellow, with green shutters, while the inside was equally colorful, the living room painted lemon yellow and the kitchen a deep blue.

Frieseke's interpretation of woman, here and in many of his canvases, is introspective; she is quietly meditative, a lovely flower among flowers.

[1] Clara MacChesney, "Frieseke Tells Some of the Secrets of His Art", *New York Times,* 7 June, 1914, section 6, p. 7.

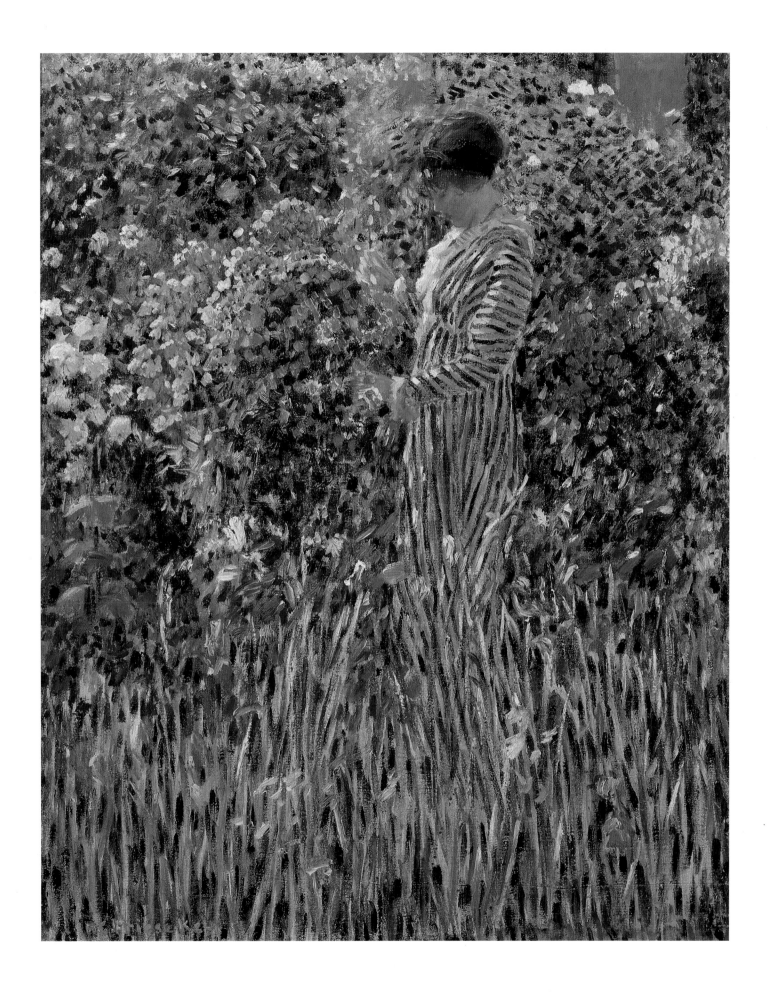

FREDERICK FRIESEKE
(1874–1939)

HOLLYHOCKS, 1912-13
31¾ × 31¾ in.; 80,6 × 80,6 cm
Thyssen-Bornemisza Collection, Lugano

Hollyhocks, probably painted around the same time as *Lady in a Garden* and expressing similar artistic concerns, is nevertheless a more outgoing image. Here, the figure is turned toward the viewer and looks directly out, while her red gown and parasol, though mirroring the colors of some of the blossoms, is nevertheless far more disengaged from the garden. The figural type is lush and inviting and reflects Frieseke's admiration for the art of Renoir. The parasol, along with the garden umbrella, is a frequent device in the artist's oeuvre; it is not only identified with warm sunlight, but also enhances the sense of glow; in addition, as a solid, colorful shape, it offers a foil for the more broken patterns within the flower garden.

The garden at Giverny was a great pride of the artist's, but the responsibility for it was his wife's. It was described in an interview in 1914 as "a tangle of flowers, with a pool in the centre, a crooked old apple tree at one end". Frieseke himself stated that "We've remodeled the house, decorated it, and, with the garden, it serves as my studio from April to December."[1] In *Hollyhocks* the flowers wall off the figure, negating space and serving to turn the viewer's attention to the forward plane. Frieseke's choice of a square format also implements this deco-rative, non-naturalistic presentation, by cancelling any traditional suggestion of breadth (as in a horizontal canvas) or depth (as in a vertical one).

Decoration is a prime motivation of Frieseke's art; it is what differentiates such later Impressionist pictures as his from the more naturalistic works of the artist's predecessors in Giverny, including Theodore Robinson who had lived and worked in the same house two decades earlier. It is not only that Frieseke has here, in *Hollyhocks*, created a picture more concerned with color, pattern, and beauty, but that he had fundamentally placed his genius at the service of decoration. Though both Frieseke and Robinson subscribed to the new freedom of brushwork and vivid colorism of Impressionism, and both were interested in exploiting the effects of sunlight, Robinson's art retains the naturalistic underpinnings of early Impressionism; Frieseke's painting is part and parcel of the Post-Impressionist concerns of Pierre Bonnard, Edmond Aman-Jean, and other artists with whom he was compared at the time.

[1] Clara T. MacChesney, "Frieseke Tells Some of the Secrets of His Art", *New York Times,* 7 June, 1914, section 6, p. 7.

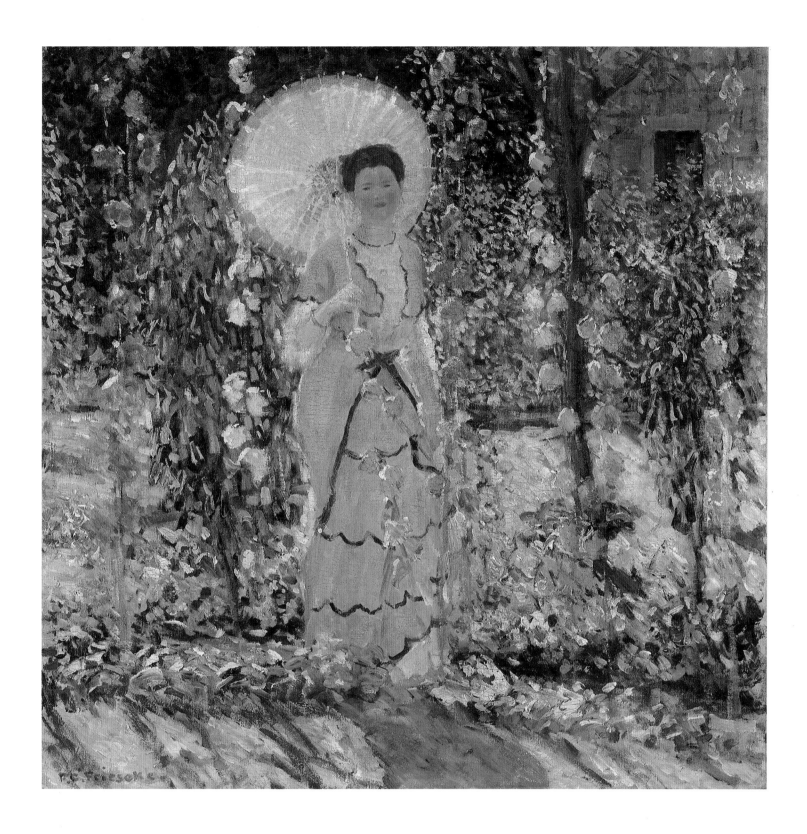

FREDERICK FRIESEKE
(1874–1939)

BEFORE HER APPEARANCE, 1913
51¾ × 51½ in.; 131,5 × 130,8 cm
Cummer Gallery of Art, Jacksonville, Florida
Women's Council Purchase Fund and Public Subscriptions

While Frieseke may be best known for his paintings of women in outdoor settings—garden scenes and the nude, especially—he painted an equal number of indoor pictures, some of the finest of which are set in the boudoir and/or at the dressing table. The present work was one of a group of seven pictures which Frieseke painted during a winter sojourn on the island of Corsica early in 1913, posed for by his model Marcelle for whom he had sent.[1] While he enjoyed his visit, the winds on the island made outdoor painting exceedingly difficult, and he determined not to return.

Such subjects as *Before Her Appearance* are concerned with the intimacies of womanhood, and, as here, they conform to traditional stereotypes. Thus pink, a "feminine" color, is the dominant tone, from the flesh tints, the subject's dressing gown, and her slippers, to the tones of the covering of the dressing table and the floor, and all the appurtenances on the table—the necklace and the maquillage, including the lip rouge which she is applying. Furthermore, the various items of cloth are appropriately "frilly", while patterns on the dressing table and the curtains are small and delicate. And of course, the business at hand is beautification, the subject being engaged in making herself as physically appealing as possible. What elevates the work far above the norm is Frieseke's masterly handling of color, light, and textures, all orchestrated to emphasize total femininity with great impact.

A narcissistic element should not be overlooked here; mirrors *do* reflect their viewers, and two of them appear in this picture, even if no repeated image is shown. Many Impressionist painters, French and American, utilized the mirror in order to present an altered view of the principal subject and/or to conflate and yet extend space, ambiguously. Mirrors are not used for such a purpose among the Americans in Giverny at this period, however; rather, they serve to provide personal gratification, while offering voyeuristic pleasure, as we see here and in Richard Miller's *La Toilette*. Many of Frieseke's pictures in fact project a gentle eroticism. This is embodied here in the revelation of a bare shoulder, in the casualness of the figure's pose, and above all, in the sense of a "keyhole" violation of the privacy associated with personal grooming.

Before Her Appearance was also exhibited as *The Boudoir,* and the two titles suggest somewhat different interpretations of the scene. The latter conforms to the intimacies of private dressing explored by such contemporaries of Frieseke as Pierre Bonnard; *Before Her Appearance* casts the young woman more in the public arena, allying the picture with the theatrical subjects of Edouard Manet and the backstage ballet scenes of Edgar Degas. While this work lacks the interpersonal tensions often associated with the pictures by those earlier masters, the satin slippers worn by the figure and the billowing cloth in the upper right suggest a theatrical costume. Thus, the subject of the picture is a performer rather than the mistress of a private home. Such an interpretation adds a further dimension to the painting, for the viewer then has a private look at an entertainer preparing for her public exposure. Or, alternatively, the ambiguity here between a private and public interpretation serves further to eroticize the image.

Before Her Appearance has a particularly noteworthy history among Frieseke's paintings. The work was one of six canvases the artist exhibited at the April Salon of the Société Nationale des Beaux-Arts in Paris in 1913. One reviewer noted that: "Mr. Frederick Frieseke's six canvases, painted in Corsica during the winter and spring, evince a slight departure from his usual gamut of color, as well as from his accustomed choice of backgrounds and his treatment of accessories. The largest one presents a dancer in her dressing room, in the act of putting the last bit of ardent rouge to her lips, before going upon the stage. Seated on a stool befor a mirror, her attitude displays to forceful advantage her generously-rounded calves, encased in transparent violet-hued hose. The other three pictures show the same model on a Corsican beach, in two of them nude and in the other clothed".[2] The picture was acquired by Gertrude Vanderbilt Whitney, who lent it to the Eighteenth Annual Carnegie International in Pittsburgh. Mrs. Whitney, in turn, later donated it to the Whitney Museum of American Art, which deaccessioned the work in 1963.

[1] Letter from Frieseke to his dealer, William Macbeth, in New York City, 24 January, 1913, Macbeth Gallery Papers, Archives of American Art, Smithsonian Institution, Washington, D. C.
[2] Review of the 1913 Salon, *Daily Mail,* 21 April, 1913.

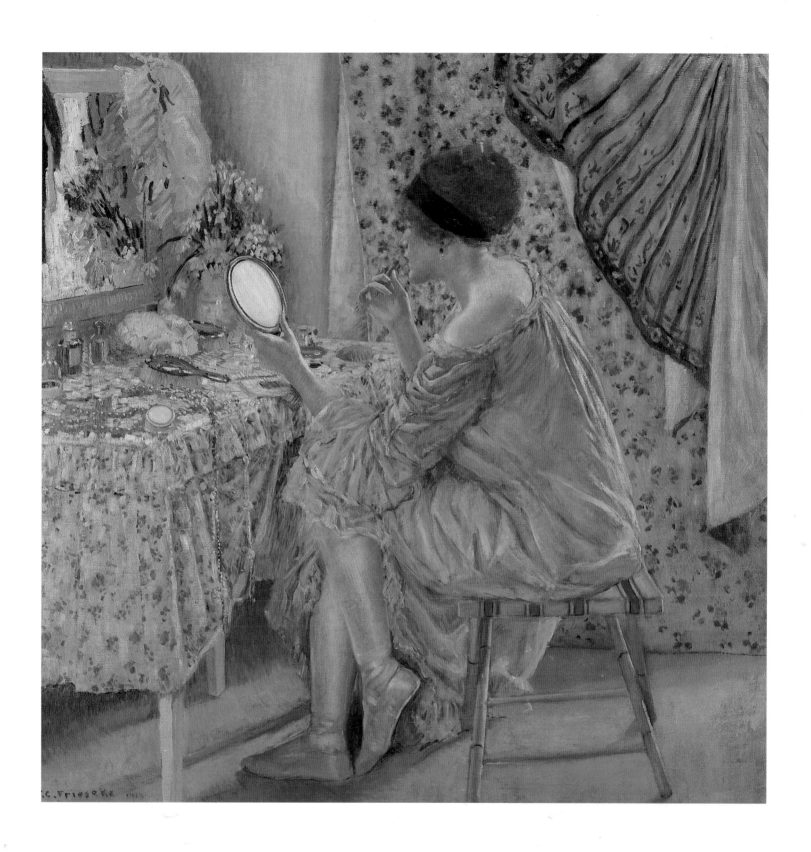

FREDERICK FRIESEKE
(1874–1939)

VENUS IN THE SUNLIGHT, 1913
38³/₈ × 51³/₈ in.; 97,5 × 130,5 cm
Manoogian Collection

Frieseke was one of the most noted of American painters of the female nude, reflecting the pictorial popularity of the theme in French painting of the time. His concern with the nude supported Frieseke's complete identification with feminine subjects, and his expatriation in France allowed him the freedom to explore the motif. He stated that: "I am more free and there are not the Puritanical restrictions which prevail in America. Not only can I paint a nude here out of doors, but I can have a greater choice of subjects. As there are so few conventionalities in France, an artist can paint what he wishes. I can paint a nude in my garden or down by the fish pond and not be run out of town."[1]

In the interview with Clara MacChesney in which Frieseke was quoted, the artist may have been referring specifically to *Venus in the Sunlight,* for MacChesney then went on to describe "one of his greatest pictures, and I saw nothing to equal it in the Paris salons or the London exhibitions. It represents a life-size woman, nude, lying on a mauve shawl, with the trees overhead and a glimpse of the stream seen in the upper left; in the upper right an open white parasol lies on the ground, making a white note in contrast to the glistening flesh tones. The sunlight flickers through the leaves and falls here and there on the satin skin. For sheer beauty of flesh painting in sunlight and shadow, no other canvas equals it today."[2]

Frieseke's success with his nude *Venus* lies in part in his mastery in the delineation of form, along with the sense of unbridled freedom projected by the luxuriating female. The dappled sunlight caresses the flesh while adding a palpitating warmth. And it is also the artist's mastery of textures, both mimetic and artistic, which induces such success. Frieseke contrasts the sharp, staccato-like brushstrokes denoting grass with the thick, blob-like strokes for the overhead leafage, and the more fluid paint handling of the large shawl, all of these differing from the smooth application of delicate tints which reproduce the flesh tones of the figure. The work is a rare instance of the artist appending a classical title, but this appeal to tradition is belied not only by the immediate impact of the figure, but by the contemporary parasol, balanced by the very modern summer hat in the lower left.

Venus in the Sunlight was acclaimed when it was shown in the spring of 1914 at the exhibition of the Société Nationale des Beaux-Arts in Paris. Its success led the artist to replicate the picture that year on a slightly larger scale, to which he added a second figure in the upper right who holds the parasol, a work entitled *Summer* (Metropolitan Museum of Art, New York City). Also in 1914, the artist painted another nude, *Autumn,* which is included in the present show; this work, by its size and composition, is a pendant to *Venus in the Sunlight.*

[1] Clara T. MacChesney, "Frieseke Tells Some of the Secrets of His Art", *New York Times,* 7 June,1914, section 6, p. 7.
[2] *Ibid.*

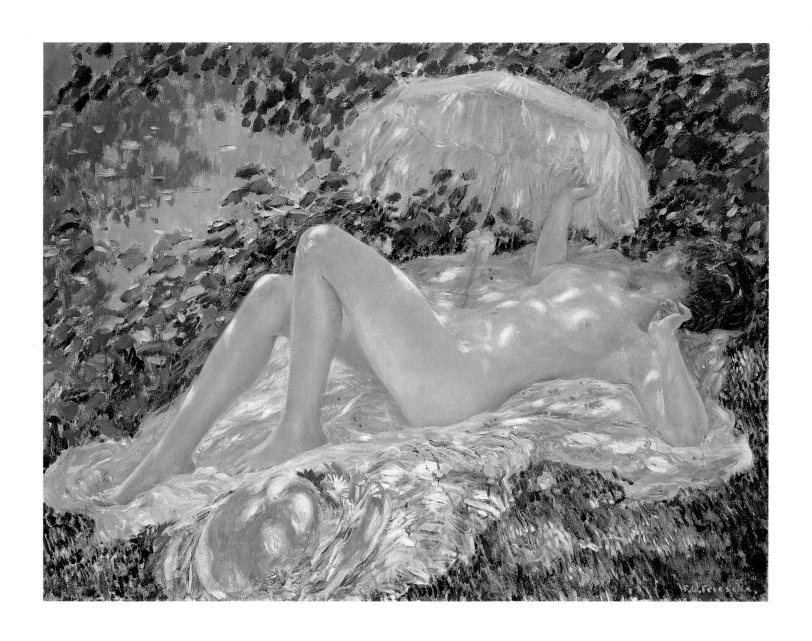

64
FREDERICK FRIESEKE
(1874–1939)

AUTUMN, 1914
38¼ × 51½ in.; 97 × 131 cm
Galleria Internazionale d'Arte Moderna Ca' Pesaro, Venezia

Autumn was painted shortly after the success achieved by Frieseke's 1913 *Venus in the Sunlight* at the annual exhibition of the Société Nationale des Beaux Arts in Paris in 1914, and is a pendant to it. That year the artist also painted a replica of his *Venus,* entitled *Summer* (Metropolitan Museum of Art, New York City), but despite the similarity of their seasonal titles and the proximity of their creation the two 1914 pictures are not companions. For one thing, *Summer* is somewhat larger than *Autumn,* while *Venus in the Sunlight* is the same size as the latter. Both *Autumn* and *Venus in the Sunlight* are single-figure works, while *Summer* contains two women, and compositionally the basket of fruit at the bottom of *Autumn* occupies the place taken by the summer hat in *Venus in the Sunlight,* an accessory removed when Frieseke replicated the latter as *Summer.*

It would seem, then, that *Autumn* and *Venus in the Sunlight* were meant to be seen together, projecting two slightly different seasonal conditions, but in fact the present exhibition is the first time they are known to have been shown together. Such depictions of the nude as these especially testify to Frieseke's admiration for the work of Pierre Auguste Renoir, though Renoir's nude figures are generally a good deal more active. In these two pictures, Frieseke's figures balance and contrast nicely,

lying in opposite directions, and while the attractive young woman in *Venus in the Sunlight* turns her head away from the viewer, that of *Autumn* faces us. Her eyes remain closed, however, and she is thus unresponsive, despite her physical availability. On another plane, her closed eyes suggest sleep and, by projection, a dream image. *Autumn* presents a slightly more open vista of the stream beyond the figure than does its companion, along with a heavier, fuller parasol, while the basket of apples again has a seasonal reference.

Frieseke's art was much admired in Italy as well as in France and in his native America. He shared a two-artist display at the International Exposition of Modern Art in Venice (the Venice Biennale) in 1909, and, in addition to contemporary critical tributes to his achievements in Italian periodicals at that time, he was the subject of several later articles.[1] It is not surprising, therefore, that in 1923 the work was acquired by its present owner.

[1] Pier Ludovico Occhini, "Karl Frédéric Frieseke, *Vita d'arte,* 7, February, 1911, pp. 58-68; Vittorio Pica, "Artisti contemporanei: Frederick Carl Frieseke", *Emporium,* 38, November, 1913, pp. 323-337.

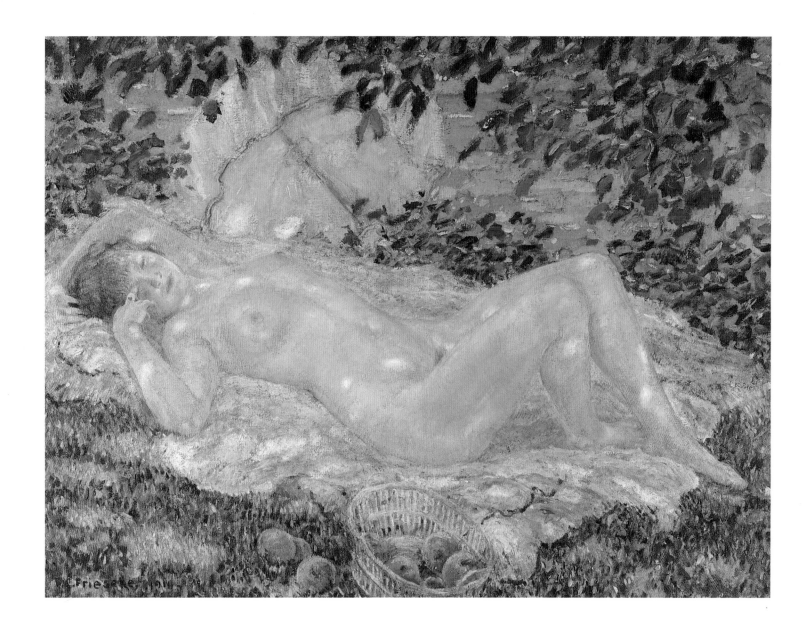

65

FREDERICK FRIESEKE
(1874–1939)

THE BLUE GARDEN, ca. 1912
32 × 32 in.; 81,3 × 81,3 cm
Mr. and Mrs. Robert B. Aikens

The first generation of American artists who visited and painted in Giverny beginning in the late 1880s were primarily devoted to landscape painting. A crucial distinction exists between those painters, such as Theodore Robinson, and the Americans who settled there in the 1900s, led by Frederick Frieseke, a group whose concerns were almost totally figural. These later painters were devoted to the theme of attractive women seen in a sympathetic and appropriate environment, sometimes inside the home or more often outdoors, usually in a garden. A woman might be shown alone or with a female companion, but never with a man. Though conforming to this arrangement, Frieseke's *The Blue Garden* is still a relatively unusual work, for here the figures are quite small and the setting takes on equal importance with the two young women placed within it. This is an especially sylvan scene, stressing the harmony between the figures and the natural setting.

Though the artist has applied his paint vigorously in small dabs which creates an overall colored pattern, and his approach is thus aligned with contemporary aesthetic strategies of Neo- and Post-Impressionism, the picture is nevertheless unusually restrained and even classical in its composition. While the garden subject is not unusual, Frieseke here stresses the traditional motif of the enclosed, *walled* garden, a theme of purity which goes back to medieval times. Formally, the picture is extremely symmetrical; two large banks of dark foliage rise up on either side, enframing the women who are centered in the composition, placed above a circular pool which fills out the lower third of the picture. Above them is an area of near white sky, the tones of which repeat the highlights on the women's gowns, and which is reflected in the still water of the pool. The middle third of the picture is occupied principally by the figures, and this band is separated from the area of sky by the sharp horizontal of the garden wall. The formality of the painting is enhanced by Frieseke's choice of the square format, which not only centers the composition but concentrates the forms within its four sides and up toward the picture plane. The poses of the two figures are even aligned along the hypothetical diagonal axes between the opposite corners of this square.

The classicism of this work, in fact, is related to the paintings created by a number of Americans who were living and painting in Giverny when Frieseke first arrived at the beginning of the century, at which tine the home of the painter Mary Fairchild MacMonnies and her husband, the sculptor-painter Frederick MacMonnies, was the center for the American art colony.

More specifically, *The Blue Garden* recalls the series of garden pictures painted in the MacMonnies' garden between May and September 1901 by Will H. Low, and is especially reminiscent of Low's *L'Interlude, Jardin de MacMonnies* (Bayly Art Museum of the University of Virginia, Charlottesville), created that September. This work also features two women, one sitting, one standing, next to a circular pool, and while Low's figures are more sharply drawn and their costumes are more overtly classical than those of Frieseke, both pictures project a similar idyllic mood.

Whether Frieseke was in attendance while Low was painting these works at Giverny in 1901 is not documented, but he was certainly in the village, and it would seem extremely probable, given the MacMonnies' dominant role in the art life there at the time. Low's series of works earned a good deal of notoriety when they were subsequently exhibited at the Avery Art Galleries in New York in February of 1902, and they were then the subject of an article written by Low which appeared in *Scribner's Magazine*, in which this specific picture was reproduced (as *By the Basin*).[1]

The Blue Garden also recalls an even earlier period of American activity in Giverny, for the pool which is featured is not the more elaborate one in the MacMonnies' garden, with a molded edge and a classical statue in the center, as seen in Low's picture; Frieseke's has a simple, solid concrete enclosing rim, and is the same pool which appears in a number of Theodore Robinson's finest paintings of 1890 such as *The Watering Pots* (The Brooklyn Museum), though Robinson's are typically peasant subjects rather than poetic idylls. In 1906, Frieseke had moved into a house that Robinson had earlier occupied; when Clara MacChesney interviewed Frieseke in Giverny, she described the garden as "a tangle of flowers, with a pool in the centre, a crooked old apple tree at one end. It has often been painted by that early impressionist, Theodore Robinson, who occupied the house for years."[2]

[1] Avery Art Galleries, *A Painter's Garden of Pictures Painted from Early Spring until Late in the Autumn of 1901 at Giverny in France,* New York, 1902; Will H. Low, "In an Old French Garden", *Scribner's Magazine,* 32, July, 1902, pp. 3–19.

[2] Clara MacChesney, "Frieseke Tells Some of the Secrets of His Art", *New York Times,* 7 June, 1914, section 6, p. 7.

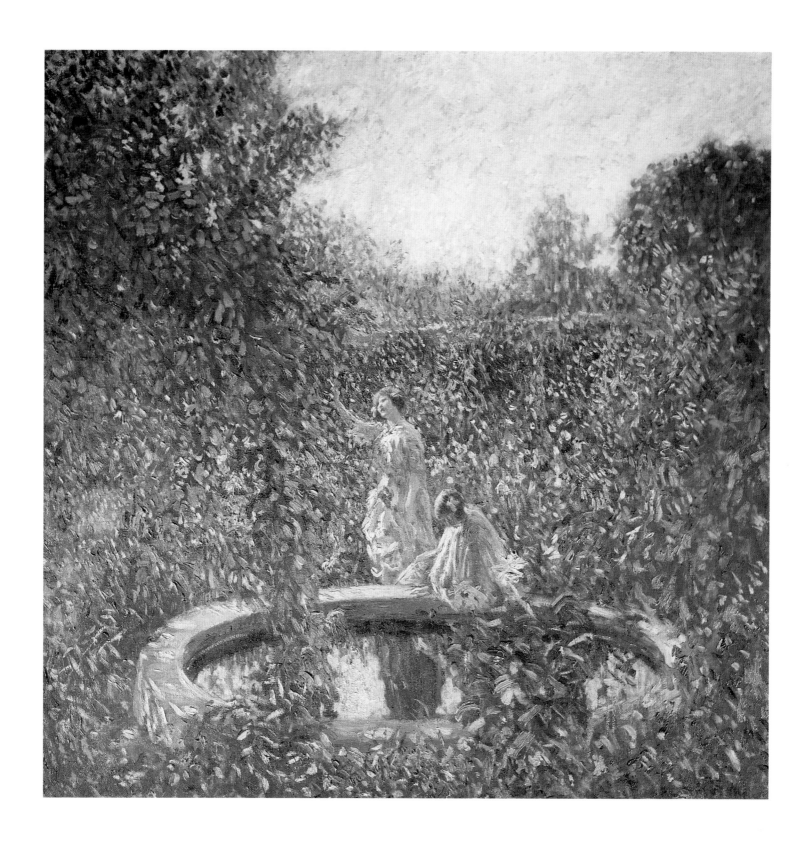

RICHARD MILLER
(1875–1943)

LA TOILETTE, ca. 1914
39³/₈ × 32 in.; 100 × 81 cm
Columbus Museum, Columbus, Georgia
Gift of Mrs. J.B. Knight, Sr. in memory of her husband

Richard Miller from St. Louis, Missouri, along with Michigan-born, Chicago-trained Frederick Frieseke, constituted the dominant American artistic presence in Giverny in the first decade of the twentieth century; it is not surprising, therefore, that they, in turn, attracted a good many other Midwestern painters to Monet's home village. Though the exact chronology of the early years of both Miller and Frieseke is not precisely established, their careers ran parallel for some time, with Miller entering the Académie Julian in 1899, probably a year after Frieseke; the two were to share an exhibit at the International Art Exposition in Venice (the Venice Biennale) in 1909.[1] Miller's transition to Impressionism would seem to have been more gradual than his colleague's, however; his early works were quite muted in tonality, culminating in a series of night scenes along the boulevards of Paris about 1905. During this time he also taught at the Académie Colarossi in Paris.

It would seem that it was shortly after this, about 1906, that Miller began to paint colorful pictures of women both outdoors and also in interiors in Giverny, where he also taught summer classes for the students of Mary Wheeler's school in Providence, Rhode Island. Intimate depictions of women were the primary pictorial concern of most the American Impressionists who worked in Giverny during the early years of the present century, and *La Toilette* represents Miller at his finest. As with many other Americans, Miller's Impressionism was selective. Though the voluptuous flesh tones are replete with myriad touches of variegated color, academic strategies of firm modelling are still pronounced. The young woman's dress is more broadly painted, matching the coloristic pattern of the table-cloth, while the flowers at the window and the garden beyond are more sketchily rendered still. While blues and purples dominate in the cloth patterns, the rich reds of the flowers beyond the figure are pulled forward in their reflection in the mirror she holds.

Miller's figural paintings such as *La Toilette* are often quite sensual. The casual deshabille reveals the graceful curve of the subject's neck and shoulders, and this sensuous line is repeated in the swelling curve of the chairback. These rounded lines contrast with the rigid geometry of the mullions of the doors to the porch, and the thin railing beyond, which separate the young woman from the freedom of the outdoors, a freedom implicit in the dashing brushwork and wild colors of the garden. A degree of narcissism is suggested in the subject's absorption in her own image in the mirror, the latter a device common among both French Impressionists such as Edgar Degas, and many Americans, including Mary Cassatt and Robert Reid. Miller projects a degree of intimacy also by defining the young woman's privacy in a circumscribed interior, contrasted with the extensive flower garden in bright sunlight seen beyond the doors.

Although Miller was an expatriate for almost two decades, his works were frequently exhibited in America, particularly in New York and Philadelphia. *La Toilette* was shown in May of 1914 at the Ninth Annual Exhibition of Selected Paintings by American Artists, held at the Albright Art Gallery in Buffalo, New York, which purchased the work that year; the Albright Art Gallery deaccessioned the painting in 1943. Writing of pictures similar to *La Toilette,* the New York critic James Huneker wrote that Miller's "interiors are cool and graceful, his women delicate and mysterious".[2]

With the impediments and dangers brought on by World War I, Miller left Giverny late in 1914 for New York and then St. Louis, and in 1916 settled for several years in Pasadena. There he taught at the Stickney Memorial School of Art, and had a decided influence upon the development of Impressionism in Southern California. He moved permanently to Provincetown, Massachusetts in 1918, and his later career was involved with the art colony there. In America, Miller continued to concentrate upon rather monumental images of women in gardens and sunlit interiors, though he also painted marines in Provincetown, and provided murals for the State Capitol in Jefferson City in his native state of Missouri, painted between 1919 and 1923.

[1] Information from Marie Louise Kane, who has undertaken extensive resarch on Miller.
[2] James Huneker, "Seen in the World of Art", *Sun* (New York), 8 January, 1911, section 3, p. 4.

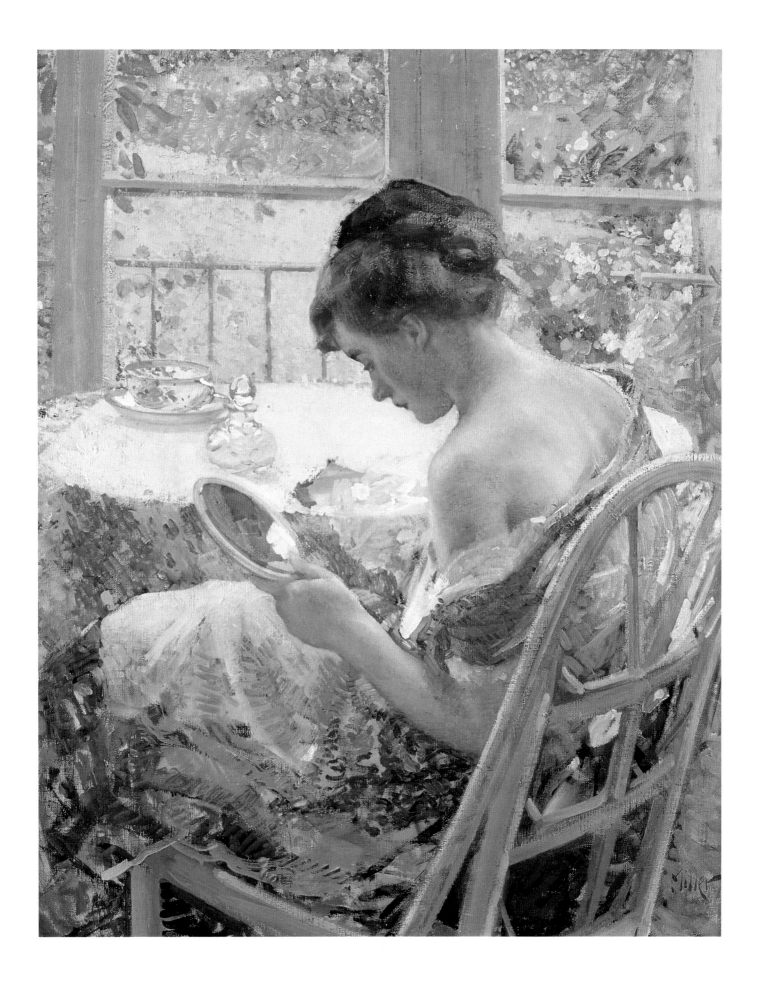

CONTINUATION
OF ENTRIES

PLATE 3 MARY CASSATT (from page 28)

charm of green apple orchards, or parks, and, very frequently, the mystery of mother love and the pulchritude of the Baby. But seldom indeed has that inefficient but most valuable of potentates been more carefully studied and faithfully rendered, in many of his various moods, and in his relations with the mother that bore him or the nurse that tends him."[6]

1 "Pictures by Miss Cassatt", *New York Times*, 18 April, 1895, p. 4.
2 "De Omnibus Rebus", *Collector*, 5, 15 December, 1893, p. 55.
3 *New York Times, loc. cit.*
4 Frank Linstow White, "Younger American Women in Art", *Frank Leslie's Popular Monthly Magazine*, 36, November, 1893, p. 542.
5 Achille Segard, *Un peintre des enfants et des mères Mary Cassatt*, Paris, Librairie Paul Ollendorff, 1913, pp. 113–114.
6 William Walton, "Miss Mary Cassatt", *Scribner's Magazine*, 19, March, 1896, pp. 354–355.

PLATE 23 CHILDE HASSAM (from page 68)

commonly good . . . showing the deep cañon between Stock Exchange and Mills building, with groups of men, cabs, and curb brokers dotted about the street. It is done in a large way, and yet the figures on the street have life and reality."[7]

1 "Pennell's Masterly Etchings of the American Scene", *Current Literature*, 47, September, 1909, p. 287.
2 The photograph is reproduced in John A. Kouwenhoven, *The Columbia Historical Portrait of New York*. New York, Doubleday & Co., Inc., 1953, p. 399.
3 "'Ten Painters' Show Pictures", *New York Herald*, 18 March, 1908, p. 9.
4 "Among the Galleries", *Sun*, 25 March, 1908, p. 6.
5 Arthur Hoeber, "Art and Artists", *Globe and Commercial Advertiser*, 17 March, 1908, p. 6.
6 Joseph Edgar Chamberlin, "The Tenth Year of The 'Ten'", *Evening Mail*, 19 March, 1908, p. 6.
7 C. de K., [Charles de Kay], "The Ten American Painters", *Evening Post*, 20 March, 1908, p. 7.

PLATE 24 CHILDE HASSAM (from page 70)

Avenue Presbyterian Church. Hassam's choice of a site in here is certainly not casual; as the Old Lyme Church was a peaceful icon of the American past, so the more massive stone edifice of St. Thomas's, gleaming in heavenly brilliance across from the flags, signified God's blessings upon the Allied war effort. Despite its traditional Gothic style, St. Thomas's had only been built in 1914; it was part of the new New York.

Reproductions of *Allies Day, May 1917* were sold for the Art War Relief Fund; after the war, in November of 1919, a signed reproduction was auctioned for nineteen hundred dollars to benefit the children's reading rooms of France and Belgium, the print purchased by Colonel Michael Friedsam as a gift for Governor Alfred Smith in Albany, New York.[6] Strangely, this picture was never shown with the rest of the Flag series when twenty-four of them were put on exhibition at the Durand-Ruel Galleries in New York on November 15, 1918; variations of that show next appeared at the Carnegie Institute in Pittsburgh in 1919; at three different locations in New York City later that year; and at the Corcoran Gallery of Art in Washington, D. C. early in 1922. Instead, *Allies Day, May 1917* was shown at the ninety-third annual exhibition of the National Academy of Design in March of 1918, where it won the Altman Prize for landscape.

The critics agreed; one acknowledged the picture as the "star" of the show, and another found it "excellent" and "peculiarly timely".[7] One of the most fulsome appreciations was rendered in the *New York Times*, where its patriotic significance was also perceived; the painting was found "a perpetual wonder that anything so difficult as flags could be manipulated with such skill and produce such a really beautiful picture. There is the deep red of the large Union Jack directly in the foreground; the Stars and Stripes, the flag a little larger, given its proper significance in the etiquette of flags, but with a modified color tone; the deep blue of the French Tricolor striking another deep note, and a wind-crumpled flag breaks the monotony of straight lines. There is another flag, the Stars and Stripes, one of the highest, again taking its place of preeminence, but without asssertiveness; there are the softened gray walls of the buildings and a glimpse of the crowds in the street: a charming picture of a difficult subject and a historic scene."[8]

The painting was subsequently displayed over the next twelve months in the annual exhibitions of American art held in Buffalo, Saint Louis, Chicago, and Indianapolis. Hassam's Flag

pictures were emulated by numerous contemporaries, including George Luks, Theodore Butler, Arthur Goodwin, Gifford Beal, Jane Peterson, and the St. Louis, Missouri, Impressionist Frank Nuderscher. In reminiscing about the flag paintings many years later, the notable art critic Elisabeth Luther Cary recalled *Allies Day, May 1917* as "The finest of the group . . . the flags floating clear and definite, keeping their individuality, above a multitude of indistinguishable individuals merging as one as they swarmed along the broad, beautiful street."[9]

1 Ernest Haskell in Nathaniel Pousette-Dart, compiler, *Childe Hassam.* New York, Frederick A. Stokes Company, 1922, p. viii.
2 Hassam interview by Dewitt McClellan Lockman, February 2, 1927, Lockman papers, Archives of American Art, Smithsonian Institution, Washington D. C., microfilm roll 503, frame, 384.
3 Donelson Hoopes, *Childe Hassam.* New York, Watson-Guptill Publications, 1979, p. 82.
4 "Painting America: Childe Hassam's Way", *Touchstone,* 5, July, 1919, pp. 272-274.
5 Alfred Noyes, *The Avenue of the Allies and Victory.* New York, Book Committee of the Art War Relief, 1918, frontispiece, quoted by Ilene Fort, in Los Angeles County Museum of Art, *The Flag Paintings of Childe Hassam,* exhibition catalogue, Los Angeles, California, 1988, p. 46. Dr. Fort's publication is the definitive study of this phase of Hassam's art.
6 Adeline Adams. *Childe Hassam.* New York, American Academy of Arts and Letters, 1938, pp. 71–72.
7 "Notes of the Studios and Galleries", *Arts and Decoration,* 8, April, 1918, p. 267; "The National Academy's Ninety-Third Annual Exhibition", *American Magazine of Art,* 9, May, 1918, p. 290.
8 "Prize Winners of National Academy", *New York Times,* 13 March, 1918, p. 11
9 Elisabeth Luther Cary, "Childe Hassam, Sterling Artist: An Appreciation", *New York Times,* 1 September, 1935, section 9, p. 9.

PLATE 27 JOHN TWACHTMAN (from page 76)

counted, a medium which appears to have prepared the way for acceptance of Impressionism not only among the public but also the artists themselves.

Whenever *Icebound* was created, it represents Twachtman's art at its finest and most personal. In Greenwich, Twachtman subscribed to the lighter color range and loose brushwork that marked his version of Impressionism, though he seldom adopted either the broken strokes or full chromaticism of orthodox Impressionism. Typically Impressionist, however, are the rich blues, not only of the water, but the distant foliage and the more immediate tree trunks, this contrasted with the touches of orange to indicate the remaining foliage. The textures of Twachtman's Greenwich pictures vary greatly, from the thick

grittiness of *Icebound* to the thinner paint application of *Winter Harmony.* In *Icebound,* the sinuous outlines along the edges of the pool suggest the rhythms of turn of the century Art Nouveau. At the same time, the swirling water, the focus of the composition, suggests movement and flux, with both the fullness of the brook and its contours appearing in the process of change through its interaction with the restless, melting snow. The reviewer of Twachtman's 1891 exhibition for *The Studio,* probably its editor Clarence Cook, could have been referring to *Icebound* when he noted that "Almost all the large paintings in the collection . . . were winter pieces, and the treatment of snow, a favorite subject of late with artists at home and abroad, has not been surpassed in truth and beauty by anyone."[3] And almost thirty years later, Duncan Phillips, too, could have had *Icebound* in mind when he wrote about Twachtman's work that "The solemn trance-like stillness of an ice-bound brook in a frozen valley yielded him a pleasure in the phosphorescent ghostly tints which he visioned out of sunlit frost."[4]

1 Dorothy Weir Young, *The Life & Letters of J. Alden Weir,* New Haven, Yale University Press, 1960, p. 190.
2 James L. Yarnall, "John H. Twachtman's *Icebound*", *Bulletin of The Art Institute of Chicago,* 71, January-February, 1977, pp. 2-4.
3 "Paintings in Oil and Pastels by J. H. Twachtman", *Studio,* 6, 28 March, 1891, p. 162.
4 Duncan Phillips, "Twachtman—an Appreciation", *International Studio,* 66, February, 1919, p. cvi.

PLATE 30 JOHN TWACHTMAN (from page 82)

the well known writer on art Charles de Kay may have had such a picture in mind when he asked in an article about Twachtman that appeared in 1918: "With the exception of John La Farge what modern has surpassed this artist in the painting of flowers?"[2]

1 Twachtman, at Greenwich, to Weir, at Branchville, Connecticut, 26 September, 1892, Weir Family Papers, Harold B. Lee Library, Archives and Manuscripts, Brigham Young University, Provo, Utah.
2 Charles de Kay, "John H. Twachtman", *Art World and Arts and Decoration,* 9, June, 1918, p. 76.

PLATE 32 JOHN TWACHTMAN (from page 86)

the titles nor the critics' reactions in the reviews of the exhibitions provide sufficient detail to pinpoint which of the many versions of the subject was the work shown in each case.

Critics and connoisseurs appreciated these pictures, however. Twachtman's *Niagara* exhibited at the National Academy in 1894 was applauded by one reviewer who noted that it had "a feeling of the rush of the cataract about it, and is, in addition, distinguished and individual in color;" while another delighted

in it as "an impressionistic sketch".[2] A more colorful version, rather than a cold, wintry scene, was exhibited with The Ten in 1900, where the painter-writer Guy Pène du Bois enjoyed its "mist of green, red, violet, yellow, blue, orange, a triumph of colors in ecstasy."[3] A winter *Niagara*, similar to the present work, was acquired from the artist's widow by the major art patron William T. Evans, and at Evans' sale in 1913, a writer noted that Twachtman had not attempted "to express the vastness and majesty of the scene, but contented himself with rendering the lovely green and purple tones of the water with the surge and swirl below it, and the further contrast of these moving masses with the smoky lightness of the wind-blown mist and spray."[4] The finest tribute to Twachtman's *Niagaras* was penned by Eliot Clark: "The variations in white, the subtle relation of values, and the delicate harmonies of closely related hues appealed to the painter's aesthetic sensibility . . . Twachtman has revealed this beauty and showed us something other than the largest falls in the world . . ."[5]

[1] Theodore Robinson diaries, Frick Art Reference Library, New York City.

[2] "The Spring Academy", *New York Daily Tribune*, 30, March, 1894, p. 6; "Academy of Design", *Evening Post*, 3 April, 1894, p. 7.

[3] Guy Pène du Bois, "Du Bois Says: The Show of the Ten American Painters Is Intensely Modern", *New York Journal*, 19 March, 1900, p. 6.

[4] "Sale of Evans' Pictures: Art Event of the Week", *New York American*, 31 March, 1913, p. 6.

[5] Eliot Clark, *John Twachtman*. New York, privately printed, 1924, p. 51.

PLATE 34 JOHN TWACHTMAN (from page 90)

[3] "Twachtman's Paintings To Be Exhibited at Mr. Fauley's Studio Next Week", *Ohio State Journal*, 27 January, 1901, section 2, p. 2, quoted by Lisa N. Peters in Ira Spanierman Gallery, *Twachtman in Gloucester His Last Years, 1900-1902*, exhibition catalogue, New York City, 1987, p. 72.

[4] Written on the back of a sketch of this scene once in the possession of Alden Twachtman, and noted in Sheldon Memorial Art Gallery, University of Nebraska-Lincoln, *The American Painting Collection of the Sheldon Memorial Art Gallery*. Lincoln, Nebraska, University of Nebraska Press, 1988, p. 188.

PLATE 36 WILLIAM MERRITT CHASE (from page 94)

In regard to Chase's pictures, de Kay asked "why should not these exquisite scenes of Central Park find their way from the artist's easel to the walls of citizens as easily as pictures of Niagara?"[5] And another writer, probably Clarence Cook, noted in September of 1890 that Chase had spent the summer painting in Central Park, commenting that "This treatment of essentially local subjects has practically been introduced by Mr. Chase in this country."[6] Though Chase's park scenes are modest in dimension and unambitious in content, critics extolled them for their localness—for Chase's exploration of prosaic American scenery in the face of excessive emphasis upon foreign subjects, both by expatriates and by American painters who had returned from European study.

[1] "Some Questions of Art. Pictures by Mr. William M. Chase", *Sun*, 1 March, 1891, p. 14.

[2] Charles de Kay, "Mr. Chase and Central Park", *Harper's Weekly*, 35, 2 May, 1891, pp. 327-328.

[3] "Address of Mr. William M. Chase before the Buffalo Fine Arts Academy, January 28th, 1890", *Studio*, new series, 5, 1 March, 1890, p. 124.

[4] De Kay, *op. cit.*, p. 328.

[5] De Kay, *op. cit.*, p. 328.

[6] "American Notes", *Studio*, 5, 27 September, 1890, p. 425.

PLATE 37 WILLIAM MERRITT CHASE (from page 96)

[3] Charles de Kay, "Mr. Chase and Central Park", *Harper's Weekly*, 25, 2 May, 1891, p. 328.

[4] "Some Questions of Art. Pictures by Mr. William M. Chase", *Sun*, 1 March, 1891, p. 14.

[5] *Ibid. Flower Beds* is presently unlocated. There is a possibility, of course, that it may actually be our picture, presently entitled *The Nursery*; or it may be such a work as Chase's *Terrace at the Mall, Central Park* (Richard M. Scaife collection, Pittsburgh).

[6] De Kay, *loc. cit.*.

PLATE 38 WILLIAM MERRITT CHASE (from page 98)

Theodore Robinson and William M. Chase—'La Debacle' and 'The Fairy Tale'"; united again in the present exhibition.[3] The picture remained unsold until 1898, when it entered the collection of William T. Evans, one of the foremost collectors of contemporary American art at the turn of the century.

[1] John Gilmer Speed, "An Artist's Summer Vacation", *Harper's New Monthly Magazine*, 87, June, 1893, p. 11.

[2] *Op. cit.*, p. 3.

[3] "American Artists' Best Show of All", *New York Herald*, 15 April, 1893, p. 4.

PLATE 40 WILLARD METCALF (from page 102)

[1] "In the World of Art", *New York Times*, 27 March, 1896, p. 22.

[2] Theodore Robinson diaries, Frick Art Reference Library, New York City, entry for March 28, 1896.

[3] [Royal Cortissoz], "The American Artists", *New York Daily Tribune,* 28 March, 1896, p. 7.

[4] "The Society of American Artists", *Art Amateur,* 34, May, 1896, p. 129.

[5] Quoted by Elizabeth de Veer in Elizabeth de Veer and Richard Boyle, *Sunlight & Shadow The Life and Art of Willard L. Metcalf.* New York, Abbeville Press, 1987, p. 59.

PLATE 46 EDMUND TARBELL (from page 114)

[1] Sadakichi Hartmann, "The Tarbellites", *Art News,* 1, March, 1897, pp. 3-4.

[2] "The Fine Arts", *Boston Evening Transcript,* 4 March, 1891, p. 4; *Boston Herald,* 8 March, 1891, p. 12; Desmond Fitzgerald, "The Benson and Tarbell Exhibition", *Boston Post,* 7 March, 1891, p. 4.

[3] "'The Academy' Exhibition", *Art Amateur,* 24, May, 1891, p. 145; "Art Gossip," *Art Interchange,* 26, April 25, 1891, p. 129.

[4] "The Academy Exhibition", *The New York Times,* 6 April, 1891, p. 4; "American Art", *Sun,* 12 April, 1891, p. 25.

PLATE 47 EDMUND TARBELL (from page 116)

The picture appeared in numerous subsequent shows, including one-artist exhibitions at the St. Botolph Club in February of 1898; at the Worcester, Massachusetts Museum in April of 1905; at the Corcoran Gallery of Art in Washington, D. C. in January of 1908; and at the Copley Society of Boston in May of 1912. Strangely, though the painting continued to garner great acclaim, it never sold, and remained with Tarbell and subsequently his family until recently.

[1] "The Sixty-Seventh Annual Exhibition of the National Academy of Design in New York", *Studio,* 7, April, 1892, p. 163; "The National Academy Exhibition", *Art Amateur,* 26, May, 1892, p. 141; Royal Cortissoz, "Art in New York", *Arcadia,* 1, May 2, 1892, p. 13; "The Spring Academy", *New York Daily Tribune,* 19 April, 1892, p. 7.

[2] William Howe Downes, "New England Art at the World's Fair," *New England Magazine,* 8, May, 1893, p. 362.

[3] [William] Howe [Downes] and [George] Torrey [Robinson], "Edmund C. Tarbell, A. N. A.", *Art Interchange,* 32, June, 1894, p. 167.

[4] S. C. de Soissons, *Boston Artists A Parisian Critic's Notes,* Boston, n.p., 1894, p. 69.

PLATE 48 EDMUND TARBELL (from page 118)

Then, almost suddenly, came the *Girl Crocheting,* which, in its quiet perfection, seemed to eclipse his own previous works . . ."[3]

The abundant literature on *Girl Crocheting* in the several decades following its appearance in 1905 concentrated upon the formal elements of the picture and its relationship to Dutch seventeenth century art; thematic concerns went unnoticed. Royal Cortissoz, for instance, described the scene as "an episode possessing no great significance in itself [though it] is justified through being made the vehicle for the expression of a purely artistic and wholly winning effect".[4]

More recent scholars such as Bernice Kramer Leader, especially, have offered a radically different interpretation of this painting and other examples by the Boston artists, emphasizing the highly idealized version of solitary, domestic life implicit in such a rarified interior. Such a picture would "seem to corroborate contemporary feminine ideals of virtuous womanhood" in the face of increasing assertions of female independence and the strong suffragette movement of the period, while such pictures, painted for patrons drawn from traditional Boston families, reaffirmed traditional values of male superiority.[5]

[1] Bernice Kramer Leader, "The Boston School and Vermeer", *Arts Magazine,* 55, November, 1980, pp. 172-176.

[2] Guy Pène du Bois, "The Boston Group of Painters", *Arts and Decoration,* 5, October, 1915, p. 459.

[3] Kenyon Cox, "The Recent Work of Edmund C. Tarbell", *Burlington Magazine,* 14, January, 1909, p. 259.

[4] [Royal Cortissoz], "The Ten American Painters", *New York Daily Tribune,* 26 March, 1905, p. 7.

[5] Bernice Kramer Leader, "The Boston Lady as a Work of Art: Paintings by the Boston School at the Turn of the Century", unpublished Ph. D. dissertation, Columbia University, 1980, p. 57 and passim; Kramer, "Antifeminism in the Paintings of the Boston School", *Arts Magazine,* 56, January, 1982, pp. 112-119.

PLATE 50 JOSEPH DeCAMP (from page 122)

Boston in the winter of 1913, and again at the Club in January of 1924 in the *Memorial Exhibition of the Work of Joseph Rodefer DeCamp 1858-1923.*

[1] The Vermeer revival, which began in France in the 1860s, is first documented in the United in the publication of a monograph on the artist in the *Masters of Art* series in 1904, which is believed to have been written by Philip Hale. Hale expanded upon this in *Jan Vermeer of Delft.* Boston, Small, Maynard and Company, 1913.

[2] Jerrold Lanes, "Boston Painting 1880-1930", *Artforum,* 10, January, 1972, p. 50.

[3] James B. Townsend, "Annual Exhibit of The Ten", *American Art News,* 23, 20 March, 1909, p. 6.

[4] Philip L. Hale, "'Ten American Painters'", *Boston Herald,* 14 April, 1909, p. 7.

PLATE 51 PHILIP LESLIE HALE (from page 124)

[1] Cited in Erica E. Hirschler, "Philip Leslie Hale", in: Museum of Fine Arts, *The Bostonians,* exhibition catalogue, Boston, 1986, p. 211.

[2] Philip Hale, "Art in Paris", *Arcadia,* 1, 1 January, 1893, pp. 375.

[3] Hale to William Howard Hart, 29 July, 1895, Philip Leslie Hale Papers, Archives of American Art, Smithsonian Institution, Washington, D. C.

[4] *Collector and Art Critic,* 2, 1 January, 1900, p. 85.

[5] "Art Exhibitions", *New York Daily Tribune,* 16 December, 1899, p. 6.

PLATE 52 EDWARD H. BARNARD (from page 126)

sionist mode to themes of social relevance. Angelo Morbelli's *For Eighty Cents* (Civico Museo Antonio Borgogna, Vercelli, Italy) of 1895 offers an especially intriguing parallel, illustrating the nearly identical theme of rice harvesters.

[1] The most thorough study of this little-known artist is the unpublished paper by Carrie Rebora, "Edward Herbert Barnard 1855-1909", Graduate School of the City University of New York, 1985.

[2] F. W. Coburn, "Reminiscences of Barnard", *Boston Evening Transcript,* 5 May, 1909.

[3] *Idem.*

[4] *South End Free Art Exhibition,* catalogue, Boston, 1895, p. 8.

[5] *Idem.*

PLATE 54 ROBERT SPENCER (from page 130)

[1] Frederic Newlin Price, "Spencer—And Romance", *International Studio,* 76, March, 1913, p. 489, quoted by Thomas Folk in: New Jersey State Museum, *Robert Spencer: Impressionist of Working Class Life,* exhibition catalogue, Trenton, New Jersey, 1983, p. 10.

[2] Price, *op. cit.,* p. 490.

[3] Price, *op. cit.,* p. 489.

[4] "National Academy's Annual Exhibition", *Evening Mail,* 21 March, 1914, p. 8.

PLATE 55 DANIEL GARBER (from page 132)

with *The Orchard Window* (private collection) of 1918, showing his daughter seated indoors in profile in front of a large-paned window, again with light streaming in through her dress as well as the transparent curtains on either side; this picture won the Temple Gold Medal at the Pennsylvania Academy of the Fine Arts in 1919.[3]

[1] Harvey M. Watts, "Nature Invites and Art Responds. The Haunts of the Painters of the Delaware Valley School", *Arts and Decoration,* 15, July, 1921, pp. 196-198.

[2] Bayard Breck, "Daniel Garber: A Modern American Master", *Art and Life,* 11, March, 1920, p. 497.

[3] Gardner Teall, "In True American Spirit. The Art of Daniel Garber", *Hearst's International,* 39, June, 1921, pp. 28, 77.

LENDERS

Mr. and Mrs.Robert B.Aikens
Albright-Knox Art Gallery, Buffalo, New York
Art Institute of Chicago, Chicago, Illinois
Baltimore Museum of Art, Baltimore, Maryland
Thomas W. and Ann M.Barwick
Brooklyn Museum of Art, Brooklyn, New York
Canajoharie Library and Art Gallery, Canajoharie, New York
Cincinnati Art Museum, Cincinnati, Ohio
Cleveland Museum of Art, Cleveland, Ohio
Columbus Museum of Art, Columbus, Georgia
Corcoran Gallery of Art, Washington, D.C.
Cummer Gallery of Art, Jacksonville, Florida
Galleria Internazionale d'Arte Moderna, Ca' Pesaro, Venezia
John H.Garzoli
Herbert M. and Beverly J.Gelfand, Los Angeles, California
Georgia Museum of Art, The University of Georgia, Athens, Georgia
F.M.Hall Collection, Sheldon Memorial Art Gallery, University of Nebraska, Lincoln, Nebraska
Hartford Steam Boiler Inspection and Insurance Co., Hartford, Connecticut
Herbert F.Johnson Museum of Art, Cornell University, Ithaca, New York
Mr. and Mrs. Raymond J.Horowitz
IBM Collection, Armonk, New York
Los Angeles County Museum of Art, Los Angeles, California
Manoogian Collection
Mead Art Museum, Amherst College, Massachusetts
Memorial Art Gallery, University of Rochester, Rochester, New York
Metropolitan Museum of Art, New York, New York
Ms. Barbara B. Millhouse
Milwaukee Art Museum, Milwaukee, Wisconsin
Mr. Joseph L. Moure
Museum of Fine Arts, Boston, Massachusetts
Museum of Fine Arts, Springfield, Massachusetts
National Gallery of Art, Washington, D.C.
Newark Museum, Newark, New Jersey
Parrish Art Museum, Southhampton, New York
Pfeil Collection
Phillips Collection, Washington, D.C.
Mr. and Mrs. Meyer P. Potamkin
Museum of Art, Rhode Island School of Design, Providence, Rhode Island
Scripps College, Claremont, California
Daniel J.Terra Collection, Chicago, Illinois
Virginia Museum of Fine Arts, Richmond, Virginia
Warner Collection of Gulf States Paper Corporation, Tuscaloosa, Alabama
and those lenders who wish to remain anonymous

PHOTOGRAPHIC
REFERENCES

William H. Gerdts, New York, Ill. 1, 3–17; Thyssen-Borne-misza Foundation, Ill. 2. catalogue numbers: Albright-Knox Art Gallery, New York, 22; Art Institute of Chicago, 32, 17; Baltimore Museum of Art, 7; Osvaldo Böhm, Venezia, 64; Brooklyn Museum, 27, 54; Canajoharie Library and Art Gallery, New York, 48; Cincinnati Art Museum, 35; Cleveland Museum of Art, 26; Corcoran Gallery of Art, Washington, D.C. 2; F. Scott Coulter, Columbus Museum of Art, 6; Cummer Gallery of Art, Florida, 62; Georgia Museum of Art, 9; Hartford Steam Boiler Inspection and Insurance Company, Fine Arts Collection, Connecticut, 53; Herbert F. Johnson Museum of Art, New York, 23; IBM Collection, New York, 49; Los Angeles County Museum, 1; Paul M. Macapia, 44; Manoogian Collection, 28, 37, 41, 45, 59, 63; Mead Art Museum, Massachusetts, 40; Memorial Art Gallery, New York, 33; Metropolitan Museum of Art, 8, 25; Milwaukee Art Museum, 46; Museum of Fine Arts, Boston, 15, 50, 51; Museum of Fine Arts, Springfield, Massachusetts, 42; National Gallery of Art, Washington, D.C., 24, 31; Newark Museum, New Jersey, 19; Parrish Art Museum, New York, 29; Giuseppe Pennisi, Foto Cine Brunel, Lugano, 18, 36, 39, 61; Pfeil Collection, 14, 20, 52; Phillips Collection, Washington, D.C., 16; Museum of Art, Rhode Island School of Design, 43; Scripps College, Claremont, California, 10; Sheldon Memorial Art Gallery, University of Nebraska-Lincoln, 34; Daniel J. Terra Collection, 5, 13, 60; Virginia Museum of Fine Arts, 3; Warner Collection of Gulf States Paper Corporation, Alabama, 55.